MASTERPIECES
OF GREEK DRAWING AND
PAINTING

MASTERPIECES
OF GREEK DRAWING AND
PAINTING

By

ERNST PFUHL

Translated, with a Foreword, by

J. D. BEAZLEY

Hacker Art Books
New York 1979

First published New York, 1955
Reissued 1979 by Hacker Art Books, New York.

Library of Congress Catalogue Card Number 79-83879
International Standard Book Number 0-87817-250-5

Printed in the United States of America

PREFACE

THE plates contain a selection from the eight hundred reproductions in my three-volume work *Malerei und Zeichnung der Griechen* (Munich, 1923, Bruckmann). The first principle of selection was naturally artistic importance : this principle usually coincides with that of importance for the history of art, but not always, for a work of slight value in itself may sometimes give an echo of some lost masterpiece. To omit such altogether was hardly possible save at the expense of coherence : but I have restricted their number to the minimum ; some may think to one only (Fig. 5). That is also the only place where I have contented myself with an inferior reproduction of the original : it does not pretend to be more than an indication, and as such it has a less painful effect than better reproductions of similar works.

For the rest this little book makes no scientific pretensions. It is intended neither as a guide to the study of vases nor as a history of Greek painting. It is what its title denotes, a collection, though not an arbitrary one, of masterpieces of Greek painting and drawing (any one who cares may call the Pompeian wall-paintings Roman, as long as he realises that the art of the Imperial age is the last phase of Hellenistic art). The chief object of the text is to answer such questions as the pictures naturally suggest to the lover of the arts : this involves at least an indication of the chief connexions. General features requiring explanation are discussed at their first appearance in our selection of pictures. Those who wish to know more will find it easily in my large work, where I have kept the main text as free as possible from archaeological ballast. For vase-painting many readers will have by them Buschor's admirable book, which has appeared both in German and in English.

There are still a few observations to make about the reproductions. In drawings after vases it is customary to indicate the purple details of the original by a grey tone. Plate 4 gives a good example of the way in which the picture-bands running round the curved surface of a vase are rolled and flattened out in the reproduction. The circular pictures are sometimes from plates but usually from drinking-cups, in which they seldom cover the whole surface of the interior. They are framed at first by narrow lines, later by bands of maeander. These borders are usually cut off square in my reproductions, and sometimes even omitted, to avoid excessive reduction of the pictures themselves : this makeshift, unavoidable in my large book, must be tolerated here also, and excused by the conditions of our time. Other matters will explain themselves. When the references in the margin of the text are bracketed, it means that the pictures are mentioned at this point but not described at length.

In conclusion I must express my hearty thanks to the leading investigator of Attic vases, Prof. J. D. Beazley of Oxford, for translating the book into English. E. P.

A word or two with the author's sanction. In books mentioned on p. 145, I have given my opinion as to the authorship of nearly all the red-figured vases here reproduced or discussed. I will therefore confine myself to a single important point : Prof. Pfuhl seems inclined to run together what I consider to be four different artists :—(1) Euphronios, painter of Figs. 46 and 47 ; (2) the Panaitios painter, painter of Figs 48 and 49 ; (3) the Pistoxenos painter, painter of Figs. 66–67, 69, and 70 ; (4) the Penthesilea painter, painter of Figs. 71–73.

Fig. 81 is not set rightly, the ground-line should of course be parallel to the bottom of the page ; Fig. 84 is impaired by the restoration of the right shoulder and arm of the youth in the original. It is clear from the original of Fig. 103 (to which the old drawing here reproduced does scant justice) that the little boy is not Dionysos, as suggested on p. 76, but a satyr. There is no reason to suppose that the unintelligible inscription mentioned on p. 52 is obscene.

A few corrections have been made in the text and in the titles of the pictures.

It may be well to point out that the term 'classical art' is used throughout in the narrower sense in which Wölfflin uses it, and not in the wider sense as equivalent to 'ancient Greek and Roman art.' J. D. B.

FOREWORD

When the publishers asked me to write a foreword to this impression of Pfuhl's *Masterpieces* and to bring the bibliography up to date, they suggested that I might wish to make some alterations in the text. I have not done this ; and turning over the pages I see that there would have been comparatively little to change. Much work has been done on the subject since 1926, but as a broad survey, clear and vivid, the book holds its own.

There is one large question on which opinion was divided in Pfuhl's time, and is divided still. How far can the wall paintings of the Roman period be regarded as faithful copies of fourth, third, second century Greek pictures, or even as preserving the essential features of the lost originals. It is a matter of degree. Pfuhl, though by no means extreme in his attitude, is inclined to place more trust in them than some scholars do. If I may state my own opinion, I feel that the originals must have differed profoundly from these copies or rather imitations.

The list on page 146 gives the artists of the Attic vases which form a large proportion of the objects reproduced. J. D. B.

CONTENTS

PREFACE *page* v

FOREWORD to this impression vi

INTRODUCTION
 General remarks. Greek sculpture 1
 Nature and technique of Greek vase-painting 3
 Greek monumental painting 7

COMMENTARY
 The beginnings. The geometric style 10
 The Orientalising style 13
 The black-figure style 15
 Ionian 15
 Chalcidian 19
 Corinthian 19
 Laconian 22
 Attic 23
 The severe red-figure style (Attic) 30
 The beginnings 32
 First bloom 38
 The prime and the late period 44
 Etruscan wall-painting of the archaic period 53
 The classical style 54
 Early classical vase-pictures and paintings 55
 The white sepulchral lekythoi 66
 The red-figure style of the Periclean age 73
 The florid style of the late fifth century 78
 The vase-painting of the fourth century 83
 Drawing on bronze and ivory 85
 Monumental painting from the later fifth century onwards 86
 Early works 87
 Copies in Pompeian wall-painting 89
 The Alexander mosaic 92

CONTENTS

The marble picture of Niobe *page* 99
Wall-paintings in the style of the fourth and third
 century 102
Wall-paintings of advanced Hellenistic style 108
Decorative wall-painting : Boscoreale, Villa Item,
 Aldobrandini Wedding 118
Portrait painting : mummy portraits 123
Special classes of Hellenistic painting 127
 The picture of manners 128
 The animal-piece and the still-life 132
 Landscape painting 139

BIBLIOGRAPHY 144

LIST OF ARTISTS OF THE ATTIC VASES
 ILLUSTRATED 146

INDEX 148

MASTERPIECES
OF GREEK DRAWING AND
PAINTING

INTRODUCTION

FROM the west coast of Asia Minor, the land of Homer, to
the Golden Gate of San Francisco and away to Sydney and
Wellington; from the immigration of the Greeks into their
historical homes to the present day: four thousand years of
history and a single culture unite the peoples of the West. The
roots of their thought and their emotion are in Hellas, where European
humanity manifested itself for the first time, and with incomparable clarity,
purity, and beauty, in house and state, in art and poetry, in thought and
science. Wherever Europeans have settled and great communities have
expressed themselves in monumental buildings, there we find Greek
columns and pediments, Greek orders and mouldings. These are some-
thing more than an historical symbol: for even where the architect has
been but partially conscious of the forms which he has employed, some-
thing of the magic of Hellas lingers in these late descendants of Greek
architecture. In architecture and the figurative arts, as in philosophy and
in poetry, the Greeks turned all they touched into forms of crystalline
clearness, whose beauty was the natural expression of their intrinsic
necessity. Their works of architecture and of political and philosophical
thought, no less than their poetical and artistic creations, are permeated
with organic life. The Greeks could not but feel organically, for man
was to them the measure of all things. Greek humanity and Greek
mastery of form laid the foundations of spiritual Europe, and raised a
structure on those foundations of a lustre which no subsequent period,
however great its achievements, has equalled: for the lustre is the light
of pure youth.

More than two thousand years divide us from the creative periods
of Hellas: and the full magic of Hellas reveals itself only to those who
live in the works of the Greeks, and who moreover know the land of

Greece, not from hurried visits, but as a second home. For those who have not enjoyed that good fortune, and who are unacquainted with the Greek language, there is only one road to the real Hellas : the contemplation of Greek art. But even direct vision is not sufficient to bridge the intervening years : some historical preparation we must have, unless we are content to see the works of the past with the eyes of our own time. The scholar also, of course, sees with the eyes of his time : but his eyes are trained to look at things historically and to see the detail as part of the whole. Moreover, it is not every one who can appreciate artistic forms at first sight : the eye for form is rarer than the ear for music. The text which follows is intended to make the pictures easier to understand, both historically and artistically.

At the mention of Greek art every one thinks first of Greek sculpture. And rightly : for however splendid the achievements of the cathedral sculptors, of Michelangelo, of Rodin, no other people has had a sculpture of such grandeur, abundance and perfection, or playing such an important part in the total life of the people. This supremacy of sculpture is the artistic expression of the idea which Greek culture embodies in a thousand forms, the idea which was resumed in two words at the entrance to the Delphian temple of Apollo :—Know thyself. Man, the noble, generous fruit of southern nature, is everything for the Greek : man, body and soul in one. To the Greek, the soul does not speak from the eye or the countenance only, but is expressed and embodied in the fine forms, the natural nobility and the well-bred demeanour of the whole body in movement or at rest. Hence the hero of a drama can say ' my body ' for ' I.' In the religious life of the Greeks we find the same plastic force at work as in their art, and the same joyous youthful consciousness being moulded into eternally valid forms by great poets and artists. In his human-shaped divinities the Greek has incorporated and transfigured all that he found in his own heart and in the whole of human life, and every impression which he received from nature assumed human form : from field and forest, mountain and valley, sea and heaven, his own countenance looked back at him a thousandfold, and he felt the influence of powers with human souls. His aim was to make himself, both in body and in soul, as beautiful, as good, as noble, and finally as moral, as his nature dictated and permitted ; to develop his qualities and capacities to their highest point ; and to fuse them into a perfect harmony : and what human imperfection was unable to attain found realisation in the ideal creations of poets and artists. What the noblest minds longed for, what the pious heart felt in its depths, stood solid and palpable in sculpture for all to see.

When the genius of Winckelmann opened a new epoch in the spiritual life of Europe, his starting-point was Greek sculpture. His divining eye detected the essence of Hellenism even when it was obscured in late works and Roman copies. To-day, except for purposes of research, we can afford to ignore many of these falsified and often wrongly restored works. For we possess what Winckelmann longed for, original Greek works of the highest rank. Archaic sculpture ; the sculpture of the Temple of Zeus at Olympia ; the sculpture of the Parthenon : what a world lies in these three words ; and how much we have besides ! With respect to Greek drawing and painting Winckelmann's position was no better, and here his power of divination seems even more remarkable. He knew, indeed, important examples of Campanian wall-painting, with its reminiscences of the monumental art of Greece. But such vase-paintings as he knew were nearly all mannered products of an aftermath. Yet even in these, in spite of their vapid and mechanical execution, he felt the high style which lay *Fig.* 109 behind. In the three generations since the first great finds in Etruscan tombs, the number of our Greek vases has become almost overwhelming. We have important specimens by the thousand, and masterpieces by the hundred, pieces which are as little inferior to the creations of monumental art as drawings or engravings by modern artists to their paintings. Comparisons with modern art are apt to be misleading, for everything was different in Greece : but this comparison is permissible, in spite of Greek vase-painting being not free but applied art, decoration of vessels. For the chief characteristic of Greek vase-painting is that, like monumental painting and like sculpture, it was dominated by the human figure. That constitutes its importance but also its limitation. Painting in our sense it could never be, without ceasing to perform its tectonic function. Realistic paintings on vases are inconceivable in Greek art. Even in the periods when monumental painting was no more than coloured drawing flatly treated, the vase-painters made but a few short-lived experiments with a colouring approximating to nature : they soon developed a kind *Figs.* 3-5, of painting better suited to their technique and their function as decorators 10 —silhouette painting in lustrous dark-brown pigment, with details ren- *Figs.* 6-9, dered by incised lines showing up light on dark, and by a decorative use 11-26 of lustreless purple and white. This is painting, of course, as understood by the early artist, but it is already a decorative painting adapted to the special conditions of the potter's art, and even farther removed from natural appearances than the monumental painting of the time. It is called the black-figure style.

Significantly enough, the subsequent development led not to **painting**

proper but to pure drawing. To satisfy the demands of a style which had now become freer, the black-figure method was abandoned, first by the leading masters, then gradually by the rest, till by the beginning of the classical period it had almost disappeared: it survived, indeed, in small ritual and local classes of vase, right into the Hellenistic period, actually *Figs.* 27-34, outliving its successor, the 'red-figure style,' an Attic invention which 36-67, 71- dominated the markets of the world for two hundred years. With the 80, 98-110 introduction of the red-figure style, the Attic potters supplanted for good a large number of other fabrics: we know of over fifty. An offshoot of this Attic style continued to flourish in Lower Italy as late as the third century. Then vase-painting died out almost completely, and was superseded by pottery with reliefs. The red-figure style was a creation which had the simplicity of genius. In monumental painting the figures were in colour, sometimes on a light, sometimes on a dark background. In the black-figure style they were dark on the reddish-yellow background of the clay. In order to be able to draw more freely, the relation was reversed: the whole vase and the background of the figure were covered with the fine lustrous black, and the ornaments, figures and objects of the pictures reserved in the natural colour of the clay.

This innovation took place during the transition from the severe to the mature archaic style, in the third quarter of the sixth century. At that time drawing was still strictly flat in character, the line simple, and the stylisation largely ornamental, so that it was easy for the pictures to perform their decorative function. The new technique was actually an advantage in this respect, for the drawing rested on a framework of lustrous raised relief-lines, the full effect of which no reproduction can give. The instrument which produced them did not lend itself to swift and complicated movements of line: there was thus a happy consensus of severe style and technical restrictions. Finer details, which did not show at a distance, could be put in with the pliant brush; the brush could also be used to apply a golden-yellow obtained by diluting the black glaze, and thus to produce astonishingly pictorial effects of blond hair, flickering fire, and the like. But these are details which tell no more in the total effect of the picture than the touches of red or white or even raised gold. In the main the drawing preserved its severely linear character, and even the perspective treatment of the body which soon came into vogue hardly affected at first the flatness of the design as a whole. It is quite true that when the black-figure style gave way to the red-figure 'the virtuosi of the ornamented surface' were succeeded by 'the delineators of the moving surface': but although the decorative effect was

not so strong as in the old silhouette style, it was not yet seriously impaired.

In the mature archaic style, from the end of the sixth century to the *Figs.* 37-seventies of the fifth, vase-painting was at its height, and the best vases rank 67 among the finest artistic products of their period, a period which offers us the incomparable spectacle of the first stages in the emancipation of art from the age-long fetters of primitive modelling and drawing. The vase-painters had already begun to sign their vases, but now the signatures multiply, and are occasionally accompanied by a word of self-praise or even a challenge to a fellow-painter. We often find two signatures on one vase, the painter's name, and the name of the owner of the factory, who might be the same as the painter but might also be different : for the larger factories could employ several painters simultaneously, the smaller several in succession. Another expression of the sense of personality is the so-called love-inscription, in praise of fair youths or less commonly girls, a custom found even in the Zeus of Pheidias, on whose finger were the words ' Pantarkes is fair.'

Side by side with the red-figure style and the survival of the black-figure we find a third technique (excluding unimportant varieties)—white-ground painting. The white ground is common in the late black- *Figs.* 35, 69, figure style, but there its only artistic importance is that it makes the black 70, 81-97 silhouettes stand out still sharper from the background. It is otherwise when the white ground is painted in the technique and manner of the red-figure style, but without the blacking-in of the background : here the contour-line as such acquired a fresh significance, and the element of drawing was thereby strengthened. But at the same time a pictorial element was added, small areas being filled in with black, larger with diluted glaze or later with lustreless colours : charming as such pictures are, they contain an inherent contradiction ; and in this form the white-ground vase neither became very common nor went through an internal development. It obtained far finer effects where it remained almost pure drawing, merely grading its delicate brush-lines within a scale of golden sepia. This happened first about the middle of the fifth century, in the classical style : and at the same time a powerful movement in the opposite direction set in, for in the oil-vessels used at tombs, the slender lekythoi, the durable glaze-painting gradually lost ground and ultimately was superseded by painting in dull colours. A special class of vase thus arose in which a compromise between painting and drawing overcame the inherent contradiction. For except in a small late variety, the painters did not attempt to work out the coloured areas pictorially in

5

accordance with the advances made in monumental painting. Outline drawing, and decorative colouring, often very vivid, united to form a thing of perfect internal balance.

The best white lekythoi are the most precious works of vase-painting in the mature classical period. For although beautiful and important red-figure vases continued to be produced in the half-century round 450, yet it became clearer and clearer as time went on that the red-figure style was by nature an archaic creation. The free drawing of the classical style, and the corporeal rounding of its figures, clashed with the technical and decorative conditions of red-figure vase-painting. And the representation of spatial environment, to which monumental art was now turning its attention, was completely incompatible with those conditions. The archaic style sometimes gave a suggestion of space, in a single plane, by means of such landscape elements as trees, rocks, buildings and the like : vase-painting also could do this without suffering, just as it could arrange incorporeal silhouettes in layers one behind the other. But now in the early classical style monumental painting began to represent space by an arrangement of the figures in tiers, with indication of the terrain : at first, it is true, the arrangement was in a single plane, but the standing-line common to all the figures—which had hitherto determined the conformation of the picture—was abandoned. And now the body perspective also, strengthened by many three-quarter views which had hitherto been avoided, acquired an increased spatial importance, and in composition also true spatial effects were aimed at. These innovations in the great monumental painting of the time, which covered wide spaces of wall with pictures containing hundreds of figures, threw the vase-painters into profound excitement. One group of them may even be described as *Figs.* 71, 75, wild men, so impetuously did they attempt to follow in the steps of 77 monumental painting. The attempt was bound to fail, because it was irreconcilably opposed to the technique of vase-painting and its decorative function. Time justified those who had never turned aside from the beaten track, and later painters learned a wise humility. Even *Figs.* 105, the arrangement of the figures in tiers on a landscape background indicated 109 by. lines was transformed into a flat decorative scheme. The finest *Figs.* 98- classical vase-pictures belong to the Periclean age. They are painted 105 with a light hand, sometimes almost sketched rather than carried out in detail. The painters, one would think, were conscious that they could not get nearly as close to monumental art as their archaic predecessors : and in the course of the fifth century the signatures become rapidly rarer, and soon disappear. But the artistic self-restraint of the Periclean epoch

6

was followed by a kind of second bloom. The florid style of the later *Figs.* 106-
fifth century did not fall immediately and never fell altogether into smooth 109
routine and cloying affectation : a spark of the genuine fire of late Pheidian
art glows in it still, and certain of its works show the influence of great *Fig.* 108
creations of monumental painting. Lastly, in the fourth century, the
Athenians tried to make a linear approximation to the new style of monu-
mental art, and it is owing to this final effort that Attic painting died in *Fig.* 110
beauty. The vase-painters of South Italy lacked the Attic sense of measure:
after promising starts, and in spite of a talent for draughtsmanship, they
fell into affectation and bombast. By the time they at last gave place to
the relief-potters, the red-figure technique had outlived itself more than
a century.

At that time, at the turn from the fourth century to the third, monu-
mental painting was in its prime : for as painting in our sense of the word,
it reached its classic prime a hundred years later than sculpture. The
Parthenon was already finished when the last third of the fifth century
witnessed the decisive achievements of the masters Apollodoros, Zeuxis,
and Parrhasios, the last step in the development from a coloured drawing,
with slight shading, on a background which was still half flat plane half
landscape, to a real spatial painting with a uniform system of light and
shade. Something new and undreamt of had come into being, illusion-
istic painting, capable of taking a piece of the outer world, seen as a unity,
and making a deceptive reproduction of it on a flat surface. If man had
not been from the beginning and always the chief subject of Greek art,
the same development might now have taken place as in modern art,
in which landscape-painting has played a great part even in the figure-
picture, and at times a leading part in the total artistic production. Not so
in Greek painting. No sooner had spatial depth been opened up than it
was circumscribed once more, and one might even say that true space
was less important in the panel-pictures of the later period than the
suggestion of it on a single plane had been in earlier monumental painting.
For a long time it was there only for the sake of the figures filling it.
This much we may infer both from our literary sources and from all
sorts of reminiscences, ranging from vase-pictures of the florid style *Fig.* 108
to Pompeian wall-paintings of the early Empire ; many details are still *Fig.* 118
disputed.

Painting is at its zenith when we find ourselves at last on the firm
ground of trustworthy copies after particular masterpieces : copies, or
strictly speaking, one copy, the Battle of Alexander. The monumental *Fig.* 121
mosaic, over five feet broad, from Pompeii, itself belongs to a good

7

Hellenistic period : and it is almost certainly a faithful copy of a picture painted by the Attic master Philoxenos of Eretria for King Cassander : the fidelity almost goes beyond the technical conditions of mosaic work. This picture, says our chief authority, Pliny, was inferior to none—an invaluable testimony. So the monumental painting of the Greeks is not entirely lost. Cautious investigation has also enabled us to discern, through the veil of late Italic painting, the main features, sometimes more, *Figs.* 119- of several other important pictures from the great period. Finally, the
125
(126, 128) art of these Italic pictures themselves is the full inheritor of an art to which no field of pictorial vision was wholly strange, even if some of them have been explored more fully by modern art.

Summing up, one may say that Greek painting, in and after its classical bloom in the second half of the fourth century, was completely master of space, light and colour ; completely, that means, as far as its general artistic purposes demanded. But these purposes led to certain limitations compared with modern art. In painting, as elsewhere, man remained the measure of all things to the Greeks, his shape and his inner life the paramount theme. This fundamental tendency in the whole intellectual life of the Greeks makes itself felt in all three departments of pictorial expression. The representation of space did not lead to a landscape-painting independent of other kinds of painting and their peer in expression and even in form. Modest decorative pictures, from which man and his works were never absent, were the most that the Hellenistic period achieved in this respect, and the best landscape figure-pictures of the Imperial age do not rise above a side-scene-like kind of decorative landscape. The epoch-making achievement lies in the principle, not in the exhaustion of the possibilities.

The artistic treatment of light went considerably farther : nor is this accidental, for the primary use of lighting was to bring about a finished pictorial rendering of the human form. From the human form, indeed, it almost immediately passed to the picture-space, first through the cast shadow, and gradually developed into an independent means of effect. We possess examples of ingenious lighting from Hellenistic and Roman times. But here also the limitations and the distance from modern art are sensible. Since the lighting subserved the form—in composition almost as much as in modelling—it remained simple and clear, and a bright, equable light predominated. The Greek masters did not attempt to exhaust either the pictorial or the expressional values of lighting, such as have been familiar to us since the seventeenth century. As far as we know, they did not take more than the first steps in that

8

direction. Light, however, subserves not only the rendering of form, but colouring as well. Now of all pictorial means of expression, colour appears to have been developed farthest : and light participated. We shall find important examples from the earliest mosaics to the Campanian wall-paintings, and our literary tradition teems with references to subtleties or even weaknesses of colouring in painters, and with theories of colour propounded by philosophers. In Plato the theory is accompanied by the artist's and poet's delight in colour. The topic was treated in the theoretic writings of the artists themselves, and what we read about colours, light and air in the pseudo-Aristotelean tracts De Coloribus and De Audibilibus can hardly be independent of these writings. A great deal of it has a surprisingly modern ring, and shows that there was a highly developed theory corresponding to an artistic practice which we can still make out in its main features. The fact is not altered by the ingenious picturesqueness of certain explanations, which merely betokens the sensuous mind of the artist. It sounds like an echo of the development which took place, evidently not without struggles, in the course of the fourth century, when Xenokrates from his early Hellenistic standpoint attributes austerity of colouring to certain painters and actual hardness to others : his standard was a perfectly free play of colour. But the limits to this rich and mature Greek colouring are shown by such Pompeian pictures as the Achilles in Skyros, full as it is of a real *Fig.* 123 riot of colour : form, that is, once more, human form in especial, was preserved intact ; colouring did not abolish drawing.

We are now prepared to set foot upon the path which will lead us from the first creations of Greek painting to the last, from the crystal-like constructions of the geometric vases to the boundless horizon of the Odys- *Fig* 1 sean landscapes from the Esquiline. The development occupies almost the *Fig.* 159 whole of the thousand years before Christ, and its last offshoots reach into the Middle Ages. We have reason to believe that the great fundamental achievements of Greek painting have come down to us in an uninterrupted line. Even where it outsoars the Greeks, the roots of our great proud painting are ultimately in Hellas.

9

COMMENTARY

THE organic development of Greek art does not begin until a thousand years after the arrival of the first Greeks in Hellas. In the second millennium the lot of the Greeks was that of every young people which finds itself under the spell of a brilliant neighbouring civilisation. Their world was bathed in the beams of that strange and shining culture which had flowered at the gates of the East under the first rays of a European sun. The spirit of those earliest Europeans, the Cretans, who in a short space of time had soared from a primitive existence to an astonishing height of civilisation, presents a sharp contrast to that of the Greeks. The trend of their art, even their architecture, is thoroughly pictorial : that of Greek art is plastic, tectonic and monumental.

This spirit shows itself even in those Greeks who first imbibed deep draughts of Cretan influence. They took Cretan art as what it was, as a radiant adornment to life. Cretan art might adorn the Greek house and adorn it richly ; but it was not allowed to alter the fundamental shape of the house, cubic, clear and monumental. The Northern megaron with open porch in front—the prototype of the Greek temple—remained the dominant form even in the palaces of Argolis with all their Cretan splendour ; and the great gate of the citadel of Mycenae bears double witness to its builders' sense of the monumental, for the massive masonry is crowned by a monumental stone relief set in the triangular void which relieves the pressure on the lintel—a pair of heraldic lions, after Oriental and Cretan models, which foreshadows the Greek pedimental groups to come. It is the only piece of monumental sculpture in Creto-Mycenean civilisation : that hyphened term accurately describes the relation between Crete and Hellas. After the middle of the second millennium the Greek genius began to assert itself against the Cretan ; the young Greek people was rising in its strength.

Then the collapse came. A great fresh wave of that movement of peoples which had brought the first Greeks to Hellas poured over the whole East-Mediterranean area and foamed right up to the Egyptian frontier. It was not a single tidal wave, but a slowly swelling tide with many successive breakers, the last of which remained in the memory of the Greeks as the Dorian invasion. When the sun of Homer rose out

of the darkness of this wild time, it shone over the ruins of Creto-Mycenean culture : but the new life of pure Hellenism grew up out of the ruins.

It is only now, about the year 1000, that the story of Greek art proper begins. The first creation of Greek art was the geometric style, which *Fig.* 1 takes its name from the forms used in its system of ornament, but the same conception of form which expresses itself in the ornament expresses itself also in the shapes of the vessels and utensils and in the abstract stylisation of the figure-subjects. A primitive form of the style is universal : but the Greeks developed it to a unique height and a unique severity, in which we can see the germ of idealistic classical art. The geometric style is not uniform throughout Greece, but exhibits dozens of local varieties, mirroring the political disunion of the country. Common to all, though seen at its richest and purest in the so-called Attic Dipylon style, is the Greek feeling for pure form ; for clarity and measure, for rhythm and symmetry, for perfect order and organic disposition. Here it reaches a degree of abstraction which is almost mathematical : its highest embodiments are the Doric temple and the statues of Polykletos, its highest intellectual expression the Pythagorean theory of numbers and the Attic philosophy of ideas, in which Plato demands an ideal art based on Order. The next and the decisive step is already prepared, the step to monumentality : there are no large statues yet, and even the temples were no more than half-primitive structures far inferior to the ancient palaces of Mycenae or Tiryns : but our man-high amphora, which served as a sepulchral monument, is already on the verge of monumentality ; we feel that a sense of the monumental has grown up in this minor art, and that the structure and rhythm of the vase herald the great architecture to come. And Athens is already the spiritual leader.

At the height of the style figure-subjects begin to appear, and side by side with vase-pictures and engraving on metal vessels we find independent pictures on small clay tablets used for religious purposes. The representation on our sepulchral amphora is one of the most severely stylised, and only by comparing it with a number of other pictures can we understand it thoroughly. The handle-areas and the reverse are but continuations of the main picture, separated from it for decorative reasons. The painting is pure silhouette, without any inner marking in the figures. The dead man lies on the bier, his kinsfolk, eighteen of them, mourning round him, the two end figures on the left shown to be men by their swords. The couch is not quite in the middle, though there are seven figures on either side : on the shorter right side a smaller figure takes the place of the filling-ornament, obviously a child, who

takes hold of the couch; the foremost figures on either side grasp the coverlet; both these are rather smaller than the rest, from lack of space. Under the bier, as one would say at first sight, are four mourners, arranged symmetrically; two sitting on chairs; two, women, perhaps kneeling on the ground. Since it was difficult to draw the legs in this position, the painter has indicated the clothing, as in the corpse, although as a rule the severe Dipylon style refuses to represent clothes. His mode of drawing is purely ideographic, not however from primitive naiveness but in conscious decorative stylisation, although the underlying principle is the primitive one of not attempting to render the appearance, but putting the figures together out of separate memory-images of the parts as seen in their most effective view and in simplified form. This simplification operates in two ways both here and in the statuettes. On the one hand, the forms crystallise into abstract mathematical shapes like the upper part of the woman who grasps her head with both hands: the lower half of an inverted triangle is filled in with colour, in the upper half an indication of the head is placed, and sometimes a bit of filling-ornament. On the other hand, the legs show a clear understanding of the organism. Thus, in little bronze horses, body and head may be thin cylinders, but in the arched neck and the legs with their joints the essential forms are there, simplified and exaggerated, it may be, but grasped in their organic significance. This transference of simple forms and clear articulation from constructional and decorative art to figurework was of great importance for the future of Greek art: but a long period of development was necessary before the habit of exaggeration was overcome—the loud utterance of archaic art, an art which could only express itself in extremes. The huge thighs and calves with the fine joints, the wasp-waist and the broad shoulders held their ground in sculpture and drawing even longer than in architecture the flat, swaggy echinus and the sharply tapering column-shaft with compressed neck.

On our amphora the picture in the midst of the ornament, despite its severe stylisation, has the air of an intruder. And an intruder it was. In time the style became less severe, the pictures expanded and encroached, and in certain vases the ornaments serve merely as modest frames for the pictures, while even the filling-ornament has disappeared. A state of affairs which did not become general until two hundred years later; one of those anachronistic anticipations of subsequent development which are not very infrequent in the otherwise extraordinarily consistent course of Greek artistic history.

The geometric style having exhausted all its own possibilities, the

impulse to a new development came from without. Greek civilisation was now faced by the critical problem in what relation it was to stand to Oriental civilisation, which seemed to be overwhelmingly superior. The seventh century decided whether Greek culture was to be an outpost of Oriental culture, or the foundation of European. Poets and thinkers, artists and craftsmen won the battle which was later fought out with arms at Marathon, Salamis and Plataea. By the time that the seventh century was nearing its close, a monumental art had been created : an art which was pure Greek for all its dependence upon Eastern influences, and which now set foot on the path which in two hundred years would lead it far beyond anything that the Orient or Egypt had known. The beginnings of monumental architecture and sculpture were accompanied by the beginnings of monumental painting, as we might infer even if scanty remains of such work had not been preserved on the metopes of Greek temples and in the mural decoration of Etruscan tombs : such remains confirm our literary references. The details of the stylistic development are easier to follow in the vase-paintings than in these scattered fragments.

Here is an Attic mixing-bowl which betrays its geometric origin. *Fig. 2* The ground of the picture is still strewn with filling-ornaments. But the drawing has already acquired a certain amplitude and a liquidity of curve ; pure abstraction has given place to a distinct approximation to nature ; and silhouette is supplemented by outline drawing and inner markings. The oriental lion, for all the childishness of the drawing, is impressive, and what is more, boldly stylised. He is also big in proportion to the vase which he decorates : the monumental feeling of the new age is showing itself in vase-painting as well as elsewhere. The geometric tradition is more strongly pronounced in a time-honoured subject, the chariot procession. The artist means to represent pair-horse chariots, for there were no one-horse chariots : he did not aim at the matter-of-fact analytical completeness of his predecessors, but has gone to the other extreme and given an exact profile view : the hither horse, like the hither wheel, completely eclipses the farther, and a simple and clear picture is thus obtained.

From this earlier stage of the orientalising style we pass, with the next *Figs. 3-4* two pictures, to its mature period, the second half of the seventh century ; the later of the two may even belong to the turn of the century. They come from the Cyclades, and the style is called the Delo-Melian from the islands in which the vases are principally found. Both pictures are from large amphorae which, like the Attic vase studied earlier, served as funerary monuments ; and hence the predominance of actual pictures

over the animal friezes which often reign supreme in the orientalising style. The filling-ornament is still very dense, making one think of coloured textiles. A technical novelty is the use, side by side with the normal colours of vase-painting, of approximately natural colours : golden brown for men, white for women, both borrowed from monumental painting, in which clay tablets were often used. The later picture is on the same level as the metopes of an old Aetolian temple ; and has advanced beyond the primitive, highly decorative drawing of the earlier work.

Fig. 3 The earlier picture probably represents an important incident in the legend of the sanctuary of Apollo at Delos : the god returning, accompanied by Hyperborean maidens, from the far north, his sister Artemis receiving him, the maidens raising their hands in greeting. The painter's forte was decorative effect. The quadriga is a triumph of the same sense of form as inspires the bold spiral ornaments regular in this class of vase. The four horses are not rendered by layers of silhouettes one behind the other, but by free waving lines drawn parallel to the silhouette of the hithermost horse and a fanlike arrangement of four heads and three manes. The steeds are characterised as divine by wings. The wings have the sickle-shape which the Greeks adopted from the Hittites of Asia Minor. The horse-type underlies the rendering of the deer as well, and that is the only reason why the deer is bitted. For the deer the artist has used the type of the walking animal almost unaltered. There are geometric survivals, and the animal frieze offers a naive alternation of old-fashioned and new-fangled geese.

Fig. 4 The later vase shows a great progress, but it also shows that no progress is made without payment, and that the gain is also a loss. The magnificent decorative calligraphy of the earlier quadriga is gone ; and the natural forms of the horses' silhouettes, now disposed one beyond the other, with the expressive bend and toss of the heads—still visible in spite of the damaged surface—appeal to us far less strongly. For a new and perfected stylisation we must wait till the succeeding period. The subject is Herakles setting out with a bride, Deianeira rather than Iole. If his eye seems a trifle wider open, and his brow a little raised, they indicate not momentary anger but the character of the mighty hero ; and the strong hook of the nose has the same intention. The bride's father has a milder air, and the lines of the female heads are tenderly felt. The athletic bodily forms are not seen so well here as in the second picture on the vase, where muscles and joints are tense, juicy and strong, especially in the legs ; here we see only the swelling thighs. There is still something of the primitive marionette-like quality of the earlier picture, but we are

14

approaching the full perfection of archaic art ; and mythical representations, which begin at the end of the geometric style, then become common.

Beside these large pictures we may set the masterpiece of contemporary *Fig.* 5 miniature painting : a little perfume-vase four inches high, which is a real miracle of technical care and archaic lovingness. It belongs to a class of vases made near Corinth, perhaps at Sicyon, and usually called ' protocorinthian.' The class begins in the geometric period, and the latest examples, simple but technically accomplished little pots, went on till the end of the sixth century and spread over the whole ancient world. The tiny vase is covered all over with plastic and pictorial decoration ; but the effect is not overloaded : the clarity of all the forms, their distinct articulation, and not least the happy gradation of proportions so that the main forms stand out with the secondary forms subordinated to them, make it into an organism which can be enjoyed as a whole. The colour, save traces, has perished : the best-preserved part is the purple of the plastic lion. But the drawing is still perfectly visible, for even the finest details are engraved as if on metal. The technique is that of the black-figure style described in the Introduction ; it was in this Argive-Corinthian area that it developed. In the main picture, just as in the Delo-Melian vases, a polychromy borrowed from monumental painting plays its part. In this picture subject-matter and decorative rhythm work happily into each other, for strict alignment, with equal step, thrust, and guard, was the rule in actual engagements as long as the formation remained intact. But the artist has gone farther and given a group of defeated warriors. The type of warrior composed of head and arm, shield and legs, is old ; the other new ; it exhibits the strength and intensity of archaic art fully developed ; and the effect of the side-view shield is cunningly obtained without true perspective. We are given a glimpse of the disciplined life of the aristocratic Dorian state, and to this life the chariot-race also belongs, with its strictly decorative deployment vivified by delightful individual traits. The driver of the leading chariot—the second in our picture, which is rolled out wrongly—looks round : the space below his team is filled by terrified geese. Under the other teams, naively distributed, is a hare hunt, as in the lowermost frieze. The motive is a favourite one in this style and is derived from Oriental art ; but here it is enlivened by a dog which has broken loose and become entangled in the leash. The power of the drawing culminates in the central group of the larger animal frieze—a lion and a bull facing.

We leave the Dorian world for the Ionian in the picture on a sarcophagus *Fig.* 6 from Clazomenae at the entrance to the Gulf of Smyrna. It was customary

15

there in the sixth century not to lay the dead on a bier before interment, but to set him upright in a clay sarcophagus of special shape : a practice borrowed from Egypt. Such sarcophagi usually had no lid : at the interment they were covered with stone slabs. The broad edges which framed the dead offered a fine field for decoration. Excepting the rare polychromy, all the techniques known to vase-painting were employed, but adapted to the special technical conditions of sarcophagi ; and commonly two techniques occur side by side, a special style being associated with each—a significant illustration of the Greek practice of keeping the several species of art separate. In this juxtaposition a historical sequence also finds expression ; for the more modern style at the period takes pride of place at the head of the sarcophagus. In our picture we have animals of orientalising style below, and above, a black-figure battle-scene and two splendid he-goats. The scene is thoroughly Homeric : two heroes have driven to meet each other in their war-chariots, and as the chariots wheel off, they rush together for the single combat. The decorative symmetry which is often pushed to meaninglessness in the sarcophagi, is here used very happily to represent an incident which is of its own nature symmetrical. The Ionian temperament reveals itself in the fiery movement of man and horse, the developed archaic style in the sureness and beauty of the drawing : we are now in the middle of the sixth century. The dogs under the horses are part of the old, originally Hittite, typology of East-Greek art ; the cloth hanging from the shield is taken from Ionian custom ; such cloths were used as a protection against the arrows of the Asiatics.

Figs. 7-8 A widely distributed class of sixth-century vase is Clazomenian like the sarcophagi. We figure a fragment and a reconstruction of the complete vase. The vase exhibits the strong decorative feeling of the Ionians in its main picture no less than in the animals and monsters : the arrangement of the chorus of maidens is wholly ornamental. The picture was painted early in the sixth century, hence the still almost geometric tightness of the forms, the naive love of contrasts and exaggerations, and the angular yet effective movements. The heads are most delicate and surprisingly individual. Every one who knows Greece will be reminded of acquaintances from Athens or Smyrna. The painter is beginning to replenish the old-fashioned types by means of direct observation.

Fig. 12 A somewhat riper masterpiece in this same manner is the chief specimen of a class of vases which without doubt originated in the Ionian East, but which settled in Etruria and gradually became barbarised. In the earliest stage of the fabric we have the pure Ionian of immigrant masters. Our

16

picture is divided between the two shoulders of an amphora and inter-
rupted by the spring of the handles; the eye cannot take in the whole
scene at once. This freedom in the disposition of the pictures is not
uncommon in vase-painting, but in later times it is seldom so abrupt as
here: in later times one of the pictures usually contains the chief portion
of the representation and is complete in itself, while the other is a not *(Figs.* 41,
indispensable supplement—the vase has a front and a back. Divided 42: *not so*
scenes also occur in the triglyph-metope frieze of Dorian temples. The *Fig.* 43)
scene is the Judgment of Paris, rendered in the fashion of primitive art,
with the figures ranged in a row or in layers one behind another, with
the decorative variety of colour dear to the Ionians, and with naive
vigour and emphasis in the treatment of the subject. Three oxen, the
shepherd's dog, and the crow eating ticks: that gives the herd of Paris.
The oxen are not browsing: the painter only wishes to count: one,
two, three, that is, many oxen. Their leftward turn is answered by the
rightward turn of dog, crow, and Paris, the alert ones, who notice a
remarkable procession approaching. In front of Hermes walks an old
man who greets Paris. In spite of the herald's staff there is no doubt
that the painter means him for Priam. He did not reflect that the omni-
scient gods did not need to inquire in the palace before being able to find
Paris in the mountain pasture. Hermes turns round to the goddesses:
'Look out! now's the moment!' Hera draws aside the matronly
mantle which covers her head; Athena, virginally slim, with her elegant
helmet-hat and her necklace, smiles and makes a gesture as if to say,
'Excuse me, here *I* am!' The spectator knows that her virginal charm
will avail no more than the maturer attractions of Hera, and the artist
has contrived to bring the ravishing potency of Aphrodite before our
eyes. Working consciously to a climax, he makes her come last. She
smiles and raises her right hand in greeting, with her left she modishly
gathers her skirt round her ankles, and her skirt is transparent, and
through it you see a splendid pair of sturdy legs. And then the saucy
snub nose, the smart turban, the dolman, the pointed red shoes—what
shepherd boy could resist such allurements?

The most important class of Ionian vases belong to a later stage of *Figs.* 9-11
development, date from the middle of the sixth century, and are related
to the sculpture of the Temple of Artemis at Ephesus. They are called
Caeretan from the place where they were found, Caere in Etruria: they
are nearly all water-pots, hydriai. They seem all to come from a single
workshop, whether in Etruria or in the East is doubtful but matters little,
for the style is pure Ionian. The master is the first real, full-blooded

personality we come across in vase-painting. Ornament and figures, the decorative and the representational, he shows the same easy mastery over all. Swelling succulent forms, controlled by tense contours ; delight in lively colouring, tempered by a fine feeling for balance of hues : these are his characteristics. There is a touch of grandeur not only in his forms, but in his relation to his subject-matter : thrilling illustrator as he can be, he yet stands above his work, and shows a superior humour even where *Figs.* 10-11 the theme is not so burlesque as in the picture of Herakles and Busiris. The Greeks related that this Egyptian monarch had the inhospitable custom of sacrificing stranded foreigners. This went on until one day Herakles fell into his hands. At first Herakles pretended to submit : then he took vengeance. Our master has added a delicate jest to his vigorous treatment of the subject : for his picture is a free variant of an Egyptian type of picture which represents Pharaoh marching proudly along with armfuls of small enemies. This is the painter's finest work. The thick-set, red-brown giant chokes, smashes, and tramples six puny yattering Egyptians at once : at his feet squirms King Busiris, and the rest of the Egyptians have fled dithering to the altar and behind it. On the back of the vase the Nubian gendarmerie, armed with batons, hastens up, late.

No other vase-picture combines such a brilliant study of national characteristics with such gripping expressiveness and such convincing movement. The painter does not feel himself trammelled by the archaic convention in which he works ; he expresses his whole self, and yet remains decorative even in the principal picture : the masses on the picture-surface are in equilibrium, and the colour-patches too. To make this possible without losing clearness, he painted the Egyptians now buff with black hair, now black with red or buff hair, and one with a buff garment to contrast with the regulation white of his neighbour. This is not the only vase in which he varies his colours to suit his purpose. White, black and red, men, weapons, and garments, appear in all sorts of combinations in a single picture, for instance in the little hunting frieze which takes the place of the usual pattern-band under the picture of Busiris. The typical patterns—the great spreading tricoloured lotus flowers, palmettes, and spirals—play less part in the Busiris hydria than in the other Caeretan vases : the sprays on the shoulder are stylised with a freedom unparalleled between the Minoan period and the Hellenistic. *Fig.* 9 The picture of the pair-horse chariot is full of the same vitality. One can almost hear the men speak and the horses snort. Here also there are traces of a foreign model, for the type of horse is Assyrian. The second

horse, and the flesh of the men, were white, but all that remains is the underpainting. The edge of the standing man's garment is already drawn in perspective with the utmost freedom and assurance.

The Ionians of Euboea occupied an intermediate position between Ionia and Hellas. Chalcidian pottery, which flourished for a few decades in the middle of the sixth century, combines stylistic elements from both areas. Brilliant in technique, and extremely decorative, it also offers one or two mythological pictures of importance in themselves. As an *Fig. 13* example we may take the lost masterpiece which this publication may perhaps help to find in some private collection. The fight for the body of Achilles is depicted with epic breadth, and with names appended in the fashion of the Greek homeland. The Trojans have fastened a rope to the heel pierced by the arrow of Paris, and Glaukos is pulling it, as if to compel us to notice that curious trait in the saga, Achilles' heel: in naive contradiction to it a second arrow is sticking in the dead man's chest. But Glaukos does not get far, for Ajax rushes at him and pierces him through, so that he writhes like the Persian in the mosaic of Alex- *(Fig. 121)* ander. Neither the retreating archer Paris can help him, nor Aeneas, who, too late, dashes up with a comrade, for Athena the battle-maiden stands by Ajax—in the literal sense of the word; not interfering, but standing there like an idol, with the great snakes of her aegis curling round her; her presence, her will, sufficing to assist Ajax. Two more warriors, one of them collapsing from a shot in the neck, complete the picture of the mellay. Contrast is furnished not only by the motionless figure of Athena, but also by a little separate scene: Diomede, slightly wounded, is standing out, and Sthenelos, who has laid his shield and helmet down, binds him up. The whole picture is drawn with a sure hand in swelling, yet tensely contoured forms, and with great skill in rendering movement. A peculiarity of the style is the helmeted heads seen from the front; and the body of Achilles displays a concession to mere appearance which amounts to a breach with all the principles of primitive drawing. Both his arms are concealed, and one of his feet is in three-quarter view. Yet this picture more than any other stamps the master as a true archaic artist. 'The crowd of incidents, the earnestness and distinctness of the rendering,' the priceless ingenuousness which at the very turn of the tide shows us a hero methodically tying up a sore finger, all this is the youth of Greek art in all its simplicity.

Corinthian pottery is related to Chalcidian, but is much more important *Figs. 14-17* in its period. It is true that the vast majority of the thousands of Corinthian vases found all over the ancient world are purely decorative products

19

of the Orientalising frieze-style, and artistically speaking mass products. They dominated the world's markets in the seventh century and circulated widely in the sixth. Side by side with these an important picture style bloomed in the first half of the sixth century, originating in the seventh. An isolated trace of it at a later period shows that it did not succumb immediately to Attic competition ; but from the middle of the sixth century it pines away. Monumental painting flourished in Corinth simultaneously, and was even said to have been invented there. Its influence upon Corinthian pottery is unmistakable, and we even possess *Figs.* 16-17 an intermediate term in the hundreds of painted clay tablets which once hung as dedications in a sanctuary. They do not differ greatly, in essentials, from the clay metopes, likewise Corinthian work, of a temple in Aetolia. As they often hung free, for instance from the branches of trees in a sacred grove, they are usually painted on both sides. The *Fig.* 16 subjects are mostly figures of gods, either single or in such groups as are called sante conversazioni in modern art ; and scenes from the life of the dedicants. These were for the more part manual workers, sometimes sailors, as might be expected in the principal industrial and maritime city of its time : the dedications of the upper classes were more costly. The most striking scenes are the pottery and foundry scenes : the two are not always easy to tell apart, for potter's oven and blast-furnace, clay-pit and copper-mine are much alike.

Fig. 17 A picture like ours reminds the archaeologist of his own experience as an excavator : for the lumps of stone or clay are being drawn up to the surface in just such baskets as are used to-day for the earth and the finds. The sectional rendering of the pit is truly archaic in its distinctness and completeness. Everything is there, the pit, the men, the tools, and not least, the refreshment which is let down in an amphora by ropes. The herculean chief workman (who bears signs of being a barbarian slave) plying his pickaxe manfully, the others collecting the yield into baskets —all this is skilfully rendered by the simplest means, with everything unessential omitted. In spite of the flat treatment and the scanty air-space above the heads of the standing figures, we receive a complete impression of space and landscape : the device of cutting off the picture at the frame stimulates the imagination and contributes to this impression. It meant a great deal to the artist to give so much landscape and to dispense with the standing-line common to all the figures : it is the beginning (*Fig.* 159) of the long way which leads to the Odyssean landscapes of the Esquiline. This was a bypath of Greek painting. The high road was reserved almost exclusively for figures of man and animal : everything else was

subordinated to them, even space, which was only there in order to be filled with figures. Of figure-painting also there are important specimens in Corinthian pottery, which show the influence of monumental painting. *Figs. 14-15* The brightly coloured pictures of monumental painting are deftly translated into the decorative technique of the vase-painter. By copious use of white, red, and often reserved outline drawing, the vase-painter contrived, even in crowded scenes with strong, irregular movement, to arrange a number of silhouettes one beyond the other without becoming confused or even undecorative. Thus arose the ' space without depth ' mentioned in the Introduction—the archaic non-perspective variety of what the Alexander mosaic uses all the devices of mature painting to achieve, *(Fig. 121)* the filling of space with organic form.

The crater in our small reproduction shows us a battle like that in the *Fig. 15* mosaic. Where all the figures are warriors, the half-compulsory, half-decorative alternations of colour stand in striking contradiction to real life. In another vase of the ·same shape, the Amphiaraos krater, the *Fig. 14* translation into the colour-world of vase-painting is more consistent. The pictures correspond in a curious degree to the description of a master-piece of the cabinet-maker's art, a daedal chest which legend connected with the Corinthian tyrant Kypselos, and which was seen by Pausanias in the Temple of Hera at Olympia seven hundred years later. The chest had next to each other the same two pictures—quite unconnected in subject —as our crater and another vase made in a different part of the world, an Italo-Ionian vase like Fig. 12. Obviously some common traditional model must have been at the back of all three. The chest of Kypselos seems to have borne a further resemblance to our crater in its medium of expression : it was of cedar wood with inlays of ivory, ebony and gold : in the vase red takes the place of gold. Pictorially, the most interesting part of our vase is the effective hurly-burly of the chariot-race at the funeral games of Pelias. No beholder, unless he counts them laboriously, will notice that the horses' heads do not correspond exactly to the number of legs. A clear, decorative effect at a distance, to our eyes a certain spatial effect as well, has been obtained by putting the four white and piebald horses nearest the eye. Our reproduction includes the prizes, huge bronze tripods, but omits the judges sitting in front of them.

The other picture gives a saga which was treated by the epic at one stage in the spiritual development of Greece, and by tragedy at another : by epic as an adventure, by tragedy as a psychological conflict. It is a parallel to the tale of Orestes. The seer Amphiaraos had sworn to submit to the arbitration of his wife Eriphyle in disputes with his wife's brother Adrastos.

When Adrastos was collecting a band of heroes for his son-in-law Poly-
neikes, to conquer Thebes, they tried to win Amphiaraos. Amphiaraos
refused, for he knew that the expedition would be his last. Then Poly-
neikes bribed Eriphyle with the magic necklace of Harmonia, and she
forced Amphiaraos to set out on the fatal road. The burden of blood-
revenge, and thereby the curse of the matricide, fell on his son Alkmaion.
Attic vase-painters, in the high period of Attic tragedy, drew from this
saga psychological pictures classical in their simplicity : Eriphyle wavering
between desire and fear as the seducer holds up the glittering gawd ;
Amphiaraos taking leave of his little son, who shyly and hesitatingly
receives the sword of vengeance. Our own painter relates the story
with epic breadth and with all the naiveness of archaic art. We are in
the courtyard of the palace : the palace front, naturally but man-high,
appears behind the women. The second building beside it is to be thought
of as really opposite : it is the gateway of the courtyard, the Propylon.
The chariot is ready to start : the driver receives the parting draught,
and a lad stands at the horses' heads to keep them still. Amphiaraos
mounts the car with a great stride. The turn of his head, and the drawn
sword in his hand, tell us what has taken place.

Overcome by anger, he would have punished the traitress, who is
standing behind her children holding the huge necklace well in view, so
that the spectator shall remember the story. But the children beseech
the father to spare their mother : the youngest boy has his hands held
out in entreaty by the girl on whose shoulders he sits. So Amphiaraos
lets the doom which he foresees take its course. An old man is sitting
apart. His name does not make what we see any clearer. He grasps his
head in sorrow, and his sitting on the ground, inappropriate to his costume,
also indicates that he forebodes or knows the event. Perhaps Amphiaraos
has enjoined him to bring up Alkmaion to take vengeance. All this was
not enough for the painter : to his broad easy mode of narration belong
the accessories also, with which the last little empty corner can be filled
up so nicely, and still more life and variety be brought into the picture.
So he added the hare with which the children play, the hedgehog which is
said to eat fleas, the lizards which scurry along the walls, the snake which
is still venerated in Greek houses as a spirit, the less popular scorpion,
the bird in the air, and last of all the owl on the high bent-up end of the
chariot-pole (you have to know that, for the owl looks as if he were sitting
on the neck of one of the horses). Happy springtime of Greek art !

Fig. 18 A picture on a Laconian cup is filled with the same spirit. This
widespread class of vases has been proved by excavation to be Laconian,

22

although it is possible that there were branch establishments in the African colony Cyrene. On the deck of a ship, under an awning, we see King Arkesilas of Cyrene, probably the second of the name. He is superintending the weighing and lading of the silphion plant, prized as a spice, and a royal monopoly. The painter has made skilful use of the round of the cup. By cutting off a segment he has obtained a straight baseline, the deck, and below it the lading-room seen in section : only the overseer is a bit crowded. The balance hangs from the same yard to which a corner of the awning is attached. Birds are sitting on it, and an ape— it is in Africa—and a great stork sails past with extended legs. The workmen are weighing, packing, and hauling with all their might ; and one of them is reporting to the King. The King sits on a graceful folding-stool under which his hunting-leopard lies. He holds a shapely sceptre, and his head with the long long hair of the aristocrat is protected by an elegant hat of the shape which we find, three hundred years later, on the heads of Tanagran maidens : it was called tholia, from the awnings of circular buildings : to us, what with the long hair, it looks rather Chinese. There was still a spot free : the painter forgot the part which he had been playing, and drew a lizard—climbing in the air, for here we can hardly supply the usual courtyard or house-wall.

This admirable scene from life in a Greek colonial harbour looks like the direct transcript of an experience, seems to be due to freshest observation. It is so : and yet the pictorial type is borrowed, even to details, from an Egyptian prototype of a far different, far more serious tone : a Last Judgment. The borrowing goes even farther than in the picture of Busiris. What matters is not what the Greek has borrowed, but (*Fig.* 10) what he has made out of it. This picture may be described as the last work of the Orientalising style. Modest as it is, artistically speaking, it shows Greek art ripe to dispense with its teacher. It had long been striving with its own powers towards higher ends.

In Attic vase-painting, which in the course of the sixth century quickly *Figs.* 19-67 rose to predominance and eventually to sole rule, archaic draughtsmanship reached a perfection which, judging from the sculptures preserved, was not surpassed by the monumental painting of the time. A modern master-draughtsman, Max Klinger, who practised the monumental arts as well, rightly maintains that the vases of the severe red-figure style were equal to the best works of their time : he calls them ' works of art in the best sense of the word,' and lays stress upon the independence of the vase-pictures with respect to monumental art. ' In monumental art, for great purposes great forms unerringly elaborated in detail ; in

23

the smaller life of the vases abundant sensuousness, humour, and enjoyment, suggested with the utmost economy of line.' He is speaking of the red-figure style : but the black-figure style had already accomplished *Figs. 19-26* marvels. This is not the place to follow its gradual development out of the orientalising style, instructive as it would be to observe the violent ferment into which the gifted and passionate artists of Athens were thrown by the struggle between the foreign influences and the national character. By the beginning of the sixth century this preliminary phase was over, and the Attic archaic style had settled down. It was a second revelation of that blend of perfect craftsmanship with true feeling for rhythm and symmetry which had created the Dipylon style two hundred years before. The product of that hundred years' struggle to master the Oriental elements was as pure as the clash had been violent. The Greek quality maintained itself intact, and the Attic in all essentials.

We must content ourselves with one or two characteristic examples of the style, without attempting to illustrate its variety. The same high sense of style which had led to the naive over-stylisation of Dipylon draughtsmanship showed the black-figure painter what the true nature of the black-figure style was : the treatment of form must be ornamental, the execution as fine and accurate as could be, and the character of the work as a whole must be strictly decorative. Such an artistic intention, appropriate to the early archaic stage of art, could not but lead to a conflict as time went on : for it was necessarily anti-naturalistic, whereas the general tendency was towards an ever-increasing approximation to nature. Complete mastery must be attained over natural forms before a new, classical stylisation could begin. As the artists were not reflective academicians but Greek craftsmen with unblunted senses, their work has all the charm of the youthful struggle between stylistic formulas and observation of nature. Late archaists, that is to say, imitators of long-past stages of development, are usually intolerable : but there is nothing more delightful than the work of these artists, who in the heart of the archaic period controlled their growing power of naturalistic expression in order to retain the splendidly decorative formulae of an earlier age and to make full use of the specific qualities of the technique in which they were working. Hence the archaic severity of style did not turn into the empty affectation of the petrified traditionalist, but into the conscious mannerism of the ' virtuosi of the decorated surface,' the last consequence of that refusal to follow in the footsteps of monumental painting which had led to the abandonment of naturalistic polychromy in favour of the black-figure technique.

24

At the beginning of this movement stands a krater in the Museum *Fig.* 19 of Florence, painted by Klitias in the workshop of Ergotimos, and known as the François vase from the name of its discoverer. Here, not long before the middle of the sixth century, we find not only the black-figure style, but the archaic gift of narrative, both fully developed and exercised with the highest art. The decoration of the chest of Kypselos must have been very similar; covered nearly all over with rows of pictures which unroll a whole saga-book before our eyes. From the decorative point of view, it might be maintained that this is too much of a good thing, and that the artist would have been wiser to restrict himself as Exekias and others did later. This objection applies not to Klitias but to that (*Figs.* 20, whole species of early archaic art to which his masterpiece belongs. He 21, 25) took this over-opulence for granted: in other vases he shows that he could decorate more sparingly. The François vase itself shows a highly conscious sense of decoration. The severe symmetry and rhythmic alignment which prevail in the neck-friezes, and which are traceable even in the main pictures although these are of their nature less regular, are not due merely to the general level of development which the art of composition had reached at the time; for one of the neck-pictures on the reverse, and the small frieze on the foot of the vase, are much freer in composition and movement. But it was only in inconspicuous places that the painter allowed himself such freedom.

The drawing is as severe as the composition: tight and definite, with a slight propensity to straight lines and sharp corners—there are still vestiges of geometric notions of form, most conspicuous in the horses —but at the same time markedly trim and elegant; the details of incredible finish, even to the almost microscopic friezes in the decorated bands of certain garments. Our reproduction of the vase is not sufficient for close study, and we shall confine ourselves to enumerating the subjects. The principal frieze is taken up with the great procession of the gods to the wedding of Peleus and Thetis, whose house can just be seen on the extreme right of our illustration. One of the chief exploits of Peleus was the Calydonian boar-hunt, which is depicted on the upper part of the neck, while a momentous deed of his son Achilles, the slaying of Troilos, appears in the lowest picture-frieze. Achilles is pursuing the boy, who was coming to the fountain to water his horses, and has almost overtaken him. On the life of Troilos, an oracle said, depended the fate of Troy, and his death also sealed the doom of Achilles, for he slew the lad at the altar of Apollo. That is probably why Ajax appears on the handle carrying the body of Achilles. The neck-picture shows the chariot-race at

25

the funeral games of Patroclus, and thus fits into the series of Peleus and Achilles pictures which fill the whole obverse of the vase as well as the main frieze right round : this shows which side is the obverse and which the reverse. On the reverse Klitias celebrates his local hero Theseus and the craftsman god Hephaistos. The frieze on the foot represents the humorous battle of the Pygmies with the Cranes, and stands in the same relation to the heroic subjects on the rest of the vase as the Battle of Frogs and Mice to the great epics. The heraldic animal frieze is purely decorative, and there is not much more than an undertone of religious feeling in the demons on the handles.

Fig. 20 Somewhat later, a true mid-sixth-century work, is an amphora by the master Amasis. His Egyptian name, and numerous Ionian elements in his style, point to his having been one of those immigrant Ionian craftsmen who were induced to settle in the Athens of Peisistratus by Solon's enactments in favour of foreigners. He does not belie his origin ; but he has adapted himself completely to the Attic style. The perfection of his technique enables him to achieve extremely decorative effects, and his drawing is firm and sure. Higher artistic values are not to be looked for in him. More than once he uses a group which must be derived from monumental painting, two friends with their arms round each other's necks—in our picture two nymphs hastening towards Dionysos, with ivy-sprays, a small stag, and a hare, in their hands. Thanks to the ornamental character of the drawing, figures fuse with pattern into a brilliant and uniform decorative scheme. Three generations later, another Attic (*Fig. 80*) vase-painter drew a similar group. Whether we are thinking of art or of human nature, there is a world of difference between the two pictures : in these years the European spirit had awakened to complete consciousness, and had reached a degree of maturity which from the point of view of pure humanity it has never surpassed.

Figs. 21-22 Beside the Atticised Ionian Amasis stands Exekias as the purest representative of the Attic spirit. His masterpiece, the amphora in the Vatican, belongs to the third quarter of the sixth century. It is supple-*Fig. 23* mented here by a fragment from the rim of a cauldron. These specimens are not sufficient for a real understanding of Exekias, but unfortunately we cannot linger over individual masters. The works of his maturity, in which he pays homage to the fair Onetorides, rank, within the limits of their kind, among the highest achievements not only of the black-figure style, but of the whole art of the time. It is not likely that contemporary works of monumental painting stood higher in artistic essentials. It is true that as in all early creative periods, Greek archaic art stood rooted

26

in a handicraft of wonderful excellence, but it would be misleading to refuse altogether to distinguish between 'handicraft' and 'art.' Although the margin is a floating one, yet nobody who is sensitive to distinctions will misunderstand us if we say that Amasis was an excellent craftsman, but that Exekias, who was originally no more than that, grew into a still better, an unsurpassed craftsman, and at the same time into a true artist. A severely archaic artist, of course, and not to be measured by the modern standard of originality, but by the standard of his own time, by strength of feeling and power of expression, both as a master of form and as an illustrator. His works bear traces, indeed, of that manneristic conflict to which we have already alluded, so that complete harmony was not vouchsafed to them. The combination of Attic austerity and Attic Charis was not yet quite organic : in places they still form a mixture rather than a compound. But the synthesis is so far advanced that no Ionian vase can match them for artistic ripeness. It is not only in decora- *(Figs. 9-11)* tiveness that the Caeretan hydriai fall short of Exekias : their redundance in form and expression has something sensibly Asiatic about it when compared with the best works of Exekias, like an early Ionian leaf orna- ment set beside an Attic. One detects in Exekias not only the light crystal-clear atmosphere of Attica, but the immemorial legacy of the geometric style. Yet tight and rigid though his form is, it is none the less full of budding life.

The Vatican amphora, like the François vase before it, is a high-water mark of the art of its time. To appreciate the shapes of the vases is no part of our task ; but here, for the sake of the pictures, an exception must be made. The full-bellied amphora meets us here in unsurpassable *Fig.* 21 perfection—unsurpassable because it is essentially an archaic shape which could not be accommodated to the classical idea of form. Here, as the Greeks say, it found its eidos ; the idea at which the development had been aiming has been attained. This matter cannot be discussed further at present, but a comparison may serve to make it clear. Greek feeling for form is so strong and general that quite different shapes can be com- pared. The François vase, in spite of the metallic rigidity of its lines, *(Fig.* 19) has a comfortable breadth and fulness which is ultimately derived from the same spirit as the epic breadth of its pictorial narrative : it recalls the heavy bellying forms of the early Doric capital. The amphora of Exekias, on the other hand, strives upwards, tight and elastic, the high-set swelling of the body and the wide mouth contouring it with a springy double curve. In Attica a like feeling for form and life took hold of the Doric capital also ; in its steeper curve the Attic sense of

27

freedom rebels as it were against the heavy pressure of the Dorian mode. This was the first step towards the later Attic Doric of the Parthenon, in which a sudden elongation of the proportions substituted light aspiration for firm-fixed rest. Once we have acquired a feeling for the shape of our amphora, we realise the decorative value of the principal picture, Ajax and Achilles playing the five-line game. The heroes bend anxiously over the board. Ajax calls three; Achilles four. The composition is just far enough removed from absolute symmetry not to seem stiff. We mentally complete the arc which swings over heads and backs to a uniform curve crowned by the crest and adapting itself to the curvature of the vase. The picture is an ornament which clarifies and emphasises the effect of the shape; and the counter-diagonals of spears and shields play their part. On the other hand, the painter has no desire to fill the space full: the voids are enlivened by fine straight inscriptions only. Only so could the composition produce its effect. The representation makes us ask ourselves why the heroes have sat down at the gaming-table in almost complete armour, with spears in their hands; and the exuberantly patterned cloaks worn over the armour—masterpieces of the graver's art—catch the eye at once. Now a later picture shows this oft-repeated group surrounded by the tumult of battle, and the answer therefore seems clear: the heroes are on outpost-duty, and are whiling the time away—so successfully that they do not hear the alarm and the Trojan attack. The origin of the scene is evidently a poem, perhaps a monumental picture as well. The drawing speaks for itself, but there is one point to which we must call attention, the happy gradation of large and small forms. Even the miraculous miniature work of the cloak-patterns is absolutely free from pettiness. The picture is a masterpiece of archaic art.

Fig. 22 The other picture is a delightful aristocratic family idyll. We can understand it without the help of the mythical names, which tell us that the subject is the Dioscuri with their parents. Castor is returning home from some expedition. His mother Leda offers him a flower, just as when one enters a Greek house to-day; his father Tyndareos strokes the magnificent thoroughbred, who being sensitive puts his ears back; Polydeukes pets the dog. A little servant brings a chair with a change of clothes on it, and an oil-vessel; for Castor will be taking a bath. As to the drawing, we will point out only the manneristic contrast in the treatment of the drapery: Leda's patterned peplos is still foldless, but the mantles have plenty of folds. The composition, made up of verticals and horizontals in simple symmetry, does not stand in the same relation to the vase as the picture on the obverse: here the figure-ornamentation

follows, like so many surface-lines, the whole curvature of the vase-surface, at the cost of its visibility as a whole picture : it subordinates itself.

We pass into a different world with the little picture of ships, two out *Fig. 23* of five which decorated the rim of a mixing-vessel inside. It is as if the ships floated on the contents of the vase. The sails have perished with the upper ledge of the rim. The ships are fifty-oarers, penteconters, the simplest form of the ancient man-of-war, which has survived, apart from the ram, with all its slim and mobile elegance in the Venetian gondola. The Greek man-of-war is as beautiful as it is high-bred. One is tempted to compare it with Castor's noble racehorse. Exekias shows his art by his wise restraint in not finishing off the heads of the rowers.

Neat miniature pictures of this kind are mostly found on drinking- *Figs. 24-25* cups of a special class, which were made in many workshops, by Exekias as well as by Klitias and Ergotimos, Ergotimos' son Eucheir, and others. In the later sixth century this class lost its distinctive character, though its more or less degenerate descendants go on for a long time. There is often no pictorial decoration at all, the painter contenting himself with the ornamental effect of carefully written signatures, short drinking-posies, or unmeaning rows of letters. The same sparseness of decoration appears in the little groups of two or three figures like that on a cup painted by Anakles in the busy workshop of Nikosthenes. On each *Fig. 25* side, Herakles attacking the hydra ; on one side the local nymph is added. Small and neat though it is, the picture is as expressive as it is decorative. Our second cup is the work of a most spirited painter, Glaukytes. One *Fig. 24* of his cups is pictureless, but here he has gone to the opposite extreme, for the frieze is filled to bursting with a wild battle-scene. This seemingly promiscuous medley is arranged, clarified, and made into effective decoration by the sure hand of a master in composition. Three chariots at the ends and in the middle provide resting-places for the eye, and these bigger patches of colour pull the welter of small forms together : the foundered horse in the middle serves the same purpose. In spite of the small scale, there is nothing of the miniature about the picture : it has a distinct touch of grandeur.

We conclude our survey of the black-figure style with a picture which *Fig. 26* takes us to the verge of monumental art. It is one of the slabs of a frieze which decorated an Attic sepulchral monument in the form of a building. The work was a kind of combination of a continuous frieze and a series of pictures. The several slabs were apparently separated from each other by small wooden borders covering the joins. The pictures represent the

body being laid on the bier, the gathered mourners, the harnessing of the funeral cart, the procession in formation and on the way. The fragmentariness makes many points doubtful, but broadly speaking one may say that the artistic method of the Parthenon frieze—the representation of a procession from preparation to arrival—is here foreshadowed, here in the middle of the sixth century; and we also find the corners emphasised, as in the Parthenon, by figures of pillar-like effect facing the procession. Single elements of this kind can be found earlier : Klitias has a straggler hastening up in his dance of Theseus, and as early as the seventh century the motive of the west side of the Parthenon frieze is anticipated in the masterpiece of protocorinthian painting, where the last warriors rush up to join the line, while others are still arming. A hundred years later we find this motive in the chariot parade on the walls of an Etruscan tomb. The slab which we illustrate offers none of these significant connections. It is a composition complete in itself—the gathering of the mourning women, at which the orphan child is handed round, just as in a Greek house to-day. The black-figure style is seen in all its severity and decorative force. Subsequently it grew looser and looser, and in the course of the general evolution to freer stylistic forms it became estranged from its true nature, which was bound up with the severe archaic style. We therefore follow it no further, but turn to the new style which in the last third of the sixth century rose swiftly to a magnificent height—the red-figure style.

Figs. 27-67

We have already spoken of it more than once : the technique is described in the Introduction, and its prevailing artistic tone at the beginning of our survey of Attic pottery. Its essential difference from the black-figure style is due to the black-figure being the style of the severe archaic period, while the red-figure is the most characteristic creation and the perfect expression of the mature and late archaic period. The intrinsic difference between the two shows itself even in the subjects. In the black-figure style artistic considerations had no particular influence upon the choice of subject. The traditional repertory of types offered so large a selection and such a field for variations that it satisfied painters of all tendencies ; unless they definitely turned off into the new paths of the red-figure style ; but what the black-figure style adopted from the red-figure was as little, compared with the mass of old, as the influence of the black-figure style on the early red-figure compared with the new. It is true in the main that the two styles stood in a different relation to their subject-matter, although not only were they in contact for more than half a century, but the red-figure style, in Greek fashion, avoided a violent

breach and took over and preserved much that was old. What we have here is an aspect of a development in the history of art which reflects in many facets the same general development in the history of the spirit: the progress towards greater freedom as compared with the manifold restrictions of the early archaic style. The change of technique was intended to facilitate freer draughtsmanship after the manner of monumental painting. The purely artistic problems of monumental painting could now take far stronger hold upon the vase-painter than in the age when art was predominantly decorative. The step was not unlike the still greater step from the purely decorative orientalising style to the black-figure picture-style. The problems of form themselves—the desire for nakedness and for new kinds of movement—influenced the choice of subject; and the intellectual tendency of the time cleared the way. The new style saw things from a much greater human proximity, and this not only led to a vastly increased interest in subjects from everyday life which were lovingly studied even to the smallest and most insignificant detail, but even influenced the mythological representations. To the Greek, myth and life were not two incompatible worlds, but interwoven parts of a single reality. The early archaic style, like the travesties in poetry from Homer onwards, shows us many a naively human trait in the life of the gods; in the François vase, for example, Athena shows her contempt for Ares who had failed to bring Hephaistos back to Olympus: but on the whole the atmosphere is that of some solemn function; and this atmosphere is retained in the later black-figure style. In the new style the gods behave more like human beings, preferring decent comfort to stiff processions, and we see them not only slaying giants as of old, but also pursuing the daughters of men. The change in the representations *Fig. 55* of Herakles is significant. His chief labours, repeated over and over again in the black-figure style, pass into the background, and one of the new scenes is the homely tale of Herakles the unwilling schoolboy and the *Figs. 66-67* unhappy fate of his teacher.

But the new spirit finds its most direct, and in the ripe archaic period its strongest, expression in the purely human. Life in the palaestra and under arms, drinking, love-making, home-life—in the severe red-figure style these things are rendered with that frank candour and detailed observation which is possible only at one period in the history of any art— just before the bloom of the classical age. The classic style is already conscious selection and restriction; while baroque realism lacks the archaic simplicity, and moreover is based on the formal achievements of the classical style. It is true that earlier archaic art had treated the same

31

subjects and had dealt with all sorts of human activities: in the too human, particularly, where no type was law, some of its efforts are distinctly expressive. But these old-fashioned works are nothing to the multitude of new red-figured representations, all incomparably richer and more powerful, both in form and expression, than the old. Again, the black-figure style used filling-figures, unemployed and often meaningless, not only in large pictures, but also, one at a time, to decorate enclosed or even unconfined spaces. It was a decorative expedient of the painter who had nothing definite to say: it reminds one of the orientalising style, and recurs, in freer form, in the 'mantle-figures' of the classical red-figure style. But the black-figure painter lacked the feeling and the power of expression which might take a youth folding his cloak, or a girl putting away her shoes, and turn it into a humanly charming and artistically interesting picture: this was reserved for the red-figure style. It is just in the simplest matters that the inherent difference between the two styles is most immediately obvious.

They were naturally in close contact at first. In the oldest group of red-figured vases both styles often appear on one vase, sometimes even in one picture. The most important workshop in this transitional period belonged to Andokides. He employed several painters, in red-figure two, one of whom has more claim than any one else, as far as we can *Figs. 27-28* tell, to be regarded as the inventor of the new technique. It was he who gave the workshop its character. His works can be recognised at a glance, for he stands outside the stylistic formulae which were soon established. His relation to the leading masters of the old technique has been fairly well expressed in the symbolic phrase that he was a pupil or partner of Exekias. His style might almost be described as a translating of 'mannerism' into the new technique, but that would be ignoring a point of capital importance: Exekias stands at the end of a blind alley, into which the old technique, in the course of general development, naturally led, Andokides at the beginning of a new road, for the new technique contained all the possibilities of development in drawing which were incompatible with the nature of the old technique. Even the most *(Fig. 23)* charming of Exekias' pictures, the Family of the Dioscuri, demands a greater effort from us before the shining black silhouettes speak to us as human beings, than similar red-figured pictures by Andokides. Andokides' figures have a more direct appeal, with their ingenuous charm, their expressiveness, and the individual vivacity of features and motives, as in Athena holding out the rose to the resting Herakles, or in the smart young gentlemen listening to the song of the citharode.

32

It is a delicious glimpse of life in Peisistratean Athens at its prime in the third quarter of the sixth century. The ' tyrant ' was a tyrant in the legal and political sense of the word alone, and it was only against his aristocratic opponents that he had to rely on force, for the great mass of the people felt itself blessed under the benevolent rule of a great man. His court drew poets and artists from afar, and Athens now began to become the metropolis of Ionian civilisation, and even the Hellas of Hellas. Some have taken our picture as evidence of decadence, such decadence as we find in our great cities : but the comparison, like all such comparisons, is only half true at best. Even the Ionians, who tended under Asiatic influence to softness and luxury, were not far removed from the simple freshness of a young people, high as their poetry and philosophy had already raised them. It is not decadence that we see, but the preciosity of young folk who are still naive but already highly refined—a refined archaic style in life as in art. The sons and grandsons of these youths fought the battles of Marathon, Salamis and Plataia, witnessed the tragedies of Aeschylus, the painting of Polygnotos, and the sculpture of Pheidias : and all these things were not a revulsion, nor a revival, but the maturity of the first fruit on the tree of European humanity. Our illustrations are the reflection of this most momentous passage in the history of mankind.

Andokides' picture shows us the life of his time through the veil *Fig.* 27 of an art which raises the subject to the second power. Young men with sprouting whiskers, with studied and various coiffures, in flowered garments—one youth wearing his over his head like a lady—roses in their hands, one smelling his, with smart smooth canes which present a significant contrast to the rough knobby sticks of the democratic period— it is really a surprising human document. The painter has stated all his facts very clearly, except one. The youth on the left should really be leaning on the stick propped under his armpit, a motive most popular later, usually with the body leaning right forward. But here the youth looks as if he were walking, and the arms are unnaturally flattened out. ' Correct ' the ' error,' and the picture is ruined : the balance and rhythm of the composition, the flow of line, the decorative effect, all gone. The realistic standard is applicable only so far as the artist uses it himself : here the leaning is only *suggested* : later artists *represented* it, because it interested them as a problem of statics. The smallness of the musician, and especially of his legs, is not due to the incompetence of an artist who could do no better : the archaic idealistic style, like the classical, has its own world, in which the only laws are those of the artistic organism.

33

The stiff fingers, too, are not due entirely to the painter's instrument. He could have made them as lively as the bent ones. It is the same with the anatomy : he gives, in his own language, what interests him, such as the sharp joints and even the seldom seen projection on the heel. The garments end in a hem with plenty of folds, while the other side of the garment ends in small arcs and serves the folds as a background : this system long remained in vogue. The drapery mostly follows the outline of the body, but already it sometimes banks up in soft masses.

Fig. 28 The unsigned picture of Herakles shows progress. Athena's under-garment is grouped about a central fold in half-perspective swallowtail folds, and the leg of Herakles is drawn under his mantle as if the stuff were transparent ; it is only Athena's over-garment that still shows the stiff squared surface of Klitias and Exekias. There is lyrical feeling in the picture. Herakles is resting from the fatigue of his labours and comforting himself with meat and drink. The couch is set under the shadow of a great vine, and in front of it stands his divine patroness and companion, smiling gaily at him and holding him out a rose. Even the eyes are full of expression, although they are drawn frontal in the profile heads, in consequence of the archaic habit, explained earlier, of working not from the thing seen but from the memory-image. With a slight shift of the iris, of the contour, of the brow, the painters can produce numerous effects of look and expression. That is why they clung to the archaic formula long after they had become capable of drawing a correct side-(*Fig.* 51) view of the eye. It was not until the classical period that the side-view came to have form and expression. The details of the picture are executed with loving archaic care, every fact clearly stated and every corner handsomely decorated, from Athena's elegant helmet and the aegis with its lovely curling snakes to the cates on the table—the loaves, the long slices of meat with the knife lying on them, a plate of fruit, no doubt dried figs, a tiny object, probably a stand, and a little cup ; the big drinking-vessel is in Herakles' hand ; it is the old Homeric goblet, the cantharos of Dionysos. The graceful table is of the shape which gave its name to the geometrical trapezoid, three-legged with a narrowing top, so as not to be in the way at the foot of the couch. The couch is a Milesian kline, such as is mentioned in the inscription about the auction of Alcibiades' effects after his condemnation. We may think of it as veneered with ivory and ornamented with coloured inlay. The clusters of the vine are in raised black, so that there are bright high-lights on the grapes : the leaves are red. Owing to a slip in the blacking-in of the background the trunk and some of the branches are interrupted between table and couch.

The same picture exactly, with a few additions, is painted on the back of the vase in black-figure technique, and undoubtedly by another painter. Thus every one's taste was satisfied, as in the comical alternation of old and new geese on the Melian vase. Other black-figure pictures are *(Fig. 3)* so like the red-figure pictures by our master that they are probably by his own hand. In any case, the second painter in the workshop, who also worked for Menon, used both techniques. He is less personal and already walks in later paths. Close to this painter stands a charming cup-picture with two hetairai at their wine. If it is actually his, it is his most vivacious *Fig. 29* work. The flute-player beats time with her foot. The other hands her a cup crying 'You drink too !' The picture is excellently adapted to the space, and the lines of the naked bodies are as sensitive as can be : the archaic scheme is filled almost to the brim with fresh young life. In the last quarter of the sixth century the drinking-cup became more and more important as a vehicle for pictures. Its prime is in the first quarter of the fifth : then the decoration of the long bands on the gently curving cup-exterior was the chief concern of a throng of masters, whose leaders were draughtsmen of real genius. The circular picture in the interior also played its part, but it no longer attracted the painters so much as in the sixth century, when it offered a special problem. To fill the round decoratively with a single figure, and at the same time to feed the newly awakened interest in the manifold motives of human attitude and movement : that was the double task which they set themselves, without submitting to it unconditionally, for it was the most gifted of them who at times declined to fill their space faultlessly and sent their figures walking freely through the round.

Our examples of early tondos belong to about 520 B.C. The first *Figs. 30,* two are not from cups, but from plates, in which the space-filling is usually *31, 33, 34* freer. They are the work of one of the chief masters of the time, Epiktetos, who combined a brilliant technique, clean and uniform, with sure and delicate draughtsmanship. His figures are mostly slim and fine-limbed, often light and winsome, though not very freshly conceived, and by no means strong in expression. The last word in this kind of art is his reveller, a portly elderly man singing as he goes ; the space is *Fig. 30* rather loosely filled, and the only supplement to the figure is the signature. More typical is the warrior with the horse, in the flat treatment and the *Fig. 31* pure contour-effect a true Epiktetos : the drawing is unsurpassably delicate and sure, but has a certain academic lifelessness.

Much fresher and more spirited was his contemporary Skythes—the *Figs. 32-34* Scythian, as he calls himself at first, a foreign slave, therefore, whose

35

barbarous name no one in Athens, perhaps, could pronounce. Foreign names from all quarters of the compass appear among the Attic potters and painters; some of the most important bear slave-names, several names show non-Greek blood. Yet their art is perfectly Greek and perfectly Attic: culture means so much, and blood so little. Skythes is not inferior to Epiktetos in technical capacity, but nothing is farther from him than the slightly academic correctness of that master. Even in his restful figures his line has more organic life, but it is only when it comes to movement that he is in his element. Even the old type of the runner looking back, a well-rounded space-filler in Epiktetos, makes the

Fig. 34 sparks fly in Skythes as he whizzes past. How ferociously Theseus
Fig. 32 grips the monster's throat, and how the monster's head falls back ! Skythes is a master of gentle movement also, and his singing reveller is artistically
Fig. 33 one of the freest tondos of the period. It is the picture in the interior of
Fig. 32 the Theseus cup. We observe the advance in the details of the drawing : the muscles of breast and belly, hardly noticed by Andokides, have received definite form, the trochanter hollow is clearly marked on the thigh, and the muscles of the ribs are at least suggested. The drapery shows the typical formulae of the archaic style : below the girdle, in mounting and descending groups of folds, but smooth ; above the girdle foldless, but covered with fine wavy lines to indicate the crêpe-like quality of the material. Typical archaic exclusiveness and love of contrast ; the artist takes from actual appearance no more than the main elements of the artistic formula. To strengthen the upper part—the wavy lines being done in diluted colour—it has a pattern of dots : why the pattern is absent below we are not meant to ask. That the two parts form one homogeneous garment there is not the least doubt, and no one

(*Figs.* 38, who is acquainted with the art of the period finds that strange. The
41, 42) bagginess at the belly is due to the stuff being pulled up over the girdle. The landscape touches are also very characteristic : a marvellously unreal spike of rock indicates the solitude in which the monster lives, and wild flora and fauna are indicated on it by a shrub and a hare, both in the black-figure technique, which Skythes used at times for whole pictures.

Before we follow the red-figure style farther, let us look at an example of the new white-ground technique, described in the Introduction. Our

Fig. 35 illustration shows the picture rolled out by an ingenious photographic method invented by Arthur Hamilton Smith of the British Museum : otherwise it would be impossible to see the whole picture at once, as it encircles a slender perfume-vase. The vase comes from the workshop of Pasiades. The subject seems to be a Dionysiac cleansing and dedication

of a house : the house is indicated by the tame heron. One woman holds what is probably a cup of lustral water, while the other runs round the house sprinkling it with wetted branches : her panther-skin points to the cult of Dionysos. The coloured areas are painted, some with black varnish, others with the same diluted to a golden yellow. The style is still very old-fashioned.

In the two pictures from the busy factory of Pamphaios, which flour- *Figs. 36-37* ished in the last third of the sixth century, the drawing is more developed. The black-figure style was practised in this factory, but its importance rests on red-figured vases decorated by various painters, including Epiktetos. The latest of the extant vases may have been painted about 510. Rather earlier than this is the amphora which at last gives us a general *Fig. 36* view of a red-figured vase. The shape is usually called a stamnos, but no doubt wrongly ; in representations of it it serves as a mixing-vessel. Here we see a sturdy old-fashioned version of the shape : in the classical (*Fig.* 102) style there are two varieties, both perfectly balanced, with **upward-straining** contour. There are palmettes at the handles, and between the palmettes, with no other framing, spaces for pictures, each of which is filled with a group. Our picture shows a peculiar conception of the fight between Herakles and the river-god Acheloos. Acheloos, like a true watercreature, tries to defend himself by transformations. He usually appears as a bull-man modelled on the centaur or horse-man, but here as a snake-man. He still has his horn, in which his magic strength resides. Herakles is breaking it off. The picture is most probably by the **painter** Oltos, not one of the great painters, but **an** important **representative** of the transition to the early prime of the red-figured style : our picture may belong to the teens of the sixth century. It does not teach us more about the painter, but shows the strength and maturity which draughtsmanship had now attained. The forms have all become simpler, and are firmly and surely stylised, even to small anatomical details, with considerable understanding of the organism.

A farther step in this direction is shown by an important cup-picture. *Fig.* 37 We do not know the master's name ; he already stands on the threshold of the early prime and his work bears affinity to the beginnings of the brilliant painter Euphronios. The subject is the recovery of the body of Memnon, whom Achilles had slain, by the spirits of Sleep and Death, under the guidance of his mother Eos, and Iris, messenger of the Gods. The excessive discrepancy in the scale of the figures does not disturb an art which is concerned with space-filling and with emphasis of essentials. The painter was interested in the monumental figure of the dead

man and in the solicitude of the rescuers. He has succeeded brilliantly in both. The figure of Memnon is not large in measurements only, he is of a large mould; the execution shows remarkable anatomical know-ledge, and the dead arms are exceedingly expressive. More limpness in the corpse would have been thought inartistic at this period. The women, with the ornamental, pseudo-perspective stylisation of their garments—the first example of the fully developed stylisation we have come across—make a sort of rich frame to the main group. The chitons of the demons are covered with a golden-brown wash of diluted varnish, an approximation to monumental painting which was tried at this time but very properly abandoned later. The picture as a whole shows us the red-figure style ready to attempt the highest and to achieve it.

The first bloom of the style, now fully conscious of its powers and in full command of its methods, comes at the end of the sixth century. It is the time when the beauty of young Leagros is in all mouths, and we still possess some fifty vases which celebrate him in word and in picture. *Figs.* 38-47 The leading painters of the period are Euthymides and the young Euphronios. The workshop of Euphronios was still flourishing in 470: *Figs.* 38-39 Euthymides we know only in the Leagros period. An amphora which is one of the most important works of the early prime of the severe period bears the words 'painted by Euthymides, son of Pollias; as never Euph-ronios.' On another vase of his the self-praise, not unknown in the black-figure period, is reinforced: 'truly well painted, yes, indeed.' His pride is justified, and the question which is the better, his work or the contemporary work of Euphronios, is still disputed. We possess too little of each to pass a final judgment, and the problem of their sub-sequent development leads us into uncertain country. But we can under-stand Euthymides' ejaculation. His principal extant works are indeed superior in several respects to those of the young Euphronios, in the execu-tion of the details especially, but also in a certain amplitude and maturity. Euphronios on the other hand discloses a talent and a temperament which lead us, considering his youth, to hope for higher things. Whether Euthymides was older or more precocious, he had reason to feel uneasy on the score of his rival.

Fig. 38 The Hector amphora, on which he claims to have surpassed Euphronios, is the best of his signed works. The names Hector, Priam, Hecuba are indeed but traditional appendages to an everyday scene, a youth arming with the help of his parents. The youthful mother holds the spear and the helmet. In front of her is the shield, leaning against nothing, as if the painter had forgotten the triangular trestle, which is rarely represented,

38

or had omitted it for the sake of balance of composition. The old father stands well wrapped up, giving good advice with raised forefinger. The young man is carefully adjusting his armour. The simple incident is treated with great love and care. The artist has no longer the simplicity of an Andokides, but his attitude towards his task is not yet so detached and superior as that of a classical master. He is an archaic master, the insignificant still fixes his attention, and the execution of details is no less important to him than the design of the picture as a whole. What a contrast to the warrior's leave-taking on a vase of the Periclean period! (*Fig.* 102) There, an easy flowing treatment on large lines, and everything subordinated to the expression of a grand and simple mood : classical ethos in the language of the Parthenon frieze, uttered easily and unassumingly, to decorate a vase. Here, loving observation of everyday life and of individual forms, the struggle with artistic problems and means of representation, all very serious, but ending in the joy of success—the pride of the artist in contrast to the modesty of the craftsman, which the painter of the Periclean picture could not but feel in face of the monumental work of his time.

The other picture on the vase shows us the naked figures of three *Fig.* 39 nocturnal revellers in lively motion, a compact composition which fills the space admirably, no doubt less important to the painter than the arming scene in point of theme and expression, but at least equally important as a study of form : the naked figures in motion are among the masterpieces of their time. Anatomy and drapery, rest and motion, expression and perspective, are all mastered, from the archaic point of view, in this amphora ; and the proud inscription is justified. Although the spatial representation is still in many particulars primitive, and although there is still a good deal of ideographic piecing together of the whole figure out of separate views of the parts, yet compared with earlier work the figures of Euthymides already have a corporeity which is by no means entirely due to their massive full-blooded forms and their heavy masses of drapery. In another amphora the value lies more in the single figures ; *Fig.* 40 once more, three of them make the picture, but the space is adequately filled and no more. The chief figure is called Phayllos. He stands with a hint of contraposto in his attitude, swinging the discus above his head. The trunk is foreshortened with considerable success, the head is of statuesque beauty. The person meant is probably the famous pentathlos from Croton, who later captained a ship at Salamis. The rendering of his forms shows an effort after fluidity and simple beauty. The anatomy is not so detailed. The painter tried various forms in the profiles of the

39

faces : Phayllos is noblest with his finely arched nose and his strong chin (foreshortened away in our illustration).

Figs. 41-42 Besides these signed works we have an unsigned amphora which can be attributed to Euthymides with complete certainty. It is in many respects his masterpiece. The subject is Theseus carrying off a maiden. The group of the young hero grasping Korone and hoisting her up need not shun comparison with the marble group from the pediment of the Temple of Apollo at Eretria. In both works a perfect blend of severe style with nature heightens the effect of both ingredients and produces a general impression of extraordinary charm. The tense, strouting figure of Theseus, fronting us as he turns, with one foot seen from above, is all of a piece. The angular extension of the arms on the picture-surface becomes a pure means of expression. The only archaic effect is that of the eye, frontal in a head which turns sharply sidewards because Helen clings to Korone. But how expressive the eye is, with the iris not quite touching the upper lid : even the eyelids, naively rendered by rows of strokes, seem to be bristling with excitement. What saucy determination in the corner of the tight-pressed lips ; and saucy also the blunted nose. On the other hand, the expressional value of the high eyebrows is here as elsewhere fortuitous : the height is due to the archaic custom of placing the eye too low (exaggerated in Helen), the artists not knowing how to *Fig.* 42 draw it in as part of the head. Peirithoos, who is covering the rear, turns round, for in the other panel two more girls are rushing up, while a man holds cautiously back. The feminine proportions of the girls show good observation. The compromise between the violent motion and the archaic drapery has the charm of a piquant contrast.

In this picture Euthymides addresses a word of personal greeting to Theseus. This is the period in which Theseus grew into the national hero of Attica, in which the cycle of his seven labours was coined in image and song. The Thesean metopes of the Athenian Treasury at Delphi belong to this time. In the person of the young hero the people of Athens saw its own fortunate and promising youth. That was the feeling which prompted Euthymides' greeting.

To the circle of Euthymides, though hardly to his hand, belongs one *Fig.* 43 of the most impressive of all vase-paintings. The revenge of Orestes is divided between two panels. Orestes seizes Aigisthos, stabs him, and strikes him, struggling desperately, with glazing eye, from the throne. Clytemnestra rushes up with the axe. Orestes, warned no doubt by Chrysothemis, who stands petrified in helpless horror, looks round at his mother : too late, unless Talthybios can wrest the axe from her hands.

This is the oldest and most important of a whole series of pictures, all free versions of a single model, probably a monumental painting, which seems to have influenced Aeschylus as well. With the simple devices of archaic art the artist has contrived to give an uncannily strong expression of wild passion, and the effect is heightened by the unintentional hardness and angularity of many of the movements. The austerity of this stage of style was admirably adapted to express the rude grandeur of this bloody tragedy in its pre-classical epic form. Aeschylus bestows no more than a passing word upon the motive of the axe, and bloody business was not represented on the stage: the classical style seeks and finds the tragic in the life of the soul alone. Archaic painting shows us the son's eyes meeting the mother's at the climax of the revenge. The whole effect is given by simple movements, by simple composition of cross-lines and counter-cross-lines, parallels and intersections, and by tiny variations in the profile of the face and in mouth and eye. Two waves of passion rear up to meet each other: between them is the trembling Chrysothemis, who here takes the place of strong Electra; for it was not until the fifth century that Electra, indelibly impressed upon our minds by Attic drama, became the daughter of Agamemnon.

It is from a later work of the same circle that two details come, which *Figs. 44-45* give us a closer view of the grandeur and beauty of the style. Even in these extracts we can feel the contrast of the two maenads: one moving quietly, with shimmering fair hair and a beauty of feature which is almost classic, the other raging past in magnificent Dionysiac ecstasy.

We return to Euphronios, whom we have already encountered as *Figs. 46-49* the aspiring rival of Euthymides. It is not possible to do justice to him in a small book based on pictures, and the principles upon which our selection is made do not even allow us to figure one of the signed works of his youth. The chief work of his early period, in many respects the masterpiece of the early prime of the style, does not admit of any considerable reduction: it occupies a triple plate in my large book. This vast picture of the wrestling-match between Herakles and Antaios, painted on a big mixing-bowl, is both in line and in expression a magnificent performance. The promise of the Memnon cup from the work- *(Fig. 37)* shop of Pamphaios is here overwhelmingly fulfilled. Euphronios has concentrated all his efforts upon the great main group. The subsidiary figures are hastily dashed in. Euthymides would not have allowed himself to do that: but on the other hand he could hardly have compassed the grand fling of the wrestling-group. We may take it that he realised this in spite of himself, and that it was not merely the outward success of

41

Euphronios which he resented. His self-respect could not brook the thought that the young lion who had shown his paw was stronger than he. One can imagine him standing in front of the Antaios krater and censuring what it was easy to censure : and hence the proud words on his Hector amphora.

Figs. 46-47 The pictures which we figure from this period are unsigned, but they may be assigned to Euphronios with the utmost confidence. We may even conjecture that the great krater with the picture of Herakles fighting the Amazons was signed on the now missing foot. This picture is a monumental work like the Antaios, and the small subsidiary frieze shows us by its contrast the wide range of the master's art. Side by side with the main picture—grandly formed and felt, and most surely and severely drawn—easy naturalistic sketches of rushing revellers. There are even young boys with fat bellies, and a bald head has the peaked skull of the Homeric Thersites. The principal picture is closely related to one of the earliest works of Euphronios, the Geryon cup which he painted in the factory of Kachrylion. The schema of the fight with the three-bodied monster is here transferred, with slight alterations, to the Amazonomachy : it goes back to a much older composition already used by Exekias in an early work belonging to the middle of the sixth century : a good example of typological tradition, that great economy which is one of the prerequisites of the incomparable sureness of style which is a characteristic of Greek art. Such limitations left plenty of scope for personality, and Euphronios is highly personal in this work. It is superior to the Antaios in its uniform perfection, perfection of composition as well as of other things. It is the maturest among the great works of his early period, and is probably not much earlier than the turn of the century. Compared with the signed vases, the drawing is not so much freer in details as more spirited in general effect. A fundamental innovation is the feeling for space which reveals itself not only in particular foreshortenings, as in the foot of one of the Amazons, but in entire figures like the splendid Telamon. Speaking generally, the composition is naturally still confined to the front plane, which is not only filled perfectly, but as it were clamped together : two symmetrical groups are firmly interlocked, Herakles and his opponents with the axis of the superimposed shields, and Herakles and Telamon with the fallen Amazons. But the construction does not thrust itself upon the eye : we do not see the artistic device at first, we only feel its beneficent effect, and the form is always filled with expression, the expression of the victory of two heroes over menacing odds. The picture has a touch of the monumental artist, and also approximates to

monumental painting in the free use of toned surfaces, an experiment which appeared in the Memnon cup but which later, in the interests of pure drawing, was restricted to occasional use for one or two details.

Perhaps a little later still is a smaller krater of a different shape, decor- *Fig.* 46 ated with unpretentious snapshots from the life of Attic youths. They are all named, but the prize of beauty is awarded to the young Leagros alone. He is represented on the other side of the vase, naturally in the same typical fashion as his companions. The young people assembled in the palaestra are nobler in physique than the nightbirds on the Amazon krater, but they show unmistakably the personal style of Euphronios, and the same ingenuous sense of reality. One youth swings the discus, but all the others are in charming motives from ordinary life. These vases and others like them lead the way to the fragments of an important cup which preserves part of the signature of Euphronios : here already we ask ourselves whether we are to supply ' painted ' or ' made.' For about the turn of the century Euphronios came into possession of a factory of his own, which flourished for at least a generation. After this we do not know for certain that he ever signed as painter, and it is theoretically possible that not one of the vases which bear his signature as maker was painted by him. In one of these his signature is followed by the fragmentary signature of another painter : and the style would have told us at once that the picture was not by Euphronios. All the other cases are disputed, and towards the end even the standard of probability fails us. But it is not impossible that he played a personal part in the stylistic development which took place in his time : if any one could, Euphronios could. That he never painted again is, considering his talent, inconceivable, and that not one of all the vases preserved is his, unlikely. The question cannot be discussed further here, where we cannot follow the minuter stylistic changes in the history of the art as a whole, much less in individual personalities. We therefore confine ourselves to presenting two more masterpieces, neither very far removed *Figs.* 48-49 from the early period of Euphronios. Each illustrates a further step in the general development. There are good grounds for assuming them to be by Euphronios himself, but no documentary certainty.

The great Theseus cup, in which the tondo occupies an unusually *Fig.* 48 large part of the interior, is one of the most important works of its period. The outside is decorated with four fights, in which the naked forms and the large movements are splendidly strong and free. The effect of the interior picture is austerer, owing to the solemnity of the scene and the quiet attitudes of the draped figures. The subject is the story of

the young Theseus, on his voyage to Crete, how he was insulted by Minos, how he sprang overboard and found himself in the palace of the lords of the sea. Here is the boy, with his protectress Athena, in the presence of Amphitrite: dolphins play round him, and a little Triton supports his feet. Amphitrite offers her hand to him and holds the precious wreath which will prove him son of Poseidon and light him in the darkness of the labyrinth. The picture is a triumph of the relief-line, with the grand yet animated severity of its drapery, and the purity and simplicity of all the lines; it is a marvel of a technical care which never sinks into pettiness. And what exquisite feeling for nature in the conception, what noble, refined sensuousness in the treatment of form. This timid yet trusting boy is the naive archaic counterpart to the classical Idolino, whose 'pure youthful modesty with its genuine blush' was felt so deeply by Julius Lange. Two hands are drawn in stiff relief-lines against an unquiet background, but all the other limbs are rendered finely and sensitively in their elegant slimness. The living wave of the arms and hands guides the eye through the many verticals of the picture, and is emphasised by the contrast with the stiff line of the spear which cuts across it. And the feeling of the picture: the same naive sensuous relation to the gods which is still found among simple folk in the south: trusting and solemn at the same time. This is not the sublimity of Aeschylean religion, but it is true popular religion in the vesture of Greek form.

The super-refinement and subtle exaggeration which invade the archaic language of form, especially in drapery, about the turn of the century—the last word of that language before it turned towards freedom and thereby towards dissolution—was not the proper means of expression for the temperament which Euphronios reveals even in his early works: for already in these the scholastic severity and regularity of his first works, such as the Geryon cup, is seen beginning to relax. And so he did not remain long at the grandiose stylisation of the Theseus, but soon fought his way through to the freedom which caught and lifted the whole of Greek art at the beginning of the fifth century. Then came the prime of cup-painting: instead of making it their ambition to create works which should have the external semblance of a monumental art, the vase-painters turned more and more to discovering and developing the specific qualities of a draughtsmanship of incredible perfection and almost limitless power of expression, a draughtsmanship which was the coruscating counterpart of a joyous national life. There is no more brilliant representative of the first half of this development than the celebrated 'Panaitios painter,' that is, the artist of numerous cups in a highly personal

style, several of which bear the name of Euphronios as maker. Two of these, and a number of others, extol the fair Panaitios, a successor of Leagros in the favour of the potters. This painter, with his inexhaustible vitality and his unsurpassable power of moulding great handfuls of pulsating human life into artistic form, is probably no other than Euphronios himself, Euphronios freed from the trammels of older stylistic traditions and become the most brilliant interpreter of the fair life and youthful exuberance of the first free democratic people in the world.

What had previously been a secondary interest soon became his chief theme, and he contrived to ennoble low subjects as the Dutch painters their topers and tavern-brawls. His picture of a drunken scuffle—unhappily too gross for this little book—is the classic treatment of the subject —in the metaphorical sense of the word ; for the real classical style, the post-Persian style, tolerated such scenes only in comedy and in caricature. The picture we reproduce stands at the beginning of this development. On a low seat sits an old man who immediately reminds us of the old *Fig.* 49 reveller on the Amazon krater. A basket hangs above him on a nail, (*Fig.* 47) one of those baskets in which you brought your food to the drinking-party. In front of him stands the lyre-player holding the loop of her girdle, from the position of her fingers tying it rather than untying : the old gentleman protests strongly. The comparison with Lysistrata and her impatient husband is not quite exact : but the spirit is the same. ' Alcaeus and Sappho,' says the old catalogue of the British Museum : so little feeling had the classicising period for the real life of the Greek world. The filling of the round is no longer two-dimensional : super-positions, foreshortenings, and accessories produce an effect of depth. The archaic style still retains a touch of its old austerity : a little while, and the incomparable beauty of its latest period breaks through.

Before we turn to that period, let us glance at two unique masterpieces *Figs.* 50-51 of the turn of the century : the later of the two, if not both, may belong to the beginning of the fifth century. The exaggeration of the archaic style which we mentioned when speaking of the Theseus cup is really (*Fig.* 48) mannerism, the mannerism which always appears when a powerful style is exhausting its last possibilities and is reluctant to turn off into new paths which are foreign to its nature. This happened with the black-figure style in the middle of the sixth century, with the classical red-figure style in the later fifth century, and here at the turn to the late archaic period. It is the last struggle of the ornamental formulae and the elegance and preciosity of archaic art against the relentless advance of the double tendency towards a plain, natural transcript of appearances and towards

Fig. 50 simplification of the means of expression. In vase-painting the cup by Peithinos is the most characteristic example of this kind of art. We reproduce the picture in the interior, Peleus wrestling with Thetis. The sea-maiden tries to escape from her unwelcome wooer by all sorts of terrifying transformations, which are indicated in the naive archaic manner : but Peleus holds her as fast as Herakles held Triton. Peithinos is of his time, but the strength of his drawing lies entirely in its ornamental quality. The chief vehicle of his style is the drapery. Although the groups of folds, the swallowtails, and the lozenge-shaped hems are based on an idea of perspective, and although the natural rounding and movement of the hems is by no means ignored, the effect is nevertheless flat and ornamental in consequence of the deliberate regularity and symmetry, of the sharp contrast to the smooth star-sown areas, and to the insubstantial quasi-transparency of the chitons and even the mantles. In the hair this linear style almost hurts the eyes : the thinnest of thin lines are ranged side by side with only a hairsbreadth between. It is significant of the painter's lack of organic feeling that the snakes of Thetis are almost incorporeal dotted bands, and that the knitted fingers of Peleus form a maeander. The lion, on the other hand, is a masterpiece in little : here the inorganic lies not so much in the ornamental treatment of the forms as in the artlessness with which the painter has borrowed a type readymade from sculpture and made it serve by turning it at right-angles downwards. The lion has something of the energy which is lacking in the human figures, even in strong Peleus. Peleus' over-delicate feet are as brittle as Thetis' fingers. But the outline of his thigh is incomparably beautiful.

(*Fig.* 48) The Theseus cup showed what a magnificent effect this style could produce in the hands of a real master. The painter of a cup from the work-*Fig.* 51 shop of Sosias was a greater and truer artist than Peithinos, and on the whole his superior in technical mastery, for where he chooses to be elaborate, his hand is so light that there is not the least stiffness even where the stylisation is strongest. To him the ornamental style is not an end in itself. He handles it with more freedom and less tightness than Peithinos, more as an ornamental accessory, so that even in the picture outside the cup, a brilliant assemblage of the gods, he does not aim at the grandeur of Euphronian stylisation. The picture in the interior is unique : Achilles binding up Patroclus' arm after removing the arrow. The wounded man sits on his shield, in much the same position as the (*Fig.* 49) old gentleman with the lyre-girl, but he presses his foot still more naively against the border. He holds his arm out ; the flap of his corslet is lifted

46

from the shoulder ;. he turns his head away, and the pain makes him draw his breath in through his clenched teeth ; in these circumstances he does not sit so decently as Greeks normally sit. Every detail is executed most lovingly, from the fur cap which protects Patroclus' head against the pressure of the helmet to the feathering of the arrow. The earlier masterpieces of Euphronios are no doubt grander than this, and the later ones freer, but the marvellous finish of the Achilles and Patroclus bears any comparison, or rather declines comparison, not because it is beyond comparison, but because it stands alone. It is a picture pure and simple : yet no one could maintain that it was not a true vase-picture, that is, not decorative enough : in a cup of no great size, the tondo, with its almost flat surface, makes no special constructional demands, and does not require to tell at a distance : and the vase-technique is handled with such easy mastery that it makes no demands but is completely subservient to the artist's aim. So even the tiniest wrinkles do not produce an effect of pettiness, for they are put in so lightly and so unobtrusively that they stand in the proper relation to the whole and even heighten its intrinsic grandeur. It has been well said that no monumental painting of the time can have been more complete, and that the differentiation of the several parts of the armour by means of patterns of varying density is a kind of substitute for the colour effects of monumental painting. The side-view of the eye, unparalleled in the vase-painting of the time, and the whiteness of teeth and bandage, must be derived from the same source. The picture still contains many naive and unnatural details like the foot of Patroclus pressing on the border : his neck, for instance, sits on his left shoulder. But no one bothers about that, any more than the general effect is destroyed by the finish of the parts. What eye familiar with the language of the archaic style sees anything here but the expression of eager, cautious solicitude in Achilles, ill-concealed pain in Patroclus, and a union of truth and beauty which is a harbinger of early classical art ?

A new world is presented to us by the pictures of Brygos, that is, *Figs. 52-57* the brilliant painter who worked in the factory of Brygos at the time of the Persian wars and as late as the seventies. External evidence points to his having been the owner of the factory himself. At least two other painters, both much less important, worked in the factory at the same time. The earliest cup with the signature belongs to the circle of Peithinos and Sosias, and as far as the technique goes, might be by the chief master ; if so, it would be a derivative school-bound early work : for the brilliant works of the maturity are as unlike it as can be. The position occupied by the vases of Euphronios-Panaitios in the early period of the development

towards freedom is taken by those of Brygos in the prime of the late archaic period. The last stage of the archaic style is marked by a beauty of form and energy of expression which are often ravishing. The painters handled the legacy of the archaic style with sovereign ease, contrived to loosen its bands or even to remove them, and without sacrificing the piquancy of the severe forms, they moved within the limits of the old style in self-confident freedom. The flat plane-surface acquired depth, the outlines plastic power, while the black background lost its opaqueness and can be thought of as air. No one achieved so much as Brygos. He performed the miracle of Pygmalion, filling the severe artistic form with the warm blood of mobile life.

In this sense his work may be described as pictorial—even apart from his copious and distinctly pictorial use of varnish diluted to a golden yellow, which combines with a good deal of red, some white, a little gold, and strong accents of black, to produce a colour effect which is, on the *Figs. 53, 57* whole, decorative rather than really pictorial. If we compare his ecstatic *Fig. 49* revellers and satyrs with similar pictures by Euphronios-Panaitios, Euphronios-Panaitios seems more of a pure draughtsman and even his liveliest creatures have a more abstract effect : we feel the quality of the line as such, the particular value of the individual figure, and that touch of grandeur which made us describe his picture of a drunken scuffle as the classic treatment of the subject. No one will call the pictures of Brygos classical : but there is hardly anything archaic left in them either. They are all life, movement, expression, and nothing more ; conceived as pictorially as their stage of artistic development and a technique which is of its nature linear would allow ; and so planned as wholes that the most splendid single figure tells only as a part of the whole. The gentle heave of the *Fig. 54* girl's garment in this tondo has nothing to do with stages of artistic development, or techniques, or classifications into pictorial and linear : it transcends all these : it is a thing seen, a thing felt, and that is all. In the treatment of the human form and in the composition we see the happy effortlessness with which Brygos manipulated those artistic methods which we saw Euphronios gradually mastering. Naturally the main forms are rendered with the utmost lightness and sureness of touch, naturally also the statement of anatomical details is as summary as it is in the latest works of Euphronios. Moreover, the linear forms are often veiled by pictorial indication of hair on the body, producing on a smaller scale the same kind of effect as his blond heads of hair. From time to time, no doubt, when its function required it, he would draw a hand carefully with all its details ; but as a rule he contented himself with

a simple suggestion of the hand and especially of the fingers. But how expressive these swiftly drawn fingers are, whether they play the flute or stretch straight out as in early archaic art! There is no trace of stiffness left in them : the old schema has become impressionist form.

Impressionist form, that is another of the pictorial elements in Brygos. But he is a draughtsman of the early fifth century, and therefore, broadly speaking, the pure line of organic form is still his vehicle of expression. In this his achievement is even greater than in the gentle swing of his chiton-folds. He has a unique faculty of setting before our eyes, by an outline of classical simplicity, the noble rounding of a beautiful female arm. His rendering of slender youth and mature fulness, whether in man or woman, is equally convincing. He seldom draws ugly people, since he can be expressive without that. The secret of his art lies in the simplicity of the means by which he achieves the most various effects. Form, movement, expression of the mind, his hand achieved them all with the greatest possible economy : he was absolute master of line to its subtlest stirrings, and therefore he does not let it dominate his figures. The same in his composition. Neither symmetrical group and simple alignment, nor an arrangement and system of grouping which are spatially freer and frequently enlivened and pictorialised by accessories, are allowed to predominate over the representation. Like the individual forms, they merely subserve expression. Even the severer forms do not obtrude themselves upon the eyesight as such, or at least not in the originals, where their decorative value tells more strongly than in the reproductions.

But in our endeavour to do the painter justice we run the risk of doing the opposite : we dismember the work into the parts which served him only to make up a whole. It is only by looking at his work that we get to know the whole artist and the whole man. This painter, who probably bore an un-Attic name, was purely Attic in spirit : keen-eyed, of refined sensuality, sensitive and fiery, changing in a moment from a subdued mood to unbridled passion, from trivial or realistic occurrences of everyday life to lofty tragedy, from the petulant pranks of satyrs to the devastating force of Dionysiac ecstasy. There is something majestic in the intellectual *Fig. 57* range which depicts with equal perfection the good-natured hetaira hold- *Fig. 54* ing the boy's head, rather sisterly, as he vomits, and the Trojan mother swinging the pestle with the strength of despair, to cover the flight of her *Fig. 52* fair-haired boy from the murderous Greeks. Such contrasts of grave and gay occur even within the compass of a single picture, but the expressions are so finely graded that there is no effect of deliberate antithesis.

The workshop of Hieron flourished at the same time as that of Brygos.

Whether Hieron himself painted we do not know. In any case the leading painter in his concern was Makron, who has left us several dozens of vases, mostly cups. Makron is not an artist like Euphronios or Brygos, and both as illustrator and as draughtsman he is on the whole inferior to Douris, whose work we shall presently consider. Makron's strength, like Douris', lies in his decorativeness ; peculiar to him is the touch of grandeur which accompanies it. What suits the mind and the decorative intention of Makron is not dramatic action soaring to a climax, but the broad stream of a state of rest or movement ; and not arrangement in space, but extension along the plane surface. But even his most rigid star-patterns of boys and youths contain many charming motives, and are not composed, any more than in Douris, of stereotyped repetitions. In *Fig. 58* the billowy riot of his best maenad choirs the row of figures swells into a grand general movement, which, owing to the perfect interweaving of one boldly-moving shape with another and to the strong swing of the garments and loosened hair, has a strangely musical quality and power. Expression and decorative form here coincide, and craftsmanship reaches the farthest bounds of art. The drawing is on the whole big, sure and spirited, but only seldom careful and subtle : more usually the rough rather slapdash execution points to the rapid methods which we associate with wholesale production.

Fig. 59 Very different is a nameless painter who worked in the factory of Hieron during its later phase. He has no particularly close connection with Makron : here and there a detail recalls Makron, but on the whole he is as different both in spirit and in draughtsmanship as possible. Measured by the standard of ripe archaic beauty of line and mastery of form, he must appear a bungler, for his misdrawings and uglinesses go beyond Makron's. But there is far too much expression, motion and observation in his pictures for that : he is really a forerunner of the naturalistic movement in early classical art. For beauty and academic correctness he cared nothing, for truth and expression everything. His skinny figures with their convulsive movements look almost like a protest against the deliberate ignoring of such phenomena, phenomena which, after all, are actually more frequent in nature than regular beauty and rhythmic motion. We content ourselves with a glance at the tondo of a cup which is decorated outside with further scenes from the sack of Troy. It shows a man fleeing wildly with a boy on his shoulders clinging to his head ; a thrilling picture of the horrors of one of those nights of massacre, with which the Greeks of the fifth century were only too familiar. If the intentions of the two artists were not so different, one might call our

painter more individual and more important than Makron. But the
personal element is thrown into the background by the strong conviction
that two intellectual tendencies and two epochs here touch and part.

We have already mentioned the name of Douris. Dozens of signed *Figs.* 60-65
vases enable us to trace his career from the turn of the century down to the
seventies ; unsigned vases take us still later ; and the signatures, in con-
junction with the love-names, provide us with a unique documentary basis
for what has been called the noblest task of the historian of art, to associate
progress in a great department of intellectual life with the destiny of
individual men. But our pleasure is not unalloyed. Douris is a master
of decorative elegance, a craftsman of unsurpassable technical excellence,
a brilliant draughtsman of the abstract linear type. But he cannot compare
with true artists like Euphronios or Brygos. He has his own specific
qualities, it is true, as a draughtsman in the higher sense and as an illustrator,
but they are the qualities of an academician, and they are often combined
with a certain eclecticism : one can trace his dependence now upon this
model, now upon that, even long after his artistic handwriting had
acquired its fixed and unmistakable character. Occasionally he succeeded
in producing works of perfect unity and convincing expression like the
Quarrel over the Weapons of Achilles : here the question of the model *Figs.* 62-63
recedes before the impression that this is a Douris through and through :
no other could have made the pictures at once so rhythmic and decorative
and so animated and expressive. The Herakles fighting with the Amazons *Fig.* 60
does not stand so high : Douris was more concerned with symmetry and
balance than with convincing statement of facts. The charm of these
pictures lies in the decorative composition, the subtlety of the line, and
the slender elegance of the figures. Elsewhere the theme itself made it
easier to transform even a severely rhythmical row of figures into a lively
picture. Thus the justly famed school-scenes are only a variation, richer *Fig.* 65
in content, of the typical ' conversation scenes.' Music, recitation and
writing-lessons can hardly have gone on simultaneously in a real class-
room : but the artist has attained a higher reality, life within the picture.
Douris, like Makron, seldom merely repeats himself in his rows of figures,
but such pleasing creatures as the bear-leader nervously listening to the
recitation are quite exceptional : his decorativeness was not favourable
to strong individualisation.

The Éos with the body of her son Memnon, in the interior of a cup, *Fig.* 64
seems to form an exception to this estimate. It is a genuine Pietà, in
which the depth of feeling and intensity of expression are hardly impaired
by one or two touches of archaic naiveness like the position of Memnon's

51

legs. But here more than anywhere else we may be sure that the creation is the work not of Douris but of another and a greater. The space-filling as such is extremely imperfect, the composition nevertheless cramped and the general effect as undecorative as can be. Douris has put up with all that because he wanted to reproduce on his cup a work of art, probably a panel or a wall-painting, which must have attracted attention at the time. The voids he filled with inscriptions, one of which appears to be coarse. The man who invents or even feels such a picture does not scribble obscenities beside it. And so the cup with the quarrel for the arms *Figs.* 61-63 remains his masterpiece. The pictures on the outside are models of decorative symmetry, which is nevertheless justified by the subject and *Fig.* 62 filled with expression. In the first picture we see on the ground the precious legacy of Achilles, his arms. How the greaves come to stand upright we must not ask, either here or in the interior : the fact is that we are meant to see them clearly. Ajax and Odysseus are quarrelling which is the more worthy to inherit the arms. The wild Ajax wishes to plead his cause with the sword : half-armed, his corslet still open, he flies at Odysseus. The sober Odysseus is forced to draw to defend himself, but other heroes hold them fast, and King Agamemnon intervenes. *Fig.* 63 The matter is referred to the vote, and in the next picture we see the voting. Odysseus notes with excitement and gratification his ballots increasing, Athena watches the decision with interest : Ajax turns away *Fig.* 61 with veiled head. The picture in the interior shows the result, which led to the end of the war : Odysseus hands the arms to the young son of Achilles, Neoptolemos. By simple means and with plain natural attitudes the good-will of the experienced hero and the solemnity of the youth are convincingly rendered.

Fig. 65 The school picture needs no further explanation. It is a late work, and it prepares us for one of the last creations of archaic vase-painting, a *Figs.* 66-67 bowl from the factory of Pistoxenos. This bowl tells the story of Linos, once the darling of the Muses, and now a middle-class music-teacher, how he tried to teach Herakles, and his sad end. The rough boy had no talent for music and brained his teacher with a chair. Douris or one of his pupils drew the murder itself : but our painter gives us only a presenti-ment of the impending disaster. He shows us Herakles on the way to Linos, while his half-brother Iphikles is already receiving instruction. The two pictures present a pleasing contrast. On the one side, facing each other, both with lyres, are Linos, the perfect type of the hard, irritable, elderly schoolmaster, unimaginative, joyless and deadly ; and Iphikles, the model youth, looking up at his master from under his brows in a

52

kind of gentle alarm, and pursing the corners of his mouth in his concentration. The whole effect is given by the poise of Iphikles' head, his almond-eye with the pupil drawn up, the furrow in his cheek, and by the wide-open eye of Linos as he watches his pupil's fingers with wrinkled brow and peevishly protruding lips. A glance at the other picture suggests that the lesson will not end well. Herakles is coming, too late, naturally, with a huge arrow as a walking-stick. He is in no hurry : he is taking shorter steps than the bent old body who carries his lyre for him. There is reluctance and defiance in the back-thrown shoulders and the pout of the lower lip, choler in the characteristic bull's eye. And then the bull-neck, and the curly pate : one feels somehow that the sufferings of many other lads will be avenged on the hated pedant, once Linos scolds him or lays hand on him, as sooner or later he must. It is superfluous to suppose that the old woman is urging him on or even advising him to make haste ; she knows better, and is no doubt glad to keep her breath for her walk. The old woman, a Thracian slave to judge from her tattooing, is a brilliant study in naturalism, but compared with the subtlety of psychological characterisation in the other figures she seems a slighter performance than they ; for wrinkled ugliness is easier seized than delicacies of expression in the type of handsomeness. This type appears in all its purity in Herakles and Iphikles. In Linos the forehead is slightly individualised and the nose was probably so, but here also the expression is obtained by the simplest means, by tiny displacements in eye and mouth and by the carriage of the body. The drawing still retains the archaic simplicity and the archaic severity of line, but little else that is archaic. In the old woman even the almond-eye is given up, but the iris is still drawn as a complete circle, which gives the appearance of a slight squint. Our painter was not a draughtsman of the same calibre as Euphronios or Brygos ; and even if he had wished he could hardly have attained the unerring elegance of Douris. His strength lies in the successful study of the expression of the individual personality : this important element in the transition from archaic to classical art he represents brilliantly.

Very little remains in Greece of archaic monumental painting : and not a single wall-painting. It is otherwise in Etruria. Etruscan art is an offshoot of Greek : in Etruria not only sanctuaries but great tomb-chambers were decorated with mural paintings, and a branch from the tree of Greek wall-painting is thus preserved to us in substantial remains. It is true that the sap in the branch is not all the original sap. A Greek scion has been grafted on to a strange tree, and it is only occasionally that

we have the sensation of seeing before us, in the work of an immigrant Greek, such a scion fresh-cut from the tree of Hellenic art. The most important ripe archaic paintings of this kind, the friezes of the Stackelberg Tomb at Corneto-Tarquinii, have suffered severely in the century or so since their discovery, and old drawings and water-colours are but an imperfect substitute for what we have lost. We content ourselves here *Fig.* 68 with an extract from a frieze in a later tomb, where Greek stylistic forms ranging over half a century appear side by side. It illustrates the saying that the archaic style of the Greeks was long the classical style of the Etruscans. The subject is a dance in a grove. The grove is indicated, symbolically rather than pictorially, by plants and small animals. The movement of the girl has a grand swing which recalls red-figured vase- (*Figs.* 44, paintings. As on the vases, the figures extend from top to bottom of the 57, 58) frieze: but we also find a few free landscapes with small figures; and the frieze-bands developed into pictures covering the whole wall. From this it was but a step to the great wall-pictures of early classical art.

These wall-paintings are lost: and there is only one parallel work which can give us some notion of their spirit, and in some measure of their form: the sculptures of the Temple of Zeus at Olympia. This is not the place to dwell upon these: we are confined in the first instance to vase-pictures, and it is only after the middle of the fifth century that we set foot in the realm of monumental art. The vase-paintings themselves, as was stated in the Introduction, show the influence of the monumental paintings of Mikon, Polygnotos and their circle. But that does not mean anything like what it would have meant in the archaic period. The beauty and importance of many classical vase-pictures must not deceive us: vase-painting no longer plays the part in the classical style which it played in the archaic. In a word, in the best works of the severe red-figure style we have archaic beauty itself, in those of the classical red-figure style we have only a reflection of classical beauty. From the very nature of the classical style, decorative, applied art is no longer on the same level as the high works of monumental art, but sinks to the rank of modest handicraft; and in vase-painting, even more than elsewhere, the technique and the decorative purpose were now felt to be cramping. This has been mentioned already: it is true primarily of the red-figure style, but also, in less measure, of the most precious creations of white-ground painting, the sepulchral lekythoi. The lekythoi are gems of Attic fifth-century art: but all the same no more than a reflection of monumental art is transmitted to us by these humble products of the lowest rank of painting. But all we have remaining of the great art which over-

shadowed vase-painting is a few sculptures, and even the most glorious reliefs are no substitute for the drawing alone of the monumental painting which has disappeared. But our knowledge of the sculpture should enable us to overlook the weaknesses and imperfections of the vase-paintings, and to feel the greatness which not only overshadows them but shines through them, seldom in all its original brightness, but seldom quite decomposed. One may refuse to enjoy the pure *form* in classical vase-painting without reserve, or restrict oneself to a few vases, mostly white-ground, of Cimonian and Periclean times: but the *expression* in a great number of pictures is irresistible. The naive emphatic manner of archaic art has given place to such a deepened sense of the inner life that one feels as if art had caught up at one bound the wide interval which had divided it from Homer and Sappho.

It could not be otherwise, for in the sweltering storm of the great Persian war the slowly ripened fruit of Greek humanity had burst its husk. The people had awakened to the consciousness of a maturity so free and so magnificent that all the achievements of the admired Orient paled before it. At Salamis and Plataea the despotic might of Asia shattered itself against the will-power of the free humanity of Hellas. The soul of Hellenic resistance was Athens: Athens, which, occupied and destroyed by the Persians, lived on free and strong in her citizens. 'The thought of the all-outweighing importance of man was the new contribution made by victorious democratic Athens to the historic development of mankind,' says Julius Lange in the introduction to his wonderful appreciation of the Parthenon frieze. This great experience made the Greek serious. The times of naive joy in life, of youthful gaiety were over: their statues smile no more, and even of Pericles Plutarch says that no man saw him laugh. Their costume also became serious and simple, for the same spirit of austere and simple grandeur came over every aspect of life. The paths of poetry and figurative art ran closer to each other than ever before. Polygnotos and Pheidias stand beside Aeschylus and Sophocles on equal terms, not only as creators of form but as speakers to the heart. Thus Athens, rescued by the political genius of Themistocles, and guided by Pericles who embodied the classical spirit in his life, became the Hellas of Hellas. There is a deep significance in Pindar's praise of Athens: the last prophet of the perishing Dorian aristocracy, that great severe structure in which the strength of archaic Hellas lay, greeted the new spirit which has created the world that is ours.

We begin with a group of vase-pictures which in more than one *Figs.* 69-73 respect point beyond vase-painting to monumental art. There are good

55

reasons for supposing, though it has been disputed, that they are all from a single hand. This painter worked in the factory of Euphronios in the seventies; one of his earliest pieces bears the signature of Euphronios as potter and the name of the fair Glaukon, probably a son of the same Leagros who had been celebrated a generation before. Both names can be restored, though not with certainty, on a fragmentary white-ground *Fig. 69* cup from the Acropolis. Our illustration gives only the most important fragments without attempting to arrange them. The subject is the death of the singer Orpheus, who fell a victim to the rage of the Thracian women. Taken by surprise, he sinks on his knee and vainly endeavours to defend himself with his lyre. The Thracian woman is tattooed like *(Fig. 66)* the old slave in the picture by Pistoxenos; streaks on the neck and an animal on the arm. The head-type is that of the transitional period, just as we find it in the statues of the tyrant-slayers made in 478 and on Syracusan coins of those years: there is the same simple and austere grandeur, the last term of a long evolution. The power of the massive lower part of the face and the noble outline of the skull blend with the subtle animation of the profile-line and the wealth of hair to form a complete harmony: severe grandeur, inward life, and festal adornment enhance each other. At last the profile eye looks, and looking guides our eyes to the speaking outline: the direction of the look is still somewhat undecided because the iris is drawn as a full circle as if seen from the front: in this these *(Fig. 51)* eyes still lag behind the anachronistic eye of the old Sosias cup; it is only in the indication of the skin of the upper lid that they outdo it. The hair is treated pictorially enough not to tell any more as ornament.

Our fragments are masterpieces of early classical drawing. But it is only in an entire picture that the whole capacity of the new style is *(Fig. 70)* disclosed. The Aphrodite cup, a somewhat later work, in which the drawing already aims at the classical profile, still bears the name of Glaukon. The whole promise of the Orpheus cup is here fulfilled, and over and above that a new note sounds in our ears, the note of the lyric mood. The lady is no longer a beauty like another: it is the goddess herself revealed. The noble simplicity of the drawing, the lofty calm of the bearing, are animated with life from within: the eye looks; the half-indeterminate attitude of the hands seems to contain the immanence of delicate motion. We have seen that the archaic vase-painters had good cause for clinging tenaciously to the formal non-perspective drawing of the eye; it made it easy for them to give a great variety of expressions. But these were mostly the naive emphatic expressions of the archaic style: the look which speaks the soul could not be rendered until the post-archaic

56

style. Not till then did the look acquire real direction ; not till then could men look deep or sharply into each other's eyes or let their gaze range far away, and the eye become the gate of the soul. Painting had an advantage over sculpture in this respect owing to the different nature of its task ; and thus the fame of the high ethos of Polygnotan painting rang through all antiquity. Ethos is the spiritual complement of the formal qualities of the classical style. We have no word for it. Mood, measure, loftiness and dignity are as much part of it as the noble modesty, unconscious of its own beauty, with which the Idolino pours his libation. Speaking in general terms, it is the external aspect of the noble soul as Pericles embodied it, Winckelmann's noble simplicity and quiet grandeur, but not only when the spirit is at rest, for it is also the preservation of carriage and control even in stormy motion and excitement. In this sense the figurative art of the period is as well acquainted with passion as Aeschylus and Sophocles : but the pathos is subdued and ennobled by ethos. It was not until the sophists and the Peloponnesian War that the Greek soul lost its balance : uncontrolled passion and sweet self-indulgence divided it, and only the inherited nobility of form covers and conceals the internal disruption.

Nothing is more significant of the deepened psychological insight with which the classical style begins its course than the way in which Polygnotos, in the face of a powerful artistic tradition, represented the destruction of Troy : not the raging night of massacre with its abundance of movement and its violent contrasts of expression, but the atmosphere of the morning after the storm, with little action to stir it, and a multitude of subtlest gradations ; not Ajax's brutal assault on Cassandra, but the oath he takes in the presence of the leaders of the host. Neoptolemos alone was still seen murdering, like the last flame of a great fire which is smouldering out. Polygnotos' treatment of the Slaying of the Suitors was similar. The slaughter and the unequal combat were over.

In a many-figured picture on a krater, of which we can give only an *Fig.* 77 extract, there is a strong echo of the art of psychological atmosphere as it was displayed in the great mural paintings. Herakles and Athena are seen surrounded by resting heroes : a picture of pure existence without action, but so full of internal tension that we ask and ask ourselves what great event is here casting its shadow. The Argonauts marooned in Lemnos and now awaking to fresh exploits, or the Attic heroes on the fateful morning of Marathon—we do not know which the Paris krater represents, if either : but we feel the spirit of Polygnotan painting in the atmosphere of the picture even more than in the composition or in the

57

Polygnotan devices of facial expression. In the composition not only is the old common standing-line abandoned for the first time in vase-painting, and the rule that the figures shall reach from top to bottom of the field broken: but the background no longer tells as a plane surface; besides the foreshortenings of the figures we have the recession into depth of the total space in which they are set. Although the painter has rendered the hilly terrain by white lines and thus adapted it to the limited resources of red-figure technique; although he has composed the principal group so rhythmically that it can be taken in at a glance; although, unlike others, he has avoided the superpositions and intricate grouping of monumental painting for the sake of clearness of outline and equable distribution of light and dark: in spite of all that he has half destroyed the surface he set out to decorate; and surface and space intermingling produce an impossible hybrid. The sitting man is floating over the reclining man's head rather than sitting above him. The frontal shield contrasts as violently with the shields seen from the side as if it were a piece of flat ornament. Recognising what their real task was, and what means they had at their disposal, the red-figure painters went no farther in this direction. They retained, indeed, the half-spatial distribution of the figures on the picture-surface, but it soon became a decorative formula, so schematic that it assured the predominance of the effect of flatness over the effect of space, especially as later generations are accustomed to far stronger spatial effects in monumental painting.

Side by side with the great pictures of lyrical atmosphere, battle-pictures with wild movement were never lacking. The Painted Porch at Athens contained, besides the Sack of Troy by Polygnotos, the Battle of Marathon by Panainos, and its mythical counterpart, the Amazonomachy by Mikon: there was another Amazonomachy in the Theseion, as well *Fig.* 71 as an important Centauromachy. Classical ethos affected these pictures also, as is shown by one of the most monumental works in Greek vase-painting, a huge cup in which the great figures almost burst the round. Four warriors bring the whole battle almost eerily close to our eyes. The motive, rare in Greek art, of the actual death-blow by the sword driven downwards into the heart is ethically deepened by the beseeching look of the beautiful woman. Figurative art had now reached the stage at which it could take up the Penthesilea motive from the old poem. But our picture goes only half-way, and the bearded giant whose gaze passes above hers and beyond it is an Athenian rather than the Achilles who was seized with love for the mortally wounded Penthesilea. A dying Amazon, and even more the hawk-look of a Greek who rushes

58

by, suffice to bring the tumult of battle before us. Strong overlappings, in spite of which the principal outlines are carefully kept clear, create an effect of space, which is heightened, though only to our modern feeling, by the gradations of size. The effect produced by the unintentional harshnesses in the drawing of the victor's arm and head, and in the contortion of the dying woman, is also fortuitous. Like most of the harshnesses in the early classical style these are archaisms as far as they concern the position in the picture-plane or vertically to it : in the rendering of form the only vestiges of such archaism are in the hems of the Amazons' clothes ; and the profile-line has attained a classic simplicity.

The progress can be followed step by step from the white cups with Orpheus and Aphrodite onwards, and further proofs of the connection with those earlier works are furnished by the pictures on the outside of the cup and the experiments in the use of patches of matt colour : dull red and light grey are preserved, and there may have been other tints ; besides this there is the yellow of the diluted glaze, and the raised gold details, these also an attempt to vie with monumental painting.

The master of the Amazon cup has understood the secret of the new style. His four figures show the spirit of a great monumental picture far better than the swarm of little fighters on a fragmentary krater which we reproduce in an outline sketch without the black background. Its *Fig.* 75 value is that it gives us a better notion of the terraced tumult of the wall-paintings than the picture of the heroes with Herakles and Athena. The attitude of a third painter towards the style is different again. We give (*Fig.* 77) an extract from one of the friezes on his krater. A banausus and proud *Fig.* 76 of it, one might say. He was not going to paint a landscape-like monumental picture on a pot, but broke the surface up into two friezes of the old kind —a reactionary phenomenon not uncommon at the time. Within this decorative framework he was anxious to show that he in his turn could also paint these new-fashioned Amazonomachies with their strange, freshly observed motives, their rich armour and costumes, and their feats of perspective. But his swan-casqued knights and heroic maidens have something strangely cutty and coarse about them without being really individual or naturalistic. All that has happened is that in the painter's hands the ideal types have become caricatured and plebeian-ised. The admirable group of the Greek collapsing before the determined Amazon and goggling in terror at the axe which threatens his bared head, almost reminds us of Dutch pictures of chawbacons. How expressive the eyes are in both figures, the mouths, the attitudes and movements, and how effective the high short skull with the lank hair ! It is hardly an

accident that the noble type is least contaminated where the painter has had to pull himself together, in the quite successful three-quarter faces. A more emphatic manner was more natural to him, and it comes out even in the stopgaps on the reverse, where friend and foe hurtle past each other at the double without engaging. This painter has even drawn a rider from behind, by purely ideographic devices without any real fore-shortening, and made the figure not only fairly convincing from the point of view of perspective, but distinctly expressive. Yet the effect of depth does not strike one at a hasty glance, and so does not make a hole in the wall of the vase. Looking closer, one seems to see that the Amazon is springing somewhat sideways to the left, while she like her horse looks to the right as she digs her heels into his flanks. These are the two ways the picture was meant to be looked at : it was not painted for archæologists who can peer still closer, and coldly, crudely pluck the painter's blossom to pieces.

Fig. 72 This droll picture has taken us far from the master of the great Amazon cup. Let us look at another work of his, the Tityos cup. The giant Tityos assaulted Apollo's mother Leto and now succumbs to the avenging god. The mother of Tityos, the earth-goddess Ge, has raised herself up as on the Pergamene frieze, but cannot move Apollo to relent. The early archaic representations of the subject are exceedingly naive : Apollo and Artemis rush up on foot or in a chariot and launch their arrows at the offender, while Tityos and his mother make off at full speed. In the ripe archaic style the treatment of the subject is larger, and already approximates to our picture : the wounded Tityos sinks on his knees at the feet of Ge and extends his arm towards Apollo imploring mercy ; Apollo, unmoved, feels for a second arrow. But it is still the emphatic archaic manner without deeper spiritual content. Our painter is the first to give his picture inward grandeur and ethical depth, and a further, unintentional effect is produced, to our eyes, by a vestige of archaic affectation in Ge, as she blenches at Apollo's look ; it heightens the expressiveness of the principal group—the vengeful wrath of the tall young god, and the terror of the defenceless giant. Finally we glance

Fig. 73 at the exterior of a small cup by our master. It is decorated with the same swift studies of youths and horses as many other cups by him, including

(*Fig.* 47) most of his big cups. The relation is the same as in the Amazon krater by Euphronios : the principal picture monumental and severe in style, the other easy studies from nature. The horses especially show keen observation without the least concession to ideal beauty, as can just be made out in our reproduction. The composition is particularly decorative,

almost heraldic, and brilliantly adapted to the shape of the vase. In more than one respect the painter is a second Euphronios : and he painted in the factory of Euphronios, at any rate at first. Can he even be the old Euphronios himself, capable, if any man, of this last and greatest change ? It is not probable, but not impossible. The enigma of his much-discussed personality is unsolved.

We mentioned a Centauromachy among the mural paintings of the Polygnotan circle; and a number of centauromachies on vases show the influence of monumental painting. We reproduce the most important *Fig. 74* specimen. The painter gives us an extraordinary blend of expressiveness and beauty. The opponents of the woodland monsters are not heavy-armed warriors as in earlier art: the wedding-feast of Peirithoos lent itself better to an ethical treatment, and the painter has availed himself of its possibilities to the full. Armed only with the trained strength and skill of their splendid athletic bodies, and with the superiority of intelligence over brute force, the Greek youths cope with the gnashing monsters in whom the beast has mastered the man. And this contrast, strong and deep both in form and in expression, is accompanied by a second contrast no less ethical in its content : between the tense, towering youth and the rushing centaur a maiden lies on the ground, her garment half torn from her breast, her head averted and her arm extended, beauti-fully and expressively, in a great gesture of horror and self-defence. The motive in itself is archaic, and the dominant of the outstretched arm is struck as early as Euthymides and Euphronios and later in monumental art as well, down to the discobolos of Myron : but compare our figure with the fallen Amazon on the krater of Euphronios in Arezzo, and see *(Fig.* 47) how the drapery and the general context enhance the expression. The interweaving of the groups and figures is masterly, and the main group attracts the eye so forcibly that we do not mind the boldness with which the frame cuts off the whole forepart of one of the figures—the kicking centaur who recurs on the frieze of the Phigaleian temple and elsewhere. The fighters make weapons of tables, vessels and any piece of furniture they can lay their hands on; and no doubt did so in the original wall-painting.

The naturalistic traits in archaic vase-painting condensed into a real artistic movement at the turn from the archaic to the classical style; we saw this in one of the artists who painted for Hieron, and in Pistoxenos *(Figs.* 59, as well. The feeling for truth and expressiveness and the desire to escape 66) from the tyranny of traditional types led to the deliberate quest for ex-pressive ugliness. Archaic art, grown old, plunged into that Fountain

Fig. **78** of Youth, observation of nature, in order to emerge in new and maturer beauty. The head of a warrior on a krater will perhaps always remain the masterpiece of this movement. For portrait quality, physical or psychic, no Hellenistic or Roman portrait surpasses it. We can judge from this how individual the characterisation of the generals in the picture of Marathon may have been. But it was not only strongly pronounced male heads, or old hags like the slave in Pistoxenos, that could now be characterised. The forms of fair women, which are less easy to catch, might also receive individual treatment: Polygnotos is said to have figured Kimon's sister, Elpinike, among his Trojan women. The individualisation even of beautiful female heads is significant of the progress from archaic vase-painting: the new age can detect what is individual in form and expression even when it does not wish to produce a violent effect. In the early classical style the old emphatic manner retreats to the sphere within which it is countenanced in every age—caricature. A brilliant *Fig.* **79** example is the picture of the poet Aesop listening to the fox.

With the picture of Aesop we leave for a moment the realm of monu-*Fig.* **80** mental painting: our next picture brings us back. The pair of maenads moving forward with their arms round each other's necks comes from a Dionysiac frieze-picture in which the other figures are not very remarkable either in movement or in expression, and helps us to imagine the effect of Polygnotan female groups. What a change from the maenads of (*Fig.* **20**) Amasis in barely three generations! Not only is the formal connexion of the two figures now perfect, but there is a depth of feeling and refinement in them to which even the maturest archaic style was insensible. The one woman, the leader, strides forward upright in her severe Doric peplos, gripping the neck of the snake coiled round her arm, and turning her head towards her friend who is clad in the soft flowing Ionic chiton and clings timorously to her, with downcast eyes. Two characters, two temperaments, revealing their diversity under the influence of the same mood: that is art beyond our master's, however much credit we give (*Figs.* **71**- him for reproducing it so well. Here also there is an accidental effect **72**) as in the great cups: the austerity of the leader seems heightened by the harshnesses, still normal at the period, in the three-quartering of her face. The comparative frequency of the three-quarter face in the early classical style is due to the influence of monumental painting; in the Periclean period it retires again in favour of the pure profile, which is far better suited to the linear and decorative conditions of vase-painting, and not until the late red-figure period is it used commonly and with unhampered freedom.

62

Another sign of the powerful impression made by monumental painting in the generation after the Persian wars is that its influence appears where one would least expect to find it, in the miniature-like drawing on small vases. Whatever is small and fine, the life of women and children in particular, which the monumental art of the high style had left almost untouched, was the peculiar department of the vase-painters, the bronze-workers, and the other masters of small decorative art. They gave it the form appropriate to the spirit of the new age. They poured over it an inexhaustible abundance of piquancy and grace, of lyric feeling and lovely fancy, and in their own sphere raised even such a memorial of their age as the painters of the white lekythoi in theirs. From the life and love of woman, treated with a fascinating mixture of truth and poetry, we pass insensibly into the circles of Aphrodite and Dionysos. In these circles the Erotes, under various names, live and work and play, and with the high style they even penetrate into the woman's quarters of the citizen's house. Such subjects gained in importance as the vase-painters came to realise the distance between their own art and monumental painting. Up to the middle of the fifth century the way is hardly trodden, though already prepared. One modest *Fig.* 81 example is actually connected with the archaic period through the name of the potter Hegesiboulos, whose factory already existed in 500. The little cup is extremely light and fine in make; the shape is based on a metal model; the technique is peculiar, for the white-ground picture is surrounded by a zone of bright red glaze. The little picture is not particularly fine in execution, but very charming: set freely in the circle, a girl watching a top spinning, whip in hand; the movement successfully caught, and straight out of nature. A similar figure appears on a perfume-pot, grouped with a second top-spinner; and only slightly modified on a hydria, playing knuckle-bones: it may have come from the monumental painting of the time. The game of skill in which the knuckle-bones of small animals are used is still a favourite in the south, and we know it to have occurred in ancient wall-painting; two maidens who had died young were playing knuckle-bones in Polygnotos' picture of the under-world, and we shall find it presently in a copy of a fifth-century panel. (*Fig.* 117)

Like the Hegesiboulos cup but infinitely finer are the three cups of *Figs.* 82-84 Sotades. They are all unique in their way, the Glaukos in subject, the Death of Archemoros in drawing, and the Apple-pickers as a whole picture, in drawing and in conception. The picture of the Apple-pickers is in- *Fig.* 82 complete: there seems to have been a second figure on the other side of the tree, under the overhanging boughs, no doubt collecting the apples.

63

The picture has the same fragrance as Sappho's simile of the reddening apple which the apple-gatherers forgot, nay, could not reach. The freshest feeling for nature embodied in the plainest and purest forms: the lyric mood in mere human things for the first time in Greek art. The feeling for nature which we here see taking hold of figurative art has the same freshness of untouched youth as the slender child who stretches so expressively and yet so prettily up to the topmost branch of the tender tree; holding her thin chiton delicately; unconsciously, following the motion, her lips part, and the step she took to stand on tiptoe still rustles in her dress. The light vesture clings to the blossoming body and flows or ripples round the translucent forms: all this is no more new than it was in Polygnotos, who was famed for his drapery, and yet compared with the archaic treatment and the red-figure technique it has a new directness of effect and the drawing is full of pictorial values. Sense of nature and lyrical content in a language which is master of every subtlety of drawing and is beginning to feel pictorially as well, and over it all a peculiar charm of unconsciousness—that is what makes this work unique. The best way of realising what is new is to compare similar things in the (*Figs.* 48, archaic style. The frail Theseus of Euphronios, the fleeing Astyanax of 52) Brygos or his girl flying from the wicked king or god, his kindly hetaira (*Figs.* 54, in the gently waving chiton, and many another picture—expressive and 55) subtle as the feeling and the drawing is in these, it is not yet feeling for its own sake, or drawing that retires behind its effect. And even if we take the most unpretentious athletic motive, or a girl holding a flower, in the archaic style it is always the formal motive and the successful observation that appeal to us (not to speak of the drawing as such), never, as here, nature and feeling, sheer and direct, which it is after all the sole object of draughtsmanship to convey to us full and pure. As a draughtsman Brygos had already set foot on the path which leads hither, and that is what makes him the master of expression: but as an artist even Brygos still belonged to another age: not only are archaic emphasis and classical feeling incompatible, but they do not flourish in the same soil. It is the new spirit that has found its form in Sotades.

The new age gave a new life to the element of landscape in its pictures. There are charming trees and shrubs in the late black-figure style and in Etruscan tomb-pictures (the red-figure style was hampered by its technique), but not only are they treated decoratively rather than pictorially, and seldom fused with the human figures into a real landscape, but above all they are not united with the figures by such a feeling for nature as we find in our cup. There is expressiveness in the storm-bowed palm-tree

64

in an archaic picture of the destruction of Troy, but how much more
direct is the effect of the reeds in the Archemoros of Sotades, and how much *Fig.* 83
greater its importance in a composition which is unusually free and almost
too unsymmetrical for the circular field ! We feel the space in it even
more than in the Apple-pickers, for the high reeds stand to one side, there
is more air-space above the figures, and the figures are much smaller.
An expressive diagonal runs across the picture, from the huge snake high
in the clump belching white steam, through Hippomedon who starts back
with a stone in his hand, to Hypsipyle sunk on her knees, beside whom
one hand of the dead child Archemoros remains. We can feel how the
snake has shot and will shoot again; his jaws threaten, and the reed-
heads threaten like spear-heads. It is as if the piercing look of Hippo-
medon held the snake for a moment spellbound—the decisive moment
which gives him time to fling his stone. The effect of his look is height-
ened by the intense excitement in his extremely individual features. This
naturalistic study in this place, a boorish huntsman in a skin and a fur
cap instead of one of the seven knights who rode against Thebes, is most
characteristic of the early classical style, which we see here in its highest
refinement, just before the Periclean period, or perhaps at the beginning
of it. In pictorial devices this cup goes even farther than the others.
The shading and modelling of the fur would be done in much the same
way by a modern etcher or wood-engraver. Even the smoke-clouds,
which, following an old practice, are in relief, hardly impair the pictorial
effect, for they are fairly compatible with the linear drawing which, after
all, still dominates the whole.

As a picture the Glaukos is naive. Its main charm lies in the rendering *Fig.* 84
of the subject-matter. It is the story of the boy Glaukos, who died.
His father Minos took the seer Polyidos and shut him up with the body
in the tomb. There Polyidos killed a snake and noticed that its fellow
revived it with a herb : he took the herb and brought Glaukos to life.
The painter wishes to show the great tomb both from the outside and
from the inside, and he has therefore made a curious blend of elevation,
section and ground-plan. This is asking too much of us : though we
can easily see that Glaukos and Polyidos are in the grave, not in front of
it, it needs exact knowledge of the legend to tell us that the seer is aiming
at one of the snakes with his spear. That the boy does not look like
a contracted burial, but watches the prelude to his revival as if he were
alive, was even more readily intelligible to the painter's contemporaries
than the view of the interior of the tomb. It is charming to see how
the delicate curves of the figures, set unevenly in the space, fit into the

curvature, indicated by slight shading, of the tomb. In the muffled boy the purplish-brown garment has the same value as a means of expression which it often has in the sepulchral lekythoi. This solution of a problem insoluble to fifth-century art is like an echo of archaic naiveness on the verge of the Periclean age. But after all, classical art always retained a happy measure of artistic naiveness in face of reality; and unless we realise that, we shall not do justice even to its greatest and purest works like the frieze of the Parthenon.

Figs. 84-87 We turn to the last and most notable development of white-ground painting, the sepulchral lekythoi. We spoke of their technique in the introduction, and of their artistic importance at the beginning of our consideration of classical vase-painting. They will be discussed here at somewhat greater length than the actual explanation of our illustrations seems to require: but in the lekythoi, if anywhere, the part is only intelligible in connection with the whole. These slender oil-vessels served only for the cult of the dead, and therefore did not need to be durable. When the body was laid on the bier, they were set beside it, open, to let the fragrance of their contents escape: oil was poured on the pyre and the vessels thrown intact or broken on the flames; others were laid in the grave, often the only vestige of once numerous grave-gifts; the gravestone was anointed and the vessels placed on the tomb as a dedica-

Figs. 87, 97 tion, as we see in two of our pictures. In one they alternate with the little jugs used for the libation to the dead; wreaths are put round them, branches and a woollen fillet fastened to the monument. Above, in the field, are more lekythoi, a mirror and a fillet, hanging on nails which we may think of as fastened in the wall of the tomb precinct. The grave has been decorated for a festival of the dead, evidently by the girl who sets her foot on the lowest step and holds the basket in which she has brought the things: there are still a few wreaths in it. In the other picture fillets hang down out of the basket, and the girl holds a perfume-vase of another

Fig. 86 shape, an alabastron. A third picture shows a lekythos in the girl's hand. The perishableness even of the dedications set outside the tomb is parallel to the burning of the sacrificial flesh and of the grave-gifts, including clothes, and the shattering of vessels after use: they are not only withdrawn thereby from earthly use but appropriated to the dead. That is the underlying idea, but the idea is already faded by classical times: the traditional usages went on, and some of them still survive. Other ideas mixed with them, and thus the ephemeral decorations of the interment and the festival of the dead were turned into permanent memorials—monumental lekythoi of marble with the same kind of reliefs as the other tombstones.

66

Like the reliefs, the pictures, and the statues on the tombs, the lekythoi are gaily coloured. It is the opposite of what we are accustomed to. Black prevailed in the vessels of the living, bright colours in the cult of the dead, in the lekythoi just as in the tomb-monument itself and in the fillets fastened to it. The most symbolic colour is the strongest, red : the colour of the life-blood for which the soul languishes. There is magical power in the wool of the fillets, the leaves of the wreaths, and so forth. Thus the bright colour of the lekythoi must not be measured by our standards, and we must take into account the light hues of southern nature, of the art round about them, and of male and female costume. Then we in our turn may receive the impression of mourning from a dark red on the white ground of a lekythos, if the painter has intended to produce such an impression. Here is a picture of the dead on the bier : *Fig.* 90 he is covered with red fillets and a mantle of strong red, while a youth and a woman in deep red garments stand at the ends of the couch. Our picture shows the youth only : he is muffled in his mantle as if shivering at the sight of the dead, head and hand only half showing out of the dark mass. There is the same effect in other pictures which we shall examine later. Our reproductions being colourless, we shall not discuss the *(Figs.* 92, colour of the lekythoi further. But we must say one thing, that it is not 95, 96) so primitive as has generally been supposed. Taken together with ancient colouring as a whole, and with nature in the south, it is quite intelligible. True that we can hardly ever enjoy it undisturbed ; many of the colours have altered, others have disappeared, so that often all we see to-day is the permanent outlines of the figures and disconnected patches of colour.

Regrettable as this loss is, we should have been much worse off, if instead of the colour much of the outline drawing had disappeared : for line is the specific medium of the painter's effects, colour only an adornment as in sculpture. Freed from the limitations which the chief instrument of the red-figure style imposed upon the movement of the lines, the painters could now give new life to their line, and a new expressiveness to the contour, which tells much more strongly on the white ground than in the red-figure technique. The emancipation of line-drawing from a technique which could not create a style of its own except in the language of archaic art and in the decorative, is much more important than the more striking polychromy, which is not even universal in white sepulchral lekythoi, for it is absent in a large class of lekythoi even so late as the Periclean period. The independent development of lekythoi-painting begins about 460 with an early class of vases, which have a distinctly *Fig.* 85 monumental character : large areas of lustrous black paint are still used,

67

especially in the garments, and for the female flesh a chalky white standing out clearly from a background which is not yet pure white ; the brush-lines are often fairly broad. There is considerable fluctuation, as is natural, in this early period : style and technique are only in process of creation. Our picture is not typical, but important in spite of the un-usually hasty execution : it is dashed in with strong brush strokes like a fresco sketch. The subject is the Eleusinian deities of the underworld, who promised immortality to the initiated : Demeter or Kore with the torch, and Triptolemos with sceptre and patera. Form and attitude are equally impressive in their simple grandeur ; the goddess especially, with the great sweep of her mantle, has the air of some statue from the neigh-bourhood of the sculptures of the Olympian Temple of Zeus ; in particular she makes us think of a very grand and austere work, often copied for the Romans, the wrongly-named Aspasia.

From the austere grandeur of this springtide we pass to the pure beauty of the Periclean age. That age, as an artistic conception, begins about the middle of the fifth century. It is to the beginning of the period *Figs.* 89, 94 that the most precious works of noble drawing belong. Whatever nobility of form, purity of line, and expressiveness of contour can attain is here attained, and fair form and simple noble attitude are filled with *Fig.* 94 life delicately perceived. In the wonderful picture of the young warrior and the seated woman the whole expression is given by the simple presence of one fair young creature with another : the picture says without words *Fig.* 89 that the young man did not come home from the war. The other picture shows a lady with her maid, who holds a box—a simple scene from house-hold life like many grave-reliefs. In the two generations down to the beginning of the fourth century the art travelled a long distance. The path was the path of drawing, not of painting : for a small group of monumental lekythoi, in a free pictorial style, does not represent the goal *Fig.* 97 of the development but an exception. Contemporary and perhaps by the same artists are other lekythoi, in which pure drawing holds the field : life and expressiveness of line sometimes rise to an almost uncanny height, and pictorial accessories, even the drapery, are of little account. This is the real goal of the development ; whither the development is tending is clear from the beginning, although the course is by no means along a single straight line. The vehicle of the beauty, and of the expression which becomes more and more an end in itself, is throughout the human form, and that alone. Compared with its line, attitude and movement, even the drapery plays a much more modest part than in the red-figure style. In red-figure, body and drapery are in great measure equipollent

68

parts of a more or less ornamental linear structure; in the lekythoi they diverge. In the human figure the line received an access of expressiveness by becoming pure outline drawing, as soon as the painters abandoned that flat effect of chalky-white flesh on a darker background which is peculiar to the early class already described. In the drapery, on the other hand, the drawing of folds sustained a check, and henceforward it is very seldom anything like as detailed as it usually is in the red-figure style : the drapery *Fig.* 87 normally tells as a coloured mass, in which even the outer contour has not the same importance as the lines of the figures. The effect of the figures is increased by contrast, at times to a thrilling height, when the white arms of a mourning maiden rise from the black drapery with a sweeping *Fig.* 96 gesture, or the fine features of a dead youth, standing a quiet apparition *Fig.* 95 in front of his grave, from the mantle which envelops his whole body. When the line tells in the drapery as well, it often plays round the body, which is usually drawn complete under the garment, in hasty, darting *Fig.* 97 strokes with nothing ornamental about them : and the rare patterns on the garments are sometimes seized by that strange life which blooms from the graves and makes the pictures on the lekythoi so peculiar : the pattern becomes a living tendril. It is owing to the same tendency to infuse organic life into the inorganic, that we find so few representations of statues and grave-reliefs on the lekythoi, and so many figures which seem to have wakened to life and stepped down from their monuments —the lady in her chair, the warrior, the hunter. The tendency is particularly obvious in the representations of sepulchral monuments. Side by side with very plain stelai and tumuli, indicated by a few lines, we soon find florid ones of all sorts, sometimes even with pedimental reliefs and small statues. But the painters soon gave up such representations, evidently feeling that the excess impaired the effect of the figures. Stele and tumulus, the old Homeric tokens of the grave, came into their own again. The stele is at first quite simple, at most crowned with a plain anthemion, and decked with coloured fillets. But with the development of the pure lustreless painting a freer life takes hold of it : a luxuriant acanthus appears, which is neither stone ornament nor bronze ornament, nor plant, but a product of the artist's feeling. Again, it can hardly be due to cursory drawing merely that the lines of the cornice sometimes curve as if the stele were a column, for a glance at the baskets shows *Fig.* 97 the same phenomenon. Once more, the outline of the tumulus often *Fig.* 87 has an impossible curve : its inorganic mass is seized with organic life, so that we feel its upward thrust as in shaft and echinus of early Doric columns. It is the same spirit as gave birth to that mysterious curvature

69

of the horizontals which lends Greek monumental buildings their living elasticity.

This inner life kept the style of the lekythoi from falling into the mannerism which appears not only in red-figured vase-painting of the florid style but also in post-Pheidian sculpture. If we compare, not hasty little lekythoi with important red-figure vases, but, as is fair, like with like, then there is a certain truth in a saying which is false as a generalisation : that red-figure painting is decorative handicraft, while lekythos-painting is art on a humble level. It is indeed going too far to say that nothing intervenes between the lekythos painter and nature, that he creates out of his imagination and observation and that he does not stand in a line of fixed craft-tradition like the red-figure painters, who constructed their figures solely of ornamental lines, carefully practised, and conditioned by the technique. Nor is it enough to admit that there were simple craftsmen as well as great artists among the painters of lekythoi, and that the line which is not bound by technique, and therefore not (*Fig.* 109) supported by it, easily goes astray. But if we compare the affected and often mawkish figures of Meidias or Aristophanes and their fellows with the pictures on the later lekythoi, we are forced to confess that in those there is much empty, dead form, and in these little ; in those hardly ever, in these almost always, direct expression. The painters of the lekythoi were in love with expression, at times even to the neglect of form ; they felt in the creatures of their imagination the eternal humanity which those creatures expressed : and hence their art has remained fresh. In the years of the great war, the death of the young and the strong spoke too penetrating a language for the feeling which it arouses to be blunted : there was no room on the lekythoi for artistic caprice. So it comes that in lekythoi we still feel the spirit of the Parthenon frieze, even when the atmosphere has become softer, the figures more sinuous and more indolent in their bearing and their movements. One may even say that the increasing softness of the line, in spite of the more sinuous rhythm of the whole figure, soon passes its climax, and the softness finally disappears just where, judging from sculpture, we should expect it to begin, *Fig.* 97 in the grandiose lekythoi which all things considered must be supposed the latest. There is no softness or sweetness here, but austere grief and austere form, culminating, with complete unity of form and expression, in the three-quarter faces with their spare hard cheeks. In extant sculpture the work of Scopas provides the closest but not a close analogy. Behind these lekythoi, we may take it, is the draughtsmanship of the great painters of the later fifth and earlier fourth century, who were renowned for their

70

power of expression : theirs is the art in which pathos begins to gain the mastery over ethos.

It took a long time for this strong expression of mood to develop. It is true that strong, even passionate and violent, expression of grief was no new thing in art : it is suggested on the geometric vases, and is *(Fig. 1)* evident enough in the black-figure representations of the funeral and the lament for the dead ; and an early classical vase with sepulchral pictures shows us the same expression clarified and graded. What is new is that the effect of mourning can now be given without the sight of the corpse on the bier or of the wild gestures of lamentation at the bier or the tomb : the picture of pure existence without action suffices to produce the strongest atmosphere of mourning. The old subsisted beside the new : the old pictures, rare in lekythoi, of the corpse on the bier, and of the lament for the dead ; and the classical pictures of persons merely *Figs. 90, 93,* present side by side at the tomb. In these classical pictures we often feel 96 that vegetative, unconscious quality which is so noticeable in the Greek ritual of to-day, especially in the women, when they suddenly become silent, and quietly, without the least intensity or even real solemnity, perform a sacred usage which from childhood has been as natural to them as their native language. There is no pathos, no very definite expression even, and yet for a moment they are rapt from the world. Here the ethos of life coincides with that of art in its simplest form. But it needed very little to give a picture like this the definite expression of a particular mood. Thus, in a vase which is not even very fine in drawing and is therefore not reproduced here, the dead youth returns the young woman's greeting shyly, as if the sight of life in its bloom made him hesitate. Another picture is no less touching : the girl with the basket of gifts *Fig. 95* looks at the youth muffled in his cloak, yet he does not return her gaze, but looks stilly and absently in front of him. The downward look, emphasised by the staff, and the dark muffling garment, speak death and mourning. The effect is the same in another picture, but there the dead *Fig. 92* woman is walking forward and her eyes rest quietly on the girl who looks at her gravely, with a touch of sorrow in her mouth. Once more, the same in another form : the dead man is sitting quietly on the steps of his *Fig. 86* grave, without noticing the girl with the gifts ; but she seems to see him and to be startled a little ; she turns away and yet looks back at him, and her look cuts across the wonderful compact composition along the line of his spear.

The communion of dead and living in the light of the grave forms the culmination of a series of pictures representing the care of the tomb ;

71

from the women's preparations in the house to the simultaneous lament of living and dead. In this ' great common lament, sung at the pale of death and life, and sounding across into both worlds,' the old realistic type of representation attains as idealistic a climax as the new type, the pure picture of mood, in the silent mourning which unites those parted by death. The burden of sorrow may be heavy, almost unbearable, and even the peace of the dead may be shaken into passionate movement : but a quiet melancholy, as if eased by consoling memories, may also brood over the picture. Again, often enough the dead man takes no part, and the living seem not to notice the silent guest from another world. It is seldom, and only in the early period, that the dead man is portrayed

Fig. 87 as a hero in the splendour of his armed or athletic body, almost like a statue. In the same period we find representations of actual statues and reliefs : these cease later, but sometimes it is as if the figure of the dead had detached itself from his monument : fighting warriors, riders, women on thrones, give us that impression. The next step is a picture of a hare-hunt in a rocky landscape, where the grave-stele has almost sunk to an accessory.

Fig. 97 There is much interpenetration and intermixture. Charon, sometimes a rude ferryman, sometimes as comely as a human being, and latterly full of compassion for those who are so fair and yet must die, not only waits for the dead on the banks of the nether world but sometimes appears with his boat at the tomb itself, like Hermes the soul-conductor and the tiny souls who fluttered round the grave in popular belief. The dead

Fig. 97 may even be absent : Charon's pitying look rests on a mourner bringing gifts. Conversely, kinsfolk appear on the shore of Acheron : the mother leads her baby boy, who sees the strange ferryman with astonishment from the rock ; and gives the little fellow a box and a bird to take with him : Charon even puts his hand into the basket of grave-gifts, as if they were meant for him : and a fillet hangs in the rushes which have followed his boat to the tomb. There are many variations in the Charon pictures. Hermes may be standing motionless, or bidding the dead embark with an imperious gesture, or leading him to the boat by the hand. Charon may extend a helping hand, as he does to the little boy we spoke of, and to another older boy who glides past the tomb, muffled in his cloak, to the shore. The dead may be standing shy and hesitating at the stream which divides the two worlds, or sitting abstracted in the boat waiting for fellow-passengers. Thus the great age of Athens gives a movingly simple manifestation of its humanity in its transfiguration of death. Even in the delicate transfiguration of burial, the epic origin of the motive

has left hardly any traces : Thanatos and Hypnos, the spirits of death and *Fig.* **88** sleep, lay not only warriors but slumbering women in the grave. And dominating everything is the same grand euphemism as in the Parthenon frieze : even here not age and suffering prevail, but youth and beauty, whose death and sorrow are doubly poignant. Once or twice only does a jarring note, as if from the depths of primitive popular feeling, penetrate into this quiet harmonious world : a grim hook-nosed death-demon chases a young woman at the tomb, and Hermes sits looking on without interfering.

The imperishable phrase in the Greek epitaph, ' so fair, and died,' is the keyword of the lekythoi in a twofold sense. In the mature style the beauty goes without saying, and the effort is rather for expression : more stress is laid on the death, and death is the topic of nearly all the pictures. In the early period there is often no indication of it at all, and only gradually does the scene of the preparations for visiting the grave, developed out of simple scenes of home life, come into the foreground, presently to retire again in favour of scenes from the care of the tomb. Just as one type of sepulchral scene is mingled with another, so purely household scenes with sepulchral : a young woman is sitting comfortably *Fig.* **91** on a chair, with a duckling on her hand which her naked child tries to touch ; can we say that she is preparing for the visit to the tomb like the girl in front of her ? But we find such scenes from ordinary life in tomb-reliefs as well as on lekythoi, and we find them on the lekythoi as reliefs or statuary groups as well as detached from the monument and living a life of their own. What appears on the surface to be a mixture of types was a unity to the Greeks and is a unity to us ; the pervading tone fuses the figures into a single picture. How can we take pictures literally, when *Fig.* **88** one of them is Hypnos and Thanatos laying the dead in the grave, a poetic image which (unlike Charon or the little fluttering souls) had no reality in any religious belief ?

The red-figure painting of the Periclean period cannot compare with the wonderful quality of the white lekythoi. True, it displays the ideal style, founded on truth to nature, of the Parthenon sculptures, and their free and noble humanity, with the complete harmony of those elements, truth and beauty, which were often separate in the early classical style ; it participates in the general emancipation from those last restrictions to which anything that was harsh and uneven in the early classical style was due ; and it perfects the beauty of the motives and the flow of the lines. There is much beauty and much that is noble, and some of its products are magnificent : but its keynote as a whole is its acquiescence in its

position as a handicraft (although a handicraft on a very high level) compared with the monumental art of its time, in the footsteps of which it is unable to follow as archaic vase-painting did, and unwilling to follow as early classical painting did in its upper ranks. The influence of monu-
Figs. 98- mental painting is nevertheless quite noticeable still, and in our two next
100 pictures, which date from the middle of the fifth century, the invention is worthy of a very great master. Hardly any vase-picture gives us so strong a sensation of the lyrical art of Polygnotos as the Orpheus among
Fig. 100 the Thracians. The draughtsmanship of the vase-painter is nothing out of the common, but it is Periclean : attitudes and line are perfectly free, the bodies are rounded, and the execution has that lightness or even hastiness which indicates the refusal to compete with monumental art. But through the veil of this draughtsmanship we see musical appreciation expressed in all its stages, culminating in the transference of the emotion from the song to the singer himself : the gaze of one of the young Thracians has found its billet in the singer and fastens and feeds on his face. There are many other finely balanced compositions of standing figures about a seated one, so that we cannot be certain that the original was a panel picture or a relief : a group like this is quite conceivable as portion of a mural picture with many figures. How far the dependence goes in details one cannot say.

We have undoubtedly only a brief extract from a large painting in the picture of the Slaying of the Suitors which is divided between the two
Figs. 98-99 sides of a bowl. The selection and the distribution show both decorative skill and a fine understanding for the most effective features of a masterly original. The natural distance between Odysseus and his victims re-conciles us to the dismemberment of even such an agitated scene, and the handle-palmettes between the two sides create that nice equilibrium of representation and ornament which heightens the appeal of many excellent vase-pictures. It was long believed that we had here a remini-scence of a wall-painting by Polygnotos in the Temple of Athena at Plataea. But the text of our account shows that there as elsewhere Polygnotos depicted not the fight itself, but the atmosphere after the fight. The art of our master is not the less for that. Even in the vase-painter's curt extract we can recognise the ethical depth of the expression with its different shades, and thus appreciate the artist as a creator independent of the poetical tradition : for to make the maids, as against the Odyssey, into dumbstruck spectators of the slaughter, was an effect for the eye and not for the ear. Nor is such a scene conceivable on the Greek stage ; on the stage it could only be related, not enacted. Only a painter could

74

mirror the terror of the unequal combat in the rigid horror and rent
sensations of the watching maids, and increase the terror by the contrast.
The maids must also have served to balance the group of Odysseus and
his helpers against the mob of suitors. In the vase-picture we can also
feel the contrast between their rooted stances and the supple tiger grace
of the merciless archer and the flinching and bobbing of the defenceless
suitors.

It is significant of the spirit of the Periclean age that we feel it even
stronger in the simplest and most unpretentious vase-pictures than in
the most elaborate. We have already compared the Hector's leavetaking *(Fig.* 38)
of Euthymides with a similar subject treated by an artist of this period.
In Euthymides a true archaic combination of moving earnestness and *Fig.* 102
ardour with the simple pride of the artist; here the modesty of the craftsman
who merely suggests, with a light hand, what was expressed in monu-
mental art, as he was well aware, in a hardly less simple but incomparably
stronger and more complex way. In spite of this, or just because of it,
he shows himself not unworthy of the great age: he fills his humble
place faithfully. In form and feeling his picture is a reflection of the art
of the Parthenon frieze, and it is as simply decorative as the mantle-
figures on the back of the vase. He repeated the picture, once, twice, and
no doubt often, in this also a craftsman without higher ambition: for
there can be no question here of a desire for self-improvement. Thus
the reproach of academic flies over his head, while high praise is due less
to him than to the monumental art which he but follows. He has achieved
his object, that decorative monumentality which begins to develop in the
late archaic period and now reaches its acme. The Periclean age alone
could fill that decorative monumentality with noble humanity and ideal
beauty.

The power of the lyrical art of the Periclean age, which, like Orpheus,
subdues every wild thing, is also seen in the Periclean treatment of
Dionysiac subjects. Our reproductions cover the whole period from *Figs.* 101,
the middle of the century to about 430. If we look through the numerous 103-105
representations of a certain Attic cult of Dionysos, the adagio of the
Periclean age is unmistakable: we find nothing to compare with Makron's *(Fig.* 58)
magnificent swarm of maenads or with the delirious procession and dance
on a famous vase of the florid style in Naples. Not till then, in the time
of the great war, does the flame kindled in the Parthenon pediments blaze
up again, even if, at this late period, the rhythm of beauty has no longer
the unimpaired strength of expression which it has in Brygos or Makron. *(Figs.* 57-
The purely lyric pictures of women engaged in the Attic cult of Dionysos 58)

75

Fig. 103 often rise to real magnificence. Attitude and movement, rich yet still simple drapery, and the solemn tone of the whole, all contribute equally to the impression of a lofty grandeur which is nevertheless full of deep-seated life. This is the very height of the classical red-figure style, and here as in the white lekythoi we hardly ask ourselves about the monumental art which the work reflects, but give ourselves up entirely to the effect of the work itself. In our picture one of the women is holding an infant boy who stretches out his arms to another woman : the boy looks almost like a little satyr, but it is probably Dionysos himself—possibly, indeed, represented by a mortal child : we cannot be certain, for the Dionysiac element had struck such deep roots in art and imagination that the boundaries are easily effaced : the reality of faith becomes the reality of art : even satyrs wait upon fair maids and women at the festival, as well-behaved as the little Loves.

Fig. 101 Our picture probably represents a custom at the festival of flowers. In spring, when nature wakens, Dionysos rushes abroad with his rout, and with the flowers the souls of the dead rise also from the depths of the earth, and many rites are required to appease them and to purify and cleanse the living. One of these rites was swinging : the draught purified. So here we have a satyr, servant of the great lord of all life, swinging a young girl who holds on tight and points her toes pertly into the air. The words which accompanied the action we learn from the inscription : ' eia, o eia.' In his first sketch the artist had drawn the satyr still pushing, then he altered him and made him standing back to catch. This quiet attitude enhances the effect of the swinging, and suits the satyr's festal gravity and propriety. Still more festal in his attire, but a trifle comic with his bent knees like some clumsy slave, is the other satyr on the reverse of the bowl, holding a sunshade over a lady who looks gravely in front of her. It is probably a procession : in the Panathenaic procession the metic women held sunshades over the citizen's wives. The vase is comparatively early, and the satyr seems to feel his old nature still jigging in his limbs : this nature breaks out later in a more or less ennobled form, but at first the new ethos took hold of the satyr, the unruly wood spirit, together with the rest of the god's retinue. Times are changed : he can now be trusted with a fair maid. At worst the satyrs behave like rough peasant-lads, even when they surprise a naked nymph asleep. We figure the finest version of that *Fig.* 104 subject : form and movement are perfectly free, and the rounding of the figures has a distinct spatial effect : but the drawing has a restraint and tenseness which gives the nymph's body the look of a fresh fruit.

76

There are only faint traces visible of the rendering of the soil, and the rendering is much the same as in our next picture.

This belongs to the end of the Periclean period, and is a late work *Fig.* 105 of the master to whom, after Sotades, we owe the most charming of the (*Fig.* 82) small pictures of female life. Dionysos is resting, and his swarm has almost come to rest. The figures, leaning, sitting, lying at their ease, are arranged on the picture-surface with a certain suggestion of space. A nymph, wearied with romping, sinking into the arms of a seated friend, relaxes her limbs completely : and the last ecstatic dancer is not far from complete relaxation. A soft swinging rhythm flows through all the figures. In this we feel the influence of late Pheidian art, of the Parthenon pediments, and the same influence is visible in the drapery with its animated play of folds. Other works of this painter are more severe : together they are the masterpieces of the Periclean style in this sphere : pure beauty and perfect charis ; conception and form large, for all the small scale ; and the charming vegetative life of Greek girls and women rendered truly, simply and on large lines.

The artistic tact of the period shows itself in the moderation of its attitude towards minuteness in drawing, just as clearly as in its refusal to compete with monumental art, for the small pictures, and often the middle-sized ones, are not sketched with a few touches, but drawn with great care, at any rate when the artists are taking their work in earnest. But they knew the limitation of the red-figure technique, and knew that the relief-line becomes dead if handled as Sotades handled his flowing, (*Fig.* 82) pictorial brush-lines, and that if the line was to remain lively and expressive the classical style made different demands from those of the archaic style. This is nowhere so clear as in the drapery and especially in the chiton, which determines the graphic character of so many pictures of female life. In vase-painting of the late fifth century the fine rippling of the chiton has stiffened into a kind of ornament, and the soft folds of the woollen material degenerate into painful flourishes. Not so in the Periclean age : the lines move lightly and freely : when working on a small scale the artist does not shrink from simplifying, the only way to avoid pettiness ; and he is always ready to use such old and tried devices of red-figure painting as the transparency of the garment over the out-lines of the body and the surface-lines, for instance, on the female breast. In the later painters of the group of Meidias strength has given place to (*Fig.* 109) over-refinement, the accomplished technique has become an end in itself, and schematises the style of the time into ornamental affectation. Compare with that the Periclean style of drapery as we see it in our picture :

77

neither archaic stylisation nor post-classical affectation, but complete freedom never abused, the same flow and pause of the material as in the Parthenon, natural, sweet-lined and monumental.

If we look at the later works of our master rather more closely than is possible here, we shall find certain traces of over-ripeness even in them : ever so little pose, and a touch of ostentation in the beautiful rhythms. It was the fate of Attic art as a whole that immediately after its greatest triumph, the pediments of the Parthenon, the form began to lose its inner life, the means became an end, and artificial feats took the place of artistic creation : in a word, manner instead of style. This is the florid style of monumental art in the later fifth century : it still contains so much beauty and life that we have to compare it with the Parthenon, with those natural beings whose nature belongs to the Platonic world of ideas, before we recognise the touches of mannerism. In architecture the chief example of the florid style stands beside the Parthenon—the Erechtheum : all the charm of its complex articulation and its manifold ornament does not equal the plain grandeur of the Periclean buildings.

(*Figs.* 106- The prospects which the new art offered to vase-painting were clearly
109) not those which Periclean art had held out : the florid style did not counsel discretion, it invited imitation. Once more, as in the archaic period, there was a profusion of easily grasped formal elements with a strong rhythmical movement and a highly decorative effect, once more formulae took the place of a large and simple conception of nature ; the garments might be adorned with rich ornaments, the folds might be stylised into a kind of pattern and fantastically curled, and glaring contrasts were considered an excellent means of producing effect. And there was no longer the same conflict as in early classical times : monumental painting had made such progress in light, colour and the rendering of space that the vase-painters could not dream of competing with it in that field. For their composition they used at most a scheme based on the Polygnotan but more or less stereotyped into a decorative pseudo-spatial expedient for filling the picture-surface. In drawing, the progress made in their time helped them rather than hindered them : the devices of plastic rounding and even strong foreshortening were now the common property of all the better draughtsmen. The lines flowed supply, and supply the figures bent and turned ; contours, inner details, folds moved in liquid curves ; the technique received a new impetus, and in the thinness of its relief-lines it almost outdid the archaic style at its height. But what in the archaic period had been pure style, and even in the mannerism of
(*Fig.* 50) Peithinos and his companions had been only an exaggeration of the current

style and current sense of form, was now, after the ideal style of the Periclean age with its close approximation to nature, something quite different. We are painfully aware of the substitution of the calligraphic formula for the fine form, of the flourish for the living curve, of routine for art. These competent vulgarians had lost not only the Periclean sense of nature, but the Periclean sense of measure ; a miniature-like treatment of form found its way into work on a large scale, thanks to a mistaken desire for increased refinement, whereas the immediate predecessors of these artists had imparted grandeur to work on a small scale : sweet, pretty, softly rounded forms drove out simple beauty, elegant movement strong movement, pose rhythm and dignity, sentimental effeminacy that noble modesty with which the Idolino and the youths on the frieze of the Parthenon inclined their heads.

Pronounced as all this is, and only too widespread, it nevertheless represents only the worst side of the florid style. It has a better side, and many painters reached an artistic level where they were not too *Fig.* 108 strongly affected by the vices of the age. They approached as near monumental art as their technique permitted, and rejected the self-satisfied methods of the vulgar. But these are exceptions and survivals, and their best always points back to the late Pheidian style, which dominates the succeeding period, and no doubt found a continuation in the works of monumental painting. An echo of these works is transmitted to us, though but imperfectly, by the best pictures on vases and by certain Pompeian paintings. Superficially these may be closer to the originals *Fig.* 118 than the simple vase-pictures of the Periclean age to theirs : but in spirit and essentials the Periclean vases are doubtless the truer reflection of the great art of their time. And if even there the white lekythoi are superior to the red-figure vases, this is even truer of the florid period, though in a different sense : the lekythoi followed the general trend of *Fig.* 97 the new age with its softer rhythms, but they kept free from mannerism and over-ornamentation, and expression and feeling retained their old purity. The show-plant of the florid style did not thrive in the cemetery.

The pictures of children on the little jugs used by the children *Fig.* 106 themselves at the spring festival were also unaffected by the new style. Unassuming though these little pictures are, there is something new and promising in them. The shape and ways of little children are at last rendered with approximate accuracy. The origin of the novelty may be inferred from the accounts of pictures of boys by the great painters Parrhasios and Zeuxis. A principle is thus established of which we

seem to find traces somewhat earlier in white lekythoi: the naive rendering of the child as a tiny youth, a survival from the archaic period, was now reſtricted to a later time of life, and the awakening of the feeling for the charm of early childhood was the firſt ſtep towards the putti of the Helleniſtic age. It is significant of classical feeling that the Greeks long hesitated to take the ſtep. Even Ariſtotle describes children as ugly dwarves, and implies that really only man is beautiful, not woman : for her body lacks the diſtinct articulation and the bigness, without which a body cannot be beautiful, can only be charming—that is, something like ' pretty ' in our sense. The philosopher is more conservative than the art of his time, but he well represents the classical ideal of bigness and of the rhythm which reveals the ſtructure ; the ideal which received its pureſt embodiment in the Doric temple and the Doryphoros of Polykletos. From this point of view, which is that of Greek art in its very essence from the geometric ſtyle onwards, women could not but seem lacking in clearness and children ill-proportioned. In this matter also the Periclean age represents not only a climax but a termination. There was much artiſtic and human development after it, but no succeeding age was at once so artiſtic, so human, so Greek.

Fig. 108 One of the moſt important pictures of the florid ſtyle, and one in which something of the fire of late Pheidian art ſtill glows, represents Pelops carrying off Hippodameia, with the divine ſteeds tearing across the sea. Two irreconcilable things are in great measure reconciled. At firſt sight and at a certain diſtance all one sees is the chariot rushing along with the car slightly oblique and the horses spread out in the usual way : the base-line is kept, and emphasised by the parallelisms of the old convention for galloping. Two trees, a pair of doves, a dolphin, seem to be mere surface-filling, and a few lines indicating soil and water do not deſtroy the effect of flatness. It is only when we look closer that this flat picture becomes a space-picture of aſtonishing power. The slight indications of the landscape force the imagination into a definite path. The chariot rushes between two trees, paſt a rocky eminence on the shore, out on to the glittering sea: the fire-breathing coursers of Poseidon snort as they set foot on their native element : the hair and cloak of Pelops ſtream back with the rush; leaning well back he keeps control of the horses, and safe at laſt looks round towards the impotent pursuer. In the midſt of this ſtorm of movement Hippodameia towers above the front of the car in queenly calm, only raising her hand in wonder at the miracle of the chariot riding the sea. The motive of her upright figure is repeated by the trees, and these quiet verticals heighten the

80

effect of the forward urging and back-surging diagonals and horizontals. These are all signs of a truly great master : the only trace of lateness is the over-rich adornment and the over-fine execution of the details. The garment of Pelops with the theatrical splendour of its patterns and the now popular girdle-wreath, the flow of the chiton, too subtle for the scale of the picture, the laurel-wreath with its white berries in Pelops' hair, which is trim and elegant in spite of the wind, and above all the niggling prettiness of his features—all this shows that the age of simple grandeur is past.

The same symptoms appear in the Theseus cup painted by Aison. *Fig.* 107 In his tondo he follows a simple and beautiful composition of Periclean date, but he has enriched it, polished it, and spoilt it. A good example of his tactlessness is his treatment of the maeander which decorated and symbolised the labyrinth in the older pictures. He has made it so small that it merges into the maeander of the frame and ceases to tell as a wall ; especially as the entablature does not now touch it, and we have steps behind it instead. The three steps are primitively rendered in false perspective ; they ought to be below the columns and the wall. The painter could not bring himself to omit them—another contact between the florid style and the archaic. Behind Theseus is a porch recalling the Erechtheum, two columns with pediment and acroterion. Theseus stands out well from the porch and from Athena in space, and the drawing of his figure is highly plastic, with the chest arching forward in three-quarter view, its spatial effect enhanced by the half-concealment of the right arm. Less here would have been more, as we see from the classical simplicity of the earlier cups. It is the same throughout. Aison wished the attitude of Theseus to be a rhythmical expression of effort. He has succeeded in a measure, but the heroic pose is over-elegant, and the strong movement of the contours, which run all in waves—in big waves where small waves are impossible—is out of keeping with the slender forms, and gives them an air of feebleness. We get the same impression from Theseus' little head, with its lovely tangle of curls and its receding chin ; and from the drapery of Athena, which is too elaborate for the small scale of the picture. And then the Minotaur ! Although he is being dragged along the ground, his arms are extended in an attitude of indolent elegance which makes one think of a dandy in an armchair. There is excess everywhere, too much elegance, too much euphony of line and motive, too much display of beauty. One recalls the saying of the painter and sculptor Euphranor about the Theseus of Parrhasios, that he seemed to have been fed on

81

roses. Aison has abused his technical ability. He could not subordinate it to an artistic or a decorative purpose ; he belonged to a generation of smaller men.

After the general observations already made, it will not be necessary to go very deeply into the picture which bears the signature of Meidias. *Fig.* 109 It decorates the curved surface of a hydria, and below it there is a frieze which we have not reproduced. The subject is the rape of the daughters of Leukippos by the Dioscuri. The scene takes place in a sanctuary of Aphrodite. The goddess is seated at her altar : to one side is Zeus, father of the Dioscuri. The maidens were gathering flowers with their playmates when they were surprised. In the background, squeezed in between the chariots, not very happily, is the old-fashioned idol of Aphrodite, gilt and with white flesh, like a chryselephantine statue. This is not the only point in which the composition is unsuccessful : in the distribution of the masses a free equilibrium is aimed at but not attained : the picture looks lopsided and sits unevenly on the vase. The strength of the painter lay more in individual figures and groups. He seems to be quite incapable of giving a unified and satisfactory rendering of an incident full of movement. The Rape of the Leucippids produces the impression of an unsuccessful attempt to introduce violent movement into a picture of a mere state. One might almost say that the only movement which was quite in Meidias' manner was the floating of light drapery in the wind : it is evidently the zephyr which even in motionless figures lifts the delicate material under the armpits and at the ankles.

The master's conception of form is betrayed by the lines for plants and soil which he engraves in the black, while it is still moist, with a blunt tool : it finds its purest expression in lovely crinkling flourishes, just as a tasteless man will betray himself by the fantasias of his signature. Finally, a certain sentimentality, regular in the quiet pictures, finds its way even into the wrestling-group in the Rape of the Leucippids. The worst feature of all is the exaggerated inclination of the head ; the sweetness of it affects the nerves of the stomach, and makes the Eirene of Kephisodotos and the statues of Praxiteles seem almost austere, because there the inclination is motived and is used with tact. What a gulf (*Fig.* 108) between the quiet majesty of Hippodameia on the Pelops vase and the soft affectation of Helera in the chariot of Polydeukes on the Meidias vase ! In the Pelops vase the racehorses tear past like the wind : in Meidias they seem rather to be curvetting, and the wind plays only in the garments and round the breast of the bride. Yet that the two works are about contemporary, the costume, with its girdle-wreaths

82

and chequered headgear, suffices to show. But the painter of the Pelops vase had still a sense of grandeur and expressiveness, even although certain details are petty ; in Meidias, on the other hand, there is nothing but graceful self-conscious trifling, delicious liquefaction, and empty pose.

Our last vase-picture comes from a different world ; it exhibits the *Fig.* 110 style of the fourth century fully developed. The early stages of this style cannot be studied in vase-painting. The vase-painters travelled for years in the beaten path of the florid style, and it was not until almost the middle of the century that the new style, which had meanwhile been perfected in monumental art, was taken over ready-made: a last, vain attempt to adjust the red-figure style to the completely altered conditions of a new age. The close adherence of the new style to monumental art makes us think of the origin of the red-figure style, which was due to the desire for freer and more expressive drawing than was possible with the highly decorative black-figure style : but the new style is less decorative than any previous one. The style of the fourth century presents a deliberate contrast to the affectation of the end of the fifth century. The old line, decoratively effective, and often stereotyped into a kind of calligraphy, gives way to observation of nature, leading to a noteworthy transvaluation of the line. Strongly rhythmical and sweet-lined as the art of the time, especially Praxitelean art, still was, the general movement of the planes and even more the style of the drapery with its allowance for light and shadow and its multitude of short interrupted lines were no less incompatible with the technical conditions of the red-figure style than the pictorial vision of the period, accustomed to a considerable measure of spatial depth, with the demand for a decorative treatment of the surface. The flattening out of the forms on the picture-surface had hitherto given the contour an extraordinary expressiveness : in the new figures, conceived plastically and often with their heads more or less frontal, the contour forfeited much of its expressiveness and significance: the clearness of the figures at a distance suffered accordingly, and the entire picture lost in decorative value. It is no wonder, in these circumstances, that the story of the Attic red-figure style of the fourth century was that of a short ascent and a long decline. It would have needed a totally new decorative stylisation, in great measure independent of monumental art, to keep the old technique alive. But that would have been a contradiction to the whole past history of the red-figure style, and the requisites for such a development did not exist. Thus the Attic red-figure style died a natural death at the very moment when monumental painting reached its prime.

Our picture represents the fateful consultation between Zeus and Themis about the Trojan war. Themis is seated on the earth-navel, the omphalos stone, which is decorated with knotted fillets. Opposite her is Athena, with a little Nike floating towards her holding a spray of laurel; behind her is Hermes; to the left sits Aphrodite with her hand-maid Peitho; on the right rides the moon-goddess Selene, escorted by Hesperos, the evening star. From Pheidian art onwards, the sun-god in his chariot usually balances Selene at the other side of the picture, so that our vase-painting is perhaps a free extract from a large picture of the Council of the Gods. The drawing, with its tenuous relief-lines, lightly indicates the shapes, with an airy, unerring mastery of form even in strong foreshortenings. A kind of pictorial effect has been extracted from that most linear of all mediums, the relief-line: we are conscious that Greek art has entered the period of pictorial vision. On the other hand, the use of colour and gold in the central group, judging by pictures in better preservation, was decorative rather than pictorial: the chief colour is white, then light blue and purple, and a little red, yellow, gold. The use of the white in the female flesh is just as flat as in the black-figure style. This contrast of pictorial, spatial line-drawing and flat decorative colouring shows us the red-figure style in an intolerable state of internal tension: the strained bowstring must break.

After the vase-pictures we add one or two examples of drawing on bronze and ivory. We have vast numbers of Etruscan and Latin engravings on bronze, chiefly on mirrors and small cylindrical boxes; but *Figs.* 111- very few Greek. Our pictures come from the insides of slightly convex 112 cases, decorated outside with embossed reliefs: these cases served as the lids of metal mirrors which they kept polished. The idea of decorating folding-mirrors with rich figurework seems to have been Corinthian. The figures and their accessories were usually silvered, the background *Fig.* 111 occasionally gilt. The better preserved of the two pictures belongs to the turn of the fifth and fourth centuries. It shows us Aphrodite, or perhaps her handmaid Peitho, playing dibs with the goat-god Pan. The ill-assorted couple seem to have quarrelled. The goddess has half turned away, as if threatening not to play any more, but her pointing hand is evidently claiming the stones. Pan is talking to her most earnestly, and we cannot resist the suspicion that justice and logic are on his side. But they will hardly help him, for the little Eros zealously supports the claim of the goddess. The two gods, who are often shown wrestling in later art, are here engaged in intellectual contest. The goddess' other bird, the goose, takes no part; and that makes the dispute seem all the livelier.

84

In form and in spirit the goddess is the later counterpart of the Athena in one of the metopes of the Temple of Zeus at Olympia. Athena there sits on a rock in much the same position, behaving a little like an artless peasant-girl. Herakles holds out the slain Stymphalian birds : she turns round and moves her hand towards them timidly ; she is curious, but the dead things are rather uncanny. A touch of archaic naiveness lingers in this early classical humanisation of the goddess. Then came the majestic deities of the high classical style. Our picture comes after these, and at the beginning of the way which led to the conscious humanisation of the gods in the fourth century, culminating in the youthful deities of Praxiteles. The young girl with the full forms, an effective contrast to the sinewy goat-god, may remind us of the famous hetairai of Corinth, the young handmaidens of Aphrodite, whom Pindar addresses with such wonderful human sympathy. So may the other picture, which shows two very young, strong girls dancing in diaphanous *Fig.* 112 drapery. Nature pure and simple : the easy flow and wave of the material has nothing calligraphic about it, and is brimful of the rhythm of the dance. It is surprising how closely the easy lines of the graver reproduce the effect of pictures in spite of the naturally unpictorial technique : Pompeian pictures furnish a standard of comparison. (*Fig.* 118)

We close this part of our study with a glance at certain precious *Figs.* 113- fragments belonging to a class of which few specimens remain : drawings 114 on ivory. They come from a wooden coffin which was veneered with thin plaques of ivory, and are the most important remains of a substantial find of wooden sarcophagi from tumuli in South Russia. As early as the first centuries of the first millennium Greek civilisation set foot in what was the ancient Scythian land north of the Black Sea : Ionian colonists laid the foundations of a provincial culture which soon passed beyond the bounds of Greek nationality and which was carried far over Europe, long after, by the great Migrations. By that time, it is true, the Oriental spirit had long gained the upper hand : but in the classical period not only the Greek colonists, but the wealthy native princes, surrounded themselves with the noblest products of Greek art.

Our illustrations give only a selection from representations of the Judgment of Paris and the Rape of the Leucippids. The delicately engraved drawing was originally coloured : the line, unhampered by technical restrictions, is exceedingly fine and light. The style is still in the main that of the late fifth century, though there are already signs of a new development. The pictures are among our most important examples of the florid style, and like the best vase-pictures of the time

they still show vestiges of the grandeur of the Parthenon. We feel this more directly in the splendid chariot than in the figures of Athena, Aphrodite and Eros. The Hera of the Judgment of Paris—not reproduced here—also shows the connection with late Pheidian art, in which we find both the veil-like delicacy of transparent material, and, even in single statues, garments rustling in the wind. Granting all this, one must nevertheless recognise that the work is only very exquisite handicraft, not great art. In spite or perhaps because of its extraordinary skill, there is something slightly academic in the drawing, especially in the faces. But there is feeling in most of it, and the slight affectation of Aphrodite's swimming gait becomes her tolerably well.

A modest fifth-century original forms a transition to the monumental *Fig. 115* painting of classical style: the picture of a warrior on a Boeotian gravestone. Its special claim is its large scale: but it cannot be called a painting: all we see to-day is the drawing—most probably only the preliminary drawing for encaustic.

The trapezoidal slab of grey limestone is in good preservation, but it is only inch by inch, and close up, that the eye can follow the little dots which make up the drawing; in the cast to which our reproduction goes back the lines are drawn over and the roughened background coloured in. In the well-preserved tomb-paintings from the neighbouring Thessaly the preliminary drawing under the colours is very detailed: we may therefore infer that our picture is a preliminary drawing; there are other proofs, but we shall mention only the most striking: the nipple is drawn over the spear-shaft. The tombstone preserves the memory of the dead in the simplest way: it gives his name, Mnason, in fine monumental lettering, and his picture in the fulness of his manhood, perhaps with a slight hint of individuality in the delicate line of the ridge of the nose. The shape and movement of the figure as a whole, and the animated flow of the folds, are rendered with great sureness of line and power of expression. It is the finished and confident beauty and the broad simplicity of ripe Periclean style: the picture may therefore be dated about 430. In its simple distinction it stands far above two other stelai of the same class, which bear all the marks of the florid style.

At the turn of the fifth and fourth centuries Greek classical style took final possession of Etruscan art. The peculiar wall-painting of its *(Fig. 68)* tombs was described and illustrated at the end of our discussion of archaic art. In the classical style it lags still farther behind Greek painting, *Fig. 116* and the earliest pictures, in which the style is purest, are not paintings

86

at all as Zeuxis or Parrhasios understood painting, but still mere coloured drawings as in archaic art and in Attic white lekythoi. Our illustration (*Figs.* 85- gives an extract from the banqueting scenes, unfortunately severely 87) damaged, in the first chamber of the so-called Tomba dell' Orco at Corneto, the ancient Tarquinii. The noble female head stands out from a background of two colours: the dark hair with its garland from the light stucco of the wall; face and neck, hair-band and dress, from the cloudy darkness of the nether world, which plays loosely and decoratively round the outlines of the figures. This flat linear treatment is better suited to the conditions of the subterranean tomb-chambers than the pictorial execution which gradually makes its way into the several figures, though never into the picture as a whole. Even from the purely artistic point of view such wall-decoration is not to be measured by the standards of Greek monumental art. It was sufficient for the painter's purpose to give a general impression of classical beauty and classical atmosphere: his drawing did not stand close examination by daylight. The harmony of the forms is not perfect, either in the outline of the skull or in the features of the face. The features lack also the living line which characterises the best lekythos pictures despite their small scale. The eyelid is too heavy, the nostril unsensitive, the upper lip pursed up too violently. We are far from the source.

We have the same painful feeling of remoteness when we turn to a masterpiece of classical painting, the picture of the astragalos-players: *Fig.* 117 for all we possess is a copy from the time of the birth of Christ. The Athenian Alexandros made the copy, presumably much reduced, on a marble slab found at Herculaneum. The preservation makes it doubtful whether it was a real painting or only a coloured drawing; if a real painting, then what remains is merely the preliminary drawing and the underpainting, and all we possess is the composition and the drawing, and even the drawing will have been coarsened by the copyist. The worst feature is the alteration of the proportions to suit the late Hellenistic ideal with its high, narrow breast. What the line has lost we are conscious everywhere, most strongly in the faces and hands: yet we can feel the proximity of the Parthenon pediment, and the original may therefore be placed in the thirties of the fifth century. The purest effect is given by the composition, which is carefully thought out both in form and in expression: it is only slightly impaired by the modern frame, which laps over too far on the left side. At the first glance we notice what in a vase-picture we should describe as defective space-filling: an empty spot in the right-hand top corner, and an empty strip, only partially

bridged, between the compact groups. These are both audacious devices to obtain certain effects.

The two playmates Leto and Niobe have fallen out over a throw of the knucklebones. Leto stands half-averse in injured dignity, hardly opening her hand to the hand offered her by Niobe: a friend of both, the dainty Phoibe, is doing her best to effect a reconciliation, but neither party is quite ready for that: Phoibe presses the shoulder of Niobe forward with her left hand, and her right, behind Niobe's back, beckons to the hesitating Leto with an insistent southern gesture. A delightful everyday scene, but heavy with presage for the Greek who read the names, and strangely impressive, from the queenliness of Leto, even to the uninformed. The effect is immensely increased by contrast with the two maidens immersed in their game and unconscious of what is taking place beside them. But this game, too, contains the seed of a similar quarrel: Aglaia follows the throw intently and grasps her last knucklebone tightly in her hand. We see the painter's art developing from the high ethos of Polygnotos into the charming play with expression in Zeuxis.

The picture is as full of form as of expression. The crouching figures conceal most of the lower part of the standing ones, whose attitudes are made clear, however, by one foot of each being shown. This gives us two compact groups, one of two and the other of three figures, both built deep into the picture. They are separated by an empty strip, which divides the masses in a happy proportion and possesses a double expression value: it stresses Leto's self-isolation, shown also by her attitude; and the bridging of the strip emphasises the wonderful play of the undulating hands. And here another contrast: below the groping hands of Niobe the right hand of Hileaira extended with the knucklebones, not reaching through the empty strip, but only into it, and displaying its beautiful lines against the quiet background. Lowest of all, the cause of the rift which runs through the picture, the knuckle-bone between the feet of the divided friends. Lastly, the void in the right-hand upper corner: in conjunction with the foot and the slanting back-blown drapery of Phoibe, it indicates her eager pressure forward, the same effect as in the magnificent Parthenon metope with one Lapith pressing the centaur against the edge: a dynamic equilibrium of masses, with no attempt at such decorative space-filling as appears in the so-called Theseus metope. This effect of pressure and avoidance leftward is assisted by all the slanting lines which run down from left to right, without any corresponding counter-movement until we come to the

lower left corner with the lower right leg of Aglaia and the folds of her cloak. The composition, then, is a mature masterpiece, which makes us regret bitterly all that we have lost: for neither relief—one thinks of Orpheus and Eurydice, where the hands are so eloquent—nor vase-painting has such complex means of expression at its disposal.

The next picture takes us into a new world. It represents the death *Fig.* 118 of the Theban king Pentheus on the slopes of Kithairon at the hands of the raging votaries of Dionysos—a mythical symbol of the convulsion caused by the penetration of the ecstatic Thracian cult into Greece. Here at last we have painting in the full sense of the word: a complete portion of the outer world in its natural appearance, conceived as a unity in space, light and colour, and shaped into a picture. It was explained in the introduction that the step which decided the future of European painting, the step to actual reproduction of seen appearance, was taken at Athens in the last third of the fifth century. We insisted that the predominance of the human form was not thereby shaken and that the spatial depth was at first limited. We found a trace of this new painting, adapted to the particular conditions of painting on vases, (*Fig.* 108) in the Pelops amphora: it corroborates the testimony of our literary documents. Other vase-pictures confirm the well-founded assumption that our Pompeian wall-painting preserves to us the main elements of a painting of this period. But our first step on the insecure ground of Romano-Campanian wall-painting involves us immediately in a tangle of questions which cannot be discussed here. A brief reference to these matters was made in the Introduction. The answer to the principal question will run, that these late wall-pictures of the century before and the century after the birth of Christ are in many respects products of their own times—above all in the substitution of decorative mural-painting for the nobler panel-painting—but not only contain, in general, the legacy of classical and Hellenistic painting, but, in particular, operate more or less freely with old material. Actual copies can seldom be pointed to with absolute confidence, but many famous old pictures are undoubtedly preserved to us in their main features. How far accuracy went in detail—the technical difference between wall-painting and panel-painting naturally set limits—remains more or less questionable: we must be content if we can recognise what may be more or less accurate, and what cannot.

Our picture cannot reproduce the pictorial aspect of a late fifth-century or early fourth-century picture. The varied play of light and shadow, the glow and shimmer of the colours, presuppose at least another

89

century of pictorial development : Apollodoros, Zeuxis and Parrhasios but laid the foundations of the fabric which is here complete. In the rendering of form, however, we do seem to catch a faint echo of the old style : but all we can trust is the general lines of the composition and of the rendering of space. We find once more the expedient which we found in the monumental painting of the early classical age—cutting off a number of the figures behind portions of the landscape : here it is used in a spatial manner, and the figures are not spread out on a plane surface meant to indicate space, but on a slope which is represented in perspective. The clear composition, with its manifold divisions and connexions, tempts us to study it more closely. But in view of the great gulf between the late picture before our eyes and the old picture in our minds, it is better to abstain : a slight modification, and how much may have been changed ! The fire of genuine passion which must have burned in the original has become languid : one feels that the demons in the background are really needed, to fan the women into fury. We shall best do justice to the picture if we take its beauties without prejudice as we find them : for even although it is less important as a work of art than as a historical document, it is not unworthy to stand at the entrance to a domain in which we shall encounter many great works of art.

Fig. 119 A picture of Perseus and Andromeda puts us on the track of a classical masterpiece. The hero is helping the maiden down from the cliff on which she had been exposed to the sea-dragon : the slain monster is weltering in his blood. The wall-painting is based on a famous original, which was copied not only in other wall-paintings, but in a statuary group and on coins. The plastic versions naturally confine themselves to the main group, but the main group recurs almost unchanged in most of the reproductions, so that its principal features may be counted certain. In the wall-pictures the main features of the landscape elements are also the same, but the accessories vary considerably. This is partly due to the special development of Italic painting. In the first century before Christ it has a free late Hellenistic character ; then it shows the pronounced classicism which is one of the chief marks of Augustan culture ; and finally, in the second half of the first century after Christ, a neo-Hellenistic movement, sparkling with pictorial life, sets in. Old masterpieces were copied in all three styles : and each style not only infused much of its own nature, of its artistic handwriting, into the copy, but often made the freest use of the traditional matter, altered it, and transformed it. A great part was played throughout by

the decorative requirements of the mural architecture. Thus the classi-
cising style liked pictures with plenty of space and comparatively small
figures; if it used older panel-pictures, it was apt to enlarge the com-
position by the old expedient of subsidiary figures: hence the shore-
nymphs or Nereids who watch the scene in the classicising examples
of the Andromeda.

The last of the three styles of wall-painting was the most remote
from the classical works, and for that very reason it is easy to see if the
artist has tried to copy accurately. So in our picture of Andromeda:
it bears no trace of the perfectly free flow and gush of light and colour
which are characteristic of the third style, our picture of Achilles in Skyros *(Fig. 123)*
being a good example. The forms, the colours, and above all the
distribution of light and shade, are severe, simple and arranged in big
contrasts: even the Pentheus, which goes back to a considerably older *(Fig. 118)*
original, is much more complex and animated in this respect, more
Hellenistic: it speaks the language of its own time.

Our picture is most probably a copy after one of the masterpieces
of Nikias, an Attic painter of the second half of the fourth century.
The severity which the style retains even in the copy suggests that it was
one of his earlier works. A modern eye will feel this severity especially
strongly in the statuesque attitudes of the figures—a sign of the pre-
dominance of the human figure in Greek painting. That is also why
the rocks look rather like side-scenes: we shall notice the same peculi-
arity in the free landscapes of the Hellenistic-Roman period. The rock-
gate is a great favourite: it has little dead mass about it, it has sharp
divisions, and it provides a background which can easily be suited to
the various requirements of the figures. Here it helps to contrast Perseus
with Andromeda: she is light against the dark rock, he dark and
impressive against sea and air. The contours stand out clearly, and
the head of Perseus has a light space round it to show it up, an expedient *(Figs. 121,*
which we shall meet again in another form. Quintilian tells us some- *122, 136)*
thing that is very characteristic of Greek painting: he says that painters
sought to prevent the shadow of one figure from falling on another,
so as not to injure the clearness of the contours. Is it possible that the
treatment of space, with the distant sea-horizon, belonged to the original
picture by Nikias? That is one of the great questions in the history
of Greek painting. There are reasons for supposing that it did, but
no convincing proof. The finer details of the original must have mostly
disappeared in the copy: we therefore say no more about them,
but content ourselves with the general impression: a peculiar

work, alien to us in many respects, and filled with a severe artistic rhythm.

Fig. 121 The mosaic of the Battle of Alexander, mentioned in the Introduction, brings us closer to its original than any wall-picture. It adorned one of the fine old houses in Pompeii, the so-called House of the Faun, but hardly originated there. In any case it belongs to a good Hellenistic period, perhaps to the third century before Christ. It is a marvel of its kind: the size is monumental, some sixteen feet by eight; the stones are only two or three millimetres square: their number has been estimated at about a million and a half. The damage which the picture probably sustained in the first earthquake, before the destruction of the city, is not ruinous, but considerable: it was not made good at the time, although many other parts of the mosaic had been previously restored with larger stones. Here and there, most obviously on the right end of the picture, the original mosaicist has not quite understood his model, which must have been injured. What he saw he copied accurately, and the gaps he filled up in the simplest way, thereby enabling us to make out much that was not clear to him. We have to mention this, but cannot go into it further: our monochrome reproduction makes that impossible, and we are only concerned here with the main points.

The mosaic is most probably an accurate copy of one of the most famous pictures of antiquity, the 'Battle of Alexander and Darius,' painted by the Attic master Philoxenos of Eretria, between the years 319 and 297. Our authority Pliny mentions only one other work by the painter, a picture of three silens: so the great battle-piece was his principal work. The terms of Pliny's eulogy are as unusual and as definite as the description of the picture: in this famous work the great crisis in the world's history was focussed in the personal encounter of Alexander and Darius. The monumental tradition tallies so exactly with the literary that it is difficult to believe in a coincidence. Apart from the mosaic we have a whole series of monuments going back to the same original: works of all kinds, found in all parts of the Greek world, ranging from the fourth century to imperial times, from the sarcophagi of Sidonian kings to South Italian vase-pictures, Etruscan urns, an Umbrian relief-bowl and a Roman sarcophagus.

There are no other representations of a battle of Alexander. The typology shows that a single painting of overwhelming effect won instant popularity and became canonical: its painter had succeeded in his great enterprise of concentrating the tremendous historical event into a convincing artistic form. He did what Aristotle vainly advised

Protogenes to do, what Apelles, from all we know of him, did no more than Protogenes : he rejected mythical allusion and rendered the reality in the higher sense of the inward truth ; but with the full creative power of the artistic imagination, not with the dry literalness of the Roman, incurably unimaginative for all his Hellenisation. The fame of this work immediately penetrated to Italy, and remained alive there for centuries. The reason must have been that it was not an ordinary battle of Alexander with the Persians, however excellently depicted, nor a hundred-figured fight like a picture by Aristeides known to us from literature only, but just this particular conjunction of Alexander and Darius, unhistorical but in its innermost core world-historical, in a picture of tragic grandeur.

These facts, and the striking words of Pliny about Philoxenos, form two converging lines of argument. That they actually intersect will be admitted to be not only possible but probable. Now, the original of the mosaic was a four-colour picture, and the teacher of Philoxenos was a four-colour painter : that greatly increases the probability, and it would become something like a certainty if the almost complete super-position of one figure upon another—some horses are reduced to an ear and a few hairs—could be taken as an example of Philoxenos' ' abbreviated ' method of painting. Unfortunately this is doubtful ; but many will be inclined to believe that Philoxenos has achieved what neither Protogenes nor any of the other great painters of Hellas could achieve : he has linked his immortality with that of Alexander. A proof of the greatness of the picture is that one may mistake its historical content completely, and yet understand its artistic quality even in the spiritual sense. Jacob Burckhardt says : ' The chief value of this picture, which is unique of its kind, does not lie in faultless draughtsmanship or expressiveness in detail, but in the overpowering rendering of an important moment with the slightest possible means. On the right side, the wheeling of the chariot and horses and a few suitable positions and gestures give a picture of helplessness and consternation which could not be plainer, or in essentials more complete. On the left side, so far as it is preserved, the irresistible advance of the victors is depicted with the utmost lucidity.' Yet curiously enough he would not hear of Alexander and Darius, but took the picture for a battle of Greeks or Romans with Celts, in spite of Goethe and Welcker. An error in Welcker's interpretation of certain details seems to have repelled him. No dispute is possible. The interpretation is made certain by the stiff tiara of Darius and the soft tiaras of his nobles, by the white band down the middle of his purple chiton, by the Persian standard, which Douris

93

knew from Marathon, and by many other external signs, down to the trousers embroidered with fabulous animals and the skids on the chariot-wheels. Details are still open to dispute. The first thing is to make sure of the main features.

The Persian host is beaten: for the King has taken to flight. Surrounded by a cavalry guard, his chariot, with the driver swinging his whip over it, plunges out of the middle distance obliquely towards the right, threatening to run over three Persians who are lying on the ground. A swift thrust of the Macedonians, in the direction of the picture-plane, strikes the fugitives in the flank, half from behind: it is Alexander himself with a few riders, the last of whom looks round, for reinforcements seem needed urgently. They have already hurled their javelins, and the horse of a noble Persian, riding on the King's right, has been struck in the lung, and has come down on its knees. His master, richly clad and, like the King, without the corslet worn by most of the others, seems to be the most distinguished member of the escort; no sooner, therefore, was his horse hit than another Persian sprang from his and turned it round for the other to mount. But Alexander is too quick: the noble Persian has only half-dismounted and drawn his sword a few inches from the sheath when the long spear of the King pierces him through. It has all happened in a flash, and now only the dying man, who stops the spear, divides Alexander from Darius. A moment of the highest tension.

The helpful Persian is horror-stricken, and the Persians riding on the other side of the chariot raise their hands or grasp their heads in dismay. But Darius does not think of his own danger or take the opportunity of sending an arrow at Alexander's defenceless head and neck; full of anguish, he stretches out his hand to the noble comrade who is dying for him, who has been dear to him: thus even in defeat and flight he shows himself a king and earns our pity in his misfortune. Fear we hardly feel for him: we are conscious that the noble Persian does not die in vain, that he stops Alexander for the short time needed to get the chariot out of the tight corner. And Darius is not yet unprotected, the Persian resistance is not completely broken. Another Persian springs into the gap at the chariot side left by the fallen man, his sword drawn, glowering at Alexander, and on the other side of the chariot more Persians are riding up, a standard-bearer among them, and in the next moment will pass behind the chariot and hurl themselves on the Macedonians: one of them turns and beckons for further assistance with the usual southern gesture.

94

Alexander himself is in danger. He has rushed forward too wildly, and followed too rashly the glance of his flaming eye. Although this part of the picture is much damaged, we can see that the noble Persian was not his first victim. Beneath his horse and behind it three or four warriors, hardly Macedonians, lay or were falling, and in front of Bucephalus a wounded Greek mercenary is still resisting gallantly: his weapon would menace Alexander, if he were not using it to parry a Macedonian spear-thrust. And just here, where his course is checked, Alexander has lost his helmet—perhaps shot off or struck off. Nay, more: close behind his right arm are traces of a Persian's head, recognisable by his moustache and perhaps a yellow tiara, remarkably near the horse's hindquarters: it is no doubt the Persian who is said to have given Alexander a slight dagger-wound in the thigh at the Battle of the Issos. Thus even the wild victor is in serious danger; if we feel pity for the luckless Darius, we feel fear for the heroic youth who stakes his life like a Homeric champion. Yet fear and pity are not only stirred, but purified by contemplation of the artistic form. Thrilled by the tragic nature of the event, by the grandeur of the courage and generosity, and not least by the art which has fused all these things into a unity, we turn away, in the words of Goethe, ' to yield ourselves to the most suitable reflexions in silence.'

So much for the picture as a whole: in the details much is disputable, but one main point is certain—the spears, which for Macedonian sarissae are too near to be unoccupied, belong to a fleeing band of Persians. This is also the only interpretation which suits the high value which the spears possess as means of expression in the general composition. Before we turn to the composition we must say a word about the question which particular fight the painter wished to represent. The only possibilities are Issos and Gaugamela, for Darius was not present at the Granikos. Now, these two great battles were so quickly and so completely overgrown by legend, that a priori we cannot expect real historical accuracy. The very kernel of the representation is unhistorical—the meeting of the kings, although legend reports it of both battles, like the story that Darius finally mounted a horse. In spite of this it can hardly be doubted that the painter meant the Battle of the Issos: for at the Issos we have a circumstantial account of how the nobles sacrificed their lives to defend the royal chariot. It is unnecessary to go further into detail, and it would be unsuitable to the legendary character of both tradition and picture. Two points seem to contradict each other—the presumed dagger-thrust of the Persian beside Alexander,

95

which is told of Issos, and the inferred lengthening of the Persian spears, which is told of Gaugamela. Neither has much historical cogency, considering how freely Greek art dealt with minor details; especially as the loss of Alexander's helmet at a critical moment recalls the Granikos, where his helmet was split by a sword-stroke. The painter evidently wanted to show the king's head clearly, and at the same time he gained an effective motive. And so with the mirror-like shield: the artist may have known it from Xenophon's description of Cyrus, but that is no reason for supposing that it has fallen from Darius' arm. Modern masters are often unable to answer such questions: in these minor matters they follow, for the most part, half-unconscious associations of ideas. Such an association may have suggested the riding-horse which is held in readiness. Obviously, to any unprejudiced beholder it is meant to replace the foundered horse of the noble Persian. Darius would be lost like him, if he tried to leave his chariot now and mount: indeed, his charioteer is whipping up the team to top speed. All the same, the suggestion may have come to the painter from the story of Darius' riding-horse; but he has altered the motive, as the creative artist may.

Of the artistic devices used in the picture the composition is the most tangible. The painter sets us a little higher than his figures and close up to them: only a small strip of ground, with a few stones and weapons, remains free in front. It is as if we were witnessing the flank attack from a kind of backwater, but the conventional base-band preserves the effect from being too realistic and creates the distance necessary for artistic contemplation: it raises the picture on to a stage. Thus the tumult of the fight thunders immediately in front of us from left to right, checks and blusters in the middle of the picture, and is about to rage past us with a fresh impetus in another direction, on our right. It is therefore not an endless stream flowing past us, but an organically articulated and self-contained whole, which nevertheless gives us a clear sense of the much larger context in which it stands: formally as well as intellectually the battle is concentrated into a focus. The general rightward movement is just sufficiently balanced by the counter-movement of the Persian reinforcements, emphasised by their spears, to prevent the picture from looking like an extract from a frieze. This effect is assisted by the last of the Macedonian horsemen, who is not cut off by the frame and is seen half from the front: in mass, movement and expression there is a caesura here. Yet the picture points beyond itself on both sides: the Macedonian looks round, a Persian beckons

for help: a skilful chassé-croisé which was perhaps still clearer before the injury to the right end of the picture.

The composition of the picture in depth is still more complex and more masterly. It illustrates the classical capacity for obtaining effects which are all the stronger because of the apparent slightness of the means. The constant overlapping of one figure by another so that all we see is often part of a head, a helmet, a spear, not only gives the illusion of depth, but makes us feel that there are far more figures than there really are. Apart from spears alone, only about thirty figures are indicated, and very few of these are seen entire or in great part. The effect of the principal figures is all the stronger, and even where they are not set against a background of sky they stand out clearly from the throng: thus Alexander is the only horseman who shows in his full extension on the picture-surface without foreshortening or appreciable overlapping. This effect is assisted by the device of the spears, which lead the eye on and divide the picture up; and the tree is used in the same way. But what shows the maturity of the art is that a single expedient may serve more than one purpose: thus Alexander's spear, and the lines which converge with it and cross it, also help to strengthen the sense of movement: we feel the wedge which is being thrust into the mass of Persians.

The treatment of the middle of the picture is particularly skilful and successful. There was a risk of the picture falling into two groups, but the expressive cleft which signifies the rescue of Darius knits the two parts all the closer together. In the plane of the picture, the chariot, with the figures belonging to its mass, is balanced by the Alexander group, which is rounded off perfectly by the contour of the transfixed Persian and his horse, with the tree. Spatially the two groups are very different, and it is in the depth of the picture that they are connected: the connection is made behind the cleft by the half-concealed figures of the riders and horses with their slanting movement. In these there are many effective contrasts: the rearing horse shows behind and above the foundered horse, and the forward movement of the rearing animal is intensified by the opposite movement of the horse which is disappearing into the press. Parts of both animals are concealed by the dismounted Persian, and thereby drawn under the influence of the strong suggestion of depth which he and his horse produce. His horse's body, with its verticals which go into the depth of the picture and show on the front plane and which have their effect strengthened by the slanting lines of neck and spear, is the point of rest in all this tempestuous movement:

97

from this point the eye finds its way in the depth of the picture as easily as from Alexander's spear on the picture-surface. The horse's body stands perpendicular to Alexander's spear and thereby to the general direction of the attack; while the horse's neck, the turn of which is accentuated and continued by the Persian with his spear, is perpendicular to the direction of the fugitives.

At first the painter cannot have been fully conscious of more than the main features of all these things; and even these he can hardly have calculated out beforehand: he saw them suddenly standing before his mind's eye. As to details his feeling must have been his guide: it is doubtful to what extent he took cognisance of them at the time. Greek theory shows that the Greeks went far in this direction. We may suspect that in a work so homogeneous and in an Attic master laborious calculation played a less important part than if the painter had been a Sicyonian: he may have drawn more freely upon the vast resources of Attic pictorial experience. So we shall not examine his devices of composition any further, although much might still be said. A word is due, however, to his objective rendering of space—that is, his treatment of landscape. It shows pretty clearly that there was as yet no landscape painting in our sense of the word: not only does the painter confine himself to the barest essentials, but he does not display the least interest in the specific properties of the soil and the vegetable world. A tint which contrasts with that of the heaven, a pair of very regular slate-like steps, a few big stones of more complex shape, and a modest little plant, still exactly like those on the monumental vases of the early classical period—that is all we see on the ground; and above the figures, only the bare tree against the light sky. In this respect classical monumental painting shows itself distinctly more reticent than archaic vase-painting.

Just so the use of shadow is remarkably reticent compared with the plentiful use of high-lights: there is enough shadow to make the unity of the lighting clear, but the cast-shadow is neither carried through completely nor used as an independent means of pictorial effect. In this matter also the painter's attitude was not naturalistic, and the same may be said of his colouring. His colouring is the ripe fruit of the old four-colour painting, which confined itself to black, white, red and yellow, and which appears in some of the white lekythoi, while others make free use of bright colours. All that a painter could aim at with this sober uniform scheme of colour was the translation of reality into a special artistic colour-world: but in this even the mosaicist has attained

a perfect harmony, nay, a certain tonality: for the abundance of half-tones and the subduedness of the contrasts produce a uniform general tone made up of white, yellow ochre, red and brownish-black, in spite of the definiteness of the local colours. It is much finer, lighter and airier than one would guess from the coloured reproductions hitherto published. We cannot analyse the colouring here as we have analysed the composition, much as the composition owes to the colouring, from balance in the picture-plane to aerial perspective. Two remarks only. Even if the head of a third black horse and a bit of yellow drapery were not preserved at the left extremity of the picture, we should have to supply those colours in that place. And even if we did not recognise Alexander from the composition and from the head-type, expressive even in the mosaic, we should know him from the colours reserved for him alone: the wonderful contrast of light silvery shimmer and deep, glowing Burgundy red. Many will think so much comment excessive, and all will be inclined, with Goethe, 'after examination and research to revert to simple admiration.'

We now turn to a picture which, after the Alexander mosaic, has the *Fig.* 120 best claim to be regarded as an actual copy of an important work from the later fourth century or the early Hellenistic period: the Niobe from Pompeii. Painted on a marble slab nearly forty centimetres high, it may have stood to its original much as a middling coloured print of the old kind to a work of the Renaissance. We may suppose that nothing appreciably more accurate could have been obtained at the time, unless by commissioning a first-rate painter to make a full-size copy direct from the original. At any rate there are no traces here of such blunders as Alexandros made when he copied the Knucklebone-players: but *(Fig.* 117) owing to the reduction in size, which is no doubt substantial, many subtleties must have been lost. True, there is no external evidence that the original was really much larger: but the spirit of the picture, and its effect upon subsequent art right down to the sarcophagi of the later imperial period, postulate a more imposing scale than that of a cabinet picture. A comparison with corresponding wall-paintings makes one feel this strongly. Besides the reduced scale, there is the bad preservation: the construction of the Niobe group itself has suffered, and what the colour was like we can hardly judge: that which remains is merely underpainting.

The picture is very important for our knowledge of Greek rendering of space. But this is not the only interest of the composition. The touchstone of its merit is that it is as simple as it is complex, that almost

every device serves more than one purpose, and that they all fit effort-
lessly into each other to produce a united effect. The intellectual content
of this effect is so strong that it would not be fair to the work to begin
with the analysis of the form. Four figures have sufficed the painter
to bring the whole catastrophe of the tragedy of Niobe before our eyes.
In front of the palace we see Niobe clasping her youngest daughter to
protect her, but without hope : understanding, dumbly grieving, almost
accusing, she raises her eyes to heaven—not to her enemy Artemis,
like her wailing child, but to Zeus, who lets her suffer this, her a goddess
of his race. Her glance crosses the emblem of her divine pride, the
great sceptre which has fallen from her hand : behind her it cuts slanting
through surface and depth of the picture like a lightning-stroke. It is
as if this lightning had struck the older girl, who sinks back dying in the
arms of the nurse : it cuts shrilly through the soft rounded lines of the
group. The nurse bends over her charge, and has eyes only for that
movingly peaceful death : she does not know whence the disaster comes.
What a contrast between the two groups, who are yet one in grief ! And
over both looms the royal palace, adorned for festival, now desolate :
for we know and Niobe divines that while the daughters are dying at
home, the sons are dying on the mountain.

The picture is so homogeneous that we could not describe its intel-
lectual content without referring to the formal means by which the effects
are obtained. They show the lofty assurance of a master who stands
on the heights of a fully developed art : for he has not merely mastered
spatial depth—his picture lives in it. As a whole, as well as in its parts,
it is constructed slanting into depth away from the spectator, and a few
pure front-views and pure side-views only act as steps to give the move-
ment into depth articulation and clearness. To apply the often mis-
leading standards of modern art, one is tempted to say that this is not
classical any longer, but baroque : no symmetry or balance in the picture-
plane, but the entire picture subordinated to a strong accent near one
side and to the movement obliquely into depth. But Greek art does
not fit perfectly into classifications made for modern art, instructive as
the comparison may sometimes be in detail. The unsymmetrical dis-
placement of the centre of interest—a kind of dynamic balance—occurs
(*Fig.* 117) already in the picture of the Knucklebone-players, which stands close to
the art of the Parthenon, and the oblique arrangement of the figure-
composition begins in pictures which are not much later. If we can find
traces of an organic development in a field where our knowledge is so
scanty, the history of the relation of the figures to the air-space above

them and to the architecture will probably have run on the same lines. The relation in the Niobe is that the figurework, or at any rate the chief figure, still dominates the picture. Greek panel-painting never went beyond this, and could not go beyond it, because it did not develop a landscape painting equivalent to its figure-painting.

The way in which the monumental architecture is made to assist the effect of the figure-composition is thoroughly Greek. We have already mentioned the expression value of the architecture : the proud building stands unharmed, while its inmates are crushed by Fate. So also its crystalline forms contrast with the organic life of the figures. Each group has a spatial layer of architecture corresponding to it. The verticals and horizontals of the corner pillars rise stiff and hard above the living curves of the bodies. These four elements in the picture are united by the sceptre of Niobe, which crosses them diagonally—like a line drawn through Niobe's pride and fortune—and provides the spatial counterpoise to the obliqueness of the composition ; in the picture-plane, also, it gives the desired counter-movement to the outstretched body of the dying girl and the look of Niobe. Overlapping plays its usual part as a space-maker. The contour of the Niobe group, with much else, has suffered. But the remains of her right armpit prove that her right hand as well as her left was clasping the child, so that the contour approaches the shape of an oval, and its compactness is only broken by the expressive raising of the head. The hand of Niobe shows, on a small scale, the same sense of form as appears clearly in the nurse group : the outline of the nurse, and the outstretched arms of the dying girl, lead the eye in melodious circles. What a contrast there is, not of expression merely, but of two epochs, two worlds of feeling, if we compare these softly dying arms with the arms of the falling Amazon on the krater of Euphronios, or even the arm of the Lapith (*Fig.* 47) woman in the early classical krater in Florence ! The only check to the (*Fig.* 74) curves in our group is the right angle of the nurse's arm : the over-lapping in the figures and the cloak spread on the ground preserve it from over-sculptural compactness.

Of the beauty of the drawing the small copy can give us but a faint echo. But the close affinity to the best late Attic vase-pictures is unmis- (*Fig.* 110) takable. There is no external evidence showing to what school the original belonged, for there was much interchange of ideas between Athens and Sicyon, as we see in sculpture and the minor arts : but internal evidence points to Athens. It is the Attic spirit which breathes in this picture, the spirit of Attic tragedy, perhaps of the Sophoclean Niobe.

Fig. 122　The wall-picture of Achilles dismissing Briseis is usually considered to be a fairly accurate copy, and its large scale allowed of a different execution and a different effect from what was possible in the Niobe. The first great outburst of Hellenism, and the last—the poetry of Homer, and the expedition of Alexander—seem to be united in this picture: the soft beauty and refinement of the fourth century, glowing with primaeval fire; the simple great humanity of the Homeric world, unspoiled by five hundred years of an unexampled civilisation. Achilles' look and his great gesture dominate the picture. From the easy dignity with which he has been sitting in his throne before his tent, he has raised his head and his hand. He looks with wide, flaming eyes at the weeping Briseis, whom Patroclus leads gently forward. Deep indignation at a wanton injury, less to love than to honour, lightens from a countenance that stands out fearfully dark against a shining shield. But the pathos does not break out; it is held in by a kingly self-control, and kingly is the gesture of the outstretched hand which releases the maid without a word. And an awful silence broods over the whole picture. Behind the throne, the aged Phoenix looks down at Achilles in deep anxiety, the heralds of Agamemnon look in front of them with a puzzled expression, and the guards in the background are silent witnesses of the fateful event.

Not a tear from Briseis. She is not Andromache, or Nausicaa: it is more a question of honour than of the maiden. Her eye affects us painfully, we would fain avoid it, like the heralds, to spare the feelings of Achilles. But at the same time we understand that the guard behind Achilles follows his master's gaze: this maiden is not his queen; he regards her in some measure as his comrade; his duty is in front of the tent, hers inside it; and the dark depth of the tent shows significantly behind her. The painter has not shrunk from establishing that connexion between the maiden and the spectator which gives many fourth-century works a touch of artificiality, of ostentatiousness, which forms an unpleasant contrast to the noble modesty of the Idolino.

We shall not discuss the composition at such length as in the preceding pictures. The great main lines are not alone in bringing pause and rest into the wealth of changing movement: the use of shields to form a restful background for the heads of the principal personages is even (*Fig.* 123) more noticeable here than in our next picture, Achilles in Skyros. Lighting is used for the same purpose: the shield behind Achilles, slightly aslant, reflects the light which streams over him, and aureoles the head which dominates the picture. The effect of the head and its gaze is

heightened rather than impaired by the echo in the helmeted head on a dark background behind the shield : such parallelisms repel us at first and do harm in unskilful hands, but they are popular with Greek painters, whose feeling was more architectural than ours. Striking examples are *(Fig. 126)* the Pergamene Telephos from Herculaneum and the magnificent Omphale from Pompeii. The head of the warrior behind Briseis answers this *(Fig. 128)* head like a rhyme, and emphasises the general displacement of the masses rightwards. In this respect the balance of the picture is dynamic : it is based on the great gesture of Achilles, which lightens into the empty space in front of him : from there he lets Briseis go ; from there she will return, after infinite disaster. In composition and expression, which are here one, arm and spear perform the same duty as the sceptre of Niobe : *(Fig. 120)* a stroke, a cut, goes through the middle of the picture. If we look at the figure of Achilles by itself, the effect of the spear is the same as in many indolent seated figures, whose swelling forms are emphasised by the stiff, straight sceptre ; there it expresses indolent rest, here the kingly moderation with which Achilles holds himself in hand.

The numerous figures and groups, dovetailed into each other in space, have been combined by the painter to give a single impression of mass : the tent provides them with a suitable background and support : we do not expect to see more, although the point of vision is not so low as in the Alexander mosaic. We are therefore surprised by a slight indication of landscape, hardly visible, it is true, in our reproduction. With a freedom which must have been readily conceded at that time, before the development of Hellenistic landscape, a glimpse of the sea is given in the left upper corner of the picture, with the high prows of three far-off ships. They overlap each other and are overlapped by the corner of the tent. The horizon is fairly high, viewed therefore from a higher point than the figures. The skilful use of overlapping not only produces a spatial effect of a general kind, but clamps together the several parts of the picture with their different perspectives. It is unlikely that this is an arbitrary addition by the copyist : it seems to give us a glimpse of the origin of landscape painting from the backgrounds of figure-pictures.

Our reproduction of the picture of Achilles in Skyros at last gives *Fig. 123* a notion of the colouring of an ancient painting. In this picture the effect of the colour is so strong that one can almost forget the representation, interesting as it is. This colour symphony, with its swift movement, its easy flow and its vaporous shimmer, is the most important extant example of ancient colouring. In the words of Paul Herrmann,

103

the finest judge of Pompeian painting, the picture ' is seen and constructed entirely in colours, as modern art, even the most modern, might understand the phrase, and a wealth of the subtlest and most delicate transitions— tones flowing, gliding, sparkling into each other—gives it an indissoluble solidity of inner artistic structure.'

The colours vary from the dominant copper-red, now brightly glowing, now subdued and clouded, which is answered by a delicate mignonette green, to the most fragrant of lilacs and whites. But what is almost more astonishing than this symphony of colour, light and air is that the form, nay, even the line, is all the while retained. This constitutes a fundamental difference between Greek painting and modern painting since the baroque period. It is difficult to believe that the Pompeian wall-painter, in an intoxication of light and colour which accords with the general illusionism of Claudio-Flavian period, by sheer dint of personal endowment surpassed everything that earlier painting had achieved: but such a contention could not be disproved in the present state of knowledge.

But the question becomes less important if we view the matter from a somewhat greater distance. Greek colouring, from the second half of the fifth century to the imperial age, even far into the Byzantine age, will appear to the northerner as a unity: the bright splendour of a fairer world, strange to him ; a wealth of colour and tone, such as Homer reveals in his epithets of the sea, such as is conjured up by a half-cloudy sunset in the light sea-fresh heat of a southern summer. In nature as in art the bright, clear southern light creates an infinite multitude of hues, tones down apparently discordant colours into a harmony by means of its subtle gradations, will not let its vapour become mist, and dyes its very veils in shining colour. Thus the sky has light cloud-lilac next to mignonette, and cloud-orange next to bluish green ; the sky colour changes from radiant light blue to blue-green, pale green, yellow-green, pale yellow, orange ; and all these colours are heightened by the contrast of the hundred greys of the clouds. Silvery tones appear in the sky by full daylight, and in the pictures many of the colours have a silver shimmer.

The old triad, yellow, light-blue and violet, which is as popular at Pompeii as in the sarcophagus of Alexander, has its prototype in nature. The strength and frequency of pale lilac and dark violet in the landscape are astonishing, and luminous light-blue shadows appear both on the mountains and on the sea, when sungilt rocks are reflected on its faintly stirred surface. Shadows so full of light are not known in the north:

one understands them when one sees how the blue and indeed at evening
the greenish colour of the sky persists unaltered in the light haze which
clothes the rocks and shore. Thus Greek colouring has its roots deep
in nature, although what it borrows it uses with full artistic freedom:
the colouring is no less idealistic than the rendering of form and the
composition. An ideal play of colour, such as Plato saw in his imagina-
tion, was the main preoccupation of the artist. It is inspired by nature,
but in Greek fashion transferred to men and things: in landscape-
painting itself a picture seldom rises to this height.

To return to our picture: the subject is Odysseus and Diomede
discovering Achilles, whom his mother Thetis had concealed in Skyros
among the daughters of King Lycomedes: thus began the fulfilment
of his destiny, to win the highest fame, but an early death. The heroes,
disguised as merchants, gained access to the maidens of the royal house:
they laid precious jewels before them, and beautiful weapons. Suddenly
one of their companions sounded the alarm, as if the house were attacked
by enemies. The maidens scattered in horror, but Achilles, though in
woman's clothes, betrayed his heroic spirit by seizing the weapons.

This is the moment shown in our picture. It is the best artistically
of a number of replicas, which must go back to an original of the late
fourth or the third century. To the left of the picture about a third of
it is lost: we tacitly restore this in our description after a complete
specimen. Only the trumpeter, however, is quite certain: part of his
long trumpet is preserved in our picture high up on the left: the maidens,
treated as subsidiary figures by the Pompeian painters, may have varied
on the left from copy to copy as they vary on the right.

The long alarm sounded by the trumpeter in the background has
done its work. Achilles has sprung up with flaming eyes and seized
shield and sword. But at the same moment Diomede clasps him from
behind and Odysseus grips his tightening arm, looks hard into his face,
and we can almost hear his voice: 'Achilles!' Deidameia flies horror-
stricken, her body almost bared by the violent movement, and looks back
over her shoulder; beside her, half-concealed, is one of her sisters,
and there is another, motionless with terror, behind Odysseus. In the
middle, Lykomedes, seated above the tumult, raises his eyes to Zeus:
he realises the critical moment, as Niobe the irresistibleness of fate.
Two warriors stand beside him: the surfaces of the shields throw up
the dark heads of Diomede and Odysseus, a popular device, as we
have seen, at the time. It helps the individual figure and the expres-
sive contour to retain their old precedence even in a crowded spatial

composition. The architecture frames and articulates the dense mass of figures. The upper half of the picture is divided into regular sections by two columns which stand in front of the door-jambs: the broad opening in the middle, with the folding-door half open, leads the eye into depth. These systems of verticals give the picture a restful background, heighten by contrast the expression of movement in the numerous diagonals connected into zigzags, and combine with the main shape of the figure-composition to form a simple, clear picture-scheme. Although this scheme does not obtrude itself upon the eye, we feel its calming, clarifying effect through the dramatic agitation of the picture.

Fig. 124 An instructive light is cast upon the practice of wall-painters by the four pictures of Theseus after his victory over the Minotaur. Two still remain, one of them—that reproduced—incomplete: the third is known from a fifteenth-century pen-drawing, and a fourth, in its main features, from a description. The fourth unites all the elements of the others: in the middle Theseus, and a pair of children expressing their gratitude to him with tender, impulsive gestures; to the right more children; to the left the entrance to the labyrinth, and the dead Minotaur in front of it; above, Artemis sitting on the rocks. The well-preserved version from Pompeii shows Theseus in front of one of the towers of the labyrinth, and to the left the corpse protruding from the dark entrance. Theseus shoulders his club; a boy kisses his right hand, another his left foot. To the right come five big girls close together, preceded by an aged pedagogue with a little boy. The heads are strongly individualised, and give us the painful impression that the family of the master of the house has here been immortalised. We leave this Roman vulgarity far behind in the magnificent picture from Herculaneum. It has suffered so severely that the figure of Theseus dominates it almost too exclusively. But this is only an exaggeration of the effect of the picture before it was damaged: the composition really does cluster more closely round Theseus, the troop of children is smaller, and the gate between it and the Minotaur is placed slanting behind Theseus. The monster's huge body slants through the picture from left front to right back; one of his knees is drawn up and shows behind Theseus' legs. Above on the left is Artemis, seated on the rocks: in the Pompeian picture she is absent, right and left are interchanged in several places, and the attitudes of the children are not quite the same.

An important painting stands at the back of these wall-pictures. The wonderful figure of Theseus in the Herculanean version shows us where to look for the original: the Theseus is a compound of Praxitelean

106

beauty, Lysippic tenseness, and Scopaic fire, an Attic work, therefore, from the second half of the fourth century. And the composition suits this date. We should all like to think that the Herculanean picture, rather than the Pompeian, preserves the original form, but that would be a mere expression of feeling, not necessarily final, were it not for the pen-drawing, which repeats the main group of the Herculanean picture almost exactly, only reversed. So three hundred years before the excavation of the cities of Vesuvius, a similar picture existed, probably in Rome, and was current, apparently in engravings—hence the reversing. Whether a transformation had taken place between these two pictures and the original we cannot say. It is by no means necessary to suppose so : we may assume that the wall-painters copied a panel picture which was preserved in Rome. It is doubtful, however, whether the original confined itself to the Theseus group with three or four children and perhaps a wall for background, or whether the entrance to the labyrinth, with more children, was also given, and the Artemis on the rocks. That the pen-drawing should give the principal group only would be intelligible even if its model contained more : but the model itself may have been a mere extract, perhaps in a decorative context. If the Herculanean composition seems a trifle cramped, that is due to the narrowness of the niched space at the painter's disposal. Other things being equal, one would regret the absence of the deep, dark entrance to the labyrinth and of the additional children, and the tall gate called for just such a counterpoise as is provided by the goddess on her high seat ; diagonally, she balances the children as well. The fundamental type of the picture can be traced back to the middle of the fifth century. An Attic cup shows Theseus, with Nike bringing him a wreath, standing frontal before the corpse of the Minotaur, which leans against a column at the entrance to the labyrinth : the atmosphere after the fight is rendered with Polygnotan simplicity, and the sentimental trait of the grateful children is still lacking.

We pass into a quieter world with a small picture (rather smaller *Fig.* 125 than the Niobe), which is one of a series found at Herculaneum (not Stabiae) and described by Winckelmann. They are stucco pictures which were let into the plaster of the wall. They mark a sort of transition from the panel to the wall-picture, and we are thus prepared for particularly careful execution. This, and the severe rendering of form and of space, make it certain that the artist intended to copy panel-pictures of the later fourth or the third century. Our picture shows us a victorious actor about to dedicate a mask as a thank-offering. The indication of space

is exceedingly simple : instead of the interior architecture seen in the other pictures of the series, all we have is a back-wall with a door-opening. In the composition there is no attempt at symmetry or equable space-filling : only a free, choicely rhythmical balance, which gives us the feeling of space even without the assistance of the architecture. The men's arms and staves lead the eye through the air with a gentle vibration, and their gaze directs ours towards the girl who is writing the dedicatory lines below the mask. She alone is shown in full profile parallel to the picture-surface : from her the movement is into the depth of the picture *(Fig. 122)* on both sides, just as from the Patroclus in the Dismissal of Briseis. Beside her, in the very middle of the picture, stands the powerful chair-leg with its sharp divisions, which gives a firm support to a composition light as air. It is assisted by the door-opening, which is moved a trifle to the left for the sake of balance. The simplicity of these devices is almost fastidious, at any rate it is ingenious and graceful. It makes us think of Menander, and it is of Menander's portrait that the head of the actor, with its simple yet subtle naturalism, reminds us. There is the same spirit in the lightsome fragrant colouring. It is much richer than our monotone reproduction would suggest. Even the apparently white garments shimmer with an extraordinary variety of delicate tints, which are blended into a harmony of Mozart-like lightness.

An extreme contrast to this delicate little picture is given by a great monumental work which is a product of the mature Hellenistic art of *Fig. 126* Asia Minor : it represents the finding of the infant Telephos in the mountains of Arcadia by his father Herakles. There is not the least reason to doubt that this wall-picture, painted by the confident hand of a master, is a copy of a Pergamene original. The character of the whole and of the parts, and internal evidence as well as external, point to its being an uncontaminated Pergamene work. Its main elements, Herakles, and the child suckled by the hind and watched over by the eagle, appear together and in the same form, even to details, on Pergamene coins : the pose of Herakles is similar in the small frieze on the Pergamene altar, and the relationship between figures, rock and air is the same. The massive heaviness and compression of the forms, and the abundance of minor forms, sometimes, as in the head of Herakles, exaggerated to grotesqueness, accord perfectly with the style of the altar reliefs : and the great draped female figure is closely akin to contemporary female statues. But, even in the copy, the picture is on a higher level than the decorative reliefs, as is natural in an unaided work by a great master : and the relation between the two is something like that between style and

mannerism. In the words of Herrmann, ' the picture is in the grandest style, the impression it gives is strangely solemn and majestic, the great, heavy figures are of heroic mould, and as if weathered by mountain air : above all, Arcadia, couched spaciously on the mountain-masses, as if made of primaeval matter and as if throned there for eternity, with the great folds of her bright garments heaving round her like the pure, clear atmosphere of the mountain-peaks.'

The nymph gazes far away into the distance, and her eyes are slightly raised : but what she sees is not of this world : the prophetic eye of the local goddess discerns the future greatness of that royal house of Pergamon, which is destined to spring from the child who is here miraculously nourished, guarded, discovered. The mythical ancestor, his father Herakles, and the eagle of Zeus, the Parthenos acting as a goddess of destiny, showing Herakles the marvel and explaining it, and the lion which does not harm the child : all these unite to glorify the Attalids, sprung from Telephos. Hence the ' solemn majesty ' of the fateful moment, which even the lion seems to feel—not a true lion; Greek artists had seldom seen living lions—but a magnificent creature of wild nature. And the effect is heightened by contrasts : the exquisite idyll of the suckling babe, unaware of his high destiny, and the unconcerned laugh of the satyr-lad, a child of nature in the fullest sense, delighted with the unusual spectacle.

All this is shaped into a picture with masterly art. The composition is as magnificent as the conception. Two diagonals cross, both on the surface and in space. From the point of view of form, the line from Herakles to the satyr is the more important. From the intellectual point of view, the other : it is determined by the look of Herakles, by the look and pointing arm of the Parthenos, it is continued in the Telephos, and spatially can be felt in the rocks. The ends converge—the heads, the wings and the shepherd's crook : and a firm hold in all this movement is provided by the vertical sceptre of Arcadia, which at the same time strengthens her air of immovable rest. Her arm is in the very middle of the surface, and the folds continue this central axis downwards. The expressive arrangement of the heads in pairs, the two heads in each pair being linked together by light and shade, and by a common or a contrasting inclination, is an expedient which we have already encountered more than once : the most effective example of two heads looking in the same direction was Achilles and his bodyguard in the (*Fig.* 122) picture of Briseis. We shall not analyse the artistic devices further : but the Telephos group, which has been rightly styled a picture in itself,

calls for a word. To bring it into proper prominence, the painter has given it a special background consisting of the rectangular side of a rock. The two diagonals of the picture are repeated in the Telephos group, but it is quite complete in itself—an ingenious organism with a profusion of lines, parallels and thrusts running through it. The head and neck of the hind bring the spatial slant back upon itself, and the right thigh of the boy cuts across it and holds it firm. The clear arrangement of all these various forms and the charming expression of the group combine to produce a most attractive effect, which is further enhanced by the special lighting. The basket of fruit is more of an accessory, but it has an existence of its own as a still-life. Such is the aspect of Greek monumental landscape-painting : Nature is suggested and incarnated.

In the colouring of the painting it is not the tint but the tone that predominates : and that is why the colouring comes out so well in the reproduction. In Greece as in the seventeenth century, tonality is a mark of a late stage of development, and the strong effects of light and shade are another. Compared with baroque painting of the seventeenth century the lighting is still classical, that is, of a fairly uniform lightness. This is typical of the relation of the so-called baroque style of the Greeks to the real baroque of modern art : the Greek style contains certain baroque elements, beginnings of baroque, but in the main it conforms to the classical style. The Telephos picture is an excellent example of this rule. In spite of the courtly feeling in it, and the complication of the contrasts and relations, it still breathes, on the whole, the spirit of classical grandeur and simplicity. The most baroque part of it is the face of Herakles, the forms of which are in part forcibly exaggerated, in part coarsely naturalistic : there are also strong contrasts of chiaroscuro in the face ; but even so the chief use of light and shade in the face is to model the forms, just as in the rich swelling body. The head of the satyr-boy has reminded some of Frans Hals : and the primaeval force with which this child of nature is conceived does indeed recall the Dutchman. But there is nothing specifically baroque in that : post-classical we may call it, and so the other Pergamene or Asianic traits in the picture.

The same art, the eastern Greek art of the Hellenistic period, no doubt gave rise to one of the most powerful of all Pompeian paintings.
Fig. 128 The theme is the shameful bondage of Herakles in the house of the Lydian queen Omphale, and the picture has a tragic grandeur. It belongs to a cycle of three magnificent compositions, all celebrating the might of Dionysos. Invention and execution are almost on a level :

mural painting reaches a point at which a further approximation to panel-painting would only have been possible at the expense of the freshness and power of the impression. Everything is so homogeneous here, so large and sure and full of blood and strength, that one hardly cares to inquire about models and accuracy. But the inquiry forces itself upon us, for no other picture gives us such a strong feeling of having Hellenistic art before us at its best, free from bombast and empty pathos, yet full of exuberant power and confident expressiveness. The Telephos from Herculaneum comes nearest to it; but in the Telephos one or two late (*Fig.* 126) Pergamene elements impair the simple grandeur of the effect: in this respect the Herakles, especially, of the Herculanean picture cannot compare with the Pompeian. We might think that we had works of the third century before us. But the Pompeian painter is so full of the spirit of the great Hellenistic age that in the absence of independent replicas it is impossible to say whether the pictures are accurate copies or fresh creations freely inspired by earlier works. It is difficult to believe that they are laboriously accurate copies down to the details of the pictorial handling.

We confine ourselves to the picture of Omphale, the only one which is tolerably well preserved. Surface and space are full of figures, with only a little air above them. There are eight full-grown persons, only three of them fully visible, and three small Erotes: and yet we have the same impression of multitude as in similar paintings by Rubens, whose name has often been mentioned in connexion with this work. All these are dominated by the athletic figure of Herakles, a head taller than any of them: his powerful body, almost naked, the sunburnt skin a wonderful shimmering golden-brown, stands out from the blue of the upper half, and leads on to the red and gold of the lower. Julius Lange says that the figure is ' of incomparable brightness, and as rich in colour as a ripe plum.' No one who is acquainted with sun-browned male bodies will consider that the comparison is unworthy of the strength shown in the figure; for the living, swelling tissue of muscle-flesh and skin is not dead steel. But this giant with the huge chest and the bull neck is unsteady on his legs: with his right arm he leans heavily on the shoulders of the obese, leering Priapus; and his head leans over in the same direction. From the point of view of composition, the slight slant of the thyrsus which he holds in his left balances the bend of the great central figure: but from the point of view of expression, the vinous dependence of the Greek hero upon his unworthy Asiatic retainer finds no counterpoise: we feel the shame which he himself betrays in

his tortured features, despite the stupefying fumes and the wild music shrilling at his ear, and we see the triumph of Omphale, who stands there with the look of a cold coquette, flaunting herself in Herakles' lion-skin and holding his club.

Herakles has reason to turn away from her : for the huge drinking-bowl, with which a little Eros is playing at his feet, has not made him quite insensible : and an iris-wreathed girl, one of Omphale's maidens, feels as he feels : she drops the eyes which have seen him thus. A second maiden beside her looks up at him, and behind Omphale is the fourth of this row of heads, that of the brown Lydian youth on whose raised knee the queen leans. His head is turned in exactly the same direction as hers—that device of emphasis by doubling which we have encountered *(Figs.* 122, several times already, for instance in the Briseis and in the Telephos. 126) Behind Priapus appear the head and arm of a girl who beats her tympanon at the ear of Herakles, while a little Eros blows hard over his shoulder into his other ear. Half-visible behind the girl is the pine-wreathed head of a sunburnt lad, probably a satyr, and behind the legs of Priapus another Eros peeps out, who lifts the long garment off the ground and wonders at the view which meets his eyes under the fruit-filled lap. The quiver of Herakles lies in the corner.

This composition of bodies, heads and garments is unusually com-*(Figs.* 121, plex, and yet as clear and simple as in the Briseis or even in the Alexander 122) mosaic. It divides itself into a larger Herakles group and a smaller Omphale group : the Omphale group is seen in three-quarter profile and extends into the depth of the picture, while the Herakles group is almost frontal and comes out of the picture-depth like a procession which stops in front of the spectator. The division is as palpable as in the mosaic, and in the picture-plane it is emphasised by the mantle and thyrsus of Herakles. In spite of their spatial values the three principal figures stand in the same plane, which reaches to the front plane of the picture and so to the spectator. This is of a piece with the low point of vision, and with the scantiness of the frame compared to the crowded luxuriance of the figures, which is heightened to a powerful mass in the figure of Herakles. Both form and spirit show the same Asianic style, exuberantly strong and sensuous, felt through and through and therefore without empty formalism : style, not mannerism.

In the colouring also we find the same habit of working freely with great masses, and of obtaining effects by means of great contrasts which are yet closely linked to each other. Thus the blue and the red of the upper and the lower halves of the picture are dovetailed into one another

by suitable distribution and through the triad with yellow, the comple-
mentary colour to blue, as well as by mixture with it : a rhythm of colour
which accompanies and intersects the rhythm of form. The rhythm of
form, as far as the plane surface is concerned, consists chiefly of the
repeated unison and counterplay of the diagonals, the dominant of the
diagonals being given in the bodies of Herakles and Omphale : a few
verticals and horizontals give support to the whole composition and rest
to the eye. We shall not go into further detail ; but we must draw
attention to the ingenious arrangement of the heads in rhyming couplets,
contrasts and rhythmic series : Omphale and her servant ; Herakles
and the sympathetic maiden ; Priapus and the tympanon player ; the
maidens looking up and looking down, while Omphale and the Lydian
look straight in front of them. All these things do not force themselves
upon us, but by clarifying, ordering and uniting they contribute to the
rich harmony of the total effect. But the whole picture is dominated
by that one great accent, the giant figure of Herakles, brought to such
shame, made the plaything of a vain woman and of little children.

The Herakles and Omphale appears to us moderns to be a thoroughly
individual creation. Not so the picture of Dionysos finding the deserted
Ariadne on the strand of Naxos. It is one term in a typological series *Fig.* 127
which can be traced back as far as the turn of the fifth and fourth centuries,
and there are many variations of it in late wall-painting. We are not
concerned, however, with the typology : our picture, as we have it,
gives us the impression of a grand creation in the Hellenistic style.
Ariadne lies sleeping in the lap of Hypnos, and a little Eros unveils her
shining body to the wondering Dionysos and to us, to whom her back
is turned. Behind the splendid figure of Dionysos, who has just come
up, his garments sweeping round him, comes the train of his followers :
they stretch obliquely into the depth of the picture. Pan raises his
hand in astonishment : the others are busy with their own concerns.
The group in the middle distance is delightful : the type occurs as early
as the fourth century on Italian vases : assisted by a satyr, old Silenus
is laboriously climbing a path between steep rocks. Beside him a young
satyr beckons to two others who clamber up the high rocks in the middle
and look down. It is not only the rendering of the forms that seems to
be Hellenistic, but the composition with its strong movement into the
depth of the picture. And the great line slanting into depth, which cuts
the picture diagonally, from Dionysos to the airy distance between the
rocks, bears witness to a strong feeling for nature as well. These are
not mere landscape side-scenes in a figure-picture : they make us feel

the progress of the god and his troop through open country. In this picture we see the legacy of the classical period, shaped in the spirit of the Hellenistic age : so much is clear, and the question whether the work is an accurate copy of an earlier painting is of minor importance.

Fig. 129 The same question arises when we turn to the picture of Apollo and Daphne. There are several versions : that which we figure enables us to appreciate the grand design of the original. Apollo has overtaken the fleeing nymph. As he embraces her, his mantle slips from his body, while Daphne's floating garment reveals the shining virgin form almost entire. She sinks on her knees, Apollo bends over her, but she swerves violently away, and the passion of her refusal flashes to heaven in the outstretched arm and the desperate look, and stirs the pity of the gods. The laurel-tree into which she is transformed crowns the group ; the trunk shining between his head and her raised arm and separating them. There is no external metamorphosis as in the well-known statue, but the spectator who is acquainted with the story knows that the next moment the god will clasp the young laurel-tree, and the passionate cry of the virgin will have died away in the dreamy rustle of leaves. Other pictures of the same subject know nothing of this stormy agitation, and many of them are so superficial that it would be idle to look for earlier originals

Fig. 130 behind them. There is one, however, in which the quiet figures glow with passion. Apollo is seated, and the maiden is leaning against a wall in front of him : with an expression of burning desire which can be felt all through him, he draws the garment from her body. She only raises her hand a little and looks away with eyes full of emotion but losing themselves in the distance. The transformation is not indicated, but we feel it : the touch of the god seems to root the maiden to the ground, and her consciousness is on the point of extinction. It can hardly be doubted, therefore, that the figure is really Daphne ; and in another purely decorative picture, where she raises her hand as here, sprigs of laurel sprout from her hair (the semblance of this in our picture is misleading). The work is summary and decorative, but skilfully executed : although the typical Pompeian landscape background is somewhat distressing.

 The main features of an important Hellenistic picture are preserved

Fig. 131 by a mosaic in Malta. The mosaic was once thought to represent Samson and Delilah : somewhat unlikely in a work of the early Imperial age. The correct interpretation is given by a passage in Philostratus' descriptions of pictures ; the book is a product of the later schools of rhetoric, but shows considerable acquaintance with art. A satyr, heavy

with wine, falls asleep, and is surprised by two nymphs, who avenge themselves on their tormentor by binding his hands and cutting his beard off. This may be amusing for us, but it is a serious matter for the participants : we must remember the oath by the beard. Hence the grandeur of the artistic treatment, almost excessive to our taste ; it could not be greater if the bard Thamyras were being blinded by the muses : but it is as thoroughly Hellenistic in its way as the subject. The composition, both in the plane and in space, is based on great diagonals and strong contrasts of direction : light and shadow are also sharply contrasted. The satyr reminds one vividly of Laocoon. More attractive are two pictures of lovers. One is a peculiar treatment of a common subject, Selene and Endymion. The youthful hunter is usually repre- *Fig.* 132 sented leaning on his rocky seat in an attitude which suggests rather than renders sleep : the moon-goddess steals or hovers towards him, sometimes enveloped in ghostly silvery vapour. In our picture Endymion is awake and waiting for the goddess, who is floating down to him. His dog turns round to look at her, and in the middle distance there is a charming group of two nymphs in each other's arms, turning their eyes from each other to watch the lovers. They are not essential to the picture, but are so appropriate that one would like to think of them as invented for it. The upper part of Selene's body in its gauzy chiton shines yellowish out of the purplish black mantle like the half-veiled moon from a dark cloud : an example of landscape anthropomorphism in colouring. The composition, both in the plane and in space, is apparently simple, but constructed and balanced, with studied art, in diagonals and counter-diagonals, verticals and horizontals. The credibility of the representation rests in great measure on the empty space in the middle, with its moonshine haze.

Finally, a work of a very special kind, the charming picture of the *Fig.* 133 lovers with the nest of Loves, a true Hellenistic idyll, which we understand without names. The replicas are very like one another, and are probably fairly accurate transcripts of the original. The picture speaks for itself and hardly requires analysis : we shall only draw attention once more to the pairing of the heads ; and to the resemblance between the youth and representations of Narcissus, Cyparissus and Endymion. Such plump, quite unathletic forms can often be observed in big boys in the South. The youthfulness of the boy and the girl is not accidental ; it is first love rendered in all the charm of its natural innocence.

From these delightful pastoral idylls we return in the two next pictures to the heights of tragic grandeur. One is almost certainly, the

Figs. 134- other presumably, a copy after the laſt of Hellenistic painters, Timomachos
136 of Byzantium, a contemporary of Caesar, and highly praiſed by Pliny.
His moſt celebrated work was a Medea which he did not live to complete :
we suppose it to have been the original of a number of wall-pictures,
gems, reliefs and ſtatuary groups. The beſt of the pictures comes from
Fig. 134 Herculaneum. Medea ſtands frontal, and the folds of the chiton over
her right leg fall to the ground in rigid verticals. But a double move-
ment can be felt in the figure : a ſtep to the left towards her children
(who are not preserved in this picture) ; this is also the direction in
which she is looking, with her eyes fixed on the ground ; and a twiſt
of the shoulders to the right, as if she would turn away. The same
conteſt appears in the countenance : rage ſtruggles with grief ; from
the half-open mouth with the upper lip drawn up we hear the groaning
of the tortured breast ; we seem to feel the quick breathing of the excite-
ment which presses half-blindly towards a decision, and in the fury of
the wide-open eyes and the agony of the drawn brows there is a battle
which we know to be between jealousy and a mother's love. The
passions are ſtill equally matched, and in the tightly clasped hands
with the thumbs pressed together the tension is closed as it were
in a ring : but we feel the imminence of the explosion which
will burſt the ring : it is not for nothing that the sword-hilt reſts in
these hands.

This is all expressed by simple, large means. One of them is the
sharp compression of the body by the twiſted mantle : it ſtrengthens the
impression of painful conſtriction, and forms a contraſt to the classic
plainness of the vertical folds. But this is nothing to the great contraſt
which pervaded the complete picture : the murderous, agoniſed mother,
Fig. 135 and the unconscious children at play. A picture from Pompeii, the
essentials of which recur on two gems, gives the moſt expressive version
of the children : they are playing with knucklebones on a domeſtic
altar—the altar on which they will be sacrificed. The background of
the picture from Herculaneum seems to have been of typical simplicity :
a wall with a dark side, and a door opening in it half behind Medea :
nothing diverted the eye from the principal figure.

Fig. 136 Now comes a grand picture of Iphigenia in Tauris with Oreſtes,
Pylades and Thoas. Many as are the variations in the treatment of this
subject in pictures, reliefs and gems, with and without Thoas, before and
after the recognition, it all comes down to one important picture, and an
echo of another : traces of a third are uncertain. The typology, as we
learn from South Italian vase-painting, goes back to the fourth century.

That the picture just mentioned was the work of Timomachos known to us from literature is quite possible, not improbable, but not proved.

Our picture comes from the House of the Citharist at Pompeii. There are several replicas belonging to the same period, but this is the only one which is both well preserved and of high artistic merit. The essential features recur, cheapened in places, on sarcophagi: this agreement alone should have deterred those critics who have pronounced the picture a patchwork. The captives stand at the altar, bound, and guarded by a Scythian in a Persian cap. Opposite them sits Thoas with his hands crossed on his staff, and gazes at them intently with his head raised: his head is set off by the light cloak of the guard who stands behind him and also looks at the prisoners. The group of the two prisoners, admirably compact both in space and in contour, is a masterpiece of characterisation by contrast; the much-tried Orestes half-resigned, and without hope, the resourceful Pylades proud and defiant and attached to life. His eyes scan the distance where he longs to be. The guard is made little of compared with the prisoners: his spears are balanced by those of the King's attendant and by a tree behind him. In the middle distance, on the steps of the temple with a curtain behind her, Iphigenia appears, above the broad gap between the groups, which contains the altar with a torch and the hydria with the lustral water. She walks forward quietly with the image in her arm, and turns her head towards the captives: we feel the secret understanding and also the rising suspicions of Thoas. The upright spears and the tree connect her with the side groups: in the original she was perhaps somewhat lower, but hardly on the ground-level, nor can she have held a torch: the sculptors of the sarcophagi made these alterations under compulsion. For the spirit of the picture is ruined if the effect of tension between the two groups is destroyed by the insertion of Iphigenia.

Thoas does not appear in the earlier treatments of the subject. It is only the Thoas picture from the Casa del Citarista and its replicas which present us with a convincing masterpiece, the figures and groups of which found their way into all the other classes of Campanian art. And the only Iphigenia in Tauris we hear of is by Timomachos. This may be a coincidence, and the picture is conceivable in any period from the later fourth century onwards. But the conjecture that it is really by the master of strong but restrained expression is inherently probable. Compared with the violent outburst of pathos in the Farnese Bull or the Laocoon, the psychological tension of these pictures almost reminds us of fifth-century ethos. This does not mean that they are classicising works,

117

but there is something of classical grandeur in them. Thus the Iphigenia, like the Medea, may be the work of the master who had the whole of Greek painting to look back on. For us he is its last great master.

The mural pictures and the mosaics hitherto considered have all been under the spell of panel-painting. Free mural paintings of grand style have been preserved in the rooms of the Villa of Boscoreale and the *(Fig. 159)* Villa Item near Pompeii. Together with the Odyssean landscapes from the Esquiline, they constitute the earliest group of wall-paintings in our collection, and are not later than the first century before Christ. The *Figs. 137-* Boscoreale pictures are set in a framework of painted pseudo-architecture *138* and stand like statuary groups on a podium which at the same time supports pilasters thought of as projecting : in front of all this there is a row of columns, with architrave, corresponding to the pilasters ; behind this the wall appears to recede. Thanks to this framework of columns, pillars, architrave and base-profile, a painful panorama-like effect is avoided, and the colouring raises the work entirely into the ideal sphere of artistic irreality. The finely attuned colours of the figures have a background of glowing scarlet, against which the columns stand out in bright ivory colour and the architrave in golden yellow. Only five of the nine pictures in the room remain. The interpretation of them is disputed : the subjects were no doubt influenced by personal matters, and so cannot be divined by us.

It is more essential to recognise that these are works of extraordinary importance. There is nothing classicising and nothing degenerate about them. They are not survivals of Hellenistic monumental painting ; they are that art itself at the height of its power, swelling with the vigour of Pergamene sculpture, murmurous with its fulness, and animated by its pulse. Even if they were copies, even if the man on the gold and ivory throne were an Attalid or a Macedonian and the lady his queen, one has the feeling that they would be copies by a painter of the same school, a painter who was speaking not a foreign language but his own. The ' broad, pictorial handling with its rich contrasts ' has rightly been admired : with perfect mastery bright heights are contrasted with gloomy depths, broad surfaces with deep furrows, the large quiet of the principal forms with the passionate movement of the minor ones, the powerful masses with the abundant articulation. As the restless light ripples and glistens over the massive body of the man, its planes, lines and contours vibrate in violent, often breathless curves, the folds of the drapery break, swerve and halt, the surface of the material bunches and crinkles. The life which is embodied in these stylistic forms is a

full-blooded southern life. These big, ample figures with their grandiose nonchalance of bearing we seem to have met in South Italy. They do not parade themselves before us, but sit and stand on the podium in unconstrained attitudes, sometimes in an almost frontal three-quarter view, sometimes, with an effective contrast, in pure profile. The paired figures turn their heads towards each other, the maiden and her servant look at us. The inaccurate perspective of the chairs is instructive. In the man's chair we have an inadvertence which the painter doubtless noticed, but could no longer correct : but in the girl's chair also there is no question of mathematical correctness. The ancients knew the rules of perspective, but their use of them in art was always a matter of feeling.

The decoration of the Villa Item is of a different kind. Our pictures *Figs.* 140- give specimens only : but we must say a word about the decoration 142 as a whole, for although it is distributed over three walls and subdivided into a number of groups, yet it is composed as a unit, so that the eye glides past the corners without difficulty. Accordingly there is no pseudo-architecture : the podium supports the figures and nothing else, and behind them there is only flat panelling. Here also the principal fields of the wall are scarlet, so that the subtly coloured figures give us the same impression of apparent irreality as at Boscoreale. The large fields are separated by narrow pilaster-like interspaces, and this wall-rhythm is taken up into the figure-composition. The interpretation is disputed : the simplest view is probably the best, that the subject is the ceremonies of Dionysiac consecration in the presence of the god and his followers. The general atmosphere is quiet, with little action or movement. The god leaning at his ease on the breast of Ariadne, Silenus giving a satyr drink, behind them another satyr holding up a *Fig.* 141 mask, and, in the spirit of a country idyll, two young satyr-girls sitting on rocks, one with a Pan-pipe, another suckling a roebuck ; in front of her a she-goat. This group enhances by contrast the effect of the most animated of all the figures, an ecstatic maenad ; more calm, but he also full of the god, a second Silenus plays the cithara beside her. Then come women quietly preparing the sacrifice, and last two women *Fig.* 140 with a boy who is reading in a scroll, no doubt a sacred writing. He is taken to be Iacchus with his divine nurses, but he may be only a young initiate. The chief ceremony takes place at the other extremity of the picture. A girl kneels at the feet of Ariadne and lifts the cloth from the sacred symbols in the winnowing-basket. The sight of the crude emblem of the power of nature rouses terror and aversion : one dainty *Fig.* 142 maiden has fled to the lap of an older friend, another starts back, and a

winged goddess, wearing, like Iris, short clothes and shoes, with averted face and a gesture of abhorrence lifts a rod to strike the kneeling girl. Who the goddess is, Aidos, Dike, Iris, we cannot tell, but the main idea of the scene is known from clay reliefs and gems. There we see a winged maiden, dressed in long clothes, fleeing away. Here she is as it were split up into two figures, and the expression of abhorrence is increased to one of divine interference: we feel as if a spiritualisation of the rude cult of nature were here indicated. The scene is closed by a naked woman dancing and playing the cymbals, and a draped woman with a thyrsus. There may be special meanings concealed here and there, but the general sense of the picture seems clear.

Since we are obliged to restrict ourselves to extracts, we shall not analyse the composition, but only refer to the solution of the corner-problem. The figures never come close up to the corner, but touch it at most with a wing or a foot. Yet the connexion between one wall and the next is always clear: two heads are turned towards one another, and the subject-connexion is so obvious as to have led to the erroneous view that the winged goddess is beating the girl who has taken refuge with her friend and whose body has been bared by her violent movement. This would be impossible even if they were on the same wall. In the several parts of his picture the painter has made use of a variety of well-known types, but the whole work is so well adapted to the particular requirements of the space, and so thoroughly homogeneous, that we cannot think of it as an ordinary copy after a famous original. We can see that the stream of Hellenistic art has not yet dried up, and we observe the influence of a magnificent art of monumental painting and a copious store of types: but exactly how this particular work originated we cannot tell.

We have already spoken about the spirit of the pictures. The figures are subtly individualised, and the rendering of the various shades of feeling and degrees of excitement is no less subtle. Motives and treatment of form are decidedly Hellenistic, and not very early Hellenistic: that is shown by the proportions—the upper part of the female body is often very slender—by the individual faces, and above all by the style of the drapery. The most striking characteristics of the drapery are large, light, uniform surfaces with sharp fold-lines and heavy shadows; and there is a good deal of naturalistic observation. But that is not the whole story, and in particular it takes no account of the essential difference between these pictures and the kindred works from Boscoreale. In those we found a full-blooded Hellenistic style, strongly recalling Pergamene

sculpture of the second century: here we have another ingredient, classicisation. The heavy vertical folds of the woman beside the reading *Figs.* 140-boy, the delicate folds of the ecstatic maenad's chiton, which fall between 141 the legs in the same dense parallels as in the Florence versions of the Niobid group, and in the upper part of the body radiate from the breasts with remarkable regularity, and finally the general tendency to sharp, narrow fold-edges and regular lines—these things and the like lie like a classicising veil over the Hellenistic life of the drapery. The whole rendering of form has something of this slightly academic coolness. A linear, plastic element contends with the pictorial. The pictorial element is less noticeable in the style than in the technique: at times, in the bodies *Fig.* 142 of the naked girls, for instance, it seems quite ousted, and the easy, broad handling has given way to a laborious draughtsman-like manipulation of the brush. But all these considerations recede into the background when we experience the effect of the composition as a whole. If we abandon ourselves without prejudice to the impression produced by a work which does not aim at being more than mural decoration, we feel more strongly than through any critical analysis the spiritual wealth and monumental grandeur of the lost art of which it is a last continuation.

We now come to the celebrated Aldobrandini Wedding, copied or *Fig.* 139 described by Rubens and Goethe, Van Dyck and Poussin. In its present state the frieze is about eight feet long. The date is about the time of the birth of Christ. The essentials of the picture are easily grasped: but the details present difficulties which increase rather than diminish as time goes on. We see before us the final customs at a Greek wedding, transfigured by Greek imagination, which here, as five centuries earlier, sets man and god together side by side—mortals in the solemn festal mood, and friendly participating deities: unless, indeed, it is a half-human rendering of the divine wedding of Herakles. The bride sits on the nuptial couch, muffled up and leaning back a little on to the cushions. She looks down, shy, anxious and very serious, hardly able to heed the friendly words of a goddess who sits beside her. The goddess is naked from the waist upwards, and will therefore be Peitho or Aphrodite. She has her right arm round the bride's neck, and speaks to her low, but with an urgent southern gesture. In front of the head of the couch, with his back half-turned to the pair, a youth, wreathed and almost naked, sits on a low threshold and turns his head with the eyes raised towards the bride. He is probably Hymenaeus, for neither his aspect nor his attitude is that of a bridegroom: and this is also against his being Herakles. On the other side of the pair a second half-clad

121

goddess, Charis perhaps or Peitho, leans on a low column, and pours oil from a perfume-pot into a shell. On the left, turned away from these, is a purely human group: the bride's mother preparing the usual foot-bath with the assistance of two little handmaidens: the basin stands on a short column: she tries the temperature of the water with the back of her hand, while one of the handmaids shakes something into it. A towel hangs from the column, and a flat dish leans against it below. Behind, half-concealed, the other handmaid holds a larger object, perhaps a water-vessel misunderstood. The group on the right side is looser. Three maidens are standing at a graceful metal laver. The left-hand figure is shaking something into it, presumably incense; the right-hand one leans back and strikes the lyre which hangs from her shoulder; and the middle one, who is distinguished by a high crown of leaves, stands still as if she were about to sing to the lyre: the wedding song at the threshold of the bridal chamber into which the bridegroom is soon to pass. This is all perfectly intelligible, and one who is accustomed to the indication of architecture in vase-painting will hardly ask how the rendering of space is to be understood: the receding and projecting pillars and walls in the background give us the feeling of open air on the right, of the thalamos in the middle with Hymenaeus sitting on the threshold, and of an adjoining room on the.left.

The expression of the picture makes a direct appeal to us: simple humanity, from the deep emotion of the bride to the quiet matter-of-factness of the women who perform the sacred rites; and human faith and feeling embodied in the deities of the marriage sacrament. Whatever the scene was which originally continued the picture on the left, it cannot have been out of keeping with this atmosphere: unless, of course, it was an independent scene. Our uncertainty becomes more serious when we turn to the question of composition, but here also we may say that what remains forms a unity, whether within a much greater whole or not, which does not admit of more than a slight extension: the symmetrical rhythm of the broad, central group between two side-groups turning away from it is too strong for that, and the symmetry is heightened by the stronger colouring in the middle. As the original termination of the picture on the left is preserved, the expression value of the turning away cannot be doubtful: it means that the bride is left entirely to her own emotion and the divine powers. Gentle womanhood is still busied about her; but soon it will be the turn of Hymenaeus, who looks up at her with shining eyes, and makes us remember that soon, after the mother and the maidens, the bridegroom will be at the

door. In this sense we can feel in Hymenaeus the impatience of the waiting bridegroom.

Artistically the composition, with its quiet perspective and the flat character of its rhythm, makes a good frieze-picture, and the effect of the colours, with their uniform general tone, is as pleasant as it is unobtrusively decorative. The technique, which strews isolated light and dark strokes and dots over the fundamental middle tones, and thereby achieves ' a loose pictorial rendering of form and a total effect of great liveliness and freshness '; the colouring; the principles of composition, and the motives : all these are inherited from a highly accomplished art. It has often been concluded that the work is a copy of some important classical or Hellenistic picture. But the conclusion is by no means binding; on the contrary, it is open to grave objections. The picture is perfectly intelligible as an eclectic creation of its own period, and there is much to be said for this view. The painter works with traditional material, but he handles it with all the skill and power of a fortunate inheritor, who has not lost touch with the great past. He never dreamed that his picture would be taken for a classical masterpiece, when it was after all only a decorative frieze of no great size. Goethe was right : he saw in this much-admired work a decorative picture ' painted on the wall lightly and with light heart,' in which at most the principal figures could have been borrowed from a famous original. But what a happy lightness and what a divine light-heartedness in this 'reliquia di quei buoni tempi'! It is not a cold academy, not the work of a petrified classicisation, but late Hellenistic art, still vital, though now eclectic and a little mechanical.

We now turn to a topic which has hitherto received but a passing mention, portrait-painting. In the second half of the fourth century, in common with the other branches of the art, it reached a height of excellence which won it a place in our literary record and which is confirmed by extant sculptures. All that remains is the faintest of echoes in the mosaic of the Battle of Alexander. One can still see that Alexander's *(Fig.* 121) features have not yet been submitted to the idealisation which we know from later times. But beyond that, a mosaic copy of a large battle-piece from the period after Alexander's death cannot be expected to teach us much about a real art of portrait-painting distinguished by the highest degree of pictorial and psychological refinement. What is preserved is only a late and more or less mechanical descendant of this art : the Egyptian mummy-portraits of the Imperial age, from the middle of the *Figs.* 143- first century after Christ onwards. We possess some four hundred of 148

them, ranging in a long series from the flourishing Hellenistic art of the first two centuries down to Coptic art. They are naturally unequal in artistic value, and the worst of them are primitive daubs ; but the best reach a level which for late provincial works like these is surprisingly high, and explicable only by the incomparable tenacity of Greek tradition in style and in handicraft.

Most of our mummy pictures come from the Fayum, a rich district in Middle Egypt which was systematically colonised by the Ptolemies. Their preservation is due to a curious combination of pure Greek art *Fig.* 148 and Egyptian funerary customs. Our last picture shows the top of a mummy wrapper. The wrappings are arranged to make a frame for the portrait, which thus takes the place of the old Egyptian mask. The picture could also be painted on the linen of the envelope itself, and this was the origin of the full-length figures painted on later mummy cloths.

Fig. 143 Our first reproduction is of a picture painted in tempera on linen : but the pictures are usually made of thin boards, painted either in tempera, or in encaustic, or in a mixture of both. Encaustic is the Greek equivalent of our oil-painting : wax was used as the binding medium instead of oil ; the colours were either laid on solid with the hot spatula, or liquid with the brush. It is to this technique, which is far the commonest, that the portraits owe their luminousness, their lustre, and the silky sheen on the noble colours, beside the special pictorial effects obtained by the pastel-like juxtaposition of separate touches of colour. This juxtaposition was a direct invitation to decompose the colours into contrast-values, the union of which on the retina of the spectator so greatly strengthens the effect. Similarly the old device of hatching, familiar to the vase-painters of the ripe archaic period, is used on the best tempera pictures : at the same time it served a linear purpose, the modelling of the form by means of surface-lines. At a distance of six feet the device disappears and the effect alone remains. The technique of this late provincial art thus shows complete command of the resources inherited from a great art of painting which in essentials was not inferior to the modern.

The portraits on wood, as we know from unmistakable signs, were not painted specially for the mummies but in the lifetime of the sitter. They were framed with crossing spars and hung on the wall by cords. Such pictures could naturally be copied for the mummy, but usually the original itself was used, and merely adapted to the narrow, low mummy window by splitting off the edges : for the mummy remained in the house as long as the family valued its presence. It stood upright against

the wall, and the picture thus showed very much as it had when hanging up. The trimming of the edges is a sensible loss: for the relation between image and background and between head and shoulders, the outline, and with it the general attitude, have suffered. This is more serious than might seem at first glance. For in spite of the mechanical simplification these pictures preserve the tradition of a great art of portraiture, which produced eloquent effects by the simplest means, with a few strokes and slight modifications. The head, which usually looks at the spectator or at any rate close past him, was never given more than a very slight turn in the direction of the three-quarter: but this was made up for by a lively movement in the bust, and even, where the lines pass into each other, a strong rhythm: the shoulders slant well away, so that symmetry is excluded, and the head sits on the neck with more or less of a turn, and therefore with a bend. Thus an animated play of line was produced, and the direct impression of actual life: for the spectator feels as if the sitter had just turned to look at him.

With this slight, at times hardly noticeable, movement in the pose, these persons are presented to us in the quiet immutability of their being and are yet at the same time brought into immediate relation with us by their look: the enduring existence and the life of the moment are combined in the simplest fashion. The individual characterisation is not impaired by the prevailing similarity of pose: on the contrary, a very slight modification suffices, in conjunction with the features and the facial expression, to produce a highly individual effect. Slightly raised or slightly sunk, gently bent or stiffly erect, the difference may only be a few millimetres, and yet the expression will be utterly changed. The same turn of the neck gives the full-blooded, short-necked man a look of *Figs.* 143, violence, and the long-necked, narrow-headed man a look of aristocratic 145 indolence. So also in the facial features: the type of head may remain the same—the same shape, the same arrangement of the parts; and yet the expression may be most individual, and it is not only mediocre painters who have a ' type ' of their own.

Having laid down this principle, we must proceed to restrict it: for it does not apply universally, and to the majority of the best portraits it does not apply at all. They show a power of grasping individuality which is not limited by any system of types, but only purified by an eye fixed on essentials. A feature which we are tired of hearing described as a characteristic of the whole species is not even true of the average: the alleged unnatural or at least racial largeness of the eyes. The catchword is more applicable to the portraits of the first half of the nineteenth

century than to the mummy portraits, even in spite of the remarkable, even astonishing, size of the eyes in many Greeks of to-day. There is the same relation between art and nature in the regularity of the contour of the face and of the eyebrows : the artistic type is the racial beauty of the south transfigured. In bad and mediocre painters we recognise the formula to which everything is reduced ; in good painters we do not know how much to believe. Conversely, not every striking irregularity is to be accepted as true to nature, for even in good pictures the irregularity is sometimes seen to be due to misdrawing.

Such considerations are almost unavoidable in dealing with what is after all, in the main, the work of artisans ; but they do not affect the essential point—the unerring combination of pictorial effect with individual expression. In this respect the average is extraordinarily high, and makes us realise what we have lost in the portraits by the great masters : for even the best of the mummy-portraits, we may be sure, could not compare with them for a moment. Throughout we find the tradition of a great art, but nowhere the hand of a creative master.

Fig. 143 We begin our closer consideration with a fine portrait which shows no trace of superficial conformity to type, but only what we find in all mature Greek art—a simple, large manner of seeing things and shaping them. The head cannot be later than the first century, and is an astonishing piece of painting. Face and neck and no more are visible, but we cannot help imagining that we see a powerful skull and broad shoulders as well, and we immediately think of this strong, full-blooded man as a Roman : the type is still common in Italy and Southern France. The head is painted in glowing colours with a broad brush and a sure hand. The face, already slightly wrinkled, with the skin not quite taut in places, is modelled completely in the flesh-tones ; the forehead wrinkles, however, are drawn with a few swift strokes of the pointed brush, and similarly the bright light on the temple is toned down by red hatching. Here and in the depths of the furrows the flesh colour is already decomposed into bluish-red and yellowish-green, between which there is a purer yellow, especially in the strongest lights. The greenish tones are most pronounced in the shaved parts, but are just as strong, though in smaller patches, elsewhere. The light comes from the left upper corner, and models the eyes, nose and chin powerfully and clearly ; strong shadows and bright lights, dashed in with firm brush-strokes, stand side by side without transitions. The head stands out well from the yellowish-grey to bluish-grey background : it is dominated by the dark eyes, which arrest our gaze, and the swelling red mouth ; their effect is

enhanced by the cursory treatment of the ears. The artist has seen the head both completely pictorially and completely plastically. That is Greek impressionism.

The other coloured reproduction gives a brilliant specimen of the *Fig.* 144 encaustic technique. A young woman of a pronounced Greek type and a somewhat animal-like, vegetative kind of beauty, looks at us with the quiet assurance of her simple large forms. The tone-values range from the whitish-yellow high-lights to the deep, dark brown of hair and eyes. Between these extremes we have the contrasts of the lilac purple of the garment, tempered to a rosier tint in the complexion, and light yellow, strengthened so as to glow and lighten in the jewels. The bluish-grey background gives the proper foil. The picture is not very individual, much less soulful: but the characterisation of the type is all the purer for that: it is the handsome Levantine of our own time. Doubly typical is the narrow, well-bred Greek head with the subse- *Fig.* 145 quently added funeral wreath: typical both of the race and of the artistic treatment of the racial type. The male head with the fuzzy hair is *Fig.* 146 on the same lines, but produces a more individual effect. Both these heads are masterpieces of encaustic. The next picture is superior to *Fig.* 147 both: the suffering countenance of an uncomely middle-aged woman with kind eyes, perhaps a Jewess. The tight lips seem to say that she has learned to suffer without complaining. Smooth, parted hair, no ornaments; a sharp furrow in the leanish neck. The portrait is painted in a large, powerful manner with complete command of the encaustic technique. The pictorial expression is not inferior to the spiritual, which compels, as has been said, our profoundest sympathy. Has the painter simplified some of the essential forms, the eyes, for instance? We cannot say for certain, but we should be unwilling to believe that this woman looked appreciably different from her portrait.

A charming portrait of a child presents a strong contrast. The picture, *Fig.* 148 which is in tempera, has darkened unevenly, so that it looks better in a photograph than in a coloured reproduction. It represents a little girl with a mop of fair hair and big brown innocent eyes in a charming face with delicate nose and small cherry mouth. She might be the child of a Celt or a German: from the Ptolemaic time onwards many fair northerners found their way to the far south.

At last we come to the most characteristic branches of Hellenistic painting: the picture of manners, the animal-piece, the still-life, and the landscape. Here also we can trace certain strands of connexion with *Figs.* 149- the classical painting of the fourth century, in the long run even with 160

archaic art, but these species did not become fully developed until Hellenistic times. They are among the most characteristic products of Hellenistic art, not only in themselves but also by contrast with the ideal species of art both old and new : one of the many contrasts which we observe in this restless, turbulent age with the wide pendulum swing in its attitude towards the self and to the world. With the picture of manners the cabinet picture comes in—the picture which has no specific destination, is not a dedication to the gods or a monument to the dead but merely a pleasant ornament in the house. In the wall-painting of the first century before Christ, which imitates the actual plastic architecture of a wall, there are reproductions of such pictures together with the ledges on which they stood. The first painter whom we know to have painted such pictures worked in the second half of the fourth century, but stands on the threshold of Hellenistic art. This was Apelles' rival, Antiphilos, an Egyptian Greek who played a part at the court of the Ptolemies. His manysidedness makes him a precursor of the Hellenistic age : but the most striking feature of his work is the combination of genre subjects with problems of pure painting, a combination familiar to us from the Dutchmen. Eyes which see things in terms of pure painting need not wander in search of important and interesting subjects. Everyday life offers sufficient material to engross their attention, and the sense of the objective charm of the world around us is thereby quickened. The same thing took place in pure painting at the turn to Hellenistic art as had taken place in drawing at the end of the archaic period, when artistic problems had led the red-figure painters to take an interest in everyday life.

Antiphilos seems to have been a painter of large pictures, but Peiraikos, mentioned in our literary tradition as the chief representative of genre painting and still-life, appears to have been a thorough 'little master,' like so many Dutchmen. He painted barbers' shops, cobblers' booths, donkeys, food, and his pictures fetched huge prices in later times. Kalates, we hear, painted small scenes from comedy, and the mosaicist Dioskourides (*Figs.* 150- has left us very expressive examples of such scenes. One of his two 151) mosaics, the masked metragyrtai or mendicant musicians of the Mother of the Gods, seems to be taken from real life rather than from the stage. In this work we have the three essential properties of the species, found also in the Dutchmen : the keenness of perception which, because of its desire for absolute truth to life, delights in plebeian coarseness, even plebeian ugliness and vulgarity ; the consequent magic power of making us join in the experience, which Burckhardt found in the Dutchmen

and which seemed to him to constitute their essential charm ; and lastly, the consummate excellence of the purely pictorial side. The essential features of genre painting are therefore the same in Greece as in modern times : but we must not forget that Greek genre painting had a much smaller range. Classical feeling tended to keep it down, and also invented playful kinds of idealism which ran parallel to it : everyday incidents, and even the brutal contests of the Roman arena, were transferred to the blithe, innocent world of baby Erotes, or caricatured with grotesque dwarves.

The Pygmy pictures stand to the pictures of Erotes much as the realistic picture of manners to the mythological idyll. The realistic picture and the idyllic are merely different manifestations of the same tendency. Civilisation has grown old and over-refined, and the search for nature and primitive simplicity leads men in all directions, into the low life of the populace as well as into the airy realm of fancy and imagination : it is the old parallelism of life and myth in a new form. With the appearance of this tendency and the growth of great cities, the time was ripe for the rise of landscape-painting—a modest, decorative, but within limits independent landscape-painting. We mention it here by anticipation, for the reason that the landscape is always peopled, sometimes by shepherds, peasants, fishermen, wayfarers, sometimes by pygmies or creatures of legend like Polyphemos and the dainty Galatea. Polyphemos stands up to his waist in the water looking like a young chaw, while Galatea flits by on a seahorse out of his reach. The town-dweller smiles and thinks of ever so many examples in life.

We now turn to the two mosaic pictures by Dioskourides of Samos, *Figs.* 150- who lived about the year 100 or in the first century before Christ. His 151 works are of the highest technical refinement. This is what he prided himself on, and what evidently brought him fame, for it is unlikely that the pictures are his own invention : both in form and in colour there is much in them that is unintelligible or misunderstood : one detail, wrong here, is given clearly and correctly not only in a fresco replica, but in a terra-cotta figure of the second century B.C. from Asia Minor. We must therefore infer a common source, some famous picture of the third or second century. The subtleties of the actual painting were evidently beyond the range of the mosaic technique even at its highest, and Dioskourides was compelled to make all sorts of small alterations. The condition of the mosaics is far from perfect. In the Metragyrtai the damage has been made good, superficially, by rubbing down, polishing and filling up. In parts of the other picture, it is only the coloured

cement cloisons that give the colour of the lost stones, and the tone, always paler, seems to have faded further with wear.

Fig. 150 The picture of the Metragyrtai, as it should most probably be called, shows us three low-class street musicians wearing small masks, and a seedy lad with the oldened look of a dwarf, against a light-coloured wall, to the left of which a door is half seen. The incident is rendered with convincing directness. It is just as when in Naples a group of mendicant musicians suddenly appears from heaven knows where, strikes up, and maintains from start to finish an animation which seems to take no account of the spectator. So these three. The stout tympanon-player, dancing up to us, dancing away from us; the cymbal-player bending clumsily over and accompanying the rhythm with his whole body; and in full contrast the woman playing the flute, upright, with only her fingers moving as she plays the melody evenly and colourlessly. The peculiarity of the effect is enhanced by the masks, the features of which, partly animated, partly unmoved, half agree and half conflict with the aspect and actions of the wearers : they vary from the laughing, satyr-like mask of the tympanist to the almost classical mask of the flute-player, and a double contrast is furnished by the maskless face of the little lad with his pined, common features. He is not actually a dwarf, as some have supposed, but a neglected guttersnipe, stunted in mind and body : hence the oldened look and the dull expression. He is obviously meant for a typical spectator of street-scenes. His stupid stare intensifies the liveliness of the picture by contrast, and reveals the miserable reality concealed behind the masks of the musicians. It is a question whether such maskless supers are possible in the New Comedy, for instance during the choruses, about which we know very little. On the other hand, the masks do not exclude a street-scene. Artistically it comes to the same.

The simple composition is finely thought out, but we shall not analyse either composition or colouring. But we must draw attention to the perfection of the lighting and to the use made of it. The tympanist, especially, is bathed in light and worked out with rich chiaroscuro, and between his arm and his mask one can really see the shimmer of the air, warm, sunny, and saturated with colour. The shadow which he casts on the wall is skilfully used to throw up the figure of the cymbal-player. The effect is not so strong in the flute-player and her shadow, owing to her standing farther back. She is badly disfigured by restorations in her lower half, which make her look flattened on to the wall instead of standing on the ground in front of it. Her original position

can still be inferred from the direction of her shin, and the wall-picture gives confirmation. The lighting is not quite consistent even here, as one can easily see if one looks close : the painter did not regard it as an end in itself, but as a means of producing artistic effects and to be used as occasion arose.

The other mosaic, which undoubtedly represents a scene from the *Fig.* 151 New Comedy, is subtler, more literary, and perhaps for that very reason more delicate in colour. What scene, contemporaries knew but we do not, and hence the appeal is not nearly so direct as in the Metragyrtai, which any one can understand : but in force or even violence of expression the comedy-scene leaves nothing to be desired. What is certain is that the old woman is one of those pharmakeutriai who dealt in love-charms. She and two ladies are sitting round a small table, on which we see the sprig of laurel which we know from Theocritus, a box for the charms, and a thurible. The squinting hag holds a silver cup, and her left hand makes the well-known gesture with bent-up fingers which may mean either deliberation or remonstrance. Since, as so often with persons who squint, we cannot be certain in which direction she is really looking and in which she only appears to be looking, the scene is open to several different interpretations. She may be deliberating, while her neighbour, with much animation, lays what is evidently a difficult case before her. Or the two may be remonstrating with the modest little figure at the left extremity of the picture : but this is less likely, for the little servant-girl—a girl she must be from her long clothes in spite of her short hair, unless Dioskourides has made a mistake—is not sufficiently emphasised. She is even less important, compared with the principal figures, than the boy in the Metragyrtai, not only coloristically as there, but compositionally as well, since half of her figure is cut off. The child cannot be the corpus delicti. Her downcast eyes only indicate the willing servant. She is probably, like the little boy in contemporary tomb-reliefs, merely a typical accessory, such as Theocritus himself is at pains to introduce. The young lady on the left seems deeply embarrassed : probably therefore she is seeking the assistance of the old lady, and employing a more experienced friend as go-between. The three types are excellently characterised, and once more the masks produce their peculiar effect of half-contrast—the rigid type opposed to the living person. The quiet little maid serves, like the boy in the Metragyrtai, to heighten the expressiveness of the other figures : the atmosphere of the picture is the stronger for her not taking part.

The space seems to be treated so as to give a realistic representation

of the scene on the stage as viewed from the auditorium. The representation was no doubt clearer in the original than in the mosaic, which contains certain obscurities in the figures as well. We look into one of those great door-openings on the upper stage, between the pillars of which the interior of a room is indicated—indicated in the stylised manner of the Greek stage, with no attempt at superficial illusion. In order to be visible to all the spectators, the actors sit on a podium of three degrees—which is so ornamented that it cannot be mistaken for a stair—framed by the pillars like figures in a relief, and with an appropriate background behind them : here it seems to be a light partition-wall, above which, and on the left side, we see what is perhaps the dark interior of the stage-building : if we were looking at it immediately from the front it would just fill the width of the wall-opening. The lighting, which comes in from the left, is perhaps like that of a real room rather than that of an open stage room, in which we can hardly conceive such a strong shadow on a raised mask as we see in the actor on the left. The colour-scheme is dominated by a light yellow, balanced by some violet. One might think of it as appropriate to the delicate conversational tone of the New (*Fig.* 125) Comedy, and perhaps bring to mind the choice little picture of the victorious actor with the Menander-like head.

Fig. 149 We now come to one of the most delightful creations in the whole of wall-painting, from the human as well as from the artistic point of view, the so-called Flora, one of those figures which were not part of a picture but placed in free decorative fashion on the wall, which here forms a light-blue background. Julius Lange says of it : ' It is a maiden in the April of her days ; like a fresh spring morning she wanders through the garden to gather flowers in the basket which hangs from her arm. One walks slowly when one is plucking flowers like that, looking to one side, looking to the other, to see what to choose. She has passed now, but there are pictures which one does not forget so easily, especially if one is a painter. On she goes, he sees her now from behind, she had almost forgotten a tall plant which grows at the edge of the path, but now she turns her head a little, stretches her hand out and plucks the end off, with thumb and forefinger, carefully ; for she loves the flowers, and takes hold of them tenderly. How beautiful the turn of the neck, how fresh the outline of the cheek ! What fine pure shoulders, and how light and quiet her walk, while the morning breeze plays with her garment ! ' Sensitive drawing, light and delicate painting : ' of morning vapour woven and clear sunlight.'

The new Hellenistic feeling for nature manifests itself not only in

landscape painting but in the animal-piece and the still-life. There are only slight traces of still-life in earlier times, and significantly enough they always consist of man-made things : but these go right back to early archaic vase-painting. The animal picture, on the other hand, has an ample history, if we take the idea in a quite general sense. Archaic art is full of animal friezes and animal groups, even to the pedimental groups of great temples ; an assortment of birds was not deemed unworthy to decorate the pediment of a Treasury at Olympia ; as sculptural dedications we know of splendid horses, powerful bulls and Myron's famous cow. There were no doubt pictures of the same kind, although we know only the rolling horse of Pauson. But decorative animals, usually combined into a strict tectonic scheme, and dedications with a special meaning—the winning racehorse, the knight's charger, the sacrificial animal, the stock-beast, or the memorial figure commemorating a chance occurrence, like the swimming horse on an early Corinthian plaque, and probably Pauson's horse itself : all these do not postulate an artistically free and independent species of painting, the animal-piece as we understand it. It may have been prepared, and probably was, in earlier painting as fully as in earlier sculpture ; and such preparation was of course possible in connexion with human representations. But a new frame of mind was necessary before it could become a branch of art which was an end in itself. The first steps towards the new point of view seem to have been taken in the second half of the fourth century ; timid steps, it is true, for Nikias can hardly have been an animal painter, though some have thought so—Nikias, who insisted upon important subjects, battles with many figures for example, and found fault with those who painted little birds and flowers. He was probably thinking of Pausias, whose flower-pieces, if we can judge from a mosaic, may have included birds. If so, we have at the very outset that introduction of living animals which remained characteristic of Greek still-life.

The Pergamene mosaics of the royal period also represented birds : the famous Doves by Sosos, of which we have imitations ; and a Parrot. *(Fig. 155)* But in two Hellenistic mosaics from Pompeii, derived from an original which influenced even the gem-engravers, we have a representation of a lion which is so magnificently powerful that Nikias would hardly have *Fig. 152* censured it.

The lion had always been a weak point in earlier Greek art, which knew the Oriental stylisation of the lion—an archaic, decorative stylisation in spite of the late Assyrian animal-pieces—but not the lion itself. It could not form a classical ideal of the lion as it did of indigenous animals,

especially the horse. The Attic lions of the fourth century, not least the lion of Chaeronea, are thoroughly unreal decorative animals, devoid of genuine expression. But then Alexander marched into the realm of the lion, and even fought with him as Herakles had fought with him when he was still to be found in Greece. The paradises, the enclosed hunting-grounds of the Oriental princes, opened their gates to the Macedonians and the Greeks, and at last Greek artists, though never all of them, discovered the overwhelming power and majesty of the king of beasts.

Fig. 152 One can hardly imagine a grander animal-piece than the better-preserved of the two Pompeian mosaics. Monumental, even highly decorative, effect is combined with an uncanny force of expression and fused with it into a masterpiece of art. Petrifying like the gorgoneion—the half-human lion-mask of the archaic period—the gigantic head with the heaving mane stares so close into our faces that we seem to feel its hot breath. The lion is seen almost full-front, so that nearly all we see besides the powerful head is the huge paws and the tail lashing over the back. His attitude still suggests the fearful leap with which he felled the panther who writhes powerless under his paws, vainly clawing and roaring and spitting in pain and fury as he looks up at his conqueror. There is not a trace of human pathos in the picture. This is the pure beast, which stands in such strange and terrifying contrast to the human race. What strengthens the effect more than anything else is that the lion does not look down at the panther, but only keeps it down by the pressure of his iron paws. His angry look, which is fixed upon *us,* seems not even to be aware of the victory : there is something of the unconscious action of natural forces in that look.

Lion and panther fill the greater part of the picture-surface. Three spandrils are free at the corners, just enough for the monumental simplicity of the landscape to produce its effect. Rocky ground with the rather artificial-looking slate steps which are not uncommon, a stone or two, tufts of grass, and in the distance a small tree, with grey background—air-coloured if you like—beside it : that is all ; and more would have been less.

(*Figs.* 153, Equally convincing effects, however, can be obtained in a wide
153*a*) landscape setting. A magnificent example of that is the Centaur mosaic from the Villa of Hadrian, which gives us a peculiar combination of imaginary creatures with real beasts of prey carefully observed. It is the tragic counterpart to the blithe idyll described by Lucian—the Centaur Family of Zeuxis. It is also a landmark in the development of the representation of landscape space ; and a masterpiece in its manipulation

of light and shade. Everything points to its being a copy, and perhaps a Hellenistic copy, of a painting belonging to the early rather than the late Hellenistic period ; and that the copy is an accurate one may perhaps be inferred from the close correspondence between the Dove mosaic (*Fig.* 155) found in the same place and Pliny's description of the work by Sosos. The tiger, which became known to the Greeks about 300 B.C., may thus be used to determine the upper chronological limit. In spite of the contrast of subject, and the strong suggestion of depth in the composition, the picture has so close an affinity to the work by Zeuxis in its general type that there must be some connexion between the two. The hypothesis that the Hellenistic master is as it were quoting Zeuxis, but at the same time has created an entirely new and independent work, is only one, but perhaps the simplest, of several possible explanations. In any case the picture, as we have it, is a thoroughly Hellenistic creation.

A broken rocky landscape, with a few shrubs, rising unevenly away from us, broadening towards us into a flat platform and breaking off in a kind of step just before the lower edge—the landscape counterpart of the usual base-strip. A pair of centaurs have been attacked by wild beasts. The centaur has managed to beat his opponent off : behind him lies a lion, whose head he has evidently smashed with the block of stone which he now raises again : for the centauress lies bleeding and as if dead under the paws of a tiger. The tiger turns from his precious prey unwillingly, not quite realising his danger, and sees the centaur—too late, we may be sure, to avoid the rock which will crush him. On a rock in the middle distance stands a panther, roaring but not really prepared to spring ; he will hardly dare to attack again. This interpretation of the events almost reaches the limit of what the painter must have had in his mind. The question whether the centauress is dead or only unconscious he might not have been able to answer, any more than many modern artists when such questions are put to them : for it goes beyond the picture.

The picture is not meant to show more than the triumph of the strong, intelligent half-man over the beasts, while the woman, too delicate for such contests, succumbs—a tragic spectacle emphasised by all the devices of art. The beautiful light-coloured female shows us the whole of her woman's body, whereas the horse-body is strongly foreshortened and partly concealed : blood streams over it where the tiger's claws lacerate the delicate skin. The face, turned earthwards, is wisely concealed by the arm. In contrast to the moving helplessness of the female under the wild beast's paws is the strong victorious centaur : but the face of

the rugged woodland creature is torn by anguish. So far the picture and Greek feeling : the sentimental hope that the couple will be happy once more goes beyond both. On the other hand, there is no ground for the ugly notion that lion and tiger had been feeding for a while on the centauress—she does not look like it—before being surprised by the centaur. No, the desert tragedy of which we see the climax develops blow on blow.

The lyric atmosphere and the feeling for nature shown in this picture, with its strong contrasts and its subtle interweaving and opposition of human and animal character, are no less Hellenistic than the spatial and pictorial devices. The composition is based on an equilibrium, both in the plane and in space, which though free is confined within simple, clear forms. The pyramidal main group is completed and led on into depth by the panther : pairs of almost parallel lines and right-angles articulate and connect the figure-groups, which start with the body of the centauress, lying in the picture plane, and move obliquely into the depth of the picture. The several forms of the landscape follow it like an accompaniment, and the total space combines everything into a harmony of forms which is not inferior to that of the expression and of the lyric atmosphere. Light and shadow are distributed in skilful alternation, and their rhythm intertwines with those of the forms and the colours. The picture has suffered in parts through injury and restoration. Hence the lack of clearness in the background ; hence also the human *(Fig. 153a)* pathos of the tiger's head, which is completely modern : the genuine head, removed because it was damaged, is the head of a real tiger with feline eyes and smooth skull, a spitting beast without false pathos.

Fig. 154 We pass into another world when we turn to a splendid Hellenistic mosaic from Pompeii, with a remarkable throng of fishes and marine life. It belongs to a class of mosaic found from Pergamon to Spain : the wall-paintings of the kind are relatively unimportant. The very best of the mosaics exhibit a curious mixture of two quite different ways of looking at things : below, there is a piece of seashore with the surface of the sea ; above, a multitude of all sorts of fishes and marine creatures as if seen through the panes of an aquarium. This is nothing else but a development of an old decorative tradition, which leads from Egyptian fayence plates through Laconian black-figure to the Attic and South Italian fish-plates : and we actually possess circular mosaics without landscape additions. It is extremely doubtful whether panel-pictures of this kind existed : such representations were probably confined to the decorative mosaic technique and the wall-painting which followed in

its steps. That the artists could not refrain from inserting the inappropriate element of landscape may perhaps be taken as a confirmation : the idea is as Hellenistic as the developed mosaic technique itself. The pictorial charm of the fish-mosaics is great, and admirably suited to the technique. A fish-picture from Praeneste, unfortunately badly injured, is one of the most tasteful and splendidly coloured of all mosaics, and in this respect even the Pompeian fish-mosaics are worthy to be placed beside the lion mosaic.

The pictures of small animals bring us into the realm of still-life, which often includes living animals. We have already made several references to the Pergamene Dove mosaic by Sosos, which Pliny describes with such clearness that we can recognise imitations of it. The one which corresponds exactly to Pliny's words comes once more from the Villa of Hadrian ; another, certainly Hellenistic, with considerable varia- *Fig. 155* tions, from the Pompeian House of the Lion-fight, and a modification also from Pompeii : in this the doves sitting on the rim of a polished basin are replaced, save one, by parrots ; the basin stands on a pedestal, and beside the pedestal are a marsh-lynx and some fruit. A parrot already appeared in a Pergamene mosaic of the royal period. The dove mosaics are extremely fine work, and have a high value of their own, but they no doubt fell short of the original. In the original the shadow of the drinking dove's head tinged the water : this feature is wanting in our copies. It is doubtful how far even the Roman copy is an accurate reproduction of the original, although it has a better claim than the others to count as a real copy made in Imperial times, whereas the Pompeian is evidently a free modification from the Hellenistic period. The pictorial effect is very complex in both. The sheen of the metal, of the water and of the doves' mother-of-pearl plumage is seized and harmonised with all the affection which belongs to an accomplished art of still-life. As animal-pieces the pictures are equally good, the shape and character of the doves being excellently rendered.

The still-life has a much more modest past than the animal-pieces. The precedence of human representations was still more unfavourable to its development. Yet we find a first step towards still-life in Corinthian vases : the archaic love of diversity occasionally led to the accessories of pictures receiving a kind of autonomy. Thus a small perfume-vase is decorated with a group of weapons which, though not yet a picture in our sense of the word, is nearer one than the lyres, drinking-horns, and the like, which are ranged side by side in the friezes of later vases. The Attic red-figure style also supplies a few examples. If Brygos

paints a helmet and a shield under the handle of a cup, this is only an accessory to a figure-representation, but the effect is almost that of a substantive picture. Even in the classical period, the spirit of which was concerned with far other things, we find one or two red-figure pictures of the same sort: a few weapons or vases, forming a modest, inconspicuous decoration. Then come the flower-pieces of Pausias, probably wreaths or festoons rather than free flower-pieces in our sense of the word; and the flowers and little birds censured by Nikias. This brings us to the verge of the Hellenistic period, in which we immediately find decorative yet symbolical still-lifes of the simplest description: athletic gear and weapons, book-boxes, rolls and writing materials, wool-basket and mirror, fruit, wreaths and fillet, usually hung on large nails, are painted or drawn on the walls of tombs or on gravestones. These are not real pictures, but only friezes or field-filling. The final step was taken by Peiraikos or some unknown predecessor: a novelty inconceivable to the classical mind, food as the subject of panel-pictures which combined realistic and pictorial feeling. This new and thoroughly Hellenistic type of picture was called xenion, from the name of the daily gift to the guests of a wealthy house, who in the Greek manner did their own housekeeping: they were sent cakes and eggs, fruit and vegetables, fish and other sea-creatures, game, fowls and small animals, wine and drinking-vessels. Real flower-pieces are rare, for the fruit-pieces, though frequent, either keep within the limits of the xenion, or represent decorative festoons, as in the famous mosaic threshold from the House of the Faun.

Figs. 156-157 We cannot always argue from the wall-pictures and mosaics to the panel-picture. To begin with, their techniques permitted no more than an approximation to what was even more important in this class of picture than in any other, the pictorial elaboration of light and colour. The elaboration, however, is often astonishingly high, and, what is more, in the very parts where the brush seems to be plied with the least effort: it shows a tradition of high pictorial accomplishment. The composition in the xenia proper, though not only in those, is often based on an arrangement in two degrees. This gives a clear view of the objects, which are often spaced out well apart: but the painters were not blind to the charm of a dense profusion of objects, either in part of the picture or throughout it. The division into two groups is usually justified by the presence of a window-seat, a parapet, or the like, with some of the objects placed on it, others in front of it. The simple lines and surfaces of these architectural forms provide a quiet background and an effective

contrast to the variety and irregularity of the representation. Our xenion strikes a mean between the extremes in every respect, and is a *Fig.* 156 model of Greek clarity and simplicity. The pictorial charm of the peach-branch is hardly visible in our monochrome reproduction, but the sparkle and shimmer of the half-filled glass can be made out tolerably well. The glass is drawn with the usual inaccuracy of perspective, though it must be said that the shapes of ancient glass vessels are hardly ever mathematically true and often remarkably lopsided. Even more compact is the composition of our flower-piece. Whether a Hellenistic *Fig.* 157 original or a Roman copy, the mosaic is a masterpiece of mature painting. It is almost inconceivable to what a point the difficulty of the technique has been overcome without the character of the technique being obliterated. One can feel not only the air, but its colour-saturated humidity, between the leaves.

The most characteristic creation of Hellenistic art is landscape-painting. *Figs.* 158- The feeling for nature, and the longing for infinite distances which 160 overpowered the classical antipathy to the limitless, led it farther beyond classical art in this direction than in any other. But here also, such were the limitations of its creative power, it did not create anything fundamentally new, but merely developed and liberated one of the elements of mature classical painting, without raising it to the position of a collateral species of art. Landscape-painting remained fanciful and decorative, and was never given a deeper spiritual content. But it served Hellenistic art to express its idyllic feeling for nature.

The foundation of our knowledge and criticism is a late Hellenistic *Fig.* 159 work of the first century B.C., the Odyssean landscapes from the Esquiline. The upper part of a wall is painted with a series of pillars, and between the pillars we seem to look out over a distant landscape with small figures in it, always Odysseus and his companions, in a succession of adventures, with the names appicted in the old Greek manner. As though from some lofty citadel our view sweeps to the horizon of the sea, which shows now here, now there, between rocks and mountains—just as in Greece, that land of coasts and islands, where we feel cramped if one day in Arcadia or Boeotia we cannot find the sea, and greet it with joy if it suddenly opens out before us from a high place. A rocky shore of clear plastic form and parts, now rising with a gentle slope, now in huge masses ; sheer cliffs and rocky pinnacles ; and the impressive outline of a turreted castle on a lofty mountain ridge. The vegetation is sparse— a little grass, rushes, scrub, an occasional tree, never leafy : here also, clarity and beauty of form. In the central picture we see this landscape

as it were architecturally crystallised into an elaborate building: there is an architectural element in the several natural forms and in the composition as a whole, and this is firmly linked by form and colour to the pillar-wall through which we look out at the landscape.

We now grasp three essential features of the work. It is Greek nature, seen with the eyes of a Greek artist, and transformed into mural decoration. The greatness and at the same time the limitations of all ancient landscape-painting known to us lies in this, that it is completely artistic, but also entirely decorative. We must not look either for intimate observation of nature, or even for a recognisable reproduction of a particular locality, or for the great master's creative vision of nature. Neither in form nor in expression did it receive the same artistic elaboration as the human figure or the life of the human soul. Plato's words remained true: in landscape Greek art contented itself with an approximation, whereas in man and animal it re-thought the thought of the creator and embodied the idea. And so men and their works are rarely absent from the landscape, and often play so prominent a part that the great majority of extant ancient landscapes have been described as mythological or architectural landscapes. And even if nature is for once left to itself, it is usually enlivened at least by animals.

The artist seldom seeks to express solemnity or grandeur; if he does, it is because the mythological representation suggests the thought: the small figures, which are really only an accessory, thus control the landscape. It is true that there are heroic landscapes with vast precipices and roaring waterfalls; but the romantic feeling is almost always softened by an idyllic touch: a rustic sanctuary shows that there are gods and men even here. Of the majority of the pictures Quintilian's dictum holds good, that only gentle, sea-laved, lovely places are beautiful. Only once or twice do far-off snow-peaks heighten charm by contrast. The sky must be glad and cloudless, the sea peaceful, blue and bright. Idyllic spots with rustic sanctuaries and peaceful farmhouses, wide stretches of country full of every kind of building and monument, shining coasts and gentle bays: that is what we find, and everywhere the light fancy and grace of Hellenistic art, resting, one might almost think, in pleasant places from the struggle and earnestness of life, and from its own grandeur, depth of feeling, and passion.

The sovereignty of man in the art of the Greeks and in their emotional life as a whole prevented the rise of a landscape-painting comparable to the modern. We know from literature that the feeling for nature grew stronger in Hellenistic times: but the new sentiment was diffused

rather than profound ; for it was predominantly the revolt of the old simple life with nature against the over-cultivated life of the great city— the same feeling which prompted Ptolemy the Second in his marble castle to ' envy the beggar who down on the dunes by the harbour lay stretched in the sun.' We have already referred to this when speaking of the picture of manners. But neither this nor contact with the Orient and its paradises and pleasure-gardens was sufficient to deepen the relation of the Greek to nature as it has been deepened in modern times ; so that a landscape-painting might arise comparable in excellence to the finished representation of the human figure which had previously been achieved. The deeper the Greeks looked into nature, the more their own countenance looked back at them from it : nature became animated with daemons of human shape. No extant Greek landscape can compare in grandeur or power of expression with the nymph Arcadia in the picture of Telephos : (*Fig.* 126) even the feeling for landscape found its only complete artistic realisation in the human form.

Connected with this anthropomorphism is the aversion to that wild and menacing nature which moves us so deeply with its grandeur. It did not make the Greek feel the might of creation, nor did he say, ' And all thy high works are lordly as on the first day.' What he felt in such nature was personal hostile powers, evil spirits. He could represent them, because he believed in them—the rugged Boreas or the bearish mountain-god Helikon : but a wild rocky solitude or the storm-lashed sea and raging surf were not fit subjects for representation, and above all not a pleasant decoration for a room. In the first of the Odyssean pictures the wind-gods are partly veiled in mist, and there is a hint of rain : but that has no influence on the landscape as a whole. The darkness of the nether world is not very deep, and the beam of light falling through its rocky portal is one of the few examples of such effects. The only common effect of the kind is one which helps to create the sensation of depth, a special tinge of the sky at the horizon, usually whitish, occasionally yellowish or reddish. The reddish colour is presumably meant to indicate the hues of morning or evening, but even here the intention may be merely decorative.

Let us now examine our reproduction closer. We have the third *Fig.* 159 and fourth of the Odyssean pictures before us. To the right of them comes the central picture, doubly recognisable as such, for the perspective of the pillars diverges from here, and the preponderance of architecture distinguishes it from the other pictures. The destruction of the sixth makes it difficult to pronounce upon the connexion of the landscapes

141

in the right half of the frieze; in the left half the connexion strikes one at once, for not only does the third picture overlap into the second and fourth, but the first and second form a compositional unit. The pillars are included in the composition, not as interruptions but as foils, and at the same time they perform the function of making the landscape recede into the distance by means of overlapping, aerial perspective, and colour-contrasts. The effect of the pillars seen close is most powerful: they are bright red with golden-yellow capitals, and they stand out strongly from the transverse pillars with their deep reddish-brown shadows; the contrast is heightened in the architrave, which is whitish-yellow in front. With this strongly coloured setting of light and dark the pictures easily acquire the haze of distance in spite of being full, as usual, of pronounced contrasts of light and shadow. The scale of colour consists of the complementary colours clay-yellow and light blue, and reddish-brown and dull green, with a great variety of intermediate tones, which in the foreground are more or less strongly contrasted, but melt into one another more and more as the picture recedes. Lighter and darker pictures alternate in an easy rhythm, but without destroying the unity of the frieze.

The three first pictures show us the Laestrygonian coast, which reaches into the fourth. Its beetling crags stand opposite the bright and gentle shore of the island of Circe, and the destruction of a Greek by a Laestrygon presents a cruel contrast to the peaceful nymphs on the Aeaean strand. The two coasts are separated by a narrow inlet into which the ship of Odysseus is sailing. On the right of the third picture the bend of a rocky coast leads the eye on towards the horizon, over which the sky is as usual at its lightest. To the left a steep promontory rises in the background. Here we have the chief deviation from Homer, for the harbour entrance is some distance off. The artistic reason is clear: the painter wanted a wider horizon-line for his effect of distance. He got it by blocking the entrance with a number of ships broadside on, over which we look into the distance. The picture is painted with a sure, easy touch and an eye sensitive to colour. The figures bear witness to an admirable tradition of handicraft: forms are given in masterly fashion by a few fresh brush-strokes, although the scale is comparatively large: in smaller pictures even more astonishing effects of sheer life are obtained. It is as if this last offshoot of the great figure-painting of the Greeks were charged to remind us, even in the wide spaces of a distant landscape, where the specific importance of Greek art lay.

Fig. 158 From this mythological landscape we turn to a heroic idyllic landscape, the picture of a grotto sanctuary at the foot of huge rocks; highly

impressive with the simple grandeur of its composition and with its strong contrasts of light and dark, of architectural regularity and irregular natural forms. Above the rocky wall there is a strip of blue sky. In front of the entrance to the grotto stand two of those combinations of a pillar, a column, and an architrave, which are represented times without number, here with gables and in pure front-view, but usually gableless and set obliquely to assist the perspective effect. Here it is only in their spatial arrangement one beyond the other that there is an oblique line; this is intersected by the oblique line of the rocks at the sides, which are crowned by single figures, on the right a shepherd, on the left a statue. The general design thus exhibits a monumental symmetry, which the large tree leaning to the left does not destroy but only emphasises by contrast. From the left foreground a herdsman pushes a goat forward to be sacrificed. They stand out clearly from the light-coloured building, and the spatial effect is good. The picture is equally successful in form and in expression: the contrast of mighty nature and graceful architecture is as Hellenistic as the pastoral atmosphere.

The last picture may be called a half-rural, half-architectural scene. *Fig.* 160 The bucolic idyllic element balances the multifarious buildings with their long rows of columns. The details of the picture must not be taken too literally: there is a river spanned by a great bridge, but where the river comes from, and whither it is bound, is a mystery; the relation between the bridge and the religious gateway is by no means clear; and so on. But what unprejudiced spectator will not gladly dismiss such questions and submit himself to the convincing impression of the whole? The great depth of the picture is obtained by the varied and delightful disposition of architecture, natural features and accessories, one above or one behind the other: the tall tree in the foreground helps to make the picture recede, and the effective arrangement of details like cattle on the bridge and the ships in the middle distance serves the same purpose. Under the tree shepherds are sacrificing, and in the gate we see the hindquarters of a horse, followed by a heavy-laden traveller. With this long-famous picture in the home of Winckelmann, the Villa Albani, we bring our journey through the thousand years of Greek art to a close.

BIBLIOGRAPHY

GENERAL

Pfuhl (Ernst) *Malerei und Zeichnung der Griechen* (Munich 1923)

Swindler (Mary H.) *Ancient Painting* (New Haven 1929)

Rumpf (Andreas) *Malerei und Zeichnung* (in *Handbuch der Archäologie*) (Munich 1953)

VASES, GENERAL

Furtwängler (Adolf) and Reichhold (Karl) *Griechische Vasenmalerei* (Munich 1904–32)

Buschor (Ernst) *Greek Vase-painting* (London 1921)

Various writers *Corpus Vasorum Antiquorum* (from 1923)

Jacobsthal (Paul) *Ornamente griechischer Vasen* (Berlin 1927)

Buschor (Ernst) *Griechische Vasen* (Munich 1940)

Lane (Arthur) *Greek Pottery* (London 1948)

PROTOGEOMETRIC VASES

Desborough (V. R. d'A.) *Protogeometric Pottery* (Oxford 1952)

CORINTHIAN VASES

Johansen (Knud Friis) *Les vases sicyoniens* (Paris 1923)

Payne (Humfry) *Necrocorinthia* (Oxford 1931)

Payne (Humfry) *Protokorinthische Vasenmalerei* (Berlin 1933)

Hopper (R. J.) *Addenda to Necrocorinthia* in *Annual of the British School at Athens*, 44 (London 1949)

Benson (J. L.) *Die Geschichte der corinthischen Vasen* (Basle 1953)

Dunbabin (T. J.) and Robertson (Martin) *Some Protocorinthian Vase-painters* in *Annual of the British School at Athens* 48 (London 1953)

Dunbabin (T. J.) and others *Perachora II* (Oxford, forthcoming)

CHALCIDIAN VASES

Rumpf (Andreas) *Chalkidische Vasen* (Berlin 1927)

LACONIAN VASES

Lane (Arthur) *Lakonian Vase-painting* in *Annual of the British School at Athens*, 34 (London 1936)

EASTERN GREEK VASES

Price (E. R.) *East Greek Pottery* (Paris 1928)

Cook (R. M.) *Fikellura Pottery* in *Annual of the British School at Athens*, 34 (London 1936)

Cook (R. M.) *A List of Clazomenian Pottery* in *Annual of the British School at Athens*, 47 (London 1952)

EARLY ATTIC VASES

Cook (J. M.) *Protoattic Pottery* in *Annual of the British School at Athens*, 35 (London 1937)

Eilmann (Richard) and Gebauer (Kurt) *Corpus vasorum antiquorum: Berlin*, 1 (Munich 1938)

Kahane (Peter) *Die Entwicklungsphasen der attisch-geometrischen Keramik* in *American Journal of Archaeology*, 44 (Concord 1940)

Cook (J. M.) *Attic Workshops around 700* in *Annual of the British School at Athens*, 42 (London 1947)

Kübler (Karl) *Altattische Malerei* (Tübingen 1950)

ATTIC BLACK-FIGURED AND RED-FIGURED VASES

Richter (G. M. A.) and Milne (M. J.) *Shapes and Names of Athenian Vases* (New York 1935)

Bloesch (Hansjörg) *Formen attischer Schalen* (Berne 1940)

Beazley (J. D.) *Potter and Painter in Ancient Athens* (London 1946)

144

BIBLIOGRAPHY

ATTIC BLACK-FIGURED VASES

Hoppin (J. C.) *A Handbook of Greek Black-figured Vases* (Paris 1924)

Beazley (J. D.) *Attic Black-figure: a Sketch* (London 1928)

Haspels (C. H. E.) *Attic Black-figured Lekythoi* (Paris 1936)

Beazley (J. D.) *The Development of Attic Black-figure* (Berkeley, Calif. 1952)

Beazley (J. D.) *Attic Black-figure Vase-painters* (Oxford 1955)

ATTIC RED-FIGURED VASES

Beazley (J. D.) *Attic Red-figured Vases in American Museums* (Cambridge, Mass. 1918)

Hoppin (J. C.) *A Handbook of Attic Red-figured Vases* (Cambridge, Mass. 1919)

Beazley (J. D.) *Attische Vasenmaler des rotfigurigen Stils* (Tübingen 1925)

Caskey (L. D.) and Beazley (J. D.) *Attic Vase Paintings in the Museum of Fine Arts, Boston* (London, and Boston, Mass. 1931–54)

Schefold (Karl) *Untersuchungen zu den Kertscher Vasen* (Berlin 1934)

Richter (G. M. A.) and Hall (L. F.) *Red-figured Athenian Vases in the Metropolitan Museum of Art* (New Haven 1936)

Beazley (J. D.) *Attic Red-figure Vase-painters* (Oxford 1942)

Richter (G. M. A.) *Attic Red-figured Vases: a Survey* (New Haven 1946)

Metzger (Henri) *Les représentations dans la céramique attique du IVe siècle* (Paris 1951)

Lullies (Reinhard) and Hirmer (Max) *Griechische Vasen der reifarchaischen Zeit* (Munich 1953)

ATTIC WHITE LEKYTHOI

Riezler (Walter) *Weissgrundige attische Lekythen* (Munich 1914)

Buschor (Ernst) *Attische Lekythen der Parthenonzeit* in *Münchener Jahrbuch* n.s. 2 (Munich 1925)

Beazley (J. D.) *Attic White Lekythoi* (London 1938)

Buschor (Ernst) *Grab eines attischen Mädchens* (Munich 1939, 2nd ed. 1941)

Beazley (J. D.) *Attic Red-figure Vase-painters* (see above: it includes the painters of white lekythoi)

ETRUSCAN WALL-PAINTING

Weege (Fritz) *Etruskische Malerei* (Halle 1921)

Poulsen (Frederik) *Etruscan Tomb Paintings* (Oxford 1922)

Bianchi Bandinelli (Ranuccio) and others. *Monumenti della pittura antica trovati in Italia: la pittura etrusca* (Rome from 1936)

Pallottino (Massimo) *Etruscan Painting* (Geneva 1952)

ETRUSCAN VASES

Beazley (J. D.) *Etruscan Vase-painting* (Oxford 1947)

WALL-PAINTING OF THE ROMAN PERIOD

Herrmann (Paul) *Denkmäler der Malerei des Altertums* (Munich 1906–50)

Curtius (Ludwig) *Die Wandmalerei Pompejis* (Leipsic 1929)

Rizzo (G. E.) *La pittura ellenistico-romana* (Milan 1929)

Wirth (Fritz) *Römische Wandmalerei vom Untergang Pompejis bis ans Ende des dritten Jahrhunderts* (Berlin 1934)

Rizzo (G. E.) and others *Monumenti della pittura antica trovati in Italia: la pittura ellenistico-romana* (Rome from 1936)

Dawson (C. M.) *Romano-Campanian Mythological Landscape Painting* (New Haven 1944)

Schefold (Karl) *Pompejanische Malerei* (Basle 1952)

Maiuri (Amedeo) *Roman Painting* (Geneva 1953)

MOSAICS

Winter (Franz) *Das Alexandermosaik aus Pompeji* (Strasburg 1909)

Levi (Doro) *Antioch Mosaic Pavements* (Princeton 1947)

MUMMY PORTRAITS

Buberl (Paul) *Griechisch-ägyptische Mumienbildnisse der Sammlung Th. Graf* (Vienna 1922)

Drerup (Heinrich) *Die Datierung der Mumienporträts* (Paderborn 1933)

Strelkov (A.) *Fayumskiĭ Portret* (Moscow 1936)

Coche de la Ferté (Etienne) *Les portraits romano-égyptiens du Louvre* (Paris 1952)

LIST OF ARTISTS OF
THE ATTIC VASES ILLUSTRATED

Fig.	Potter	Painter
2		Analatos Painter [J. M. Cook]
19	Ergotimos	Kleitias
20	Amasis	Amasis Painter
21–3	Exekias	Exekias
24	Glaukytes	
25	Anakles and Nikosthenes	
26		Exekias
27–8	Andokides	Andokides Painter
29		Oltos
30–1		Epiktetos
32–4		Skythes
35	Pasiades	near the Euergides Painter
36	Pamphaios	Oltos
37	Pamphaios	Nikosthenes Painter?
38–42		Euthymides
43		Berlin Painter, very early [Martin Robertson]
44–5		Kleophrades Painter
46–7		Euphronios
48–9	Euphronios	Panaitios Painter
50		Peithinos
51	Sosias	Sosias Painter
52–4	Brygos	Brygos Painter
55–7		Brygos Painter
58	Hieron	Makron
61–3	Python	Duris
64	Kalliades	Duris
65	Python	Duris
66–7	Pistoxenos	Pistoxenos Painter
69	Euphronios?	Pistoxenos Painter
70		Pistoxenos Painter
71–3		Penthesilea Painter
74		Florence Painter
75		Painter of Bologna 279
76		Geneva Painter
77		Niobid Painter
78		Achilles Painter

LIST OF ARTISTS OF THE ATTIC VASES ILLUSTRATED

Fig.	Potter	Painter
79		Painter of Bologna 417
80		Achilles Painter
81	Hegesibulos	related to the Sotades Painter
82–4	Sotades	Sotades Painter
86		Inscription Painter
87		Bosanquet Painter
88		Thanatos Painter
89		Achilles Painter
90		Shuvalov Painter
91		Painter of Munich 2335
92		Thanatos Painter
93		Painter of Athens 1934
94		Achilles Painter
95–6		Thanatos Painter
97		Group R
98–9		Penelope Painter
100		Orpheus Painter
101		Penelope Painter
102		Kleophon Painter
103		Phiale Painter
105		Eretria Painter
107		Aison
108		related to the Dinos Painter
109	Meidias	Meidias Painter
110		Eleusinian Painter [Schefold]

INDEX

ACHELOOS, 37.

Achilles, 19, 25, 28, 46-7, 51, 52, 58, 91, 102, 103, 105.

Actor, 107.

Aegisthus, 41.

Aeneas, 19.

Aeschylus, 40.

Aesop, 62.

Agamemnon, 52.

Aison, 81-2.

Ajax, 19, 25, 28, 52.

Ajax Oileus, 57.

Alcibiades, 34.

Aldobrandini Wedding, 121.

Alexander, 92-9.

Alexander Mosaic, 7, 21, 92-9, 123.

Alexandros, painter, 87, 99.

Alkmaion, 22.

Amasis, 26, 27.

Amazons, 42, 51, 58, 59.

Amphiaraos, 21.

Amphitrite, 44.

Anakles, 29.

Andokides, 32-5, 36, 39.

Andromeda, 90-1.

Animal-pieces, 133-7.

Antaios, 41, 42.

Antiphilos, 128.

Apelles, 93, 128.

Aphrodite, 17, 56, 63, 82, 84, 85, 86, 121.

Apollo, 14, 60, 114.

Apollodoros, 7, 90.

Apple-pickers, 63-4.

Arcadia, 109, 141.

Archemoros, 63, 65.

Argonauts, 57.

Ariadne, 113, 119.

Aristophanes, vase-painter, 70.

Aristotle, 80, 92.

Arkesilas, 23.

Artemis, 106.

Assyrian, 18.

Athena, 17, 19, 31, 34, 57, 81, 84, 85, 86.

Attic vase-painting, 4-7, 11-12, 23-84.

BAROQUE, 110.

Black-figure style, 3, 15-30, 35.

Boeotian gravestone, 86.

Boscoreale, 118.

Briseis, 102.

Brygos, 47-9, 50, 51, 53, 64, 75, 137.

Burckhardt, 93, 128.

Busiris, 18.

'CAERETAN' hydriai, 17, 27.

Cassandra, 57.

Centaurs, 58, 61, 134-6.

Chalcidian vases, 19.

Charon, 72-3.

Children, 79-80, 127.

Chrysothemis, 40-1.

Circe, 142.

Clay-pit, 20.

Clazomenian sarcophagi, 15 ; vases, 16.

Clytemnestra, 40.

Colouring, 9, 104-5.

Comedy, 131.

Corinth, 15, 84, 85.

Corinthian plaques, 20, 133 ; vases, 19-22, 137.

Corneto, 54, 87.

Cretan art, 10.

Cyrene, 23.

DANCERS, 85.
Daphne, 114.
Dareios, 92.
Delo-Melian vases, 13.
Delphi, Treasury of Athenians, 40.
Demeter, 68.
Diomede, 19, 105.
Dionysos, 26, 37, 63, 75, 76, 77, 88, 113, 119, vi.
Dioscuri, 28, 82.
Dioskourides of Samos, 128-9.
Dipylon vases, 11.
Doric architecture, 11, 17, 27, 69, 80.
Douris, 50-2, 53.

FAYUM portraits, 124.
Fleas, 22.
Florid style, 7, 70, 75, 78-83, 85.
Four-colour painting, 98.
Fourth-century vase-painting, 83-4.
François vase, 25, 27.

GE, 60.
Geometric vases, 11.
Geryon, 42, 44.
Glaukon, 56.
Glaukos of Lycia, 19.
Glaukos, son of Minos, 63, 65.
Glaukytes, 29.
Goethe, 93, 98, 121, 123.

EARLY-CLASSICAL vases, 55-65.
Egypt, 16, 23, 26.
Egyptian mummy-portraits, 123-7.
Egyptians, 18.
Electra, 41.
Encaustic, 124.
Endymion, 115.
Eos, 37, 51.
Ephesus, sculpture of Temple, 17.
Epiktetos, vase-painter, 35-7.
Erechtheum, 78.
Eretria, sculpture of Temple, 40.
Ergotimos, 25.
Eriphyle, 21-2.
Eros, 63, 84, 111, 112, 115, 129.
Esquiline, landscapes from the, 139.
Ethos, 51, 58.
Etruria and Etruscan art, 16, 17, 30, 53-4, 64, 84, 86, 92.
Eucheir, 29.
Euphranor, 81.
Euphronios, 37, 38, 41-5, 47, 48, 50, 51, 53, 56, 60, 61, 64, 101, vi.
Euthymides, 38-42, 61, 75.
Exekias, 26-9, 32, 34, 42.

HALS, 110.
Hector, 38.
Hecuba, 38.
Hegesiboulos, 63.
Helen, 40.
Helios, 84.
Hephaistos, 26, 31.
Hera, 17, 86.
Herakles, 14, 18, 29, 31, 32, 35, 37, 41, 42, 51, 52, 57, 85, 108-10, 110-13, 121.
Herculaneum, 87, 103, 106, 107, 111, 116.
Hermes, 17, 72, 73, 84.
Herrmann, Paul, 103.
Hetairai, 35, 49, 85.
Hieron, 49-50, 61.
Hippodameia, 80.
Hippomedon, 65.
Hittites, 14, 16.
Horses, 13, 14, 18, 21, 28, 29, 35, 60, 94.

Hunting, 15, 18, 72.
Hymenaeus, 121-3.
Hypsipyle, 65.

Lysippos, 107.
Lysistrata, 45.

IDOLINO, 44, 57, 79, 102.
Ionian vases, 15-19.
Iphigenia, 116-17.
Iphikles, 52-3.
Iris, 37.
Italian vases, 7, 92, 113, 116, 136.
Italo-Ionian vases, 16, 21.
Item, Villa, 118, 119-21.
Ivory plaques, 85-6.

MACEDONIANS, 94-6, 118.
Maenads, 62.
Makron, 49-50, 51, 75.
Malta, 114.
Manners, the picture of, 127.
Marathon, 57, 62.
Medea, 116.
Meidias, 70, 77, 82-3.
Memnon, 37, 38, 51.
Menander, 107.
Menon, 35.
Metragyrtai, 128-31.
Mikon, 54.
Minos, 44, 65.
Minotaur, 81, 106.
Mirrors, engraved, 84-5.
Mnason, stele of, 86.
Mosaics, 7, 92-9, 114-5, 129-32, 133-7.
Mummy-portraits, 123-7.
Myron, 61, 133.

KACHRYLION, 42.
Kalates, 128.
Kephisodotos, 82.
Klinger, 23.
Klitias, 25, 29, 30, 34.
Knucklebone-players, 84, 87, 99, 100, 116.
Korone, 40.
Kypselos, Chest of, 21, 25.

NEOPTOLEMOS, 52, 57.
Nike, 84, 107.
Nikias, painter, 91, 133, 138.
Nikosthenes, 29.
Niobe, 88, 99-101, 105.
Niobids, statues of, 121.

LACONIAN vases, 22-3, 136.
Landscape-painting, 8, 20, 64, 110, 139-43.
Lange, 44, 55, 111, 132.
Laocoon, 115, 117.
Leagros, 38, 43, 44, 56.
Lekythoi, white, 6, 54, 66-73.
Leto, 60, 88.
Leucippids, 82, 85.
Light, 8.
Linos, 52-3.
Lions, 13, 15, 109, 133-4.
Love-names, 5.
Lucian, 134.

ODYSSEUS, 52, 74, 105, 139, 142.
Oltos, 37.
Olympia, 21, 133; sculptures of Temple of Zeus, 54, 68, 85.
Omphale, 103, 110-13.
Orestes, 40, 116.
Orientalising art, 13.
Orpheus, 56, 74.

Pamphaios, 37, 41.
Pan, 84-5.
Panainos, 58.
Panaitios painter, 44, 47, 48, vi.
Paris, 17, 19 ; judgment of, 17, 85.
Parrhasios, 7, 79, 81, 87, 90.
Parthenon, 7, 30, 39, 55, 66, 70, 73, 75, 77, 78, 79, 87, 88, 100.
Pasiades, 36.
Patroclus, 46-7, 102.
Pausias, 138.
Pauson, 133.
Peiraikos, 128.
Peirithoos, 40, 61.
Peithinos, 46, 47, 78.
Peitho, 84, 121, 122.
Peleus, 25, 46.
Pelias, 21.
Pelops, 80, 88.
Penthesilea, 58.
Pentheus, 88.
Pergamene painting, 103, 108-13 ; sculpture, 118, 120.
Periclean vases, 6, 39, 55, 73-8, 79.
Perseus, 90-1.
Persians, 93-9.
Phayllos, 39.
Pheidias, 5, 55, 79, 80, 84, 86.
Philostratos, 114.
Philoxenos, 8, 92-9.
Pindar, 55, 85.
Pistoxenos, 52, 56, 61, 62, vi.
Pliny, 92, 116, 135.
Polygnotos, 54, 55, 57, 58, 61, 62, 63, 64, 74, 88, 107.
Polyidos, 65.
Polykletos, 11, 80.
Polyphemos, 129.
Pompeii, 89, 92, 99, 103, 106, 110, 114, 116, 117, 118, 133, 136.
Portraiture, 62, 123-7.
Praxiteles, 82, 83, 85, 106.
Priam, 17, 38.
Priapus, 111.

Protocorinthian vases, 15.
Protogenes, 93.
Pygmies, 26, 129.
Pylades, 116.

Quintilian, 140.

Red-figure style, 4, 30-84.
Rubens, 111, 121.

Sappho, 64.
Satyrs, 48, 76, 109, 113, 114, 119.
Scopas, 70, 107.
Sculpture, 2.
Scythians, 85, 117.
Selene, 84, 115.
Sepulchral monuments, 11, 29. See also Lekythoi.
Ships, 29.
Sicyon, 18, 98, 101.
Silenus, 113, 119.
Silphion, 23.
Skythes, 35-6.
Sleep and Death, 37, 72.
Sosias, 46, 47, 56.
Sosos, 133, 135, 137.
Sotades, 63-6, 77.
Space, rendering of, 6, 58, 78.
Sthenelos, 19.
Still-life, 133, 137-9.
Suitors, Odysseus and the, 57, 74-5.
Swing, 76.

Tablets, votive, 20.
Talthybios, 40.
Telephos, 103, 108-10, 111.
Themis, 84.
Theocritus, 131.

Theseus, 26, 36, 40, 43, 44, 81, 106, 107.
Thoas, 116-7.
Thracians, 53, 56, 74.
Timomachos, 116, 117.
Tityos, 60.
Top-spinner, 63.
Triptolemos, 68.
Triton, 44.
Troilos, 25.
Troy, taking of, 49, 50, 57, 58, 65.

Wedding, Aldobrandini, 121-3.

Welcker, 93.
White-ground vases, 5, 36, 56, 59, 63-73.
Winckelmann, 3, 57, 107, 143.

Xenia, 138.
Xenokrates, 9.
Xenophon, 96.

Zeus, 82, 84.
Zeuxis, 7, 79, 87, 88, 90, 135.

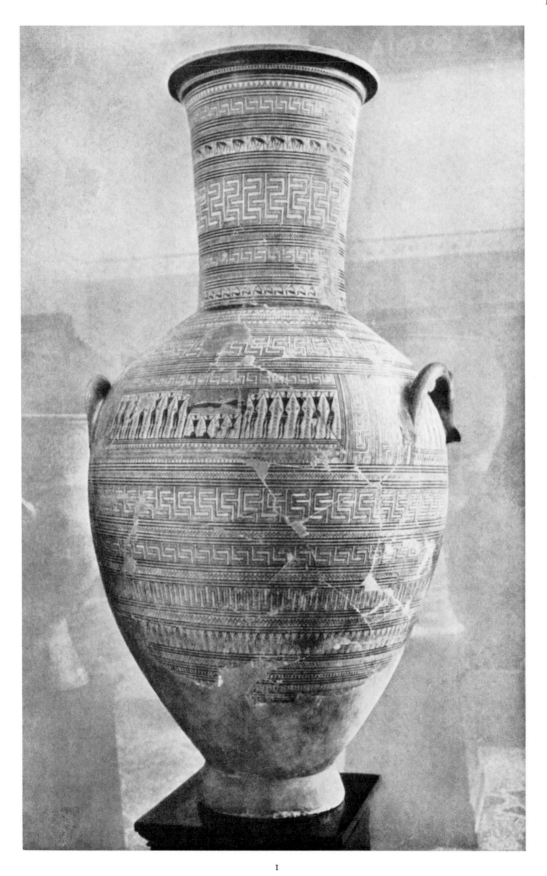

I

Attic sepulchral amphora, 8th Century B.C.
The dead on the bier and the lament (p. 11)
Athens, National Museum

2

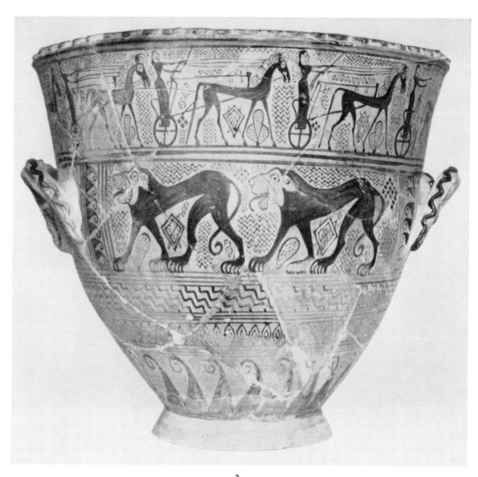

2
Attic krater, 7th Century B.C.
Procession of chariots: lions (p. 13)
Munich, Museum antiker Kleinkunst

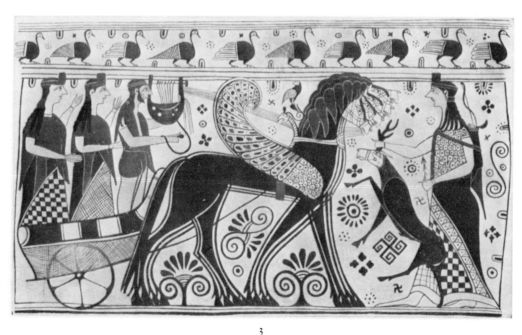

3
From a Cycladic amphora, 2nd half of the 7th Century B.C.
Apollo, with the Hyperborean maidens, received by Artemis at Delos (p. 13)
Athens, National Museum

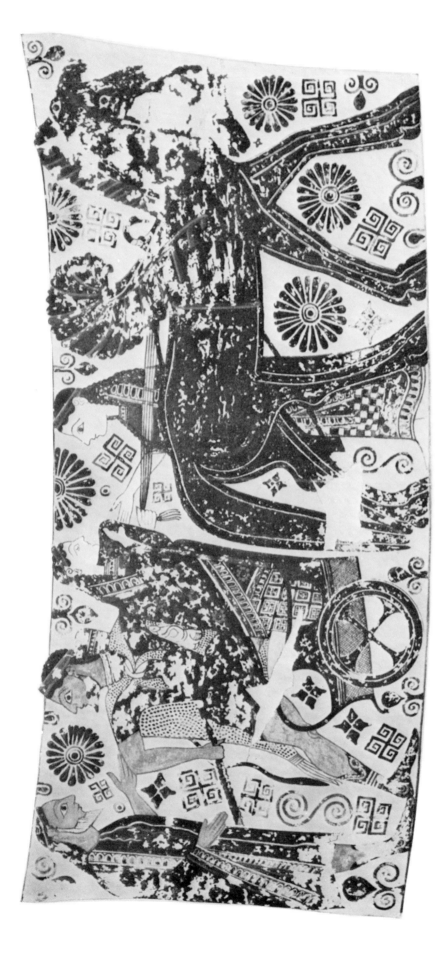

4

From a Cycladic amphora, c. 600 B.C.
Departure of Herakles with a bride (p. 14)
Athens, National Museum

4

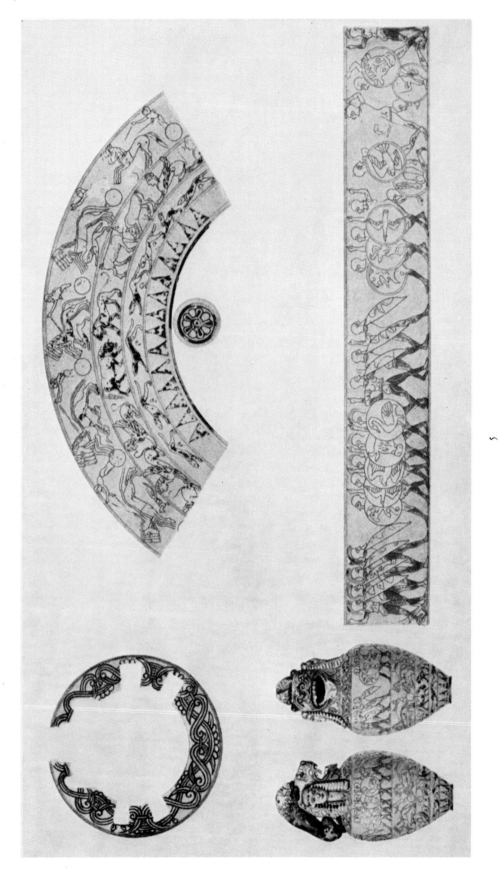

"Protocorinthian" (Sicyonian?) Perfume-vase, 2nd half of the 7th Century B.C.
Fight, chariot race, animal frieze, hare-hunt (p. 15)
Berlin, State Museums

5

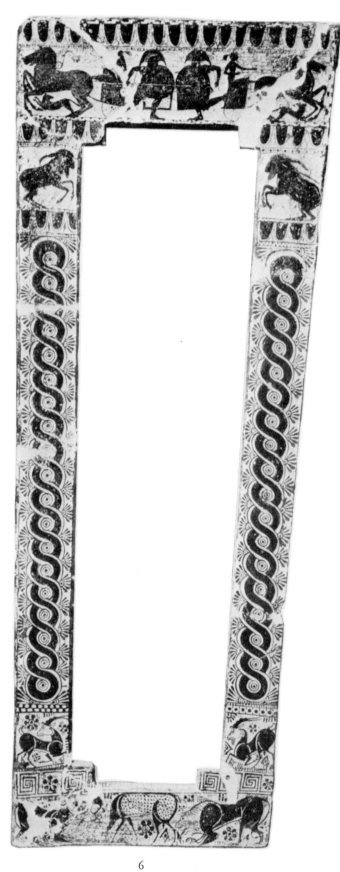

6

Clazomenian clay sarcophagus, middle of the 6th Century B.C.
Homeric combat; decorative animals (p. 15)
Hanover, Kestner Museum

6

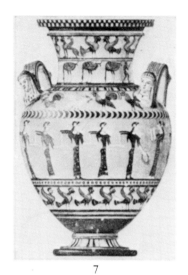

7, 8 Clazomenian amphora, 1st half of the 6th Century B.C.
Dance: animal frieze (p. 16)
Berlin, *State Museums*

7

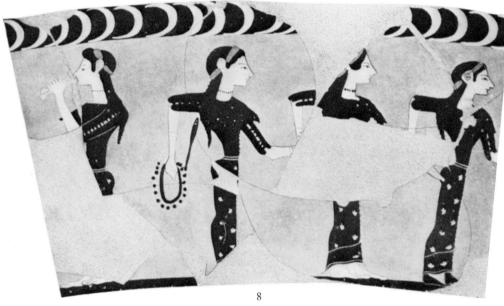

8

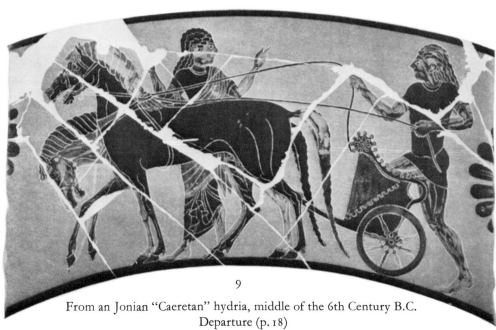

9

From an Jonian "Caeretan" hydria, middle of the 6th Century B.C.
Departure (p. 18)
Berlin, State Museums

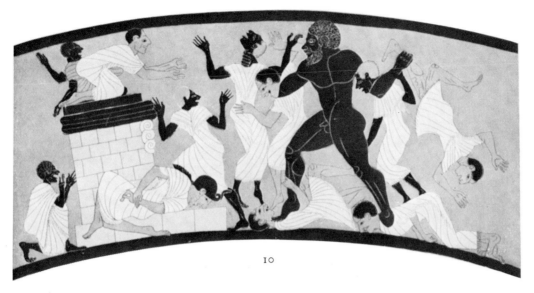

10

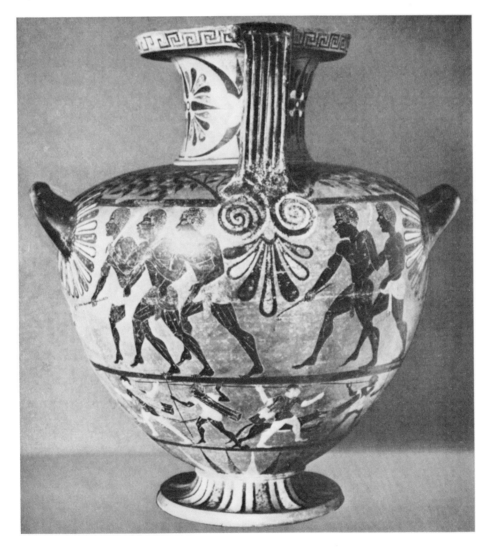

11

10, 11 Ionian "Caeretan" hydria, middle of the 6th Century B.C.
Herakles and Busiris King of Egypt: hint (p. 17)
Vienna, Oesterreichisches Museum

8

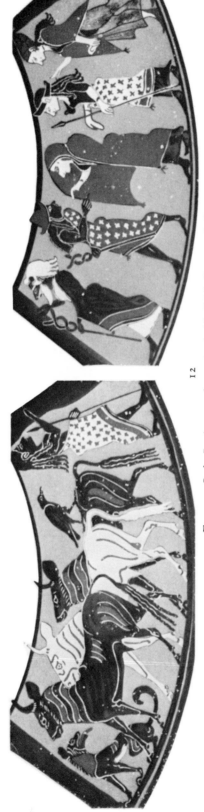

From an Italo-Ionian amphora, 1st half of 6th Century B.C.
The Judgment of Paris (p. 16)
Munich, Museum antiker Kleinkunst

12

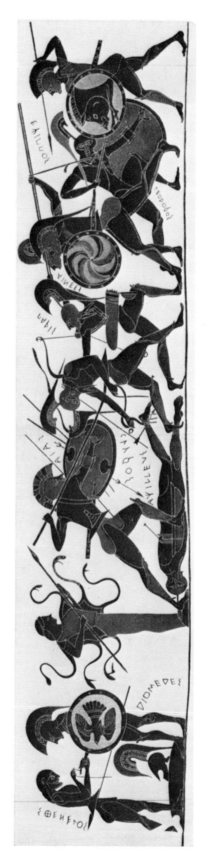

From a Chalcidian amphora, 1st half of the 6th Century B.C.
The Fight for the Body of Achilles (p. 19)
the original lost

13

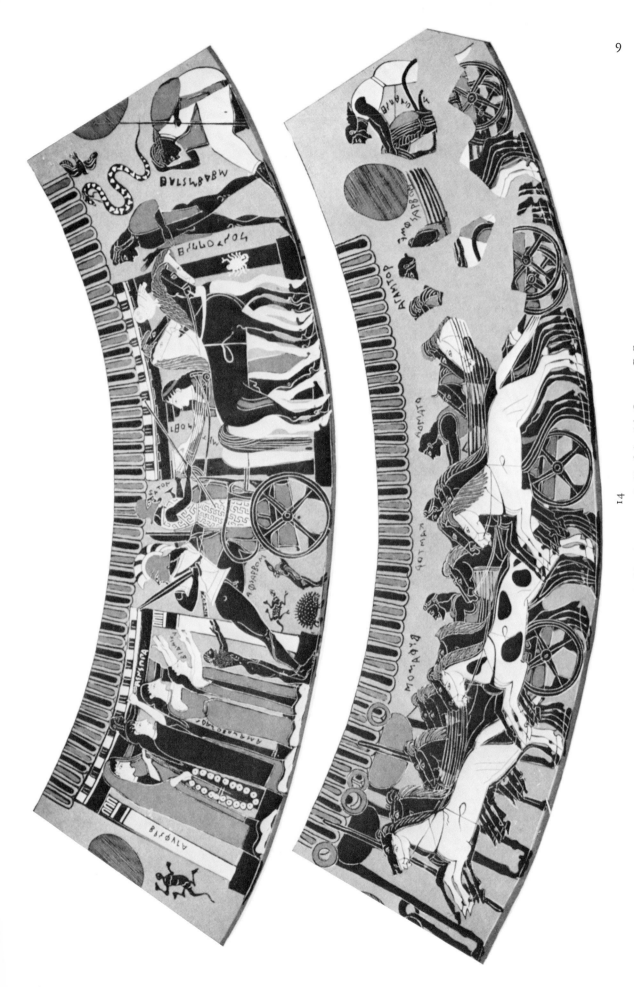

From a Corinthian krater, 1st half of the 6th Century B.C.
The Departure of Amphiaraos: the Chariot-race at the Funeral Games of Pelias (p. 21)
Berlin, State Museums

15

16

Corinthian krater, middle of the 6th Century B.C.
Battle (p. 21)
Paris, Louvre

17

16, 17 Corinthian clay tablets (dedications), 6th Century B.C.
Poseidon, Amphitrite and Hermes: Copper-mine (p. 20)
Berlin, State Museums

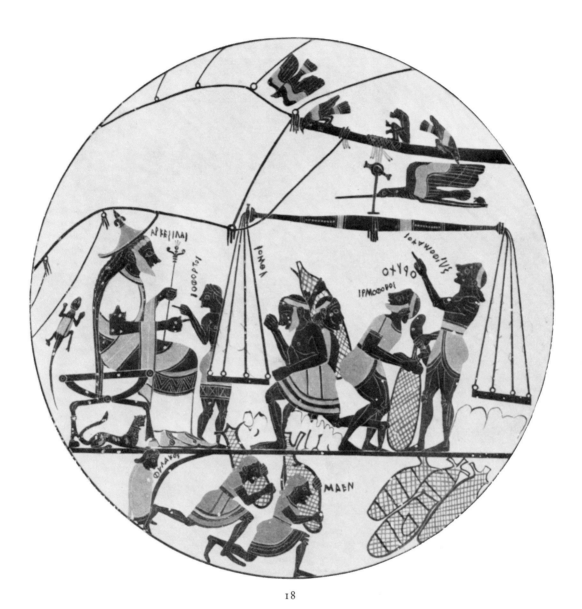

18

Laconian cup, 1st half of the 6th Century B.C.
Weighing and packing of Silphium under the eyes of King Arkesilas of Cyrene (p. 22)
Paris, Cabinet des Médailles

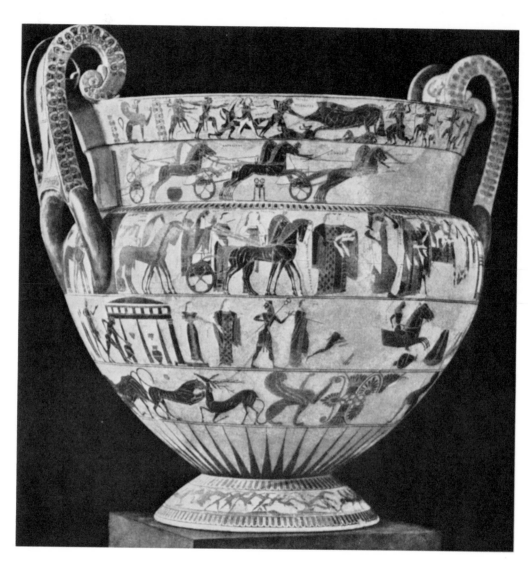

19

Attic krater from the workshop of Ergotimos, painted by Klitias, about the middle of
the 6th Century B.C.
The Calydonian Boar Hunt; the Funeral Games of Patroklos; the Gods going to the Wedding
of Thetis; Achilles pursuing Troilos; animal frieze; Battle of Pygmies and Cranes (p. 25)
Florence, Museo Archeologico

20

Amphora by the Attic master Amasis, middle of the 6th Century B.C.
Dionysos with two nymphs (p. 26)
Paris, Cabinet des Médailles

21
Amphora by the Attic master Exekias, 3rd quarter of the 6th Century B.C.
Achilles and Ajax playing (p. 26)
Rome, Vatican

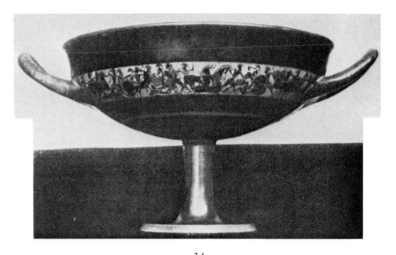

24

Cup by the Attic master Glaukytes, middle of the 6th Century B.C.
Battle (p. 29)
London, British Museum

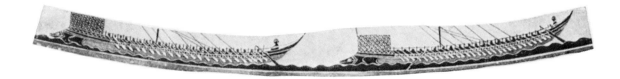

23

From a dinos by Exekias.
Warships (p. 29)
Rome, Castellani Collection

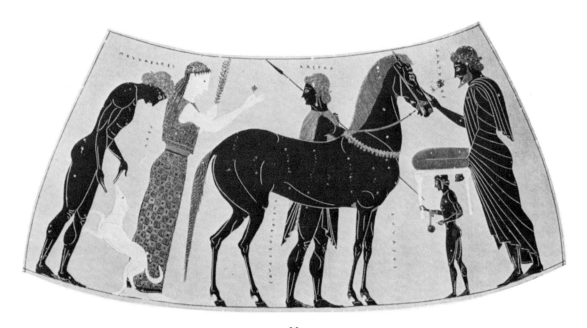

22

From the amphora Fig. 21
The Dioscuri with their parents (p. 26)

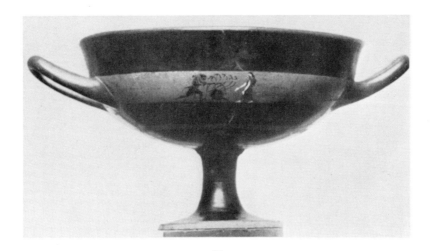

25

Cup by the Attic masters Nikosthenes and Anakles, 3rd quarter of the 6th Century B.C.
Herakles and the Hydra (p. 29)
Berlin, State Museums

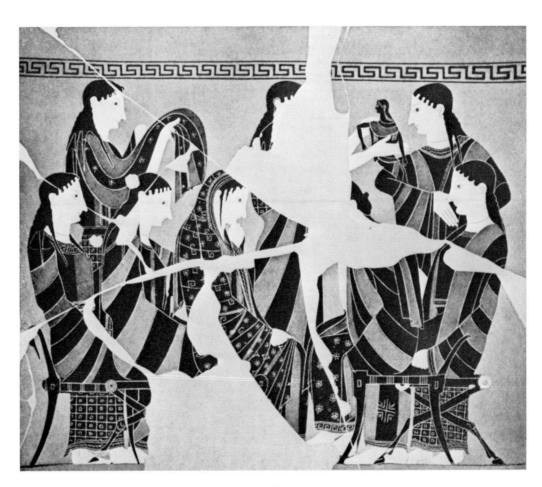

26

Clay plaque from the frieze of an Attic tomb, middle of the 6th Century B.C.
Women in the house of mourning (p. 29)
Berlin, State Museums

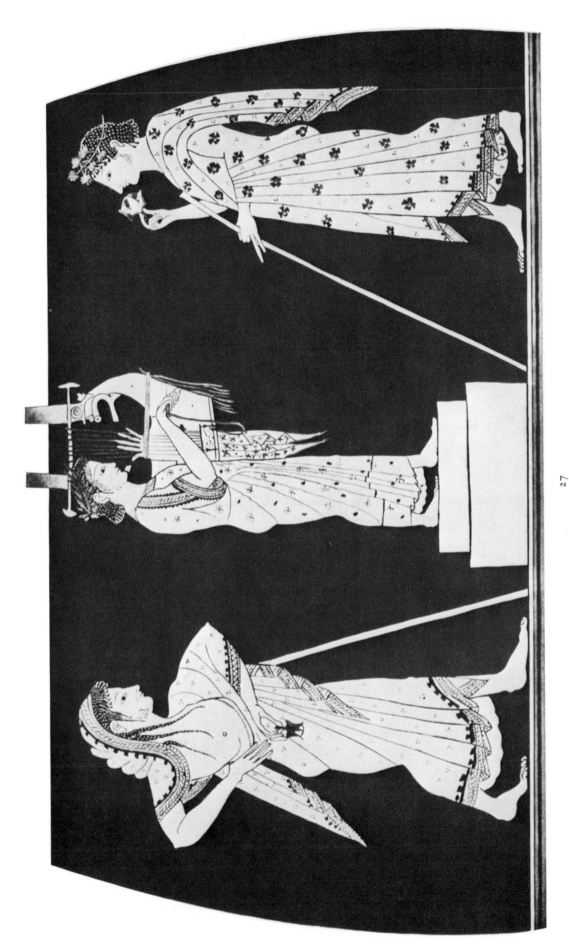

From an amphora by the Attic master Andokides, *c.* 530 B.C.
Citharode and listeners (p. 33)
Paris, Louvre

27

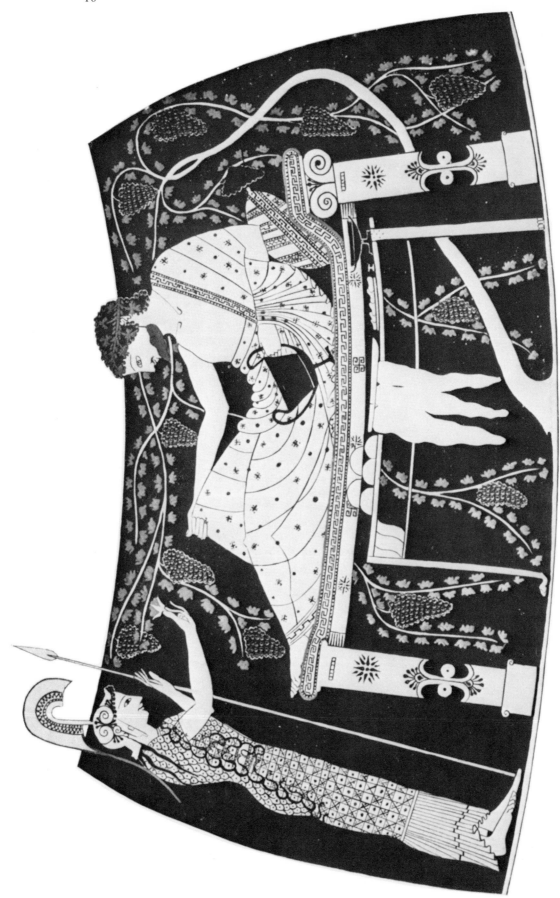

28

From an unsigned amphora by the chief painter of the factory of Andokides, cf. Fig. 27
Herakles feasting, with Athena (p. 34)
Munich, Museum antiker Kleinkunst

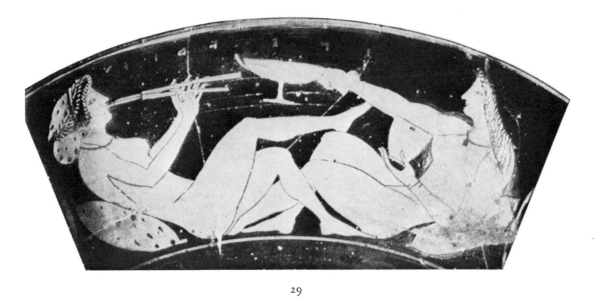

29

From an Attic cup, *c.* 520 B.C.
Women at their wine (p. 35)
Madrid, Archaeological Museum

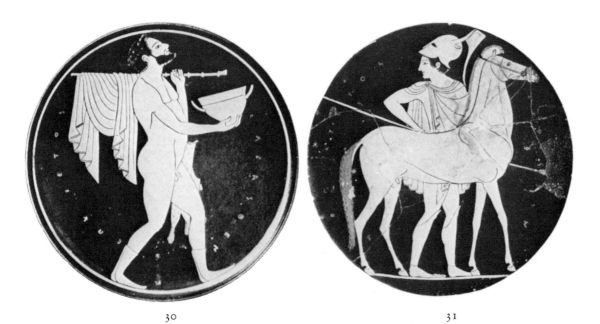

30 31

30, 31 From two plates by the painter Epiktetos, *c.* 520-510 B.C.
Reveller; Warrior with Horse (p. 35)
Paris, Cabinet des Médailles *London, British Museum*

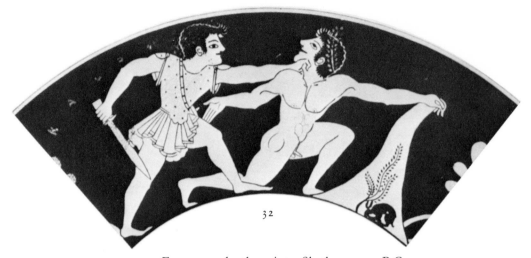

32

32, 33 From a cup by the painter Skythes, *c.* 520 B.C.
Theseus and the Highwayman; youth playing and singing (p. 36)
Rome, Villa Giulia

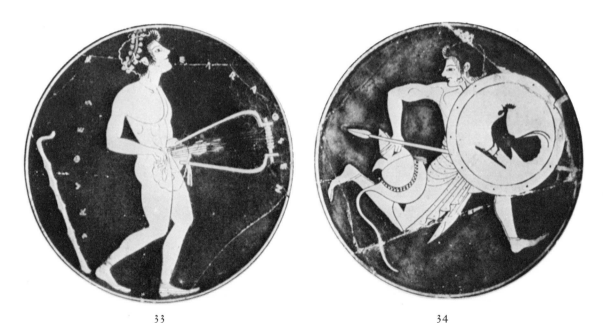

33 34

34 From an unsigned cup by the painter Skythes, *c.* 520 B.C.
Warrior running (p. 36)
Paris, Louvre

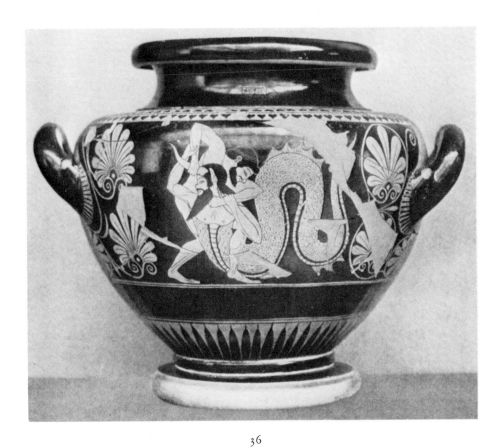

36

"Stamnos" from the workshop of Pamphaios, probably painted by Oltos, *c.* 520-510 B.C.
Herakles and Acheloos (p. 37)
London, British Museum

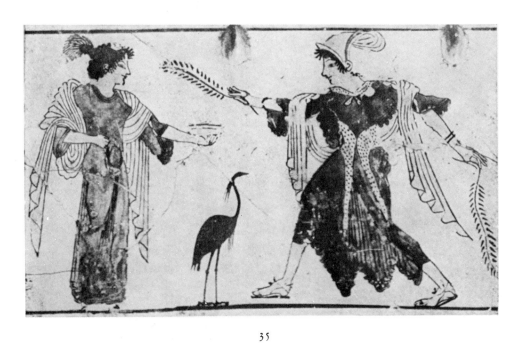

35

From a perfume-vase by the master Pasiades, *c.* 510 B.C.
Consecration to Dionysos (p. 36)
London, British Museum

22

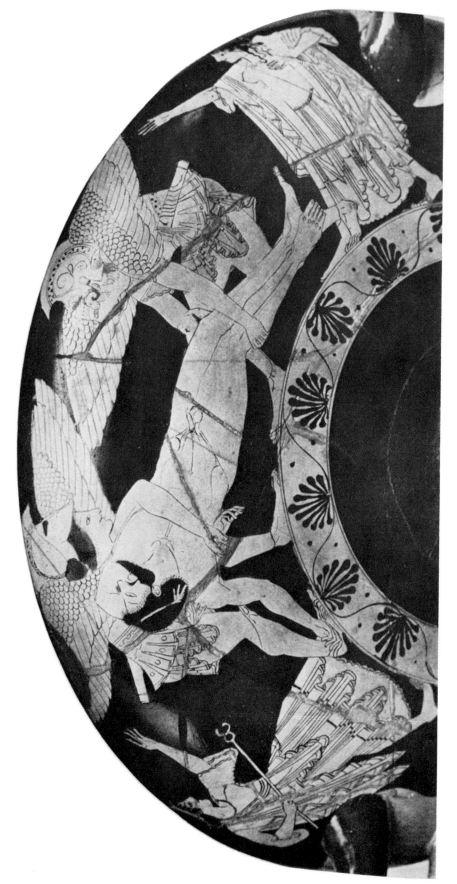

37

From a cup by the master Pamphaios, *c.* 510 B.C.
Sleep and Death lifting the body of Memnon (p. 37)
London, British Museum

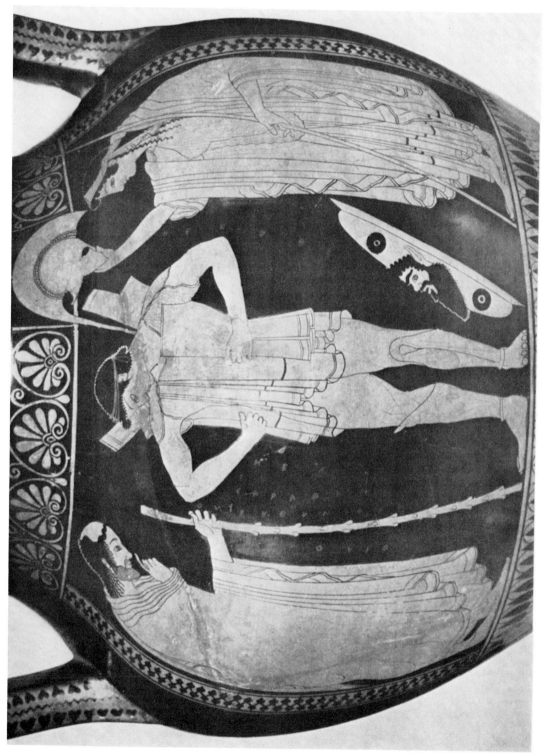

38

From an amphora by the painter Euthymides, end of the 6th Century B.C.
A youth ("Hector") arming with the assistance of his parents (p. 38)

Munich, Museum antiker Kleinkunst

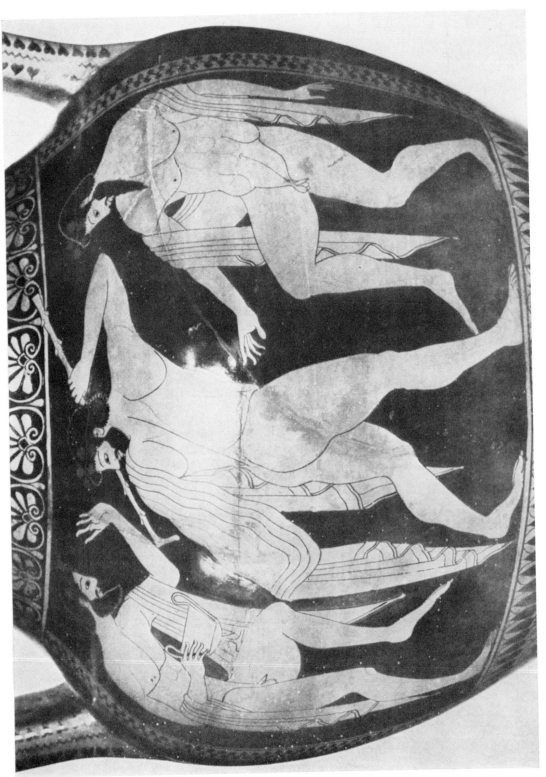

39

From the amphora Fig. 38
Revellers (p. 39)

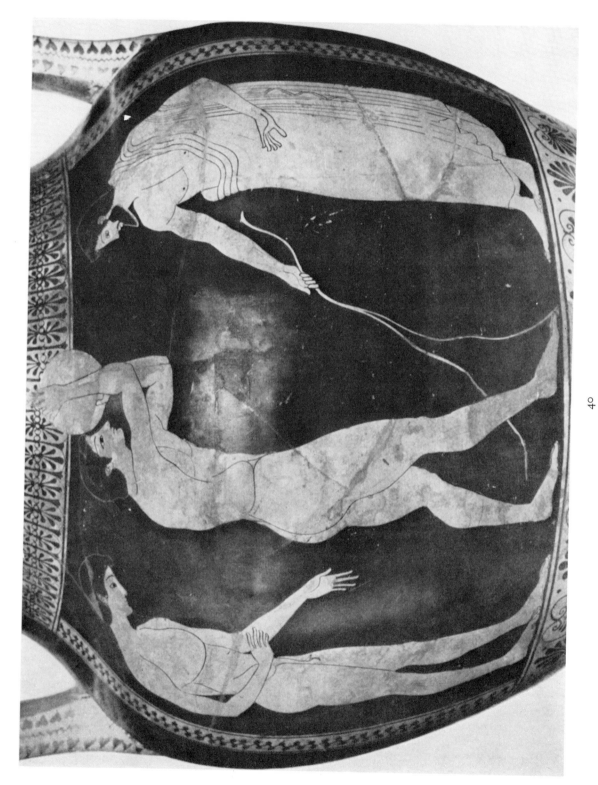

40

From an amphora by the painter Euthymides, end of the 6th Century B.C.
Discos-thrower practising (p. 39)
Munich, Museum antiker Kleinkunst

26

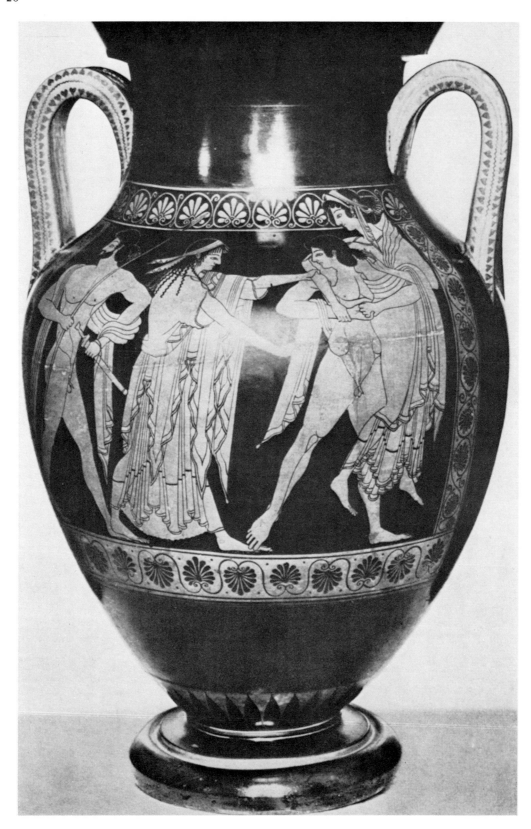

41

Unsigned amphora by the painter Euthymides, end of the 6th Century B.C.
Theseus carrying off Korone (p. 40)
Munich, Museum antiker Kleinkunst

41 a

Detail of Fig. 41

42

Reverse of Fig. 41

28

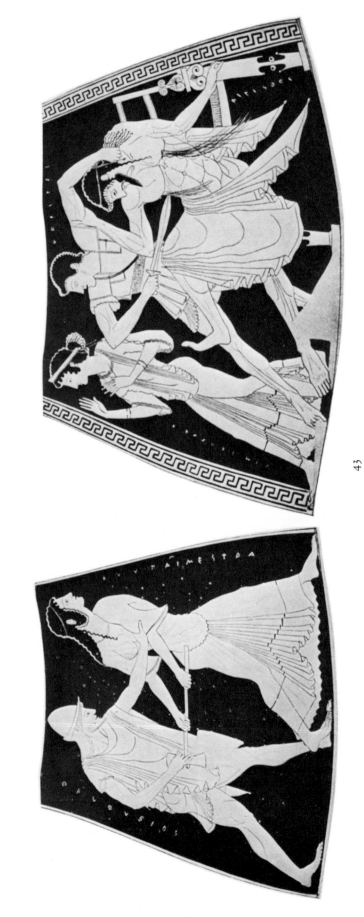

43

From a "pelike" from the circle of the painter Euthymides, end of the 6th Century B.C.
Orestes slaying Aegisthus and threatened by Clytaimestra (p. 40)
Vienna, Oesterreichisches Museum

44

45

44, 45 From an amphora, about 500 B.C.
Maenads (p. 41)
Munich, Museum antiker Kleinkunst

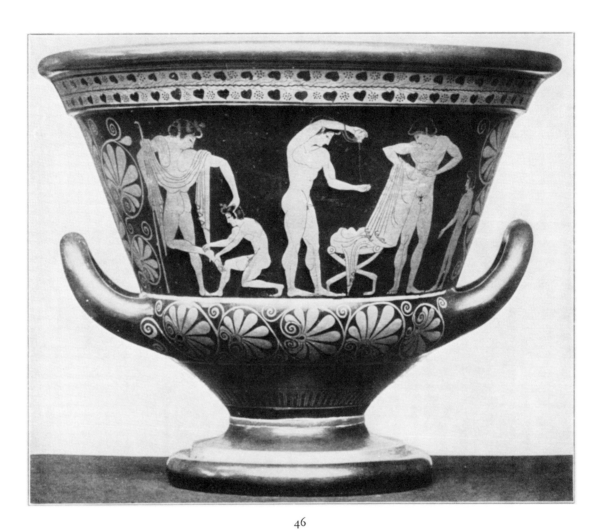

46

Unsigned krater by the painter Euphronios, end of the 6th Century B.C.
Youths in the palaestra (p. 43)
Berlin, State Museums

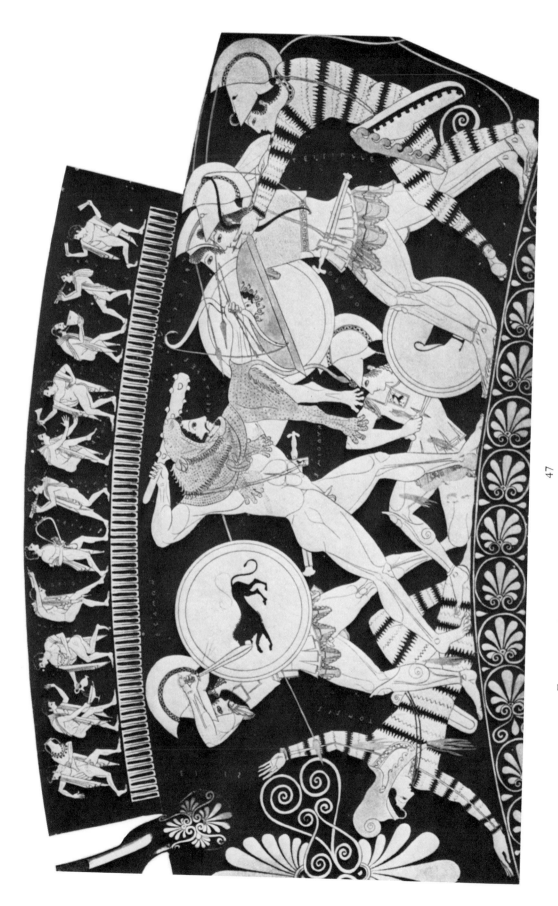

47

From an unsigned krater by the painter Euphronios, end of the 6th Century B.C.
Herakles and the Amazons: Revellers (p. 42)
Arezzo, Museo Pubblico

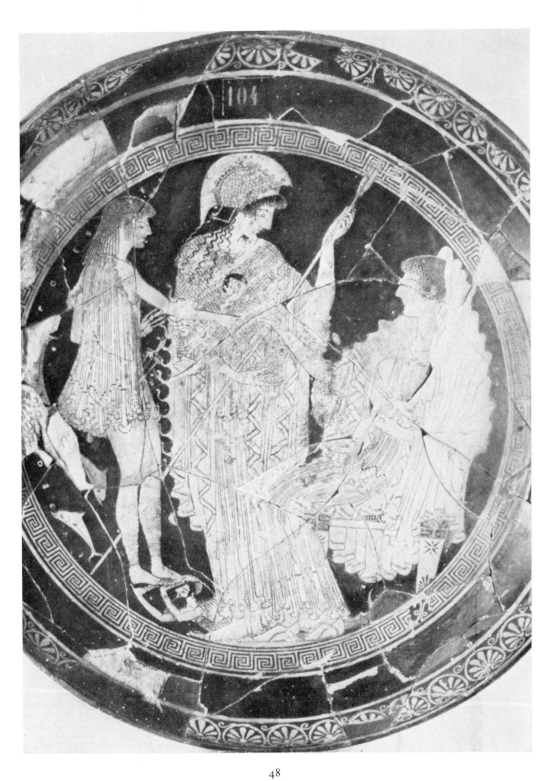

48

Cup with the signature of the master Euphronios, *c.* 500 B.C.
Theseus with Athena before Amphitrite (p. 43)
Paris, Louvre

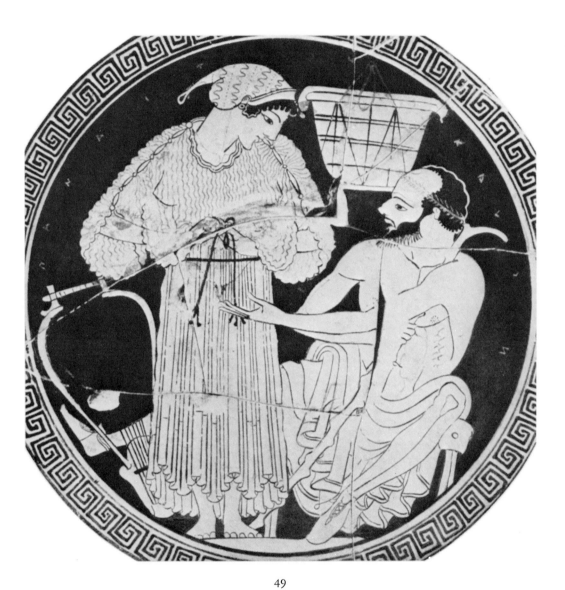

49
From a cup with the signature of the master Euphronios, *c.* 500 B.C.
Old gentleman and lyre-player (p. 45)
London, British Museum

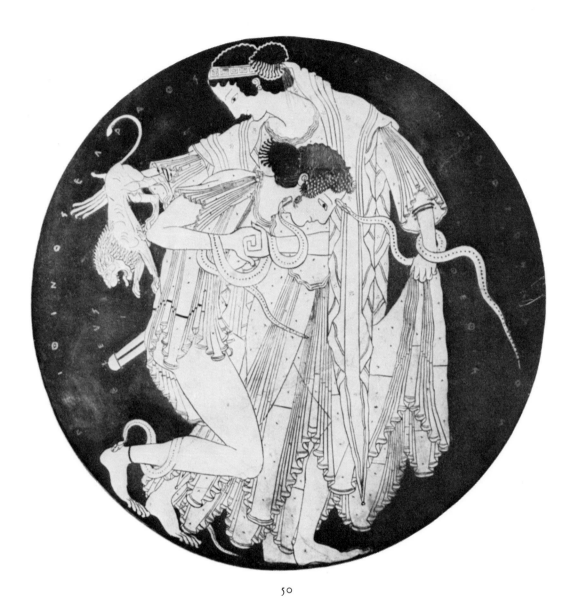

50

From a cup by the painter Peithinos, *c.* 500 B.C.
Peleus and Thetis (p. 46)
Berlin, State Museums

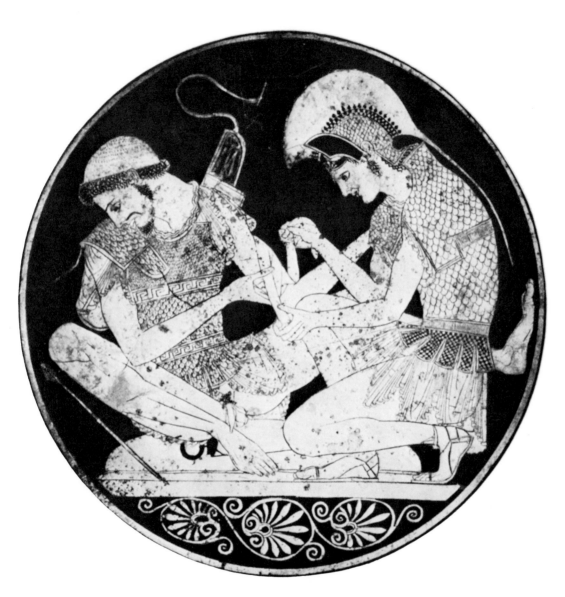

51

From a cup by the master Sosias, beginning of the 5th Century, B.C.
Achilles binding up Patroclos' wound (p. 46)
Berlin, State Museums

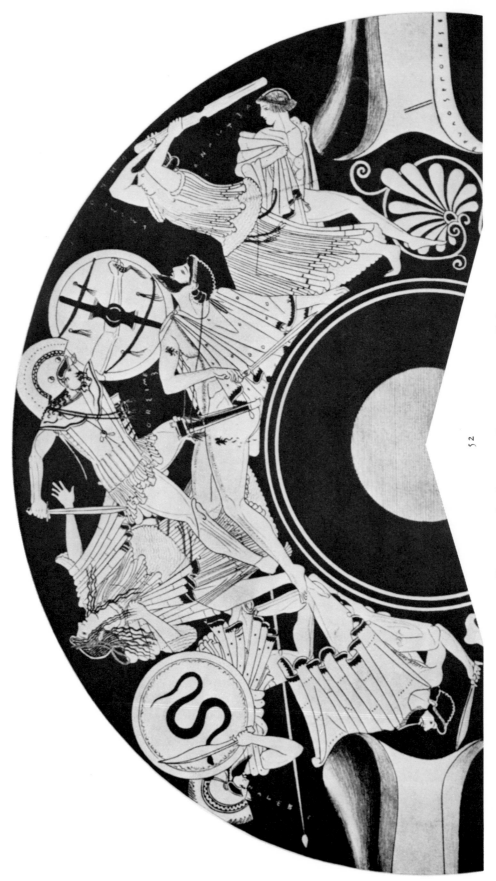

36

52

From a cup by the master Brygos, c. 490-480 B.C.
The Sack of Troy (p. 47)
Paris, Louvre

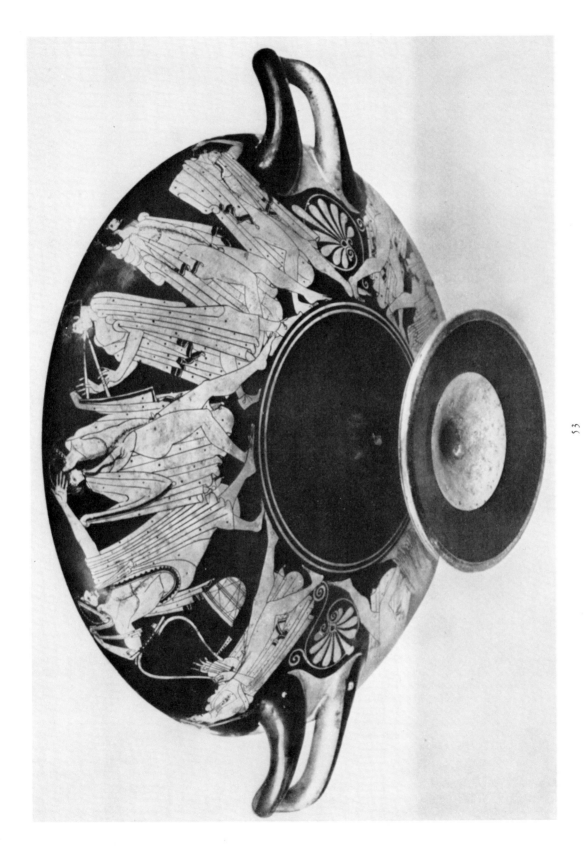

53

Cup by the master Brygos, *c.* 480 B.C.
Revellers with girls (p. 48)
Würzburg, Kunstgeschichtliches Museum

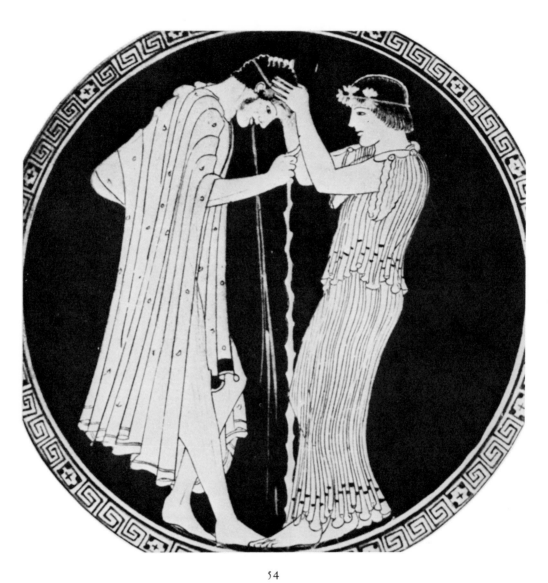

54

From the cup Fig. 53
After the wine (p. 49)

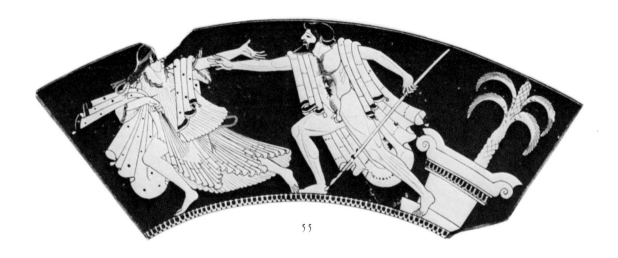

55

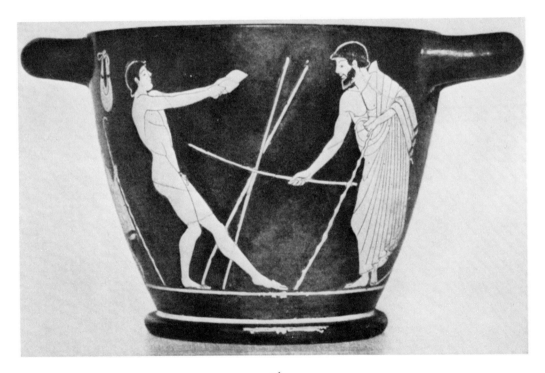

56

55, 56 Kantharos and kotyle by the master Brygos, *c.* 490-480 B.C.
A god pursuing a maiden; practising for the long jump (p. 47)
Boston, Museum of Fine Arts

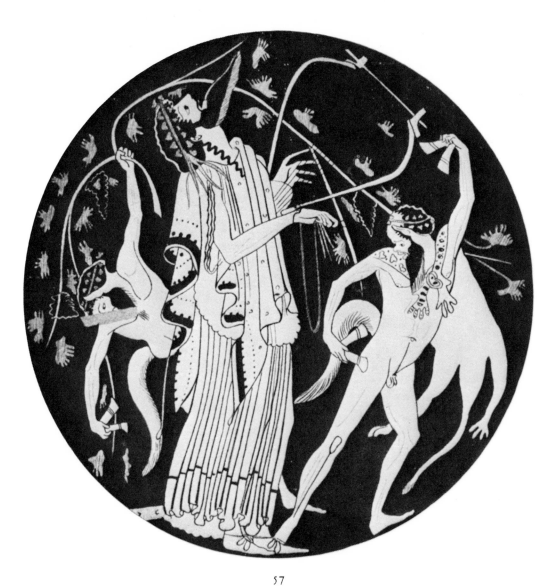

57

From an unsigned cup by the master Brygos, *c.* 490 B.C.
Dionysos and Silens (p. 49)
Paris, Cabinet des Médailles

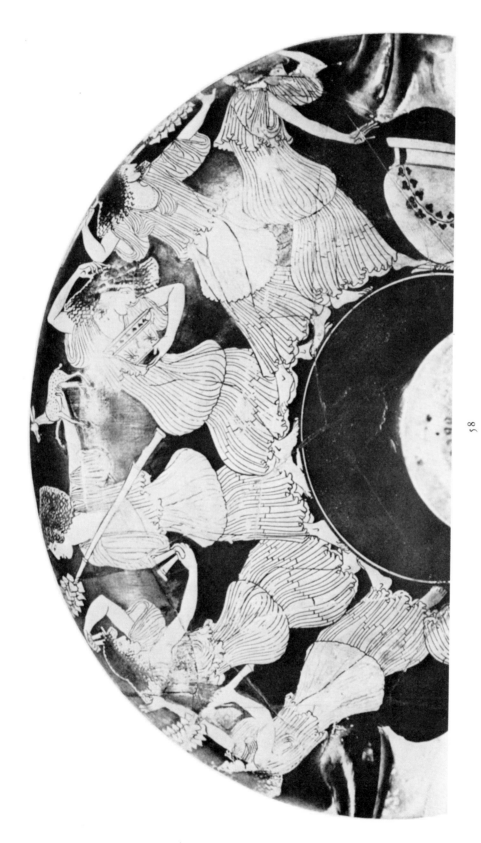

58

From a cup from the workshop of Hieron, painted by Makron but without his signature,
c. 490-480 B.C.
Dancing maenads (p. 50)
Berlin, State Museums

59

From an unsigned cup by a painter who worked for Hieron, *c.* 480-470 B.C.
Episode from the Sack of Troy (p. 50)
Petrograd, Hermitage

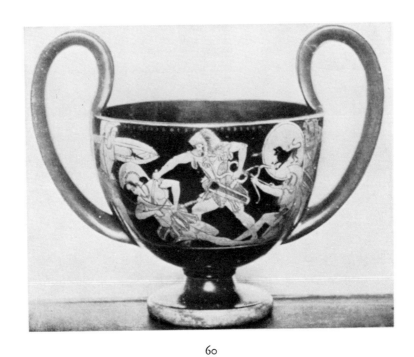

60

Kantharos by the painter Duris, *c.* 490 B.C.
Herakles and the Amazons (p. 51)
Brussels, Musée du Cinquantenaire

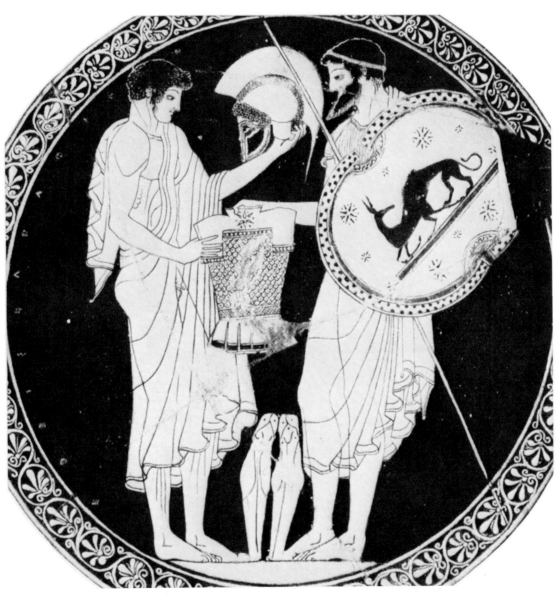

61

From a cup by the painter Duris, *c.* 490 B.C., cf. Figs. 62 and 63
Odysseus handing Neoptolemos the armour of Achilles (p. 52)
Vienna, Oesterreichisches Museum

44

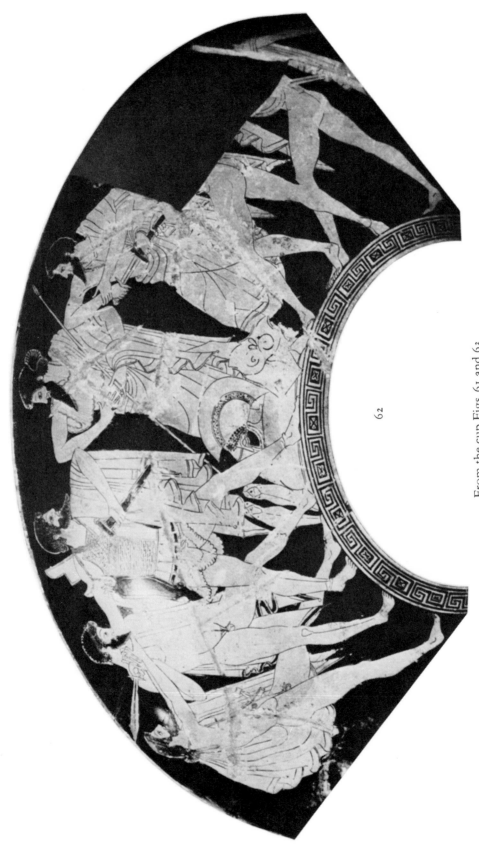

From the cup Figs. 61 and 63
Ajax and Odysseus quarrelling over the armour of Achilles (p. 52)

62

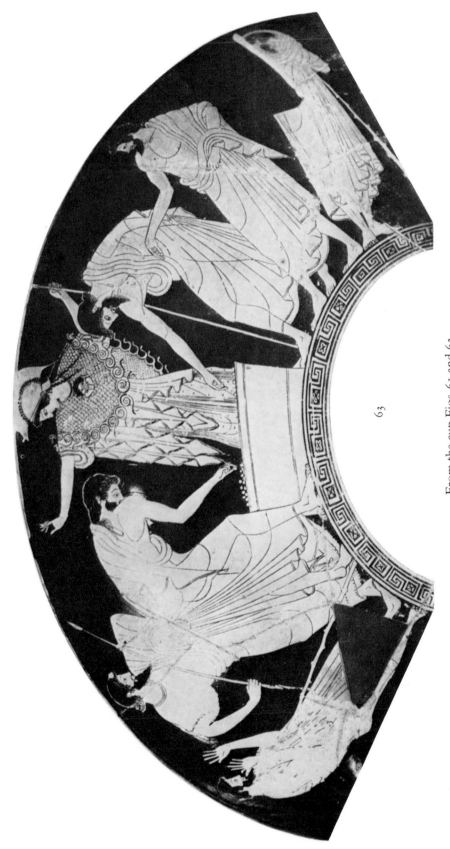

63

From the cup Figs. 61 and 62
Voting between Ajax and Odysseus (p. 52)

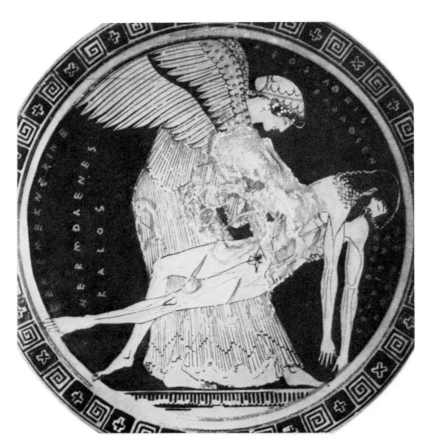

64

From a cup by the painter Duris, *c.* 490-480 B.C.
Eos with the body of her son Memnon (p. 51)
Paris, Louvre

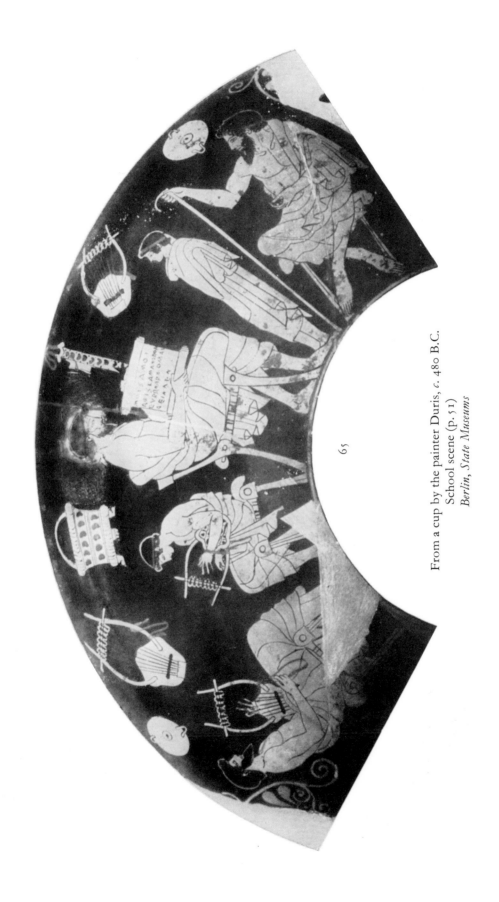

From a cup by the painter Duris, *c.* 480 B.C.
School scene (p. 51)
Berlin, State Museums

48

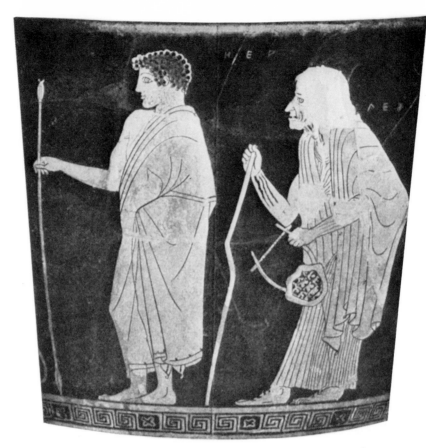

66

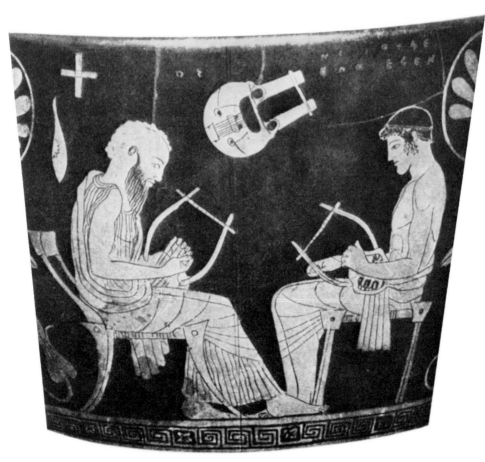

67

66, 67 From a kotyle by the master Pistoxenos, *c.* 470 B.C.
Herakles on the way to the music-master Linos (p. 52)
Schwerin, Museum

49

68

Etruscan tomb painting, 1st half of the 5th Century B.C.
Dance (p. 54)
Corneto, cemetery of Tarquinii

From a white-ground cup, *c.* 470 B.C.
Orpheus and a Thracian woman (p. 56)
Athens, National Museum

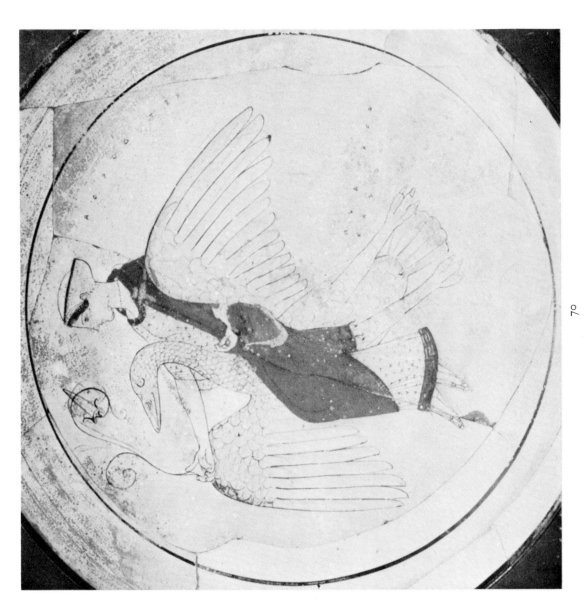

70

White-ground cup, *c.* 470 B.C.
Aphrodite on the Goose (p. 56)
London, British Museum

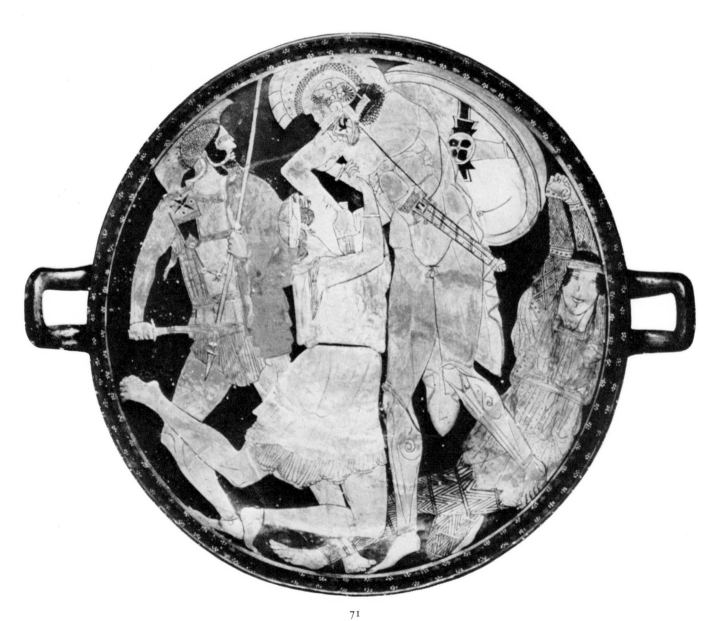

71
Large half-polychrome cup, *c.* 460 B.C.
Amazonomachy (p. 58)
Munich, Museum antiker Kleinkunst

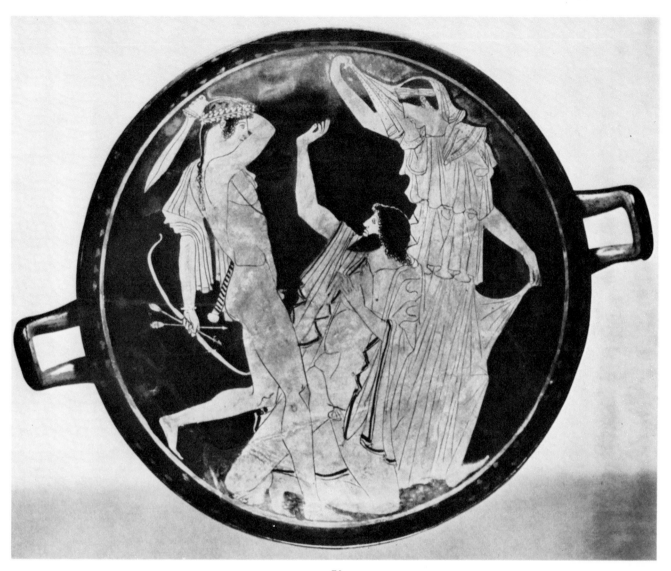

72
Large cup, *c.* 460 B.C.
Apollo and the giant Tityos (p. 60)
Munich, Museum antiker Kleinkunst

73
Cup, *c.* 460 B.C.
Attic youths with army horses (p. 60)
Hamburg, Museum für Kunst und Industrie

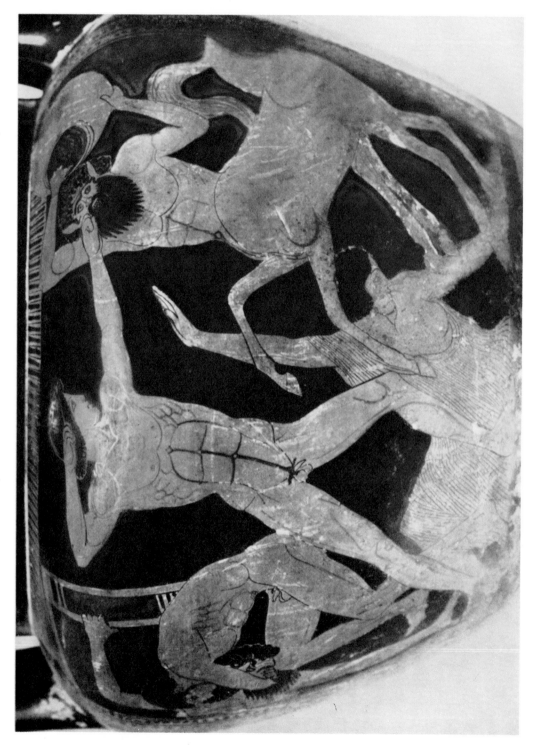

74

From a krater, *c.* 460 B.C.
Centauromachy at the wedding of Peirithoos (p.61)
Florence, Museo Archeologico

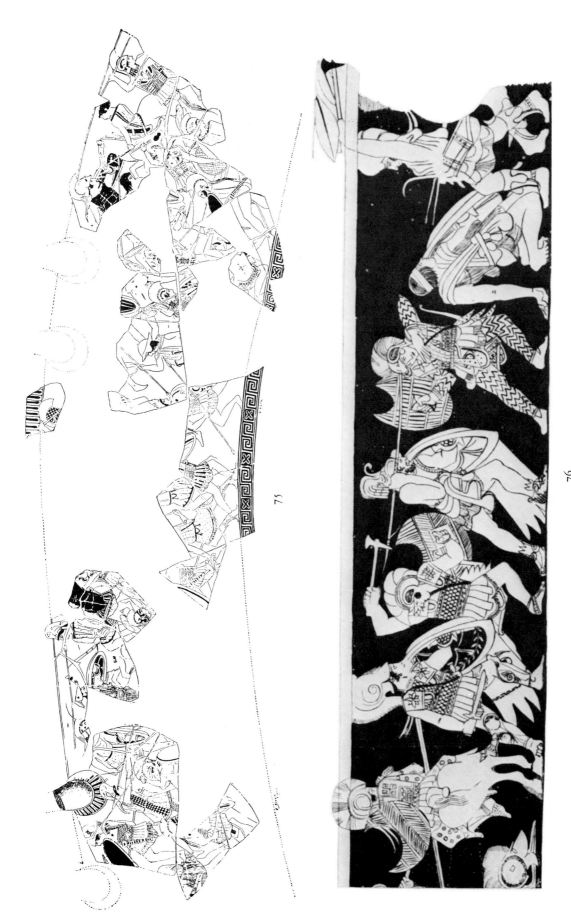

55

75

76

From two kraters, *c*. 460 B.C.
Amazonomachies (p. 59)
Bologna, Museo Civico – Geneva, Musée d' Art et d'Histoire

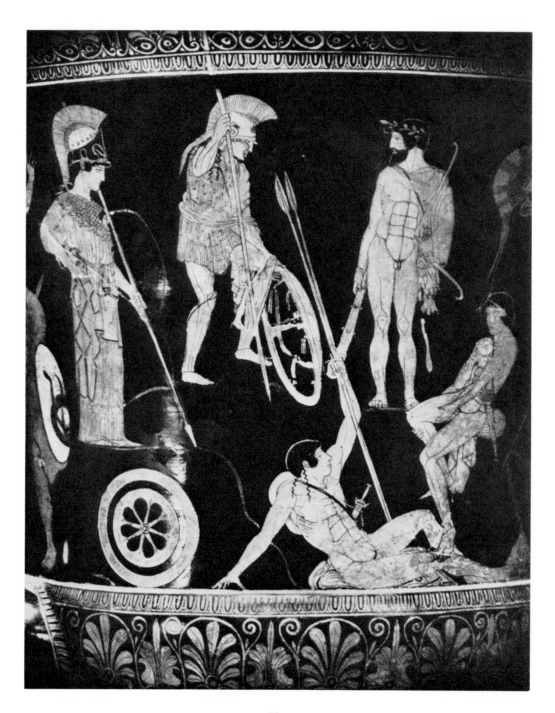

77
From a krater, *c.* 460 B.C.
Herakles and Athena and heroes (p. 57)
Paris, Louvre

79
From a cup, *c.* 460 B.C.
Aesop and the Fox (p. 62)
Rome, Vatican

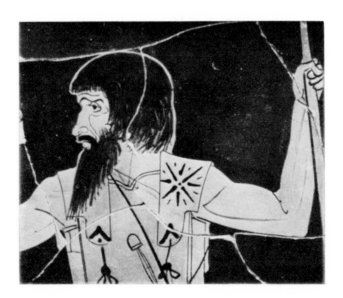

78
From a krater, *c.* 460 B.C.
Warrior (p. 62)
New York, Metropolitan Museum

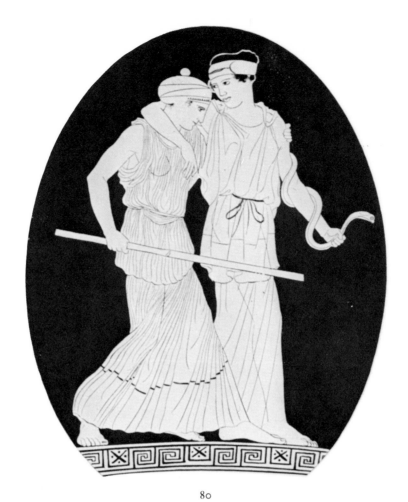

80

From an amphora, *c.* 450 B.C.
Two maenads (p. 62)
Lower edge of the garments, and feet, save the toes on the right, restored
Paris, Cabinet des Médailles

81

Cup by the master Hegesibulos, *c.* 460 B.C.
Top-spinner (p. 63)
Brussels, Musée du Cinquantenaire

82

83

82, 83 From two cups by the master Sotades, about the middle of the 5th Century B.C.
Apple-picking; the Death of Archemoros (Hippomedon and the Snake) (pp. 63 and 64)
London, British Museum

60

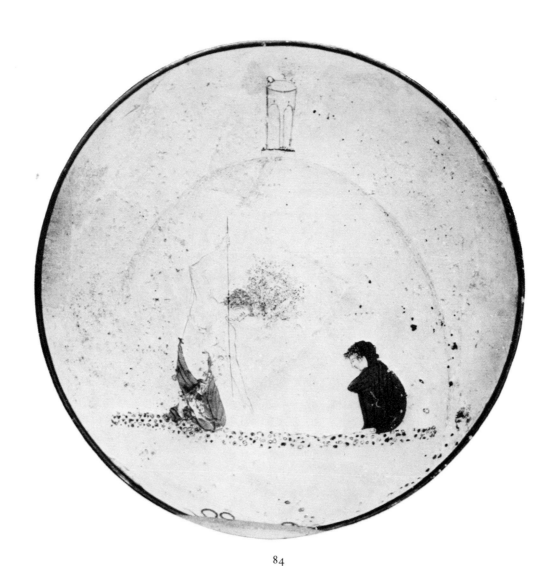

84

Cup by the master Sotades, about the middle of the 5th Century B.C.
Glaukos and Polyidos in the Tomb (p. 65)
London, British Museum

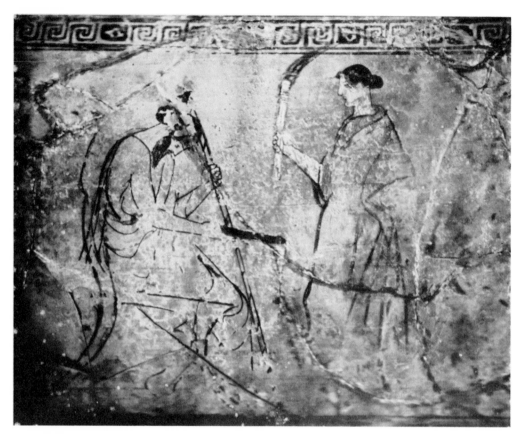

85

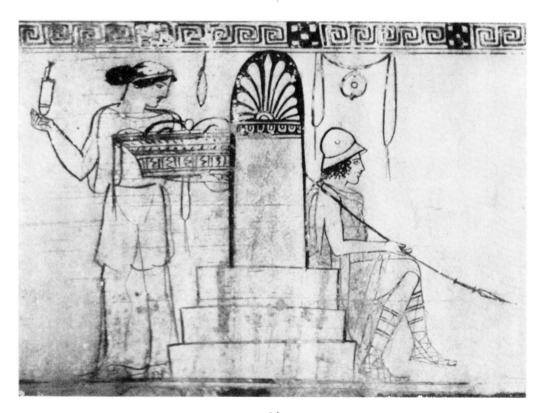

86

85, 86 From two white-ground tomb-lekythoi, about the middle of the 5th Century B.C.
Eleusinian divinities; the dead youth and the girl with gifts at the tomb (pp. 67 and 66)
Berlin, State Museums – Athens, National Museum

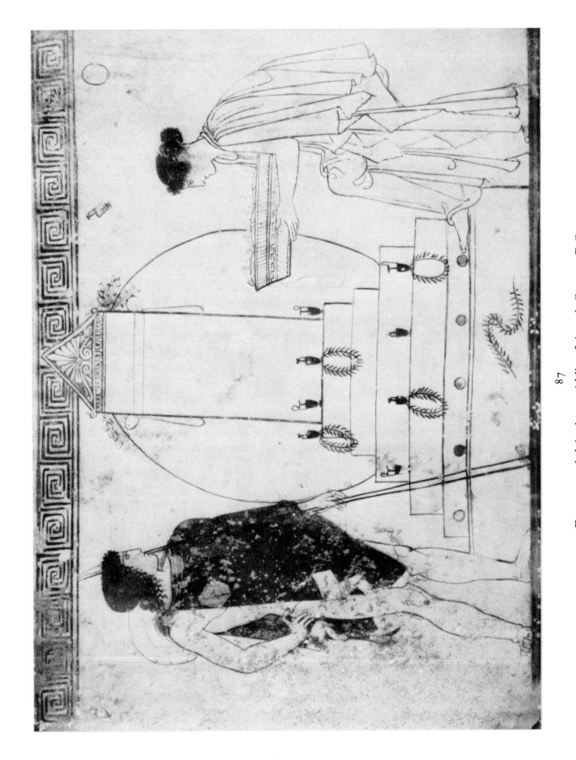

87

From a tomb-lekythos, middle of the 5th Century B.C.
The cult of the grave, with the dead youth (pp. 66 and 69)
Athens, National Museum

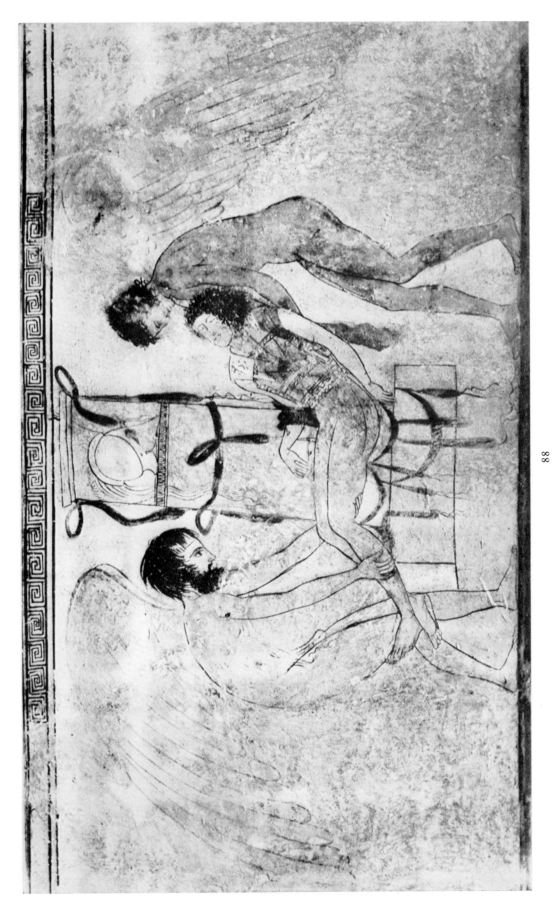

88

From a tomb-lekythos, middle of the 5th Century B.C.
Sleep and Death with a young warrior at the grave (p. 73)
London, British Museum

64

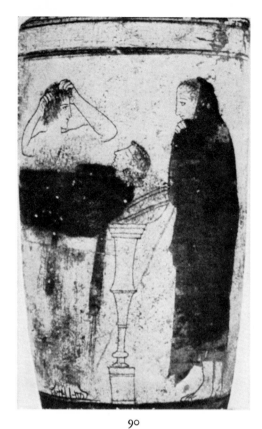

90

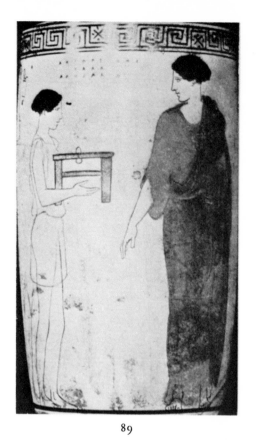

89

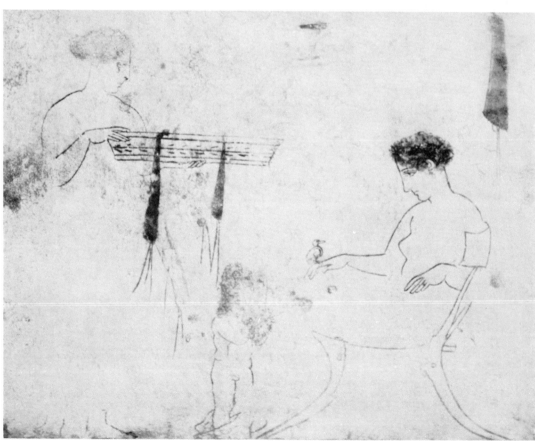

91

89–91 From tomb-lekythoi, 3rd quarter of the 5th Century B.C.
Woman and handmaiden; the dead on the bier; before the walk to the cemetery (pp. 67-73)
Boston, Museum of Fine Arts – New York, Metropolitan Museum – Athens, National Museum

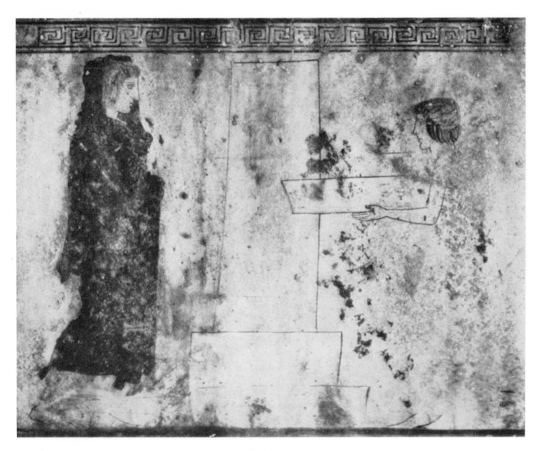

92

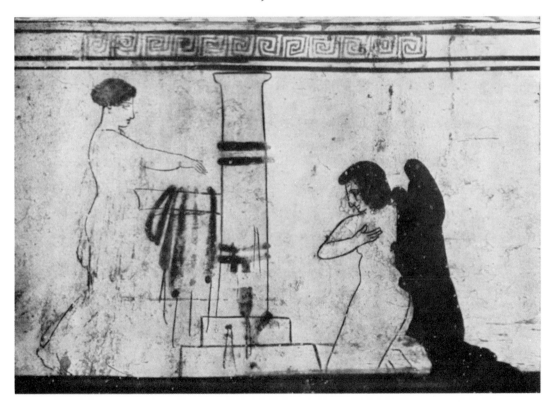

93

92, 93 From tomb-lekythoi, 3rd quarter of the 5th Century B.C.
The dead woman and a girl with gifts at the grave; lament at the grave (p. 71)
Athens, National Museum

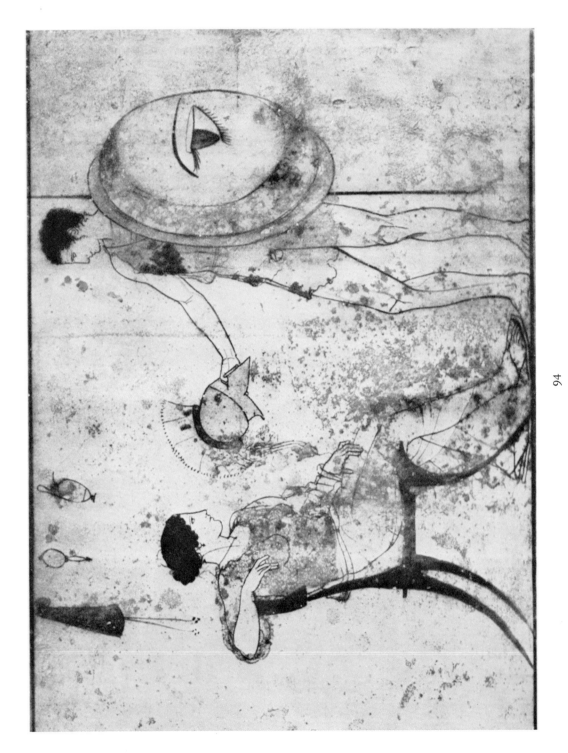

94

From a tomb-lekythos, middle of the 5th Century B.C.
Leave-taking (p. 68)
Athens, National Museum

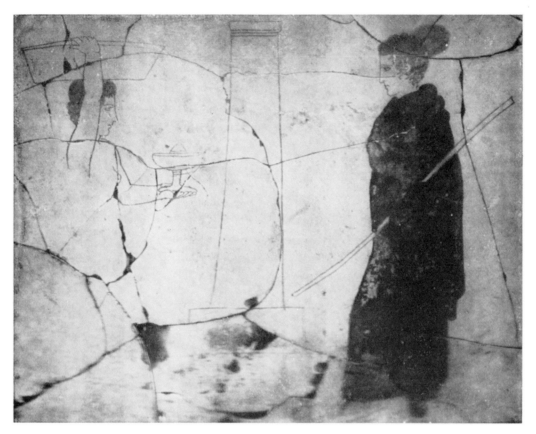

95

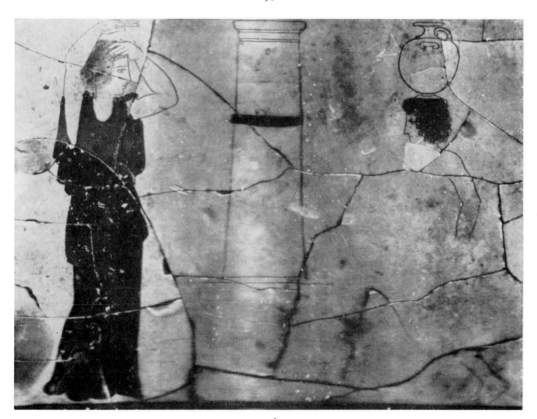

96

95, 96 From tomb-lekythoi, 3rd quarter of the 5th Century B.C.
The dead youth and a girl with gifts at the grave; lament, and libation to the dead (pp. 69 and 71)
Berlin, State Museums

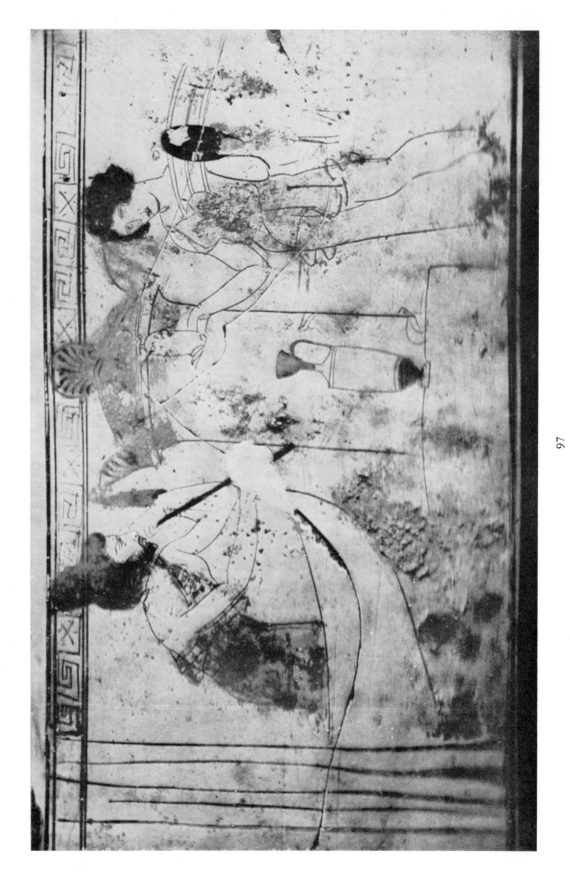

97

From a tomb-lekythos, *c.* 400 B.C.
The care of the grave, with Charon present (pp. 72 and 79)
Paris, Louvre

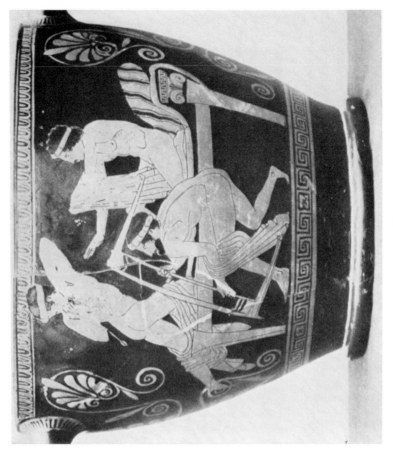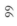

99

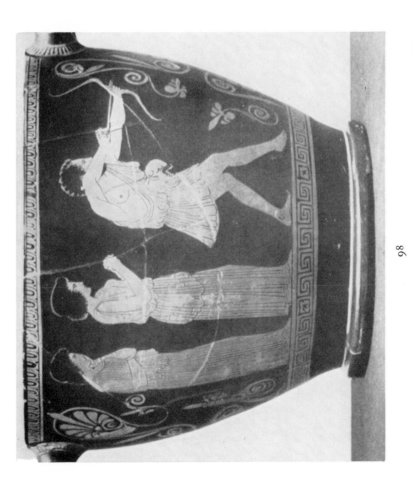

98

Bowl, middle of the 5th Century B.C.
Odysseus and the Suitors (p. 74)
Berlin, State Museums

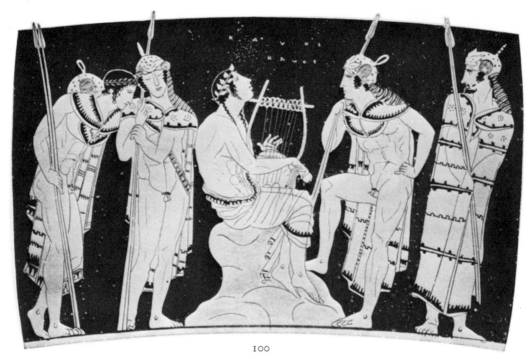

100

From a crater, middle of the 5th Century B.C.
Orpheus among the Thracians (p. 74)
Berlin, State Museums

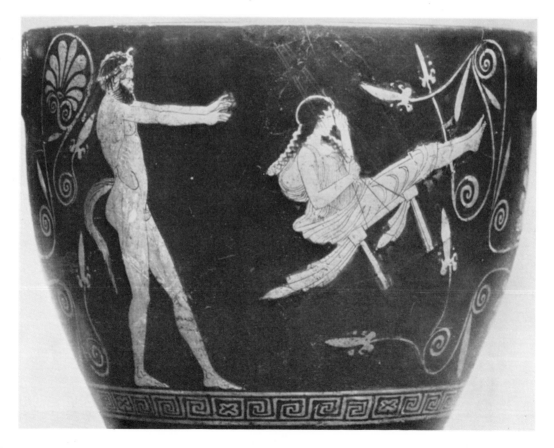

101

Bowl, middle of the 5th Century B.C.
A satyr swinging a girl at the spring festival (p. 76)
Berlin, State Museums

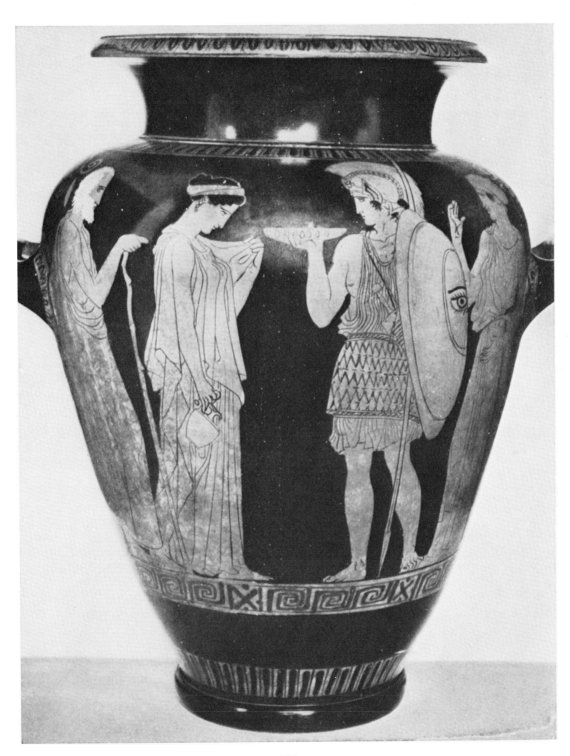

102

Krater ("stamnos"), 3rd quarter of the 5th Century B.C.
Warrior leaving home (p. 102)
Munich, Museum antiker Kleinkunst

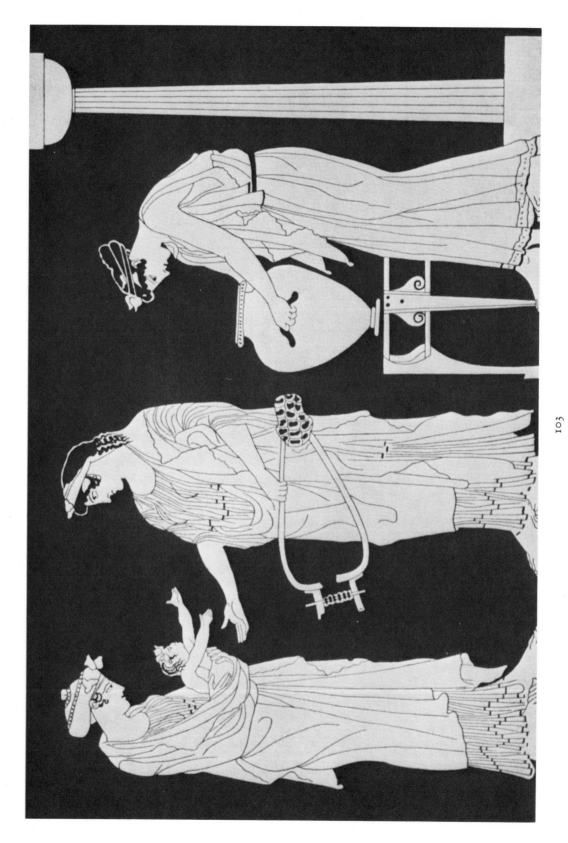

103

From a krater ("stamnos"), middle of the 5th Century B.C.
Festival of Dionysos (p. 75)
Gołuchów, Czartoryski Collection

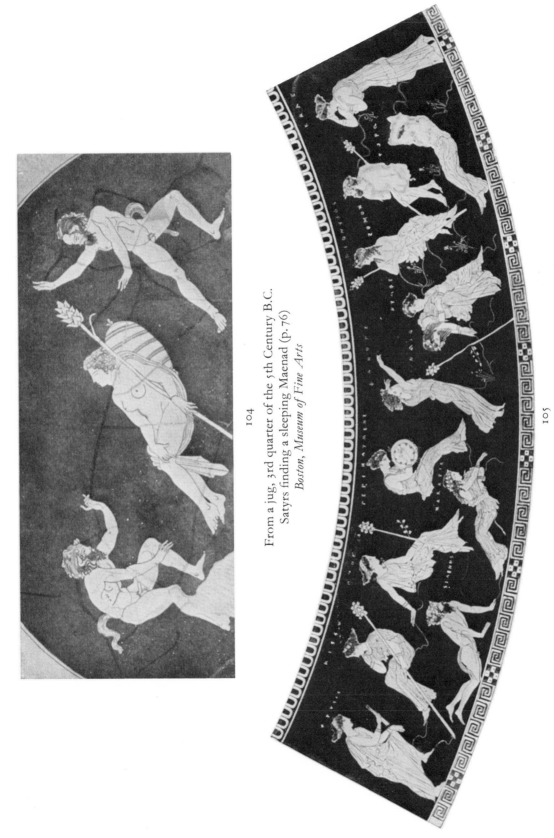

104

From a jug, 3rd quarter of the 5th Century B.C.
Satyrs finding a sleeping Maenad (p. 76)
Boston, Museum of Fine Arts

105

From a perfume-vase ("pquat lekythos"), about 430 B.C.
Dionysos and his followers (p. 77)
Berlin, State Museums.

106

Small jug for the spring festival of the little boys, about the end of the 5th Century B.C.
Boy and hare (p. 79)
Munich, private collection

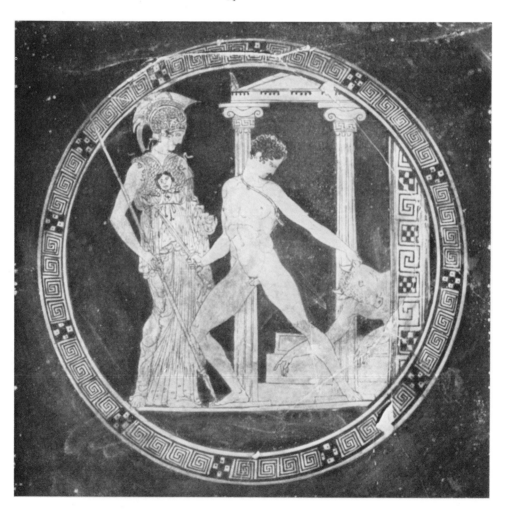

107

From a cup by the painter Aison, towards the end of the 5th Century
Theseus with the dead Minotaur (p. 81)
Madrid, Archaeological Museum

75

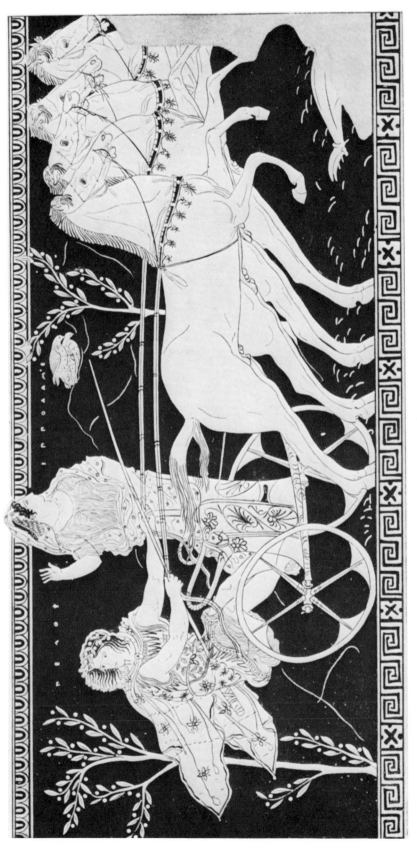

108

From an amphora, last quarter of the 5th Century B.C.
Pelops carrying off Hippodameia (p. 80)
Arezzo, Museo Pubblico

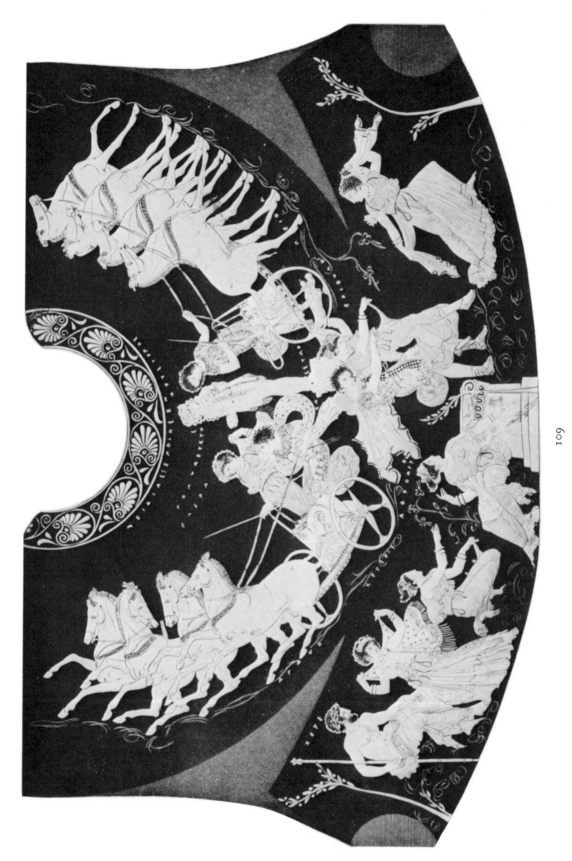

109

From a hydria by the master Meidias, last quarter of the 5th Century B.C.
The Dioscuri carrying off the daughters of Leucippos (p. 82)
London, British Museum

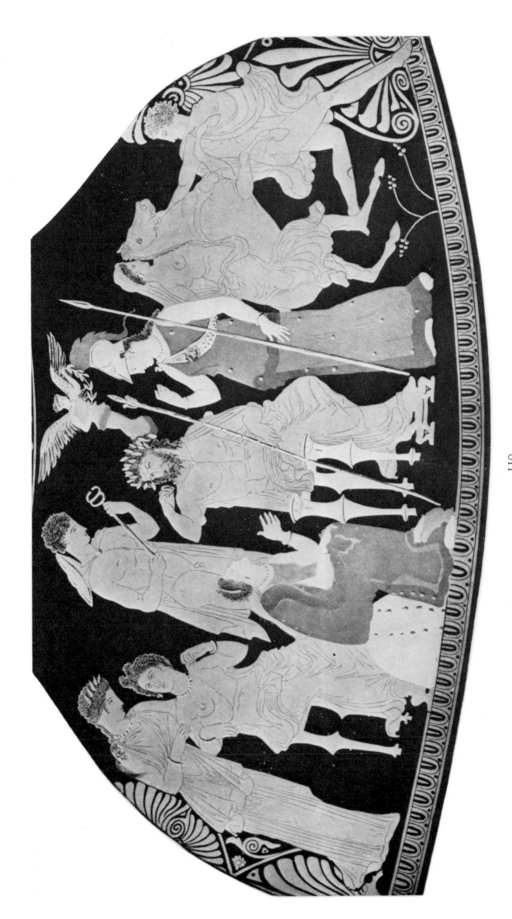

110

From an amphora ("pelike"), about the middle of the 4th Century B.C.
The Gods deciding to let loose the Trojan War (p. 83)
Petrograd, Hermitage

111

Engraved bronze mirror-box, mid 4th Century B.C.
Aphrodite or Peitho and Pan playing dibs (p. 84)
London, British Museum

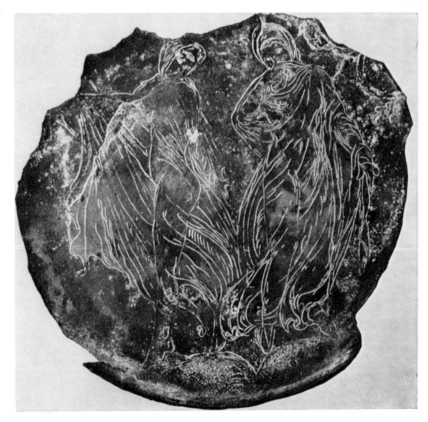

112

Mirror-case like. Fig. 111, about the second half of the 4th Century B.C.
Dancers (p. 85)
Paris, Louvre

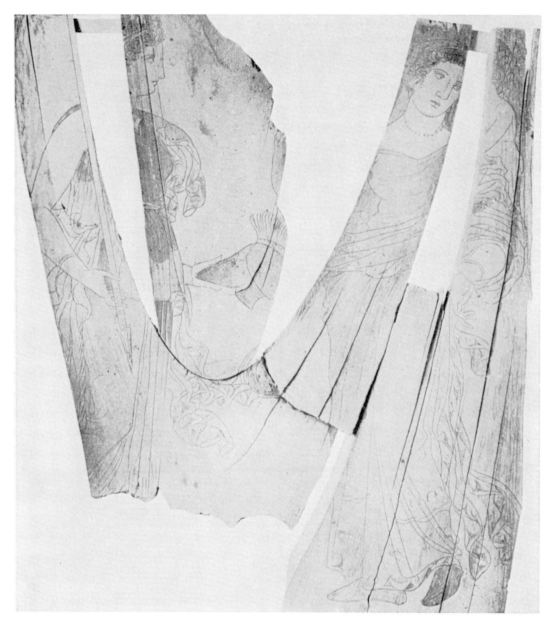

113

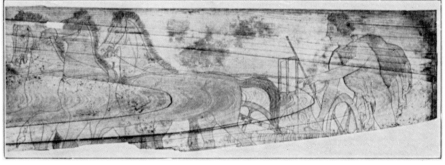

114

113, 114 Ivory veneer from a wooden sarcophagus, mid 4th Century B.C.
Athena and Aphrodite: Chariot (p. 85)
Petrograd, Hermitage

115

Tombstone of Mnason, from Thebes, *c.* 430 B.C. (p. 86)
Thebes, Museum

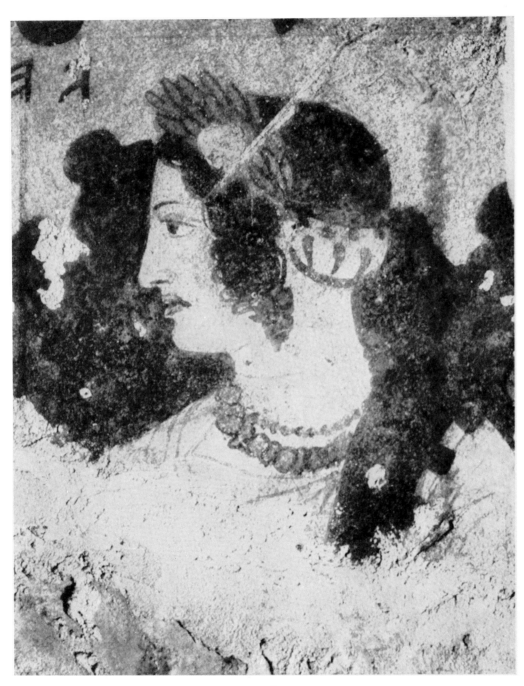

116

From the wall-painting in an Etruscan tomb-chamber, *c.* 400 B.C.
Female head (p. 87)
Corneto, cemetery of Tarquinii

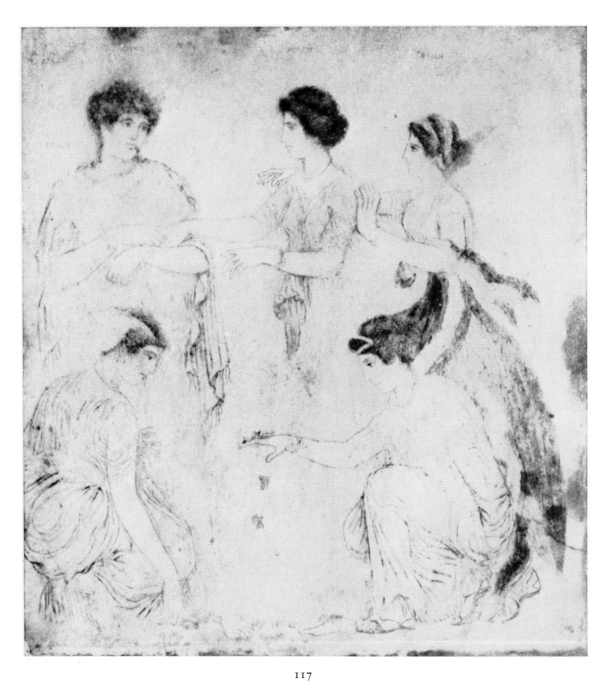

117

Copy on marble after a classical picture of *c.* 430 B.C.; from Herculaneum, by Alexandros of Athens,
1st Century B.C. or A.D.
Leto offended by Niobe while playing astragaloi (p. 87)
Naples, Museo Nazionale

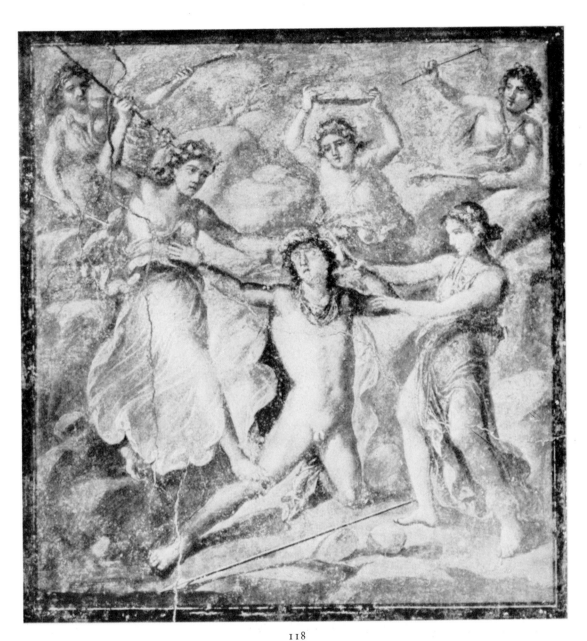

118

Pompeian wall-painting, 1st Century A.D.
Pentheus torn by the Maenads (p. 89)
Pompeii, House of the Vettii

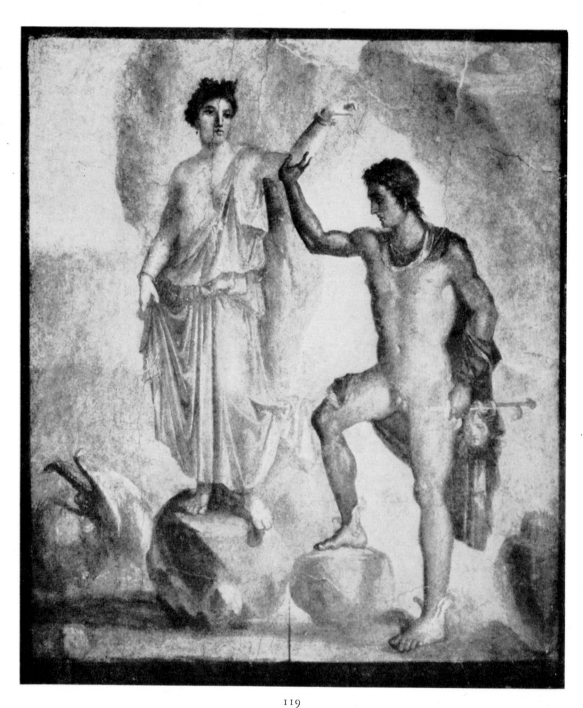

119
Pompeian wall-painting, 1st Century A.D. (probably after a picture by Nikias,
second half of the 4th Century B.C.)
Perseus freeing Andromeda (p. 90)
Naples, Museo Nazionale

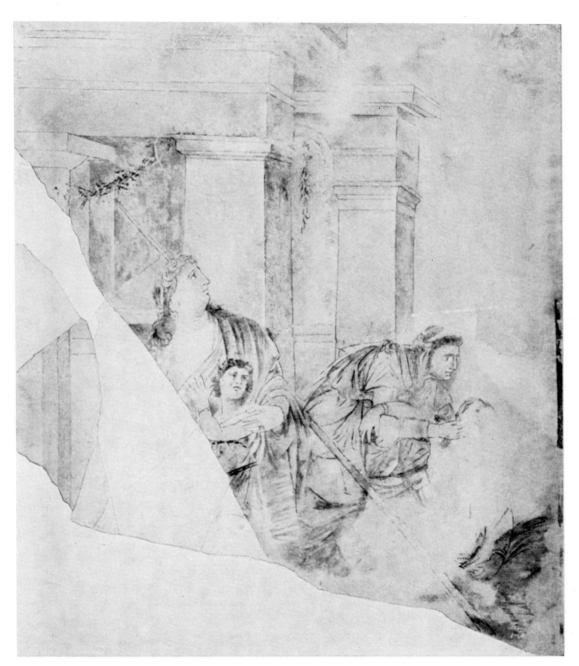

120

Copy on marble after a picture of the 4th–3rd Century B.C.; from Pompeii, 1st Century B.C. or A.D.
The daughters of Niobe slain by the arrows of Artemis (p. 99)
Naples, Museo Nazionale

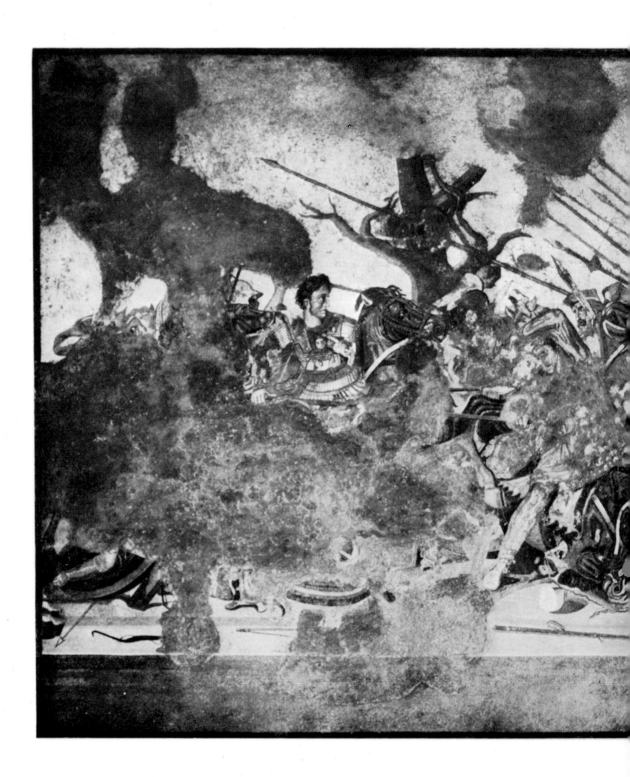

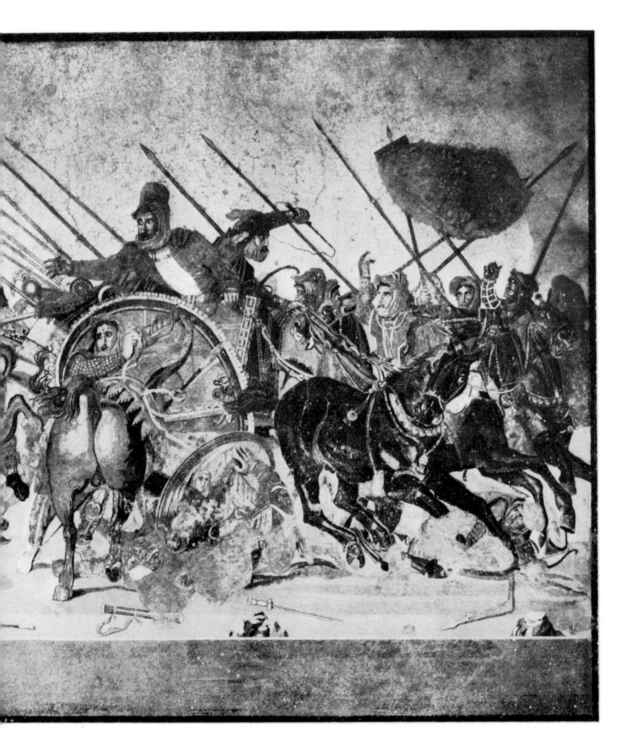

121

Copy in mosaic from a painting of the end of the 4th Century B.C. probably by Philoxenos: found in Pompeii; 3rd–2nd Century B.C.
Alexander the Great threatening the fleeing Darius (pp. 7 and 92)
Naples, Museo Nazionale

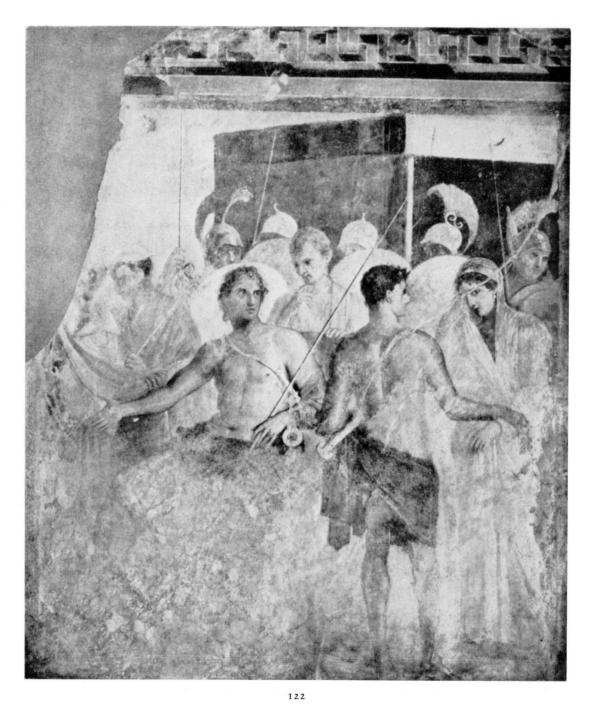

122

Pompeian wall-painting, 1st Century A.D.
Achilles handing over Briseis to Agamemnon's heralds (p. 102)
Naples, Museo Nazionale

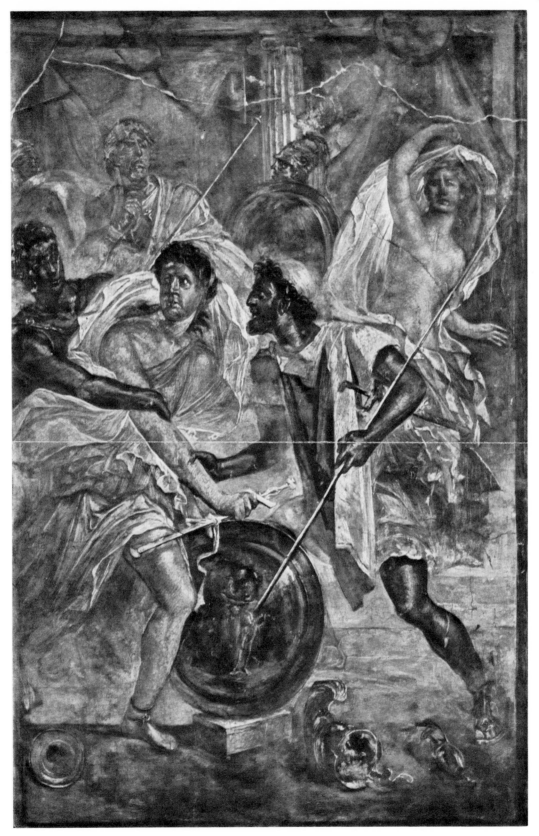

123

Pompeian wall-painting, 1st Century A.D.
Achilles discovered by Odysseus and Diomedes among the daughters of Lykomedes at Skyros (p. 103)
Naples, Museo Nazionale

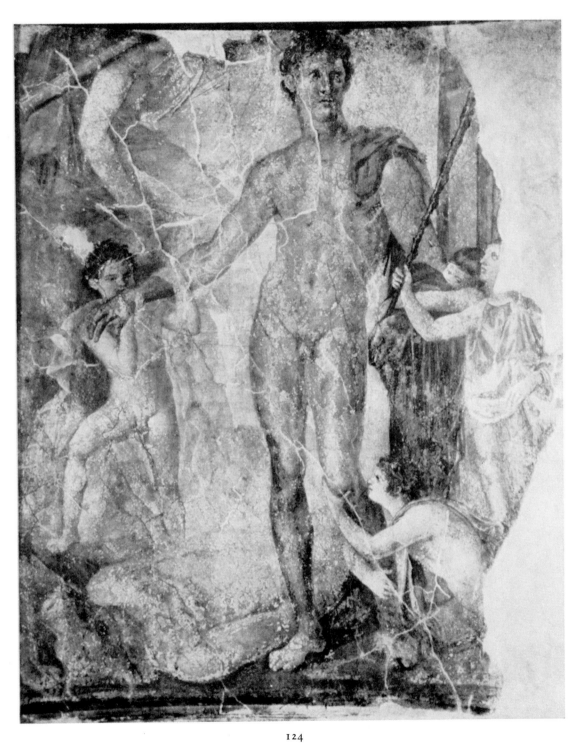

124

Herculanean wall-painting, 1st Century A.D.
Theseus victorious over the Minotaur (p. 106)
Naples, Museo Nazionale

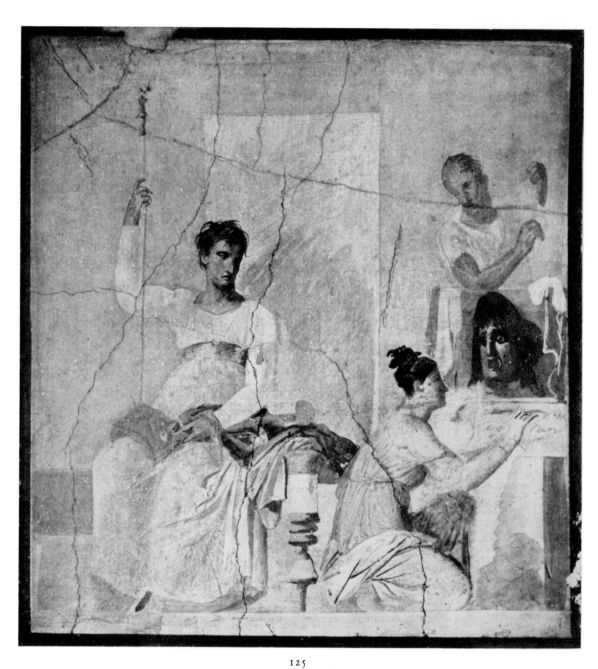

125

Picture on stucco from Herculaneum, 1st Century A.D.
An actor dedicating a tragic mask (p. 107)
Naples, Museo Nazionale

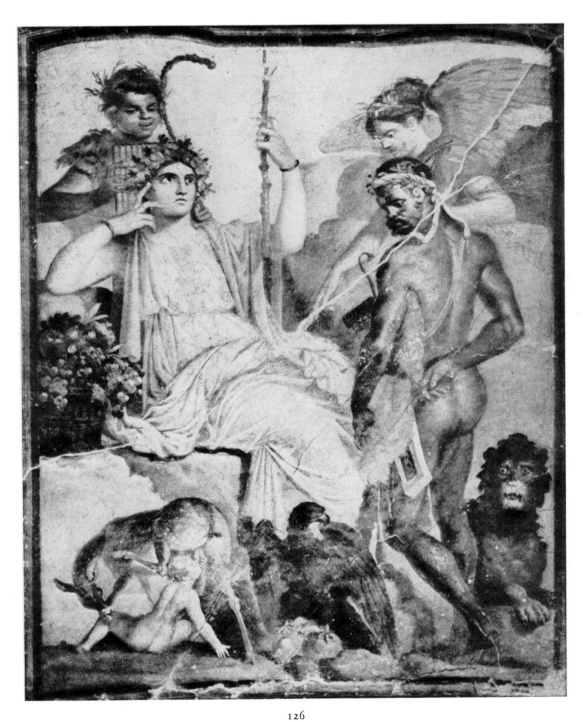

126

Herculanean wall-painting, 1st Century A.D.
Herakles finding his son Telephos in the mountains of Arcadia (p. 108)
Naples, Museo Nazionale

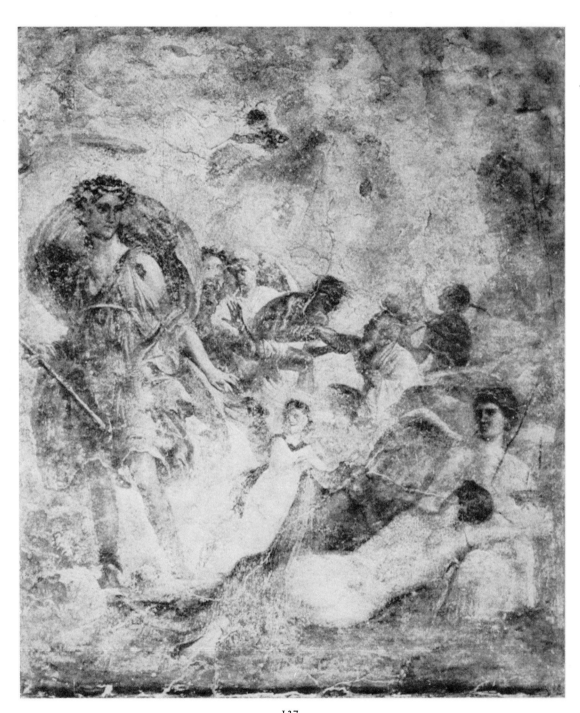

127

Pompeian wall-painting, 1st Century A.D.
Dionysos finding the sleeping Ariadne in Naxos (p. 113)
Naples, Museo Nazionale

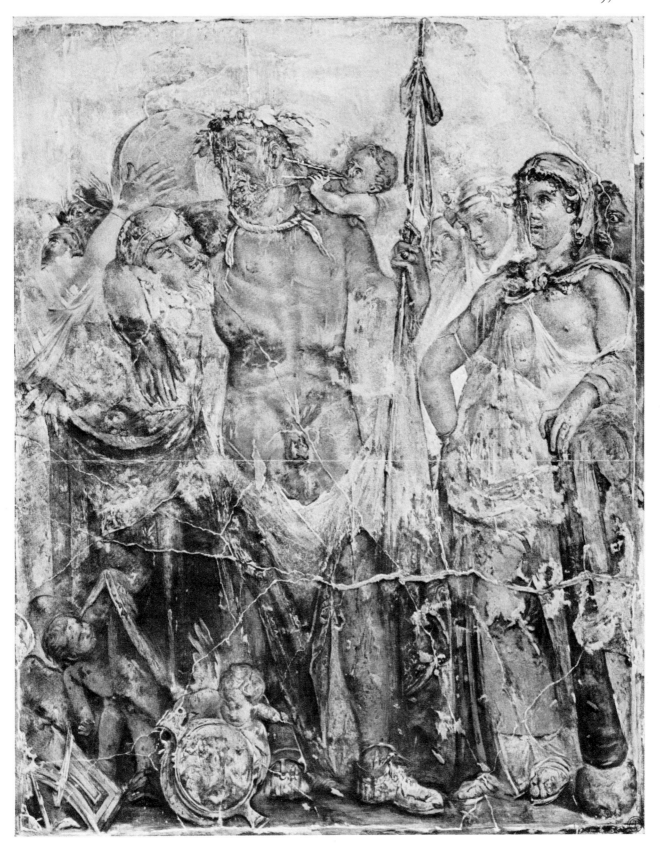

128
Pompeian wall-painting, 1st Century A.D.
Herakles as slave of the Lydian Queen Omphale (p. 110)
Naples, Museo Nazionale

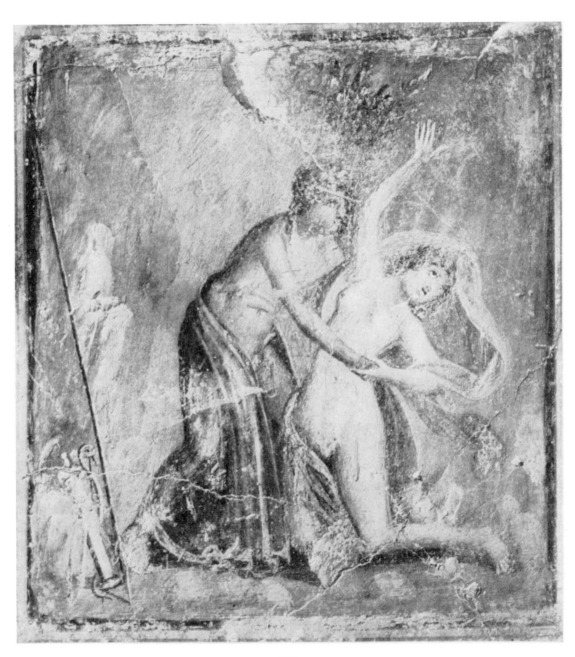

129

Pompeian wall-painting, 1st Century A.D.
Apollo and Daphne (p. 114)
Pompeii, House of the Dioscuri

98

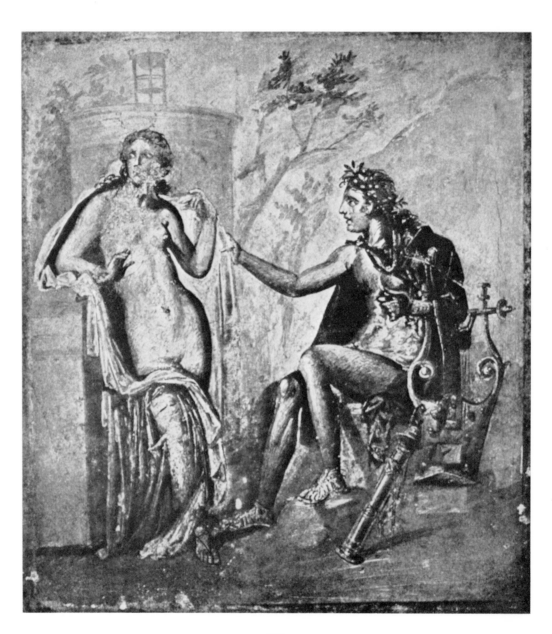

130
Pompeian wall-painting, 1st Century A.D.
Apollo and Daphne (p. 114)
Pompeii, House VII, 12, 23

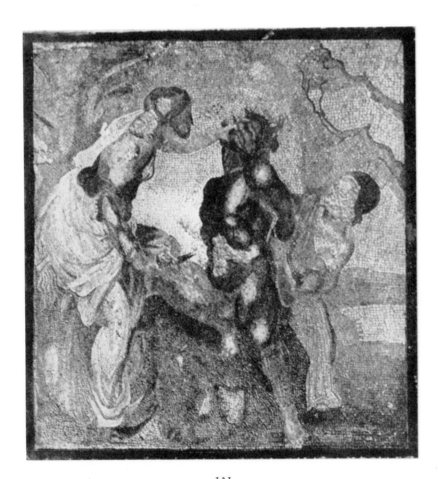

131
Mosaic from Malta, about the birth of Christ
Nymphs cutting off a satyr's beard (p. 114)
Malta, Rabato excavations

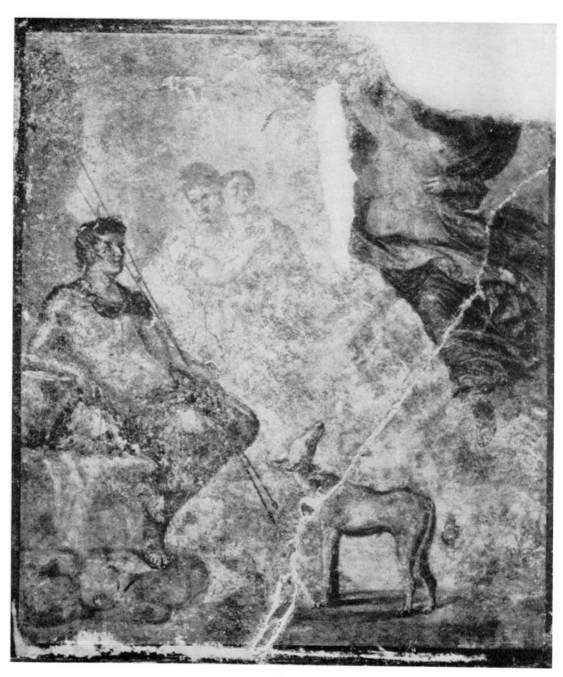

132

Pompeian wall-painting, 1st Century A.D.
Endymion and Selene (p. 115)
Naples, Museo Nazionale

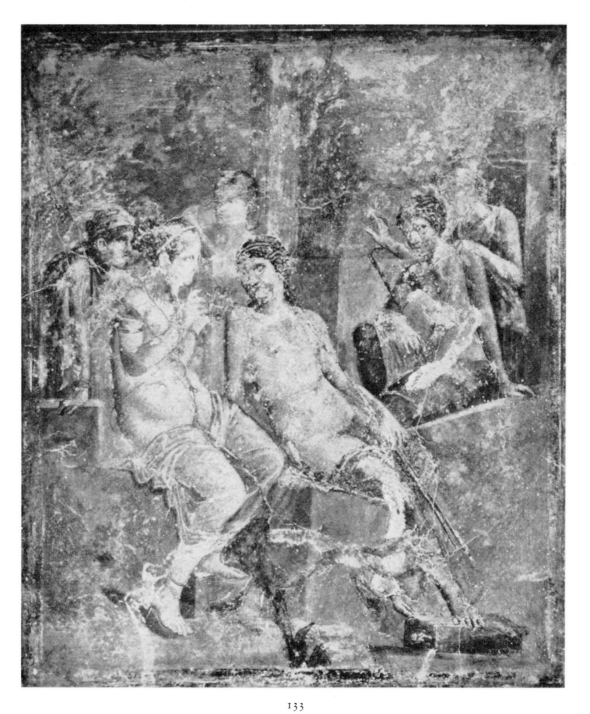

133
Pompeian wall-painting, 1st Century A.D.
Lovers with a nest of Erotes (p. 115)
Naples, Museo Nazionale

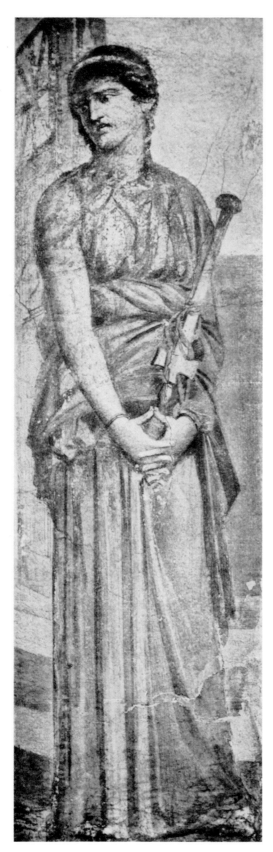

134

134, 135 Herculanean wall-painting, 1st Century
A.D., and engraved gem: probably after a picture
by Timomachos (1st Century B.C.)
Medea before the murder of her children (p. 116)
*Naples, Museo Nazionale–Florence, Museo
Archeologico*

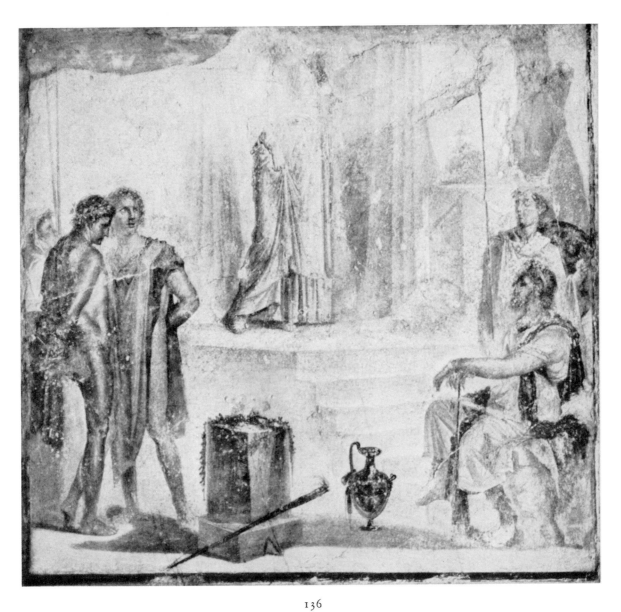

136
Pompeian wall-painting, 1st Century A.D.
Orestes and Pylades before King Thoas (p. 116)
Naples, Museo Nazionale

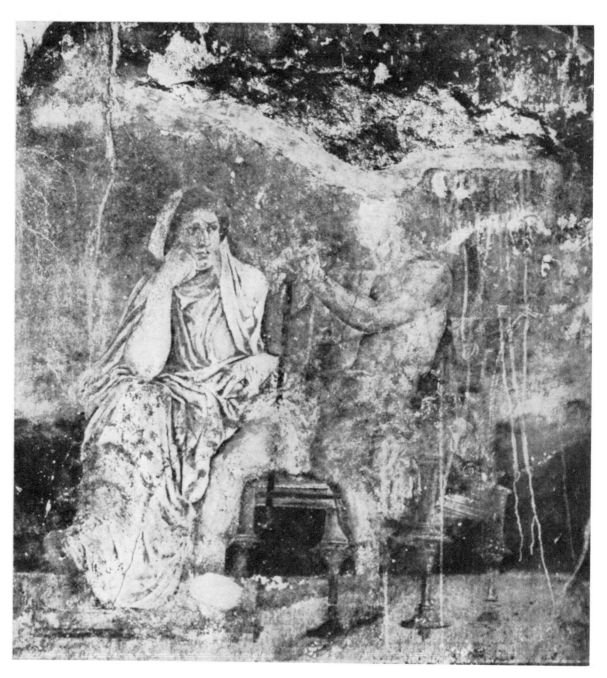

137
Wall-painting from Boscoreale near Pompeii, 1st Century B.C.
Husband and wife (p. 118)
New York, Metropolitan Museum

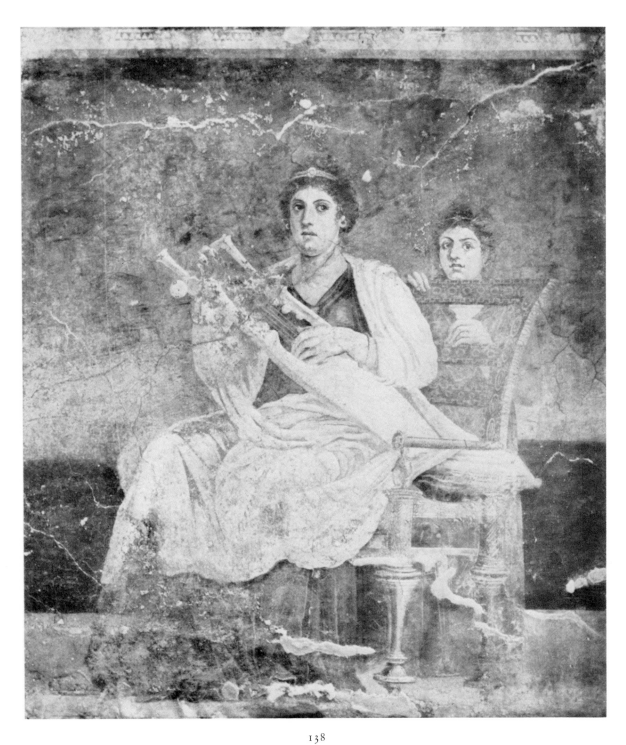

138

Wall-painting from Boscoreale near Pompeii, 1st Century B.C.
Girl playing the lyre (p. 118)
New York, Metropolitan Museum

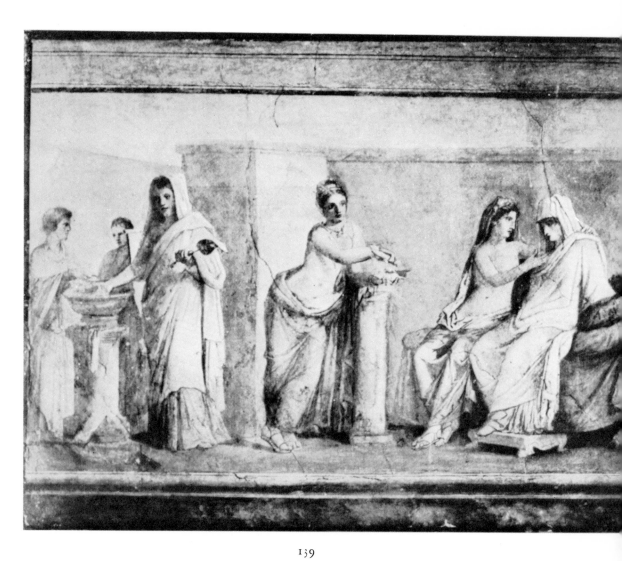

139
Roman wall-painting, about the birth of Christ
The bride waiting for the bridegroom (the "Aldobrandini Wedding", p. 121)
Rome, Vatican Library

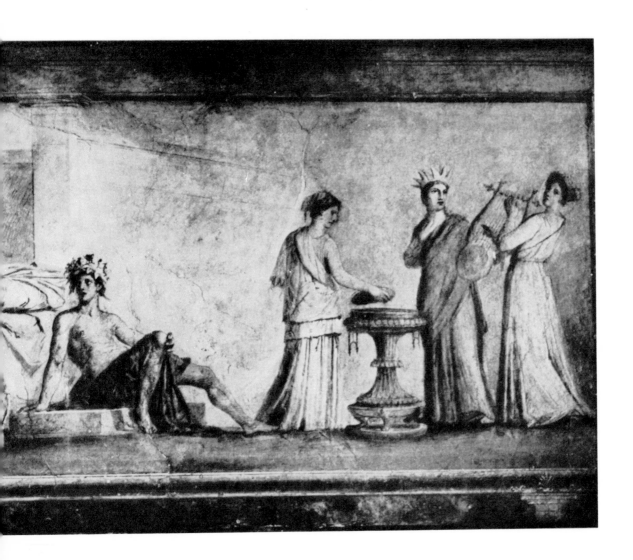

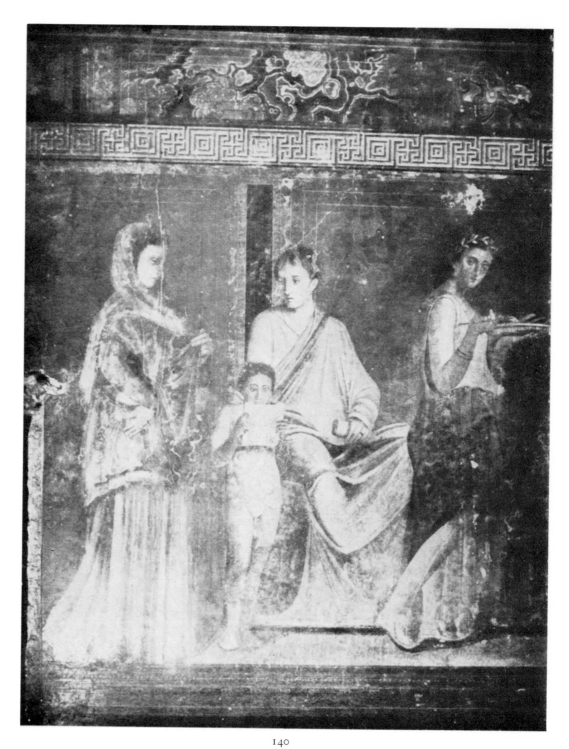

140

Part of a wall-painting in the Villa Item near Pompeii, 1st Century B.C.
Dionysiac Initiation (p. 119)

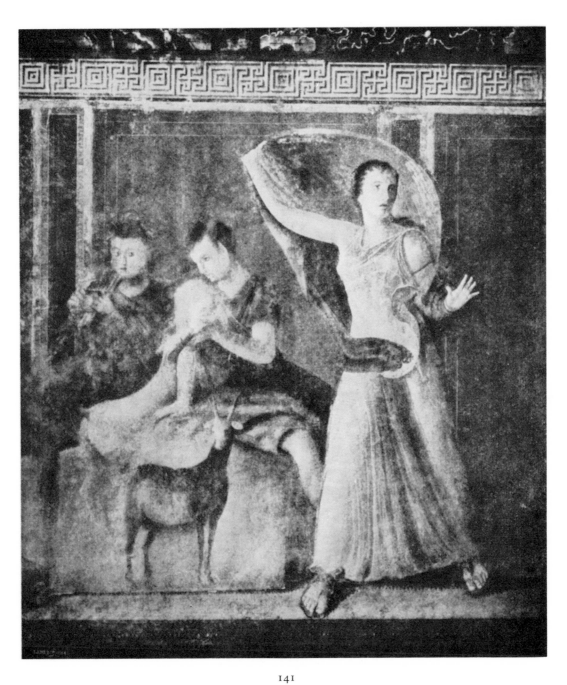

141

Part of a wall-painting in the Villa Item near Pompeii, 1st Century B.C.
Dionysiac Initiation (p. 119)

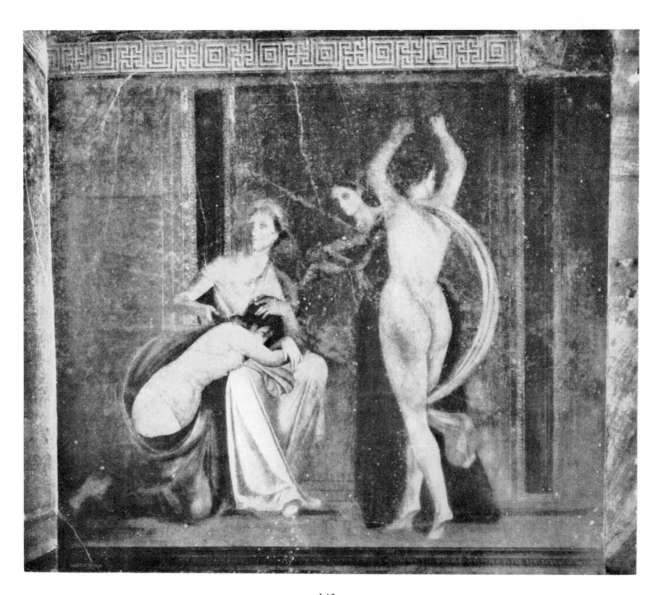

142

Part of a wall-painting in the Villa Item near Pompeii, 1st Century B.C.
Dionysiac Initiation (p. 119)

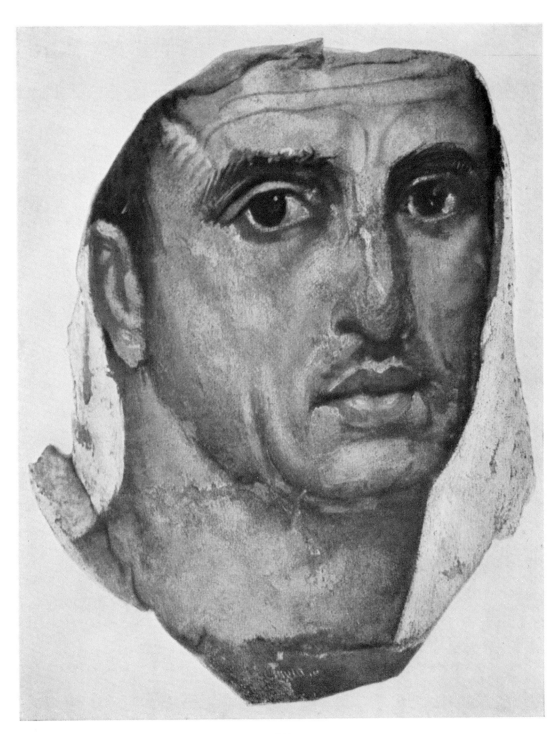

143

Mummy portrait, 1st Century A.D. (p. 126)
Copenhagen, Ny Carlsberg Glyptotek

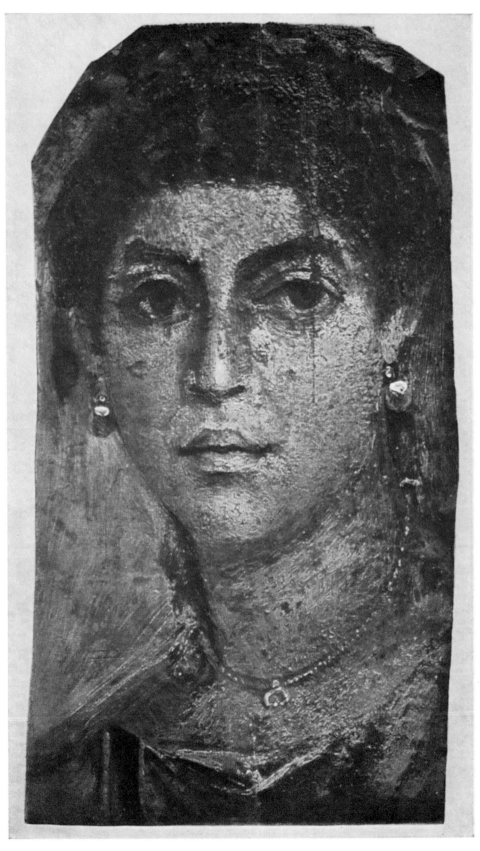

144
Mummy portrait, 2nd Century A.D. (p. 127)
London, National Gallery

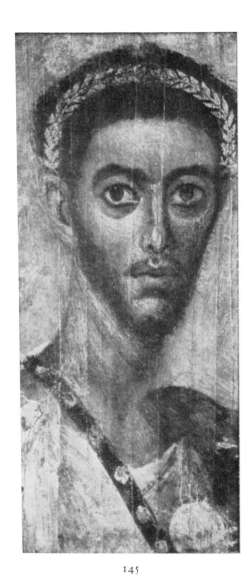

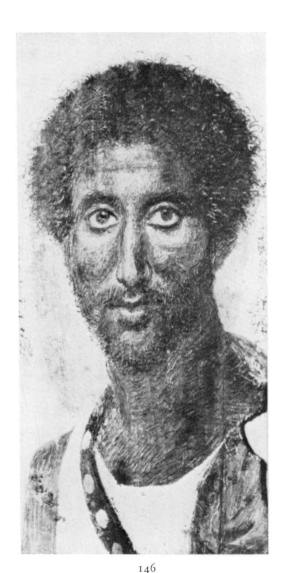

145

146

145, 146 Mummy portraits, 2nd Century A.D. (p. 127)
Vienna, Graf collection

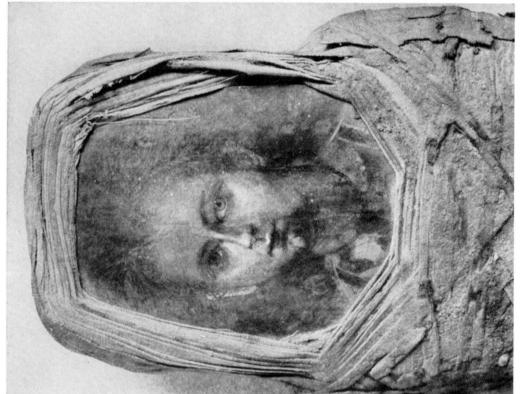

148

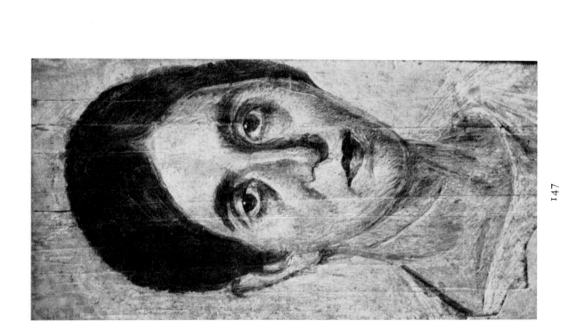

147

Mummy portraits, 2nd Century A.D. (p. 127)
Vienna, Graf collection – Munich, Museum antiker Kleinkunst

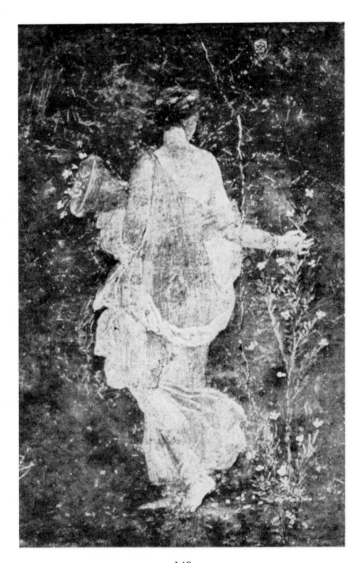

149
Wall-painting from Stabiae, 1st Century A.D.
Girl plucking flowers (p. 132)
Naples, Museo Nazionale

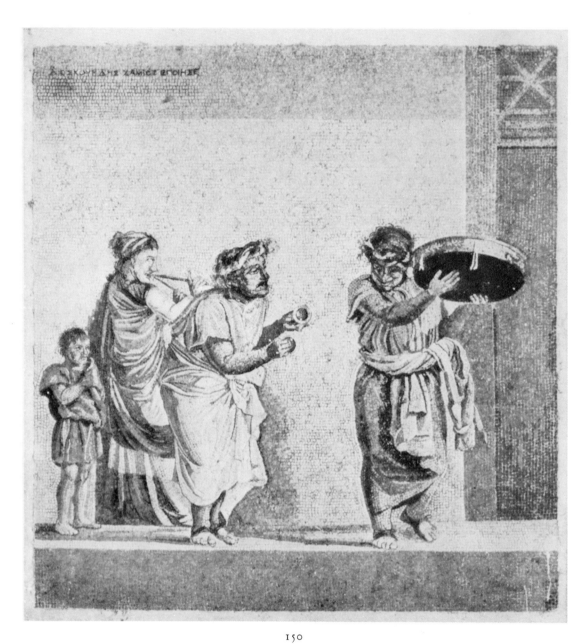

150

Mosaic by Dioskourides of Samos, from Pompeii, 2nd–1st Century B.C.
Mendicant musicians (p. 129)
Naples, Museo Nazionale

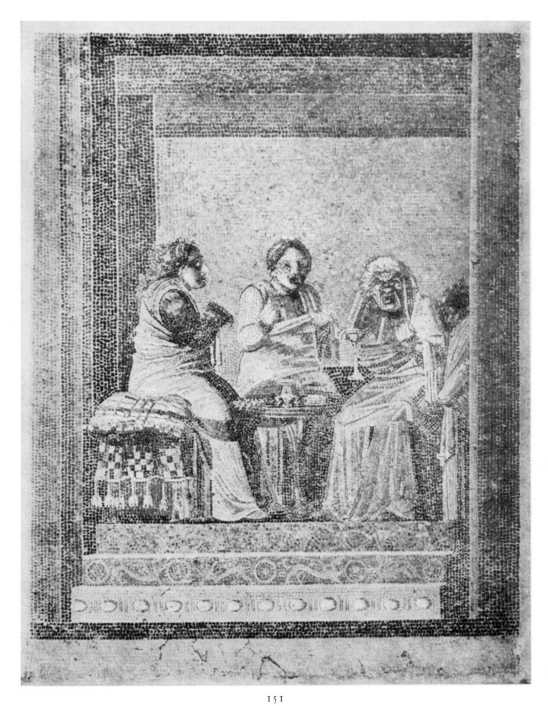

151

Mosaic by Dioskourides of Samos, from Pompeii, 2nd–1st Century B.C.
Scene from comedy (p. 131)
Naples, Museo Nazionale

152
Mosaic from Pompeii, *c.* 2nd Century B.C.
Lion and panther (p. 134)
Naples, Museo Nazionale

119

153

Mosaic from the Villa of the Emperor Hadrian
Centaurs attacked by wild beasts (p. 134)
Berlin, State Museums

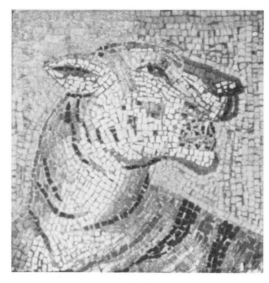

153 a
Mosaic from the Villa of the Emperor Hadrian
The genuine head of the tiger in Fig. 153, there a modern restoration (p. 136)

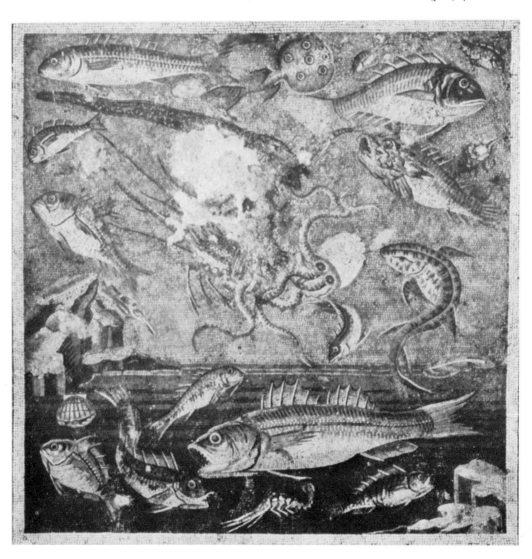

154
Mosaic from Pompeii, *c.* 2nd Century B.C.
Sea-creatures and shore landscape (p. 136)
Naples, Museo Nazionale

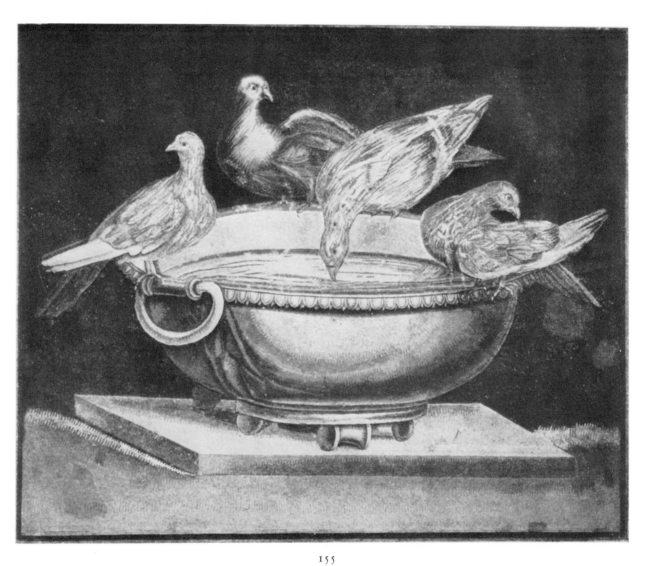

155
Mosaic from the Villa of the Emperor Hadrian,
after an original by Sosos at Pergamon (3rd–2nd Century B.C.)
Doves on a basin (p. 137)
Rome, Capitoline Museum

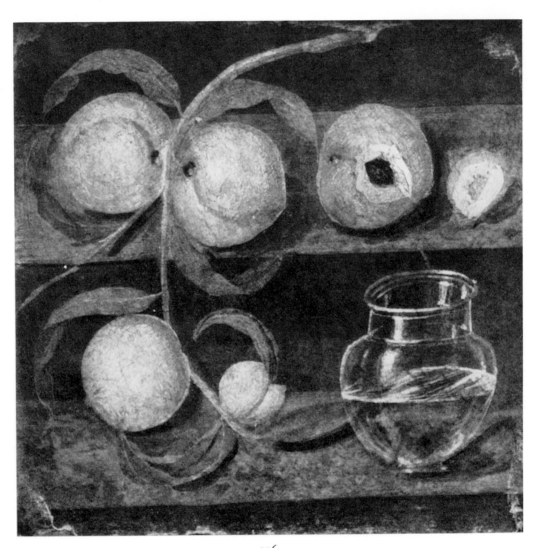

156
Pompeian wall-painting, 1st Century A.D.
Still-life (p. 139)
Naples, Museo Nazionale

157

Mosaic from a Roman building of the 2nd Century A.D.
Basket of flowers (p. 139)
Rome, Vatican

158

Pompeian wall-painting, 1st Century A.D.
Mountain sanctuary (p. 142)
Naples, Museo Nazionale

159
From a Roman wall-frieze, 1st Century B.C.
Landscapes from the Odyssey: the Laestrygons destroying the ships of Odysseus:
to the right the island of Circe (p. 139)
Rome, Vatican Library

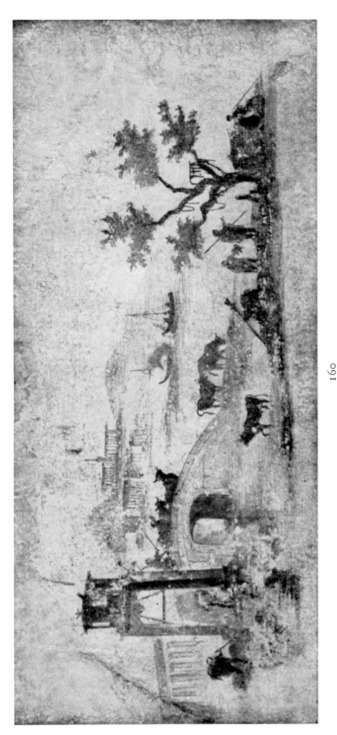

160

Roman wall-painting, 1st Century A.D.
Landscape (p. 160)
Rome, Villa Albani